THE TUMULTUOUS FIFTIES

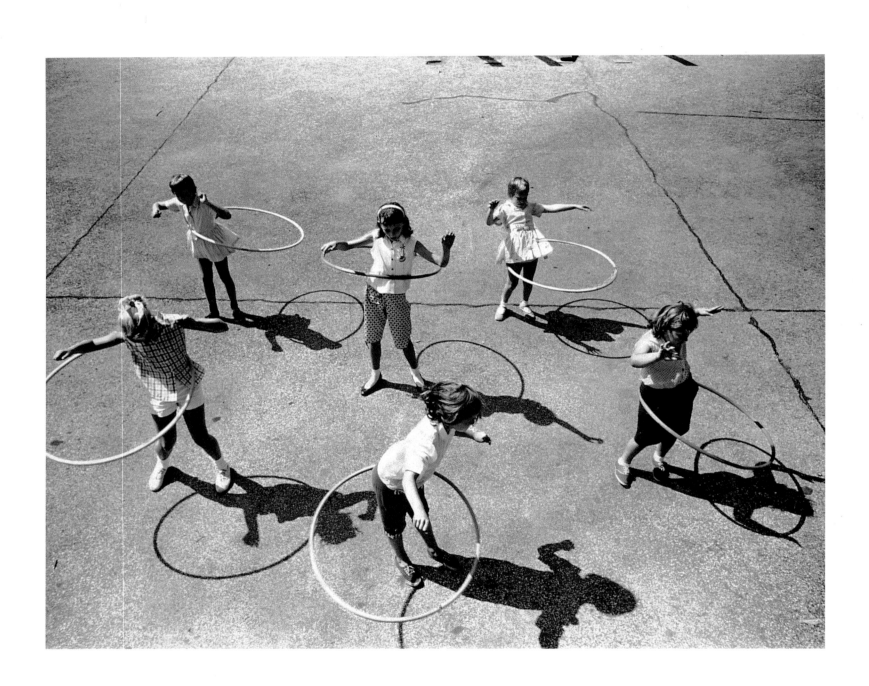

THE TUMULTUOUS FIFTIES

A View from The New York Times Photo Archives

Douglas Dreishpoon & Alan Trachtenberg
with Nancy Weinstock,
Special Projects Picture Editor, The New York Times

including a contribution by Luc Sante

Albright-Knox Art Gallery
Buffalo, New York

In cooperation with The New York Times Photo Archives
and Times History Productions, a division of The New York Times

Yale University Press
New Haven and London

THE TUMULTUOUS FIFTIES: A VIEW FROM THE NEW YORK TIMES PHOTO ARCHIVES is made possible with major funding from The ABC Companies, Inc. and the New York State Council on the Arts.

State of the Arts

NYSCA

The Albright-Knox Art Gallery is supported, in part, by public funds from the New York State Council on the Arts, and by grants-in-aid from the County of Erie and the City of Buffalo.

First Edition

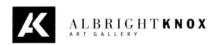

ALBRIGHT**KNOX**
ART GALLERY

Albright-Knox Art Gallery Editor: Karen Lee Spaulding

Yale University Press Editor & Designer: Adam Freudenheim

Indexer: Judith Wardman

Library of Congress Cataloguing-in-Publication Data

Dreishpoon, Douglas.
 The tumultuous fifties: a view from the New York Times photo archives / by Douglas Dreishpoon, Alan Trachtenberg, with Nancy Weinstock.
 p. cm.
 Includes bibliographical references and index.
 ISBN 0-914782-99-1 paper
 ISBN 0-30008821-3 cloth
1. Photojournalism—History—Exhibitions. 2. New York Times Company—Photograph collections—Exhibitions. 3. Photograph collections—New York (State)— New York—Exhibitions. I. Trachtenberg, Alan. II. Weinstock, Nancy. III. Title.

TR820.D74 2001
779'.990982'5—dc21 00-052955

A catalogue record for this book is available from the British Library.

The paper in this book meets the guidelines for permanence and durability of the Committee on Production Guidelines for Book Longevity of the Council on Library Resources.

10 9 8 7 6 5 4 3 2 1

Frontispiece: Eddie Hausner / The New York Times, *On the Town*, September 2, 1958, Courtesy The New York Times Photo Archives (Plate 92)

This catalogue is published in conjunction with the exhibition

THE TUMULTUOUS FIFTIES: A VIEW FROM THE NEW YORK TIMES PHOTO ARCHIVES

Albright-Knox Art Gallery	Buffalo, New York January 25 – April 7, 2002
The New-York Historical Society	New York, New York April 30 – July 21, 2002
Tang Teaching Museum and Art Gallery, Skidmore College	Saratoga Springs, New York October 12 – December 15, 2002
CU Art Galleries University of Colorado, Boulder	Boulder, Colorado January 23 – March 23, 2003
Museum of Art	Fort Lauderdale, Florida May 2 – July 13, 2003
University Gallery University of Massachusetts, Amherst	Amherst, Massachusetts September 13 – October 26, 2003
Terra Museum of American Art	Chicago, Illinois December 12, 2003 – February 8, 2004
National Museum of American History, Smithsonian Institution	Washington, D.C. March 12 – May 9, 2004
Michael C. Carlos Museum, Emory University	Atlanta, Georgia June 12 – August 8, 2004
Harn Museum of Art University of Florida, Gainesville	Gainesville, Florida September 5 – November 28, 2004

Contents

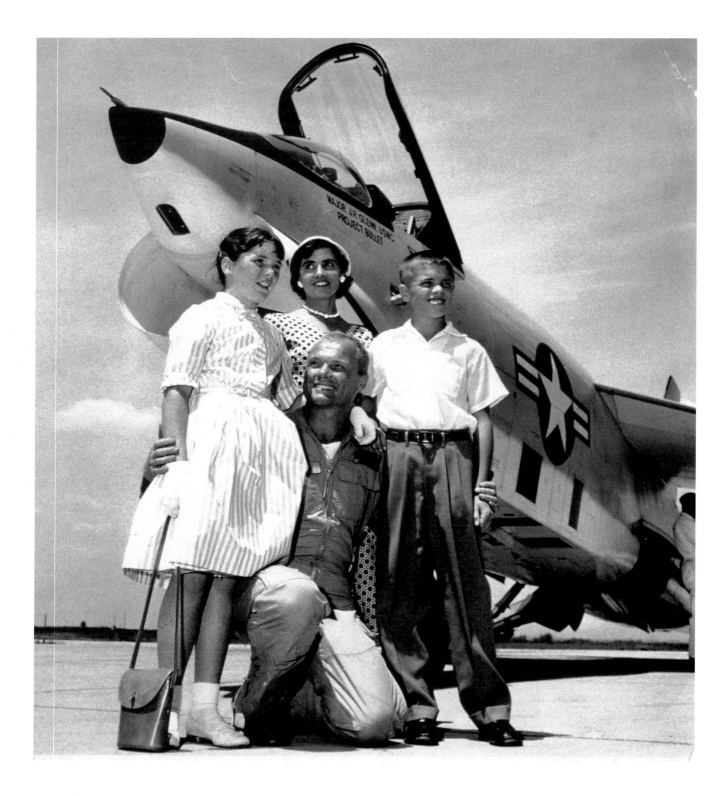

"Major John Glenn is greeted by his wife, Ann, and their two children, David, 11, and Lynn, 10."
Allyn Baum/The New York Times. Courtesy The New York Times Photo Archives.

Foreword

The *New York Times* has an immense picture archives – literally millions of images (mostly silver-gelatin prints) dating from the turn-of-the-century, when the first halftone reproduction appeared in the inaugural issue of the *Sunday Magazine* in 1896 to the 1980s, when digital processing superseded traditional darkroom techniques. Recognized early on as an important cultural resource, the *Times* archives has been the subject or source of several broad-spectrum exhibitions (particularly at New York's Museum of Modern Art), from *The Exact Instant*, organized by Edward Steichen in 1949 to *Pictures of the Times: A Century of Photography from the New York Times*, organized by Peter Galassi and Susan Kismaric in 1996.

The exhibition at the Albright-Knox Art Gallery, coorganized by the astute team of Gallery Curator Douglas Dreishpoon and Guest Curator Professor Alan Trachtenberg, takes a more focused approach, concentrating on a decade distinguished by monumental transformation in the cultural, social, and historical landscape of America and, indeed, the world. I am grateful to both of them for the enormous energy and enthusiasm that they brought to this project. Nancy Weinstock, Special Projects Picture Editor at the *New York Times*, was an indispensable partner in this significant endeavor; I know she has won the deep admiration and respect of both curators.

We are extremely pleased that this exhibition is traveling across the United States to museums and academic communities where the dialogue surrounding these photographs will be rich and provocative. We extend our appreciation to our colleagues for their support and for making this endeavor possible: President Betsy Gotbaum, Director Jan Ramirez, Director of Public Relations and Public Programs Stewart Desmond, and Director of Exhibi-tions Grady Turner at the New-York Historical Society, New York; Director Charles Stainback and Curator Ian Berry at the Tang Teaching Museum and Art Gallery, Skidmore College, Saratoga Springs, New York; Director Susan Krane, CU Art Galleries, University of Colorado, Boulder; Director and CEO Kathleen Harleman, Museum of Art, Fort Lauderdale, Florida; Director Betsy Siersma and Curator Regina Coppola, University Gallery, University of Massachusetts, Amherst; former Director and Curator of Collections John Hallmark Neff, Terra Museum of American Art, Chicago, Illinois; Director Spencer Crew and Curator of Prints and Photographs Helena Wright, National Museum of American History, Smithsonian Institution, Washington, D.C., Director Anthony G. Hirschel at the Michael C. Carlos Museum, Emory University, Atlanta, Georgia; and Interim Director Larry David Perkins at the Harn Museum of Art, University of Florida, Gainesville.

Public and private sponsorships are critical components of funding for any cultural institution. We are, therefore, most grateful for the generosity and trust that are extended to us by this exhibition's sponsors: The ABC Companies, Inc., Buffalo, and the New York State Council on the Arts.

Much has been made of the new millennium. As we stand at its cusp, we're given an excellent opportunity to review, reflect, and respond to the midpoint of a remarkable century through the photographs from *The Tumultuous Fifties: A View from The New York Times Photo Archives*.

DOUGLAS G. SCHULTZ
Director
Albright-Knox Art Gallery

A view of The New York Times Photo Archives, known as the "morgue," circa 1951.
Courtesy The New York Times Photo Archives.

Preface

Little did I know that my visit to the New York Times Photo Archives in 1995 to see my friend Nancy Weinstock — then a news picture editor detached from the newsroom in order to facilitate special projects and new business enterprises based on the archives collection — would lead to a full-blown exhibition of photographs from the fifties. I went out of curiosity. It was a chance to see the archival digs of a major New York newspaper. Who could pass up such an opportunity?

I had no idea what I would find there. When I stepped off the elevator, through a minimal security doorway and into a vast sprawl of antiquated file cabinets, another world confronted my senses. There was nothing glamorous about these lackluster environs, which reeked of fixative — the chemistry used to stabilize paper prints — and made my nostrils flare. I realized then that I had entered an archival mortuary, in this case a vast stockpile of under-utilized, though not insignificant, photographic images stored in hundreds of file cabinets occupying the entire floor of an unpretentious high-rise office building on Forty-third Street. The tour began. I was shown yellowing folders containing remarkably pristine prints of War World I battle scenes. I glimpsed vintage prints of Admiral Perry's expedition to the North Pole, another documenting one of the Wright Brothers' momentous flights at Kitty Hawk, and, in general, saw enough stellar material to be utterly captivated. By the afternoon's end, I was determined to find a way back to this cultural treasure trove.

Tackling an exhibition gleaned entirely from the archives of this paper was no radical notion. Others have mined the morgue's impressive holdings for various projects. The first to do so was Edward Steichen during his curatorial tenure at the Museum of Modern Art. Being a seasoned photographer who embraced the medium's many incarnations, Steichen infiltrated the temple of modernism with photographs in ways that today seem prescient. Through a series of innovative shows, beginning in 1942 with *Airways to Peace* and culminating in 1955 with the highly influential *Family of Man*, he endowed seemingly quotidian images published in daily newspapers, Sunday supplements, rotogravure sections, and news picture magazines with unprecedented credibility: He liberated them from the textual constraints of the printed page, in some cases cropping and enlarging their dimensions, and presented them in the hallowed galleries of a major New York art museum. As early as 1949, for *The Exact Instant*, Steichen had drawn from the archives of several national newspapers, including the *New York Times*, and presented this material on its own terms. Twenty-four years later, Steichen's successor, John Szarkowski, organized *From the Picture Press*, which also featured selections from the *Times* archives. Then, in celebration of the *Times*'s centennial in 1996, Peter Galassi and Susan Kismaric organized *Pictures of the Times: A Century of Photography from the New York Times*. Once again, the archives of this stalwart paper proved a formidable repository for historically significant images that brought the century to life in unexpected ways.

Compared to its predecessors, this project takes a more focused view. My reason for choosing the decade of the fifties, as opposed to, say, the sixties or seventies, had a lot to do with personal archaeology, wanting to revisit a time in my own life that remains vague at best. When I lectured about the project early on, I usually began with a family snapshot of myself at age three, dressed in lederhosen and a white woolen tennis sweater, playing with our faithful weimaraner in the backyard of my parents' first home in Poughkeepsie, New York. Here's the would-be curator, I'd say jokingly, a carefree boomer semi-conscious of the world around him. Though certain impressions — of fallout shelters, duck-and-cover drills, drive-ins, and "atomic fireball" candies — remain indelibly etched in my mind, mine was an insular world buffered from life's existential traumas. Here was the opportunity to revisit the decade of my youth through images grounded in the time of their making.

Admittedly, a professional fascination with postwar American art and culture also catalyzed the project, which introduced new areas of research and alternative ways of looking at photographic images. Traditional courses in "fine art" photography were of little help when it came to sorting through hundreds of photojournalistic prints. The world represented in a photograph by *Times* photographer George Tames, for instance, is a far cry from the rarefied world of an Alfred Stieglitz "Equivalent". Granted, subjectivity, present in both, is a question of degree. But in journalistic photography, subjective tendencies are tempered by objective facts, the imposition of specific circumstances and settings. In a news photograph, there is no such thing as an insignificant detail, be it an article of clothing, an unexpected object caught in the frame, or an animated gesture. Extracted from life's flux, journalistic images are loaded with significance, if one has the eyes to see it.

When it comes to reading photographs for their cultural significance, there are no finer eyes than Alan Trachtenberg's. Alan signed on as co-curator, and during the summer of 1999, we spent three whirlwind weeks in the morgue with Nancy Weinstock and Photo Archives Services Supervisor Dennis Laurie. It was an image blitz, an exhilarating and, at times, daunting task. The morgue is teeming with remarkable material, but without proper subject headings, access to it is limited. We arrived with some provisional ideas about how the show might look. Now our expectations had to be translated into a viable retrieval system. Fortunately we had experienced guides. Not only did we find what we were looking for, along the way we also made surprising discoveries.

What began as an empirical, wide-ranging search for relevant material (each subject folder, containing photographs from various decades, had to be carefully sorted through) became more focused as time went on. It took a few days just to get acclimated, to figure out the most efficient way to review the many folders that arrived daily in cardboard boxes at our workstation. Soon, we were on a roll. In any given folder, certain images gave pause because of their content and compelling composition. These were immediately set aside. As we became more familiar with the material, vintage prints were discernible at a glance, based on paper stock, tonality, compositional values, and depending on the photographer, a distinctive style. When in doubt, to verify a date, confirm a photographer's identity, or clarify content, we scanned the back of an image – a palimpsest, as

Luc Sante calls it, of its temporal existence, its publication history, and caption information.

By the end of three weeks, 500 images had risen to the top. From this lot we culled 195. Almost every print is vintage. Many are dog-eared and torn. Some retain their original crop marks, and, if airbrushed for publication, the residue ghosting of that process. We realized early on that an organizing principle was needed to bring some kind of order to an otherwise unwieldy mass of images. It was Alan, arriving early one morning after a productive evening, who proposed the use of thematic categories. Such categories and subcategories – "America in the World: War Hot and Cold"; "Mechanization in Command"; "Growing Up American"; Fame and Infamy; and "American Ways of Life" with its six subheadings: "Politicking," "Scapegoating," "Demonstrating," "Striking," "Serving," and "Struggling" – provide the theoretical framework for a revisionist, pictorial history of the fifties. We set out to reconstruct, from as many points of view as possible, a decade still shadowed by misconceptions and stereotypes. Having the archives of a major newspaper at our disposal provided endless options. Needless to say, ours is a selected history, one that we trust will encourage new lines of inquiry and alternative approaches to this watershed period in American history.

DOUGLAS DREISHPOON
Curator
Albright-Knox Art Gallery

Acknowledgements

The Tumultuous Fifties: A View from The New York Times Photo Archives evolved as a collaboration among numerous individuals, all of whom gave generously of their time and expertise. Early on, Susan W. Dryfoos, Director of *New York Times History Productions*, became an inside advocate and unwavering ally. Susan's former assistant, Adele Riepe, was always available to field innumerable queries as they came up.

Nancy Weinstock, who remained committed to the project even after leaving the morgue to return to the newspaper as Special Projects Picture Editor, was an indispensable guide and colleague. Over the course of three years, she monitored every conceivable production detail, assisting with the final selection of prints, reading drafts of essays, generating a wall text for the exhibition, and reviewing caption information for all photographs. Her unstinting efforts on our behalf, while juggling the myriad responsibilities of her primary role as a picture editor, were, at critical junctures, nothing short of heroic.

Dennis Laurie is the unsung morguemeister, technically Photo Archives Services Supervisor, and a first-class archivist. No one knows the morgue's idiosyncratic nature better than he does. On more than one occasion during our whirlwind stint, when groping to access an image in our mind's eye, Dennis generated the requisite subject heading and had the goods to our desk by the next morning. Through his expertise, an otherwise chaotic blitz seemed entirely manageable.

Interviews with *Times* staff and former staff provided a firsthand understanding of the paper's internal machinations and ample grist for the text "Pictures Among Words." Arthur Gelb, a *Times* employee since 1944, at various times its Drama Critic, Chief Cultural Correspondent, Cultural Editor, Metropolitan Editor, Assistant Managing Editor, Deputy Managing Editor, Managing Editor, and most recently President of the *New York Times* Company Foundation, was an invaluable source and facilitator for the project.

John Morris, the *Times* Photo Editor from 1967 to 1975, consented to respond to a series of questions faxed to his home in Paris. His candid recollections about the bullpen, staff photographers and their equipment, and the paper's graphic and pictorial development during the fifties and sixties were illuminating, as was his book, *Get the Picture* – required reading for anyone curious about the quixotic world of photojournalism. Oliver Morris kindly forwarded the request for an interview. Sheldon Heitner, a friend of John's in Paris, recited the questions and monitored the recording.

In the capacity of Assistant Managing Editor and Corporate Art Director of the *New York Times* Company during the sixties, Louis Silverstein, along with Gelb and Morris, implemented a typographic strategy that eventually created new spaces for pictures. Having begun his affiliation as Promotion Art Director in the fifties, Lou's was an unexpected and refreshing perspective.

Carolyn Lee, Assistant Managing Editor, offered the neophyte a succinct overview of the paper's daily production, its departmental organization, and the influence of editors and photo editors in determining the play of pictures. Her willingness to meet informally at the paper on a quiet Sunday morning over coffee and bagels shall be fondly remembered.

Eddie Hausner, Senior Photographer, is the kind of primary source one dreams about. A staff photographer since 1946, with an elephant's memory at the age of seventy-one, his colorful anecdotes about the trade, besides being chock full of technical insights, were touchingly humane. Morton Stone joined the *Times* in the fifties as a deputy picture editor. Reminiscing with him in the whirl of the third-floor newsroom was akin to time traveling with an experienced guide. David Frank, Manager of Picture Desk Technology, clarified the many ways digital technology has affected the paper's production, especially with regard to photographic imaging and archival practice. Fred Ritchin, former Picture Editor of the *Sunday Magazine* and now Professor of Photography and Communications at New York University's Tisch School of the Arts and Director of Pixel Press, is the author of a thought-provoking book, *In Our Own Image: The Coming Revolution in Photography*; its contents enhanced the conclusion of "Pictures Among Words." At the eleventh hour, Director of the Photo Archives, Jim Mones, kindly procured historical reproductions of the *Times* and its *Magazine* for publication in this catalogue. Mark Bussell, former Picture Editor of the *Times* as well as its *Magazine*, was a generous source of information and a trustworthy advisor whenever called upon.

Others at the *Times* contributed constructive advice. Thomas Carley, President of the News Services Division, and Lee Riffaterre, Senior Counsel, convened early on to formulate the terms of a preliminary contract with the Albright-Knox Art Gallery and subsequently reviewed the final contract for all participating venues.

Special thanks and appreciation go to Charles Zoeller, Director of the Associated Press News Library, for his generous assistance and cooperation and to our copyright and licensing colleagues in agencies throughout the country who gave us invalu-

able help in navigating permissions and clearances.

At the Albright-Knox Art Gallery, Director Douglas G. Schultz supported the project from beginning to end, committing financial resources and key personnel to ensure its completion. Curatorial Assistant Holly Hughes, a key point person, monitored numerous aspects of the exhibition and its catalogue. She not only compiled the catalogue's chronological timeline and generated the exhibition checklist over and over again but transcribed caption information for all photographs from frequently indecipherable photocopies. Once again, she proved an invaluable asset to the curatorial team. Curatorial Intern Thomas Smrtic participated in the initial stages of research, and Editor of Publications Sarah Hezel was invaluable in helping to prepare the final manuscript. Karen Lee Spaulding, Editor for Special Projects, graced every page of this publication with her perceptive eyes and collegial spirit. When Yale University Press early on expressed an interest in co-publishing, Karen followed up with Managing Director John Nicoll and Editor and Designer Adam Freudenheim and made it happen. Editorial sensitivity and good sense are a few of her many virtues. Anne Hayes, Development/Membership Officer, and a welcome voice of encouragement, brought David I. Herer, President of the ABC Companies, Inc., into the fold as a generous benefactor who, in the process, became a friend. Jennifer Bayles, Curator of Education, along with Associate Curator of Education, Mariann Smith, initiated an innovative series of educational programs for adults and children. The Library dream team of Janice Lurie, Tara Riese, and Susan Kelleher compiled the selected bibliography. Image Resources Librarian Yvonne Wide-

nor promptly and cheerfully processed all slide requests. And finally, Registrars Laura Fleischmann, Daisy Stroud, and Michael Benner, along with preparators Mark Burakowski and Bruce Rainier, brought definitive order to *The Tumultuous Fifties* by helping to realize its premiere at the Albright-Knox.

When it came to the catalogue, we were keen on including an essay Luc Sante wrote in 1996 for a special centennial issue of the *Sunday Magazine*. "The Morgue is Alive" made the perfect introduction to our project, and we are pleased to be able to reprint it here.

Others contributed in subtler, though no less significant, ways. In 1996, Ruth Beesch, then Director at the Weatherspoon Art Gallery, The University of North Carolina at Greensboro, endorsed a preliminary proposal for *The Tumultuous Fifties* and in doing so set the whole thing in motion. Tobi Kahn and Paul Tucker made timely introductions that enabled the project to germinate and, eventually, to blossom. Lisa Rafalson now knows more about the curatorial process than she'll ever want to. Through it all, she remained a behind-the-scenes voice of reason, and when the going got tough, a comforting soul.

DOUGLAS DREISHPOON
Curator
Albright-Knox Art Gallery

ALAN TRACHTENBERG
Neil Gray, Jr. Professor of English and American Studies
Yale University

THE TUMULTUOUS FIFTIES

The reverse side of an old photo often has its own tale to tell.
Photograph of the reverse of an Associated Press print by Tom Loonan.
Courtesy AP/Wide World Photos.

THE MORGUE IS ALIVE

Luc Sante

It is nowhere recorded just how and wherefore the name "morgue" first came to be given to the archives that newspapers keep of their own materials. It almost certainly happened more than 100 years ago – within a century during which the French word, meaning "a haughty and contemptuous attitude," came to be applied (rather mysteriously) to the building in Paris that temporarily housed the transient and unknown dead. The forgotten newsroom wordsmith who took the word to its next stage performed a wonderful act of compression – of poetry, really.

About two-thirds of the space in the *New York Times* morgue, which covers an entire floor of a nondescript office building near Times Square, is given over to photographs, filed in nearly 1, 500 drawers. Included are not only pictures that have been published in the *Sunday Magazine* over the last century, but also those run in the daily *Times*, and many that have never been published. The files devoted to clippings, which account for much of the balance of the space, contain a great deal of wonderful writing, to be sure, but they also include antediluvian wedding announcements, summaries of club speeches that everyone slept through, articles about the comings and goings of ocean liners. In the picture files, by contrast, can be found photos of the wedding party, of the assembled clubmen in their mahogany-paneled banquet room, of the crowd waving to the ship – and they are alive.

As I browsed among the three to six million photographic images (estimates vary considerably), thoughts of death and cold storage lagged well behind a dazed sense of wonder at the simultaneous presence of what seemed like every jot of the twentieth century. I found myself thinking that a better name for the picture morgue would be "The Aleph," after Jorge Luis Borges's notion in his story of the same name. That was the "small iridescent sphere of almost unbearable brilliance" he purports to have glimpsed in a Buenos Aires cellar, which contained "all space": "I saw the teeming sea; I saw daybreak and nightfall; I saw the multitudes of America . . . I saw bunches of grapes, snow, tobacco, lodes of metal, steam . . . I saw the delicate bone structure of a hand; I saw the survivors of a battle sending out picture postcards . . ."

The organization of the *Times* picture morgue is, to put it mildly, ad hoc. There is one major division: portraits sit in one area and pictures of everything else in another. Both sets are ordered numerically and consecutively, but that is as far as it goes. The various juxtapositions could not have been premeditated. A set of many folders devoted to prisons in New York City, say, is followed by an envelope of pictures of the folkways of German peasants, then one labeled "Expedition 1927 River of Doubt, Brazil," and then by a thick series containing photographs of nightclubs. One distant drawer, opened at random, yields "England – demon-

strations up to 1933": flat caps, rawboned features, grave and anxious countenances, threadbare tweeds, leaden skies. A nearby drawer contains "Sea Monsters": artists' conceptions, dubious-looking remains, people pointing urgently at placid lake surfaces. The personality files are no less haphazard in their arrangement: athletes of the 1980s bunk with chorines of the 1920s and insurance executives of the 1950s; countless brides of all decades share space with con artists and professional greeters. The most absolute democracy reigns, that of chance.

The first photographs that the *Times* published appeared in the first issue of the *Sunday Magazine*, in 1896. (In 1905, the newspaper began a separate Sunday pictorial section, which lasted until 1942.) The first halftone reproduction of a photo to appear in an American newspaper had been published in New York in 1873, in *The Daily Graphic*; but while the technology to print such pictures was available, the *Times* and many other newspapers were slow to abandon their traditional daily formats. It was not until 1914 that the *Times* caught up, when it began publication of the *Mid-Week Pictorial*, a weekly supplement that was sold separately for a dime. Until its divestiture in 1936, the *Mid-Week Pictorial* published a regular barrage of splendid photographs, splashed across the page in bold modernist layouts. The *Times* also operated its own picture agency, Times Wide World Photos, which was sold to The Associated Press in 1941, and until the 1960s kept an in-house commercial portrait studio that often immortalized the faces of sundry captains of industry.

The morgue reflects all this activity, and then some. There are pictures generated by every known agency and wire service, pictures bought over the transom from freelancers (these frequently bear a penciled notation like "$10" on their backs), pictures mailed in by amateurs (sometimes accompanied by prolix explanatory letters). The earliest personality files reveal untold treasures: that of Yvette Guilbert, the grand turn-of-the-century French singer, for example, contains glorious cabinet-card portraits by the major photographers of both Europe and America, one of them Napoleon Sarony, New York's own Nadar at least in social eminence. Elsewhere there are genuine, sometimes signed, Edward Westons and Dorothea Langes. The *Times* also ran photographs by Margaret Bourke-White, Henri Cartier-Bresson and Edward Steichen; there are 1930's Farm Security Administration photographs by the bunch, by Lange, Walker Evans, Ben Shahn, Russell Lee — the whole team.

But then, too, many beautiful pictures remain unattributed. Photography, especially news photography, was for so long considered a trade, not an art, that its practitioners bothered to sign or stamp their works only when they were concerned about copyright protection, a matter that did not affect staff or agency employees. Thus there is no way to find out who shot the astonishing scenes that fill the "Mexican Revolution" folder, for instance. They are by diverse hands — some are printed on postcard stock, at least one having been mailed directly to the *Times* editor — but their quality is consistently high. That complex debacle, which began in 1910 and ran episodically until 1920, was a prototype of the modern idea of war as a media event. The war was taking place, after all, next door to the United States, and it coincided with a huge demographic expansion of photography in America, so it was covered by hundreds of wildly competitive photographers. With the lens of the new century trained on the ragged elements of a feudal society, almost every picture is sadly ironic — a forecast of many small wars to come.

In the files, too, are works that not even the most discerning contemporary would have viewed as art, but that the passage of time allows us to see differently. The annual "Crimes and Criminals" files, begun in 1946, are particularly rich in such specimens: close-up views of workaday objects, made ineffably dramatic by the lens; massive crowd scenes captured with pinpoint precision by Speed Graphics, every face in focus; enigmatic shots of cops examining intangible evidence, the photographs sometimes featuring arrows drawn in white ink, pointing at unguessable clues. These pictures, recording stray bits of daily life, have acquired a greater mystery now that their specific import has been forgotten, their ordinariness making them all the more ominous. Sometimes detachment from context can make a photograph happily surrealistic: the policemen seemingly engaged in a passionate rooftop tango are actually recruits, back in 1934, practicing a method of disarming criminals.

But all these pictures are haunted. Even the dullest head shot of a minor diplomat is a window into a lost world. Not only clothing and manner but also faces themselves seem to change over the course of the century. Even stranger are those pictures that, owing to some accident of lighting, look as if they had been taken yesterday, but turn out to be 70 years old. And then there is New York City, subject of tens thousands of these photographs. It always looks like itself, deeply familiar to any resident, even when all the specifics of a given scene have vanished. It is hard not to feel a queasy dislocation when looking at pictures of the Third Avenue El, or the rows of neon signs along 52nd Street in the bebop era, or the completely erased neighborhood known as Dry Dock, around 10th Street east of Avenue C — they look as available as the view out the window.

Sometimes the only way to tell the age of a photograph is by examining its reverse side, more often than not a palimpsest of rubber stamps and scrawls. These may begin with the identification of the photographers or originating agency, include a pasted-on clipping of the caption, feature a flurry of stamped dates if the photo proved perennially useful, gather cropping indications or editorial cautions or background details or stray wisecracks. In some cases the surfaces of the photographs are equally lay-

ered, made almost three-dimensional by the work of the retoucher. Computers have relegated this once indispensable craft to the historical dustbin, but the morgue provides proof that the *Times* was routinely highlighting details of murky pictures until the 1970s. In the 1920s and 30s, though, retouchers were painters who took photographic prints as raw material and entirely reconstituted them. Their work, in white and black ink and the bluish-gray tones of the airbrush, can make pictures of minor Broadway canaries look nearly Ingres-like in their velvety seamlessness. If, on the other hand, they were out to isolate one or two features of a busy composition, consigning the rest to an oblivion of shading, their impasto could become positively Abstract Expressionist.

The technological forces that have eliminated the retouchers' brushes have also sealed the morgue. Over the last few years, the filing of prints has been nearly terminated at the *Times*; most photographs are now preserved directly on computer disk. This,

of course, hardly means the morgue's end – its resources will continue to be drawn upon for as long as the paper or its cyberspace analogues exist. But it is now bracketed, a memory lobe covering the century almost exactly. It is a magnificent chaos – the world under hypnosis, images pouring forth helter-skelter: murder and ceremony, famine and high jinks, rush hour and the lunar surface, bowling leagues and grand juries, record snowfalls and roof-garden orchestras, Hitler and Stalin and Seattle Slew, Judge Crater and Fanny Brice and Father Divine and the Sex Pistols, Porfirio Rubirosa and Pearl Buck and the Boston Strangler and the Mormon Tabernacle Choir. You might well be in there, too, if only in the depths of some street scene, unaware of the camera, on a day you now don't remember at all.

This text is reprinted in its entirety with the permission of the author and The New York Times. *First published in the* Sunday Magazine, *June 9, 1996, pp. 92 and 93.*

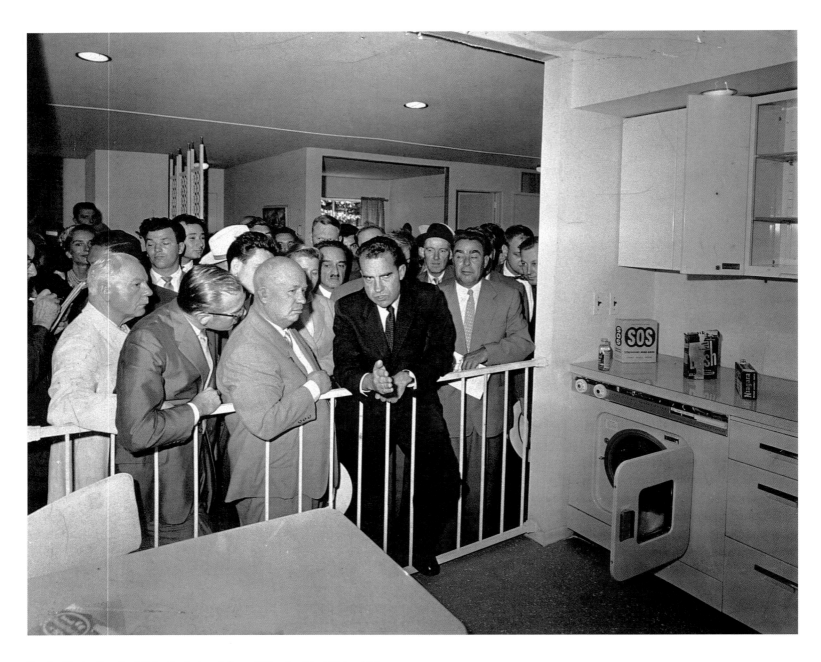

Fig. 1 "Soviet Premier Nikita Krushchev, left, and Vice President Richard Nixon talk as they stand in front of display in kitchen area of the U.S. exhibit in Moscow's Sokolniki Park, July 24 [1959]. The exhibit was formally opened this day in the Russian capital. The Vice President traded barbed comments with Soviet leader as they toured the exhibit."
Anonymous/Associated Press. Courtesy AP/Wide World Photos

PICTURING HISTORY IN THE MORGUE

Alan Trachtenberg

Here is revealed an amazing and often startling mass of insignificant data about people, places, events, and instants. Things ordinarily unseen and seen from strange angles, postures, gestures, phenomena, evoke new visual perceptions. The news camera has looked upon and fixed a period in the story of our time.[1]

Edward Steichen

PARCELLING HISTORY INTO DECADES seems a chronic American habit. Very likely it owes its appeal to the swiftness of change in modern times; one era gives way to another with such alacrity that decades have come to seem natural frames for historical memory. From the perspective of the 1930s, the "depression" decade, the fast living and quest for pleasure of the 1920s seemed singular enough to earn an epithet: the Jazz Age. The upheavals of the 1960s, which have needed no further tag than "the sixties," produced "the fifties" and its indelible monograms of conformity, affluence, and anxiety. But how much do the tags tell us?

Rather than homogeneous passages of time, decades are better understood as containing key moments in dialectical tension with each other. The fifties in particular was a segment of time so split between conflicting values and self-images that it might well be called, among other epithets, the "schizoid decade." The fifties was an age of "abundance," of "loyalty" and "security," but also of rebellion: rock-and-roll, abstract expressionism, the Beat generation, the beginnings of the civil-rights movement in the South. While cold-war ideology speaking through the mass media celebrated America as a society of virtue fulfilling its special destiny as "nature's nation," a model of righteousness, a "city on a hill" to the rest of the world, social critics were describing a society of alienated, anomic, and conformist ("other-directed") individuals, of groups set against each other by race and class, of white-collar labor as degrading, of "growing up" American as growing up "absurd."[2]

Moreover, links between decades are less discontinuous than the stereotypes imply. As interesting and significant as we find the differences between the fifties and the sixties, similarities and continuities may be equally interesting and even more important. Unless we are content to be no more than consumers of information, we normally think about the past with an eye to and from the present. What we want to know is what the past has to teach the present. People live their history with little regard for the calendar, and it's we in the present who, looking backwards, select and arrange facts and images to compose a story, a "usable past," in order to explain how our society got to be the way it is, and how it might be changed for the better.

■ ■ ■

Two key elements of historical thinking come together in this exhibition of photographs from the fifties. The first is thematic, represented by the selection of images that show how the era was portrayed in photographs published in the nation's leading newspaper, the *New York Times*. The selection seeks to represent the many subjects and figures deemed by the editors of the *Times* as

newsworthy, deserving (or requiring) photographic depiction. The exhibition provides an index to the visual culture of the decade, its variety of images and styles, and the role of newspaper photography in the making of that culture. The fact that cameras and images (including television images) figure prominently in the selected pictures tells us that the mechanical making, reproducing, and circulating of images played a conspicuous role in giving the decade its special character, perhaps its most formative process. In addition, the exhibition has another purpose or hope, that it will induce viewers to think about the relationship between photography and history, about the difference photography makes in our understanding of the past. How do images of the past *become* history in our eyes and minds? This is the theoretical component of the exhibition, the implicit question posed by the photographs and their arrangement: what does it mean, what does it entail, to think about history through photographs?

The theoretical question concerns the relation between raw fact, which photographs are often thought to represent, and some principle of order, some way of cooking the raw into digestible form. Should historians interpret the past according to ideas current in the present, or should they try only to recover the past as it really was – *"wie es eigentlich gewesen?"* The German historian Leopold von Ranke offered this famous definition of historicism in 1824, just fifteen years before the invention of photography. The coincidence suggests a teasing relation between a fundamental change in thinking about history and the emergence of a medium that cannot help but reveal, without judgment or commentary but as pure visual occurrence, exactly how things were in the precise space and at the precise moment of exposure. The French poet Paul Valéry encapsulates the historiographical significance of the camera in these words: "The mere notion of photography, when we introduce it into our meditation on the genesis of historical knowledge and its true value, suggests this simple question: *Could such and such a fact, as it is narrated, have been photographed?"*[3] The question alone would seem to enlist photography as an ally and adjunct of historicism, a technical means toward the end of showing and telling how things really were. If, as Siegfried Kracauer writes, "historicism is concerned with the photography of time," then the camera performs as the perfect historicist, a mechanical recording machine whereby every present moment instantly becomes a preserved past moment, a relic for future wonderment and study.[4]

Valéry suggests a way of taking history, "our meditation on the genesis of historical knowledge," from the point of view of photography. Invert the question and ask how photography looks from the point of view of history, and the results are a bit different. The idea of photography affects history by giving to our imaginations the possibility that whatever exists in fields of light can be photographed, made permanent, from all conceivable angles of vision. But does the idea of history give to each and every photograph a warrant of *historical* significance, a guaranteed place in a field of knowledge? Many in the nineteenth century, and many still today, believed with Lady Eastlake, as she put it in an essay written in 1857, that "no photographic picture that ever was taken, in heaven, or earth, or in the waters underneath the earth, of any thing, or scene, however defective when measured by an artistic scale, is destitute of a special, and what we may call an historical interest."[5] Lady Eastlake's words represent a high utopian moment in the history of the idea of photography, the hope that the new medium would reveal the world, mirror-like, in its pristine *thereness*, making it available as intimate experience and natural knowledge. This was still a time when the photographs you saw were either daguerreotypes, one-of-a-kind images shimmering on mirrored metal surfaces, or paper prints made directly from negatives on emulsified albumen paper, brilliant images suspended as if magically in an ethereal medium. The medium itself fostered illusions of closeness to actual objects in the world, the image seeming truly a mirror, an unmediated experience of the world.

Although this utopian hope for photography has never entirely expired, it has slowly given way to skepticism. The deluge or "blizzard" (Kracauer's metaphor) of images injected into the world by the advent of mechanical reproduction of photographs in media of print and ink decisively changed how photographs were seen, consumed, and used by a vastly enlarged audience. The simultaneous emergence of serious artists in photography early in the twentieth century gave the lie to the idea of the camera as an inert mirror indiscriminately copying the world; the first self-conscious photographic "art" stressed the formative creativity of the selective eye and the personal realization of technique. With the rise of halftone illustrations in newspapers and magazines in the same years, what one saw now most often were not photographs but dim copies of photographs made of tiny black-and-white dots, no longer uniquely captivating images of things we might imagine ourselves close to, but images repeated in countless numbers, seen simultaneously by anonymous masses of people. They seemed substitutes for things and scenes rather than magical mirrors of the world.

It is as if mass photography in the mode of halftone reproduction had replaced the world instead of opening upon it. The historicist wish for an account of "how it really was" underwent a sorcerer's apprentice transformation, as if a colossal machine for turning out simulacra were bent on converting the entire visible world instantaneously into a past as instantly dead as yesterday's news. Transformed into reproducible image, the world-as-such recedes from experience; images no longer mediate but stand in the way, actively preventing free visual experience from occur-

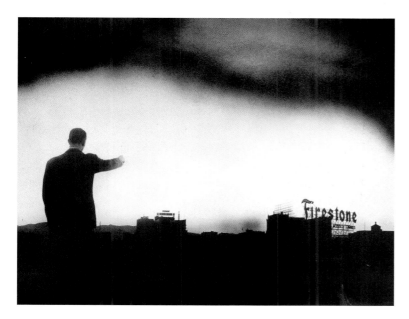

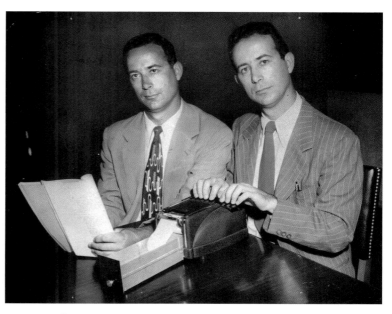

Fig. 2 *Lights in Las Vegas*, February 11, 1951. Perry Bowler/International News Photo

Fig. 3 *Out for a Record*, August 15, 1954. Drennan for The New York Times. Courtesy The New York Times Photo Archives

ring. A newspaper photograph lives only as long as it delivers novelty; "dead" means it no longer excites or satisfies curiosity. It exaggerates, but not by much, to say that the deluge of mechanically reproduced newspaper images delivers a world already dead, or at least in the final stages of the startlingly brief half-life of modern everyday curiosity about "news."

How to bring discarded filed-away newspaper images back to life as history is the challenge posed by this exhibition. What is offered here is another way of looking at that decade toward the end of stimulating thinking about the fifties as part of the history of the present. All the photographs come from a single source, the *New York Times* Photo Archives, familiarly known as "the morgue." Images are stored here when they have already served their purpose and are now considered, as far as "news" goes, no longer alive. But as countless researchers who regularly search here for pictures of specific people and events know, the millions of images buried in the morgue have a second life awaiting them, as if they were simply filed away for another day.

The principle underlying this exhibition is that photographs are important vehicles of historical knowledge, a unique way of acquiring a familiarity with the past. Not that the camera promises absolute truth. Photographs can be as elusive, arcane, and as partial as any other source of information. Who is that silhouetted figure pointing toward a glare in a dark sky and a horizon marked with a "Firestone" sign in Roman letters, and what does his gesture mean? (fig. 2) What's the story of those twin-looking young men in jackets and ties sitting at a desk, one with his fingers on a stenography machine, the other holding a sheaf of papers,

both looking archly at the camera? (fig. 3) What do such images have to do with "the tumultuous fifties?" To make the best of an image we need supplementary data in words. Who took the picture, when and why, and how was it distributed and viewed at the time? We also need an ordering structure, a narrative that captures and holds the image as a source of meaning, something we *need* to see and understand in order to make sense of the history to which we belong. Without a story motivating our response to these images, they are likely to perish in our eyes as only so much more or less legible information. We need narratives as supplements to images, what Walter Benjamin has in mind when he speaks of "captions which understand the photography which turns all the relation of life into literature, and without which all photographic construction must remain bound in coincidence."[6] Every photograph shown here has a story or stories to tell, if we only know how to tell or write them.

The historical value of these pictures begins in the fact that they appeared at the time, seen by hundreds of thousands of daily readers of the *Times*. They represent the *Times*'s version of the decade, the *Times*'s contribution to the visual culture of the time, an opportunity to catch important elements of that culture in formation. Many of the pictures show photographers at work, arrayed in audiences where public figures speak, where candidates perform their tricks, or, in sports stadiums, where chance and randomness offer spectacles of excitement against the monotony of daily life; with cameras in hand, they stand ready to make the ephemeral and the transient seem eternal, at least for a moment. We see television cameras at work in studios and on sound stages, and we see their products, flittering

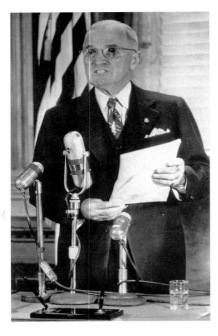

Fig. 4 Truman Gives A-bomb Warning, November 30, 1950 (made). Henry Griffin/Associated Press. Courtesy AP/Wide World Photos

images proclaiming "reality" on tiny cathode-tube screens in lonely rooms and even lonelier public places. The pictures shown here showed the era to itself, what the world looked like in the guise of news, what the newspaper-reading public took as the day's "reality."

Properly speaking, news photography was born with the invention of the halftone process in the 1890s, which enabled newspapers to print images along with type on the same page. By the 1930s, the·news photographer clutching a four-by-five-inch camera with flashbulb was a familiar urban type, like Weegee, a prowler of city streets by day and by night. Now, in the fifties, smaller, faster cameras joined with the new television cameras to make the camera eye virtually ubiquitous. News photographs were part of an expanding image-world that made the era look and feel different from any previous decade. "The image" defined the decade, a ready means of communication but also a surrogate reality, a way of thinking about what is real. Cameras were likely to appear at any time at any place, poised to capture, preserve, and reduplicate bodily gestures, nuances of faces, dramas small and large enacted in public and private places: President Harry Truman baring his teeth as he announces to three microphones his threat to drop an atomic bomb on North Korea (fig. 4); a man in uniform carrying a mannequin from a busted store window on a city street (fig. 5); sixteen women, some in fur coats, others in drab cloth coats, standing in a line facing a camera beneath a highway overpass, each carrying a sign with an alphabet letter that together spell "SAVE OUR VILLAGES!" (fig. 6) What idea of political demonstration do we witness here, what idea of women as civic beings and agents of social change? They hardly seem the bored housewives we associate with the "complacent" fifties. Just as there was no escaping the camera eye, there is no escaping the incompleteness and ambiguity of inadequately captioned images. What is it that each image denies us in way of knowledge, in way of emotion? What more do we need to know? Photographs initiate chains of inquiry, which might lead by surprising routes from then to now.

News photographs often catch unguarded moments of revelation and present them as the stuff of everyday drama, only to

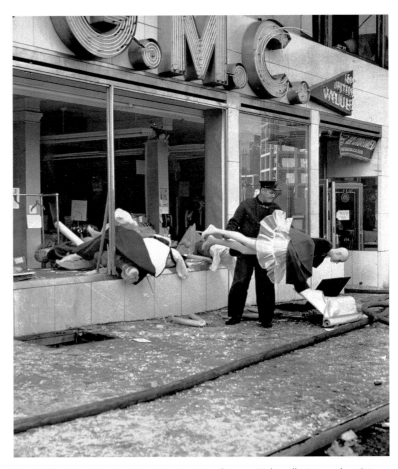

Fig. 5 Gas Explosion in Store Scatters Manikins on Sidewalk, November 24, 1956. Meyer Liebowitz/The New York Times. Courtesy The New York Times Photo Archives

expire the next day, fading from eye and mind. They are fleeting memory traces let loose by a visual culture of pure sensation. Presented in the newspaper as an adjunct to a written story, the photographs intrude with eye-catching imagery upon the staid columns of the *Times*, a stage of print upon which images perform their work. The photograph tempts the eye to abandon the print world momentarily for the less determinate, more ambiguous realm of visual expression. The pictures transform readers into viewers, enticing them to imagine themselves at the scene of the picture, to put themselves in the place of the camera. How did they stand in relation to their initial print contexts, the story they illustrated? This can tell us a good deal about how visuality functioned in the daily press in this era. Viewed some forty years after the fact, the images now challenge the historical rather than the journalistic imagination. What new captions need to be written for them? Each viewer will imagine the stories implied by the pictures, the contexts hidden and obscured by the frames of the picture.

These photographs feed the historical imagination in yet another important way. They expand our view of the materials of history. Pictures of striking workers raise questions about the role

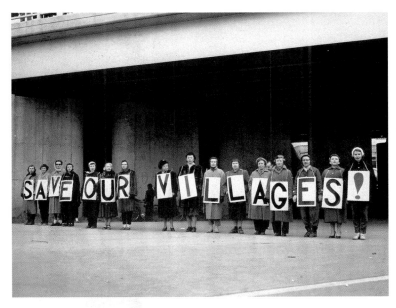

Fig. 6 Thruway Opening, December 16, 1955. Anonymous/The New York Times. Courtesy The New York Times Photo Archives

played by organized labor in this era. The major unions attempted to comply with the temper of the times by expelling Communists and ardently supporting US foreign policy. It's clear from the pictures that this did not mean that labor abandoned its goal of achieving economic justice by means of the mass strike. The threat of crippling strikes in major industries such as steel and transportation hung over the fifties. Pictures of workers tell a story not just of uneven distribution of the expanding wealth of the society, but also a story of the changing character of work, the changing relation of human labor to the machines of production. We see assembly lines, workers tending single machines, laborers on the floor of steel mills, and we see the transition to automated mills. What we don't see explicitly are the social and cultural consequences of piece-work or automation; they have to be inferred or conjured from larger narratives of the times. We see women industrial workers as well as men, and we wonder about the role played by working women, in white-collar as well as blue-collar jobs, in this period when television commercials, as we see in several stills, advertised women's place as the home not the factory, operators of domestic machines like vacuum cleaners and washing machines.

Many of the pictures show scenes of everyday life, moments of normalcy: drive-in movies, ball games, shoppers looking for bargains, vacationers at a crowded Florida resort, crowds attending a political rally, a famous athlete sitting casually in the backyard with his family. The pictures comprise a kind of source book of social-landscape imagery, from which other fifties' photographers like Robert Frank, William Klein, and Diane Arbus might have drawn for quite different purposes of portraying the inner emotional life of the times. Taken as a whole, the Times photographs

democratize our sense of the past. Filled with crowds, with unnamed demonstrators, strikers, pedestrians, factory workers, shoppers, clerks, children at play, the pictures disclose people undergoing experiences together or separately, the experience especially of inhabiting spaces already dominated by images and image-making apparatus. Were they conscious of living "in history," in a time shortly to be known as "the fifties"? The presence of the camera inevitably insinuates a sense that this very moment is about to become "past." This awareness of time about to be collapsed into space, experience reduced to two-dimensional image, makes for a revealing continuity between what we see here as "the fifties" and what we know about our times, our own even more image-saturated, virtualized, and manipulated visual culture.

The topical headings that organize these pictures offer key words, provisional categories to help contextualize each image: "America in the World: War, Hot and Cold," "Mechanization in Command," "Growing up American," "Fame and Infamy," "American Ways of Life: Politicking, Scapegoating, Demonstrating, Striking, Serving, Struggling." It's a thematic rather than chronological order, the aim being to suggest continuities and conflicts in the decade, brushing against strict chronology or timeline. Conventional written history organizes itself by events: the Korean War (1950–1953); the first American explosion of a hydrogen bomb (1952); the discovery of DNA (1952); the McCarthy hearings (1954); the Supreme Court decision against segregation in schools (1954); the distribution of the Salk vaccine against polio (1954); rebels entering Havana under Castro (1959). The history-by-photography offered here demands a different kind of reading: less linear, less by event, and more by textures and forms, by recurrences and variations of experience – people in crowds, individuals alone, aerial views of large spaces, close-up views of faces and bodies, rooms, streets, people at play, people at work. Pictures demand a different kind of attention, a willingness to imagine oneself within the scene of the image.

Apart from their usefulness as guides to large thematic patterns in the period, the categories also point up the underlying paradox that each image at once belongs to a pattern and stands as a world unto itself, its own field of light. To resist the reductive historicism of mass photography, both Kracauer and Benjamin urged that viewers recognize images as cognitions, constructions rather than passive reflections, opaque rather than transparent. What Kracauer calls "camera-reality," that which the camera looks out upon with its own resources – monocular vision, a lens with a specific range and depth and angle of vision – resists easy interpretation; camera-reality presents an obdurate world in which meaning does not come naturally but must be wrested with intellectual effort. It is part of the purpose of this exhibition to confront viewers with images that have all the earmarks of randomness, incompleteness, uncertainty – children crouching under school

desks while a smiling teacher hovers above them; four boys in suit jackets standing in a circle in a park, each holding a camera. The challenge is to make sense of each image, to discover in each a visual intention, without obliterating what remains raw, amorphous, uncooked: the everyday setting within which most of the depicted actions occur. Just as each picture can be taken as a more-or-less deliberate effort to "redeem" a segment of unprocessed visual reality by making a picture from its varied and often resistant materials, so the whole selection can be thought of as seeking redemption in the form of the viewer's effort to tell a story, to write an adequate narrative-caption.

■ ■ ■

The decade of the fifties has come down to us as an age of conventionality and meretriciousness, a time without great drama or credible heroes. Tacky suburban houses, ostentatious automobiles designed as marauding fish, men in gray-flannel suits, television quiz shows that turn out to be faked (even a distinguished university professor among the culprits), and glass-sheathed skyscrapers – the new clean look of corporate power – are among the era's tangible symbols, each representing something deceptive, something hidden, something denied. Contradiction is a better descriptor of the period than conformity. Preparations for "total war" and "massive retaliation" against an evil foe coexisted with feverish construction of suburbs, shopping malls, interstate highways, and expanding horizons of television. More and more of the society, the culture, the landscape itself, came within reach of "the system." In 1950, Diner's Club introduced the easily available credit card, a boon to economic demand, and a new tightening of corporate control over "consumers," an identity that began to seem as decisive and credible as "citizen."

Older racial and class distinctions, however, remained in place. Housing covenants excluded blacks from new suburban communities such as Levittown in New York (fig. 7) and segregation, unequal access to jobs, and unequal pay kept masses of African-Americans and other "colored" peoples in poverty, outsiders rather than participants in the burgeoning consumer society. Television in its commercials and melodramas, along with newspapers in their photographs, pictured America as virtually all-white and middle-class. The title of Ralph Ellison's great revelatory novel of 1952, *Invisible Man*, rings absolutely true for the picture of the nation purveyed by the mass media in these years: the invisibility of race, of poverty (or extreme wealth), of rage and conflict. What the socialist critic Michael Harrington would later call "The Other America" was out of sight, excluded from the media of visualization until the anger of the excluded broke into the news with the Montgomery bus boycott of 1955. The civil-rights movement emerged as the first significant rupture of the

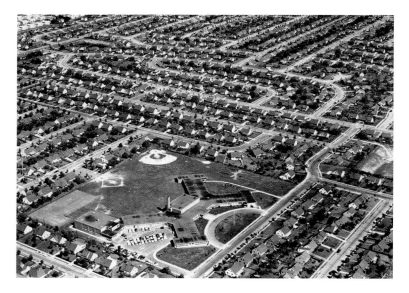

Fig. 7 Detail, Untitled [Aerial view of Levittown, NY, used in article "Bias in Suburban Housing"], April 17, 1957. Meyer Liebowitz/The New York Times. Courtesy The New York Times Photo Archives

fiction staged by the media of a racially homogeneous and classless society. It was as if, in the very years it expanded its powers exponentially, visual culture lay under a monitoring eye to assure that its images accorded with interests wishing to keep the status quo in place.

Contributing in a large way to the economic expansion were the weapons of mass destruction stockpiled across the national landscape. Prosperity implied popular confidence in the future, yet fear qualified confidence, fear of "the Bomb," of "subversives," of "enemies within," white fears of blacks, male fears of women, parents' fears of children. The advertised good life of middle-class security itself bred insecurities. Fear colliding with desire, distress with promise, desperation with hope, gave the decade its defining tone, a hesitant, uncertain, somewhat cynical hopefulness, a willingness to be duped in the pursuit of pleasure and happiness. The entertainment business emerged in this decade as a major provider of "reality," the forms as well as the content of what masses seemed eager to accept as their world. Was it a wish to be deceived? Was it that life felt safer, more secure, in the grip of manipulated fantasies? The opening of Walt Disney's first theme park, Disneyland, in Anaheim, California, in 1955 was surely one of the decade's most pregnant moments.

The mechanized make-believe represented in Disneyland, in which nostalgia for a simpler past joined fantasies of a happy American future, cast a spell over the entire era. The United States had emerged virtually unscathed from World War II, the most powerful and wealthy society on earth. At the close of the war in 1945, the nation seemed poised to fulfill the vision Henry Luce,

publisher of *Time* magazine, articulated in 1941: "a vision of America as a world power which . . . will guide us to the authentic creation of our 20th Century – our Century."[7] In command of two-thirds of the world's industrial capacity, the American economy took off, inaugurating a period of unprecedented growth that would last close to thirty years. One result was a drastic change in expectations from the last peacetime decade, the depression-stricken thirties. Returning veterans under the G.I. Bill could imagine themselves achieving a good education, a secure job, a comfortable style of life. Aspiration replaced depression; the worried look in photographs of the thirties gave way to smiling faces in ads and television commercials of the fifties. One pervasive ideal was a ranch-style house in the suburbs, white-collar husband, dutiful and resourceful housewife-mother, kids well-scrubbed and neatly combed, front lawn also trimmed, latest-model car, television set in the living room near the picture window. It was a cloying but compelling image and remains the most potent visual image of "the American Dream," a term invested with new power in these years after World War II.

Wasn't the American capitalist system the best expression of human nature one could imagine? An item of near-sacred belief, the mantra appeared hypnotically in sound and image. Television commercials advertised commodities as symbols of the nation, the words "America" and "USA" attached to everything from mouthwash to automobiles. Less subtle means for persuading the public of the identity of capitalism and Americanism were political instruments such as loyalty oaths and witch-hunts; the jailing of Alger Hiss in 1950 and the execution of the Rosenbergs for treasonous espionage in 1953 offered the most extreme instances of the effort to link Left political views with "disloyalty." Paranoia public and private lent a lurid tone to the standard picture. The pursuit of security harbored secret anxieties, fears of seeming different, of stepping out of line. The decade is known by its affects, and the fifties seem a dull parade of outward complacency and hidden angst, an "affluent society" harboring "the lonely crowd." In retrospect, the decade offers a pre-history to what came next, the eruption of protest and dissent in the sixties, rebellion on the campuses and in the streets, drugs, sexual revolution, cultural and political radicalism. Sixties radicals aimed their scorn and critique at virtually everything taken for granted as "normal" in the fifties, and the stereotype has remained in place.

The fifties seem prehistoric in yet another way. Still running on analog rather than our own digital time, the fifties had no personal computers, no e-mail, no faxes. It took longer to get from place to place, to reach around the world by printed or spoken word. Transistor radios were just then arriving on the market but there were no CDs, no point-and-shoot cameras, no digital images. Was the world simpler, more measured, more assured? There were anxieties about the "Bomb" and "Reds under the bed," but

the world as a whole was neatly folded into two parts, "free world" (i.e., capitalism identified as democracy) and "communism," one all good, the other all bad, and that made for a certain comforting reassurance. There was a palpable "enemy," a point of reference that explained who "we" were, what "we" stood for in opposition to "them." Views of the nation have not been as unified, as consensual, in the decades since the fifties. Passionate talk of "diversity" and "multiculturalism" in the nineties have made the fifties seem even more remote, even more ignoble, a ghost-ridden era.

Were the times really so monochromatic, so homogeneous, and acquiescent? The decade opened with another war, deftly misnamed a "police-action." In addition to the exhortation to national pride that accompanied the Korean War, it was a chance for the flexing of the latest advanced weaponry so lucrative to what retiring president Dwight D. Eisenhower in 1961 would call "the military-industrial complex." Korea was a foretaste of the Americanism that would founder later in Vietnam. After the election in 1952, national politics for the remaining years of the decade were dominated by an often-befuddled Eisenhower, his edgy and ambitious vice president Richard M. Nixon, and his two-time opposing candidate, the endearing "egg-head" Adlai Stevenson, standard bearer for a middle-of-the-road, anti-Communist liberalism. "He [Stevenson] has no clear policy on war or preparation for war, on water and flood control, on reduction of taxation, on the welfare state," wrote the august African-American leader W.E.B. Du Bois in 1956, explaining why he would not vote in the election of that year. After a final gasp of the influence it had garnered during the social crisis of the thirties and the wartime alliance with the Soviet Union, the Left ceased to be a force in national politics with the defeat of Henry Wallace and his Progressive Party in 1948. With anti-Communism as the nation's apparently consensual ideology, conservatism seemed to dominate.

But an altered picture comes into focus when we put back the turmoil and anger and fervor of the early civil-rights movement and the frequent labor strife. Social struggles of the thirties variety may have diminished in scale but they did not disappear altogether. Pressures toward political and cultural conformity may have ruled the day, but there was also considerable rebellion and creativity. Individuality flourished in music, in painting, in fiction, in social criticism. We tend to forget demonstrations *against* the House on Un-American Activities Committee. Although developments in the arts and in popular culture may have seemed detached from each other, viewed together – as the photographs of jazz artists and writers and abstract expressionist painters give us occasion to do – a pattern of cultural rebellion comes into focus. The continuing exodus of Southern, rural blacks into northern cities spurred a further infusion of African-American influence

into mainstream popular culture in rhythm and blues, rock and roll, and be-bop jazz. A youth culture arose to the beat of new rhythms and lyrics, whose prime note was defiance of bourgeois order for the sake of personal freedom and pleasure. Elvis Presley and Little Richard; the characters played on the screen by Marlon Brando and James Dean; Jack Kerouac and Allen Ginsberg, and the Beat generation, which flamboyantly flaunted anti-bourgeois values in dress and style of life and resisted the color line that separated blacks and whites, all brushed against the grain of the suburban "good life." Social critics like C. Wright Mills and Paul Goodman helped prepare the ground for the dissent and the search for alternative politics and social visions in the sixties. The fifties bred the energies that became the cultural revolution of the following years.

The mainstream continued to fly the flag and mouth the prayers. Fears of a life-and-death struggle between "good" and "evil," between American "freedom" and Soviet "slavery," created a mood in which conservatives were able to write the national agenda. Individualism, private enterprise, and religion were promulgated as basic tenets of the nation. With no significant opposition, no persuasive alternative able to make headway in the media-controlled public life, conservatism was able to rename itself "Americanism." The creed put economic doctrine first, making capitalism, democracy, and America synonymous terms. Ecumenical piety completed the package. "Recognition of the Supreme Being," President Eisenhower declared, "is the first, the most basic, expression of Americanism. Without God, there could be no American form of government, no American way of life"; in 1954, he had God inserted into the Pledge of Allegiance, "one nation, under God, indivisible."[8] Saturation of such rhetoric, in schools, churches, mass media, commercials, made it seem, as historian Eric Hobsbawm observes, that the nation defined itself in "exclusively ideological terms."[9] The true American was portrayed as the believer in the rectitude of individualism and free enterprise; of religion (any church will do, said Eisenhower); the male-dominated family; and, until Martin Luther King, Jr. in the early sixties made it impossible any longer to speak of "the American dream" in exclusionist terms, in white supremacy.

To be sure, rising levels of the GNP together with a hawkish militarism helped give the conservative version of Americanism credibility; lack of persuasive alternatives gave the field to the flag-wavers and boosters. Any dissent or skepticism toward dominant values fell under suspicion. Early in the decade, as Senator Joseph McCarthy thundered his charges of spies in the Army and the State Department and the House on Un-American Activities Committee scoured the country hunting for "Reds," a chilling fear set in. The election of mild-mannered Eisenhower in 1952 suggested that the nation wanted a reprieve from cold-war hysteria. McCarthy himself never recovered from the censure vote against

him in the Senate in 1954 after the famed McCarthy hearings had been televised the previous year, but the chill lingered. In 1958, the respected Harvard economist John Kenneth Galbraith remarked in *The Affluent Society*: "These are the days when men of all social disciplines and all political faiths seek the comfortable and the accepted; when the man of controversy is looked upon as a disturbing influence; and when, in minor modification of the scriptural parable, the bland lead the bland."[10]

The belief system required negative examples, scapegoats, and public rituals of cleansing. The execution of the Rosenbergs in 1953 was one such sorrowful event; another was the hounding of Paul Robeson, world-famous African-American athlete, actor, singer, and activist who became a target of hatred and vilification, his concerts disrupted, his passport confiscated, his life threatened. Firings of teachers and entertainers and government employees for suspected "disloyalty" or refusal to sign an oath or to testify against others at congressional hearings were also part of the often fearful spectacles of purification played out in the media, with real lives at stake. In the same years, from a different angle, the Kefauver hearings into organized crime performed a similar role by identifying Italian-born criminals as poisonous aliens within the body politic. In a strange recurrence of the witch-hunt hysteria of seventeenth-century Salem, "loyalty" or true Americanness could only be confirmed by tangible proof, visible signs of inner faith, such as swearing that one did not belong to any organization deemed "subversive" by the investigators. Avoiding any signs to the contrary seemed a life-and-death necessity; the pressure was to conform, to toe the line, to show oneself as a "team-player."

Most Americans went along with the credal imperatives of Americanism, at least passively. The cautionary mood virtually eliminated any "left" alternative from American politics; "socialism," the program of many Western European political parties at the time, became a forbidden word. If Americanism seemed to some people an empty slogan, the name of false dreams, a facade hiding inequality and injustice, those doubters remained relatively silent in the political realm, expressing their dissent or divergence from the norms of Americanism in non-political ways: watching foreign movies, listening to jazz, dancing to rock and roll, going "beat." Increasing numbers of dissidents joined demonstrations for nuclear disarmament (SANE, the best-known antinuclear organization, was founded in 1956), and at the end of the decade, for civil rights in the South. But a more or less tranquil normalcy seemed to prevail in everyday life. Communists were purged from labor unions, anti-Communist intellectuals held symposia on Americanism as the answer to Marxism, and "the end of ideology" seemed in sight. Look at the impossibly serene faces of women shown in photographs modeling clothing or demonstrating some household gadget on television, or the bland

smiles of performers playing happy families in sitcoms, and the whole story is revealed.

The line between blankness and blandness is not always discernible. In fact, while turmoil seethed beneath the surface and at the margins of mainstream life in the fifties, life was relatively stable and peaceful in these years. President Truman's firing in 1951 of General Douglas MacArthur as commander-in-chief of the United Nations (mainly American) forces in Korea because he wished to carry the war into China, showed that the Cold War had its limits. The policy to "contain" Soviet communism rather than overthrow it showed that in spite of apocalyptic fulminations on both sides, a state of de facto détente existed between the two nuclear powers, that the cold war was really, in Hobsbawm's words, a cold peace.[11] Was it all, or some of it, no more than a mirage, a set of pictures effectively deployed to keep a population on the edge of its seats and to cast a pall upon dissent and opposition? Opposition was portrayed as domestic disloyalty and foreign threat, and actual foreign examples in this period tended not to be white-skinned Russians but dark-skinned Puerto Rican nationalists, Cuban revolutionaries, Iranian nationalists, North Korean soldiers, and by the close of the decade, Vietnamese peasant guerrillas. The United States often intervened covertly and overtly in what came to be called Third World countries to assure that American "interests," which often translated into the interests of its companies doing business in these lands, would be "respected," that is, allowed to continue business-as-usual. Cold War rhetoric provided convenient defense of government protection of private economic interests. The stoning of Vice-President Nixon in Caracas in 1958 revealed the resentment and anger US policy often aroused. During this decade, Americans became increasingly aware of a larger world to which they were inextricably tied by their government's overt and covert actions, and photographs showing scenes of battle overseas, military installations, intercontinental ballistic missiles standing at the ready played their role in constructing persuasive pictures of American power overseas and at home. After the Russians launched Sputnik in 1957, the horizon of "world" included "outer space," which became another site of nationalist contest, another Cold War race. Whose science and technology were superior? While science represented progress, it also held a threat of more sophisticated weapons, more vulnerability to assault from elsewhere. Relatively stable, life in the fifties nevertheless felt precarious in the shadow of the Bomb.

While Cold War news dominated the headlines, actual preoccupations lay elsewhere, not with worries over subversives or accidental tripping of doomsday weapons, but with making a living and bettering one's life according to the precepts and opportunities conveyed by the mass media. The fifties saw new patterns and new volumes of consumption. Spending became a principle

of the American Way. From early in the century, consumer culture represented a shift from an economy geared mainly to production to one dedicated more to selling goods. A further transformation with worldwide implications occurred in these years, a pattern of interconnected changes: the rise of suburbia, which gave new importance to the privately owned automobile and led to the building of new highways, including an interstate system (one of Eisenhower's pet projects), and new shopping malls linked to those highways. Heavy construction projects were underway in every section of the country. The demographic shift represented by the flight to the suburbs eviscerated the older urban downtown shopping and entertainment districts, leaving behind slum areas populated predominantly by poor people of color; expanding suburbs and fast highways facilitated the "white flight," which wholly changed the character of city life. Abandoned centers, in another paradoxical movement in the period, began to fill with free-wheeling and free-speaking young people, artists, musicians, writers, white and black, male and female. In the shadow of the new glass towers, a new kind of bohemia emerged in the major cities, a seedbed of the rebellions and alternative life-styles of the sixties.

Suburban living has been taken apart in scholarly treatises, looked at from every angle, hailed by developers as the fulfillment of the American Dream, ridiculed in popular songs and films, blamed for frustrated housewives and disgruntled youngsters. Symptom of virtually everything thought to be wrong with the decade, including whites' fears of blacks, suburbia is the caricature of the fifties: fake "rustic" communities, desperate mothers and bored children, enjoying physical comfort but festering, as one recent commentator writes, with "a growing undercurrent of rebellion."[12] Like most caricatures, there's some truth in the image but more exaggeration and simplification. Suburbia actually represented major social transformations worldwide. In the fifties, writes Hobsbawm, "many people, especially in the increasingly prosperous 'developed' countries, became aware that things were indeed strikingly improved."[13] The perception flowed from several developments that formed a single pattern of global change: huge population movements away from rural to urban and suburban areas; a continuing sharp decline in the number of people working as farmers, and at the same time, sharp increases based on science and technology in agricultural productivity; dramatic increases in industrial productivity, especially of consumer goods, while the percentage of workers engaged in blue-collar industrial labor also declined, so that in the course of the decade more people male and female were employed in white-collar or sales work than in manual labor. Applied science and technology, including early forms of automation, reduced the role of human labor in industrial production. It became possible to imagine production without people altogether. Leisure became a popular topic

in the media and in academic studies. The idea of progress seemed confirmed by the proliferation of machines. Science brought electronics, integrated circuits, synthetics, a cure for polio, exploration of space, breaking of the genetic code (DNA). Who could imagine what next? The implications of this change defied easy understanding. As Galbraith put it,

> One would not expect that the preoccupations of a poverty-ridden world would be relevant in one where the ordinary individual has access to amenities – foods, entertainment, personal transportation, and plumbing – in which not even the rich rejoiced a century ago. So great has been the change that many of the desires of the individual are no longer even evident to him. They become so only as they are synthesized, elaborated, and nurtured by advertising and salesmanship, and these, in turn, have become among our most important and talented professions.[14]

The American consumer society of the fifties, typified by private ownership of mortgaged single-family houses in the suburbs with perhaps two automobiles, represented a condition of abundance and affluence fundamentally new in human history. For most inhabitants, the suburban home with all its appurtenances (including TV dinners and easy access to malls) represented a major step upward in the scale of comfort and material well-being, a move from tenantry to a newly democratized (qualified by racial discrimination and social inequality) condition of property-ownership. With more widely distributed home ownership and the welfare state (social security, unemployment benefits, welfare), one can see why the fifties throughout the world but especially in America seemed a "golden age" of post-World War II prosperity, as Hobsbawm puts it, that was to last until the oil crisis and downturns of the seventies.[15]

An era of expanded opportunity in all realms is bound to heighten frustration among those deprived by reason of color and social class. The upheavals in the South, which filled the news in the closing years of the decade, had their roots far back, in the first slave ships to deposit their human cargo in the New World, in the Civil War, the betrayal of Reconstruction, the "strange career of Jim Crow" laws, continuing discrimination and humiliation of blacks even after the war against fascism. The changed climate of expansion of social hopes mixed with anxiety about the future fueled the movement of which Martin Luther King, Jr. emerged as the leading activist and symbol (fig. 8). The 1955 bus boycott initiated by the domestic worker Rosa Parks and mobilized by King and his colleagues in Montgomery, Alabama, marked the most significant turn in the decade toward a grassroots politics seeking to realize democratic promise. The previous year, the Supreme Court made its epochal ruling that "separate

Fig. 8 Untitled [The Rev. Dr. Martin Luther King, Jr.], March 20, 1956 (taken). George Tames/The New York Times. Courtesy The New York Times Photo Archives

but equal" schools defied the law. The entire intricate structure of segregation by race in public institutions and facilities in the South – a structure that had been pieced together at the turn of the century as a way to keep blacks and whites separate and the Southern ruling class safely in power – was now ruled to be outside federal law. The Court said segregation must end "with all deliberate speed," but Southern states and municipalities dragged their feet. Segregation had to be fought case by case in the courts, and by the early sixties, in the streets. The marchers, the mobs, the bombings, and killings that ensued were the decade's first serious rupture in civil order, a foretaste of what would follow in the sixties. Events in Little Rock, Arkansas, in 1957 proved the most terrifying and the most prophetic: white hatred unleashed against black children who peacefully, with deeply affecting grace under pressure, exercised their rights by trying to enter a school building; Army troops ordered by a reluctant President Eisenhower to quell what he called "mob rule" and to protect the image of the nation as a society of law and freedom; school children at risk because of their skin color, pursued tenaciously by the media, which transmitted photographic images around the world. This attempt to put the Supreme Court ruling into practice revealed a terrifying underside to the ideology of Americanism: the photographs taken at Little Rock and throughout the South in this period of White Citizen Councils and civil-rights activists, remain

as summarizing symbols of the era: citizens of the nation at their worst and at their best, the camera close at their heels.

■ ■ ■

Tumult veered toward turmoil as the decade drew to a close, a prelude to the coming era of assassinations, bombings, battles between soldiers and students. While political violence has subsided in the decades since the sixties and seventies, issues of justice that first achieved visibility through the photographic media in the fifties remain troubling elements in a national discourse divided over key terms like race, gender, class, diversity. Once thought safely embalmed in historical memory as a time of shabby conformity, a drab background for nostalgia-inducing, machine-tooled furniture and the flamboyance of Elvis Presley, the fifties come to life in these photographic traces and show that these years can still trouble us with their tumult and turmoil. The pictures open a view down a stack of years, a perspective backward and forward, and an opportunity to piece together a narrative of change from then to now. These are images found in a morgue and given another chance to live. Benjamin writes: "The past can be seized only as an image which flashes up at the instant when it can be recognized and is never seen again. . . . For every image of the past that is not recognized by the present as one of its concerns threatens to disappear irretrievably."[16] We can speak of these fifties photographs as having *reappeared*, retrieved from the dead, and restored to life because they so vividly speak to the concerns of the present.

NOTES

I wish to thank Jean-Christophe Agnew and Betty Trachtenberg for their generous reading of a preliminary draft of this essay. A.T.

1. Edward Steichen, "'News' Photography," in Fred J. Ringel, ed. *America as Americans See It* (New York: The Literary Guild, 1932), pp. 293–94.

2. I draw this summary of keywords in the social criticism and historical interpretation of the period from several significant books published in the decade, including Paul Goodman, *Growing Up Absurd* (New York: Vintage Books, 1960); C. Wright Mills, *White Collar: The American Middle-Classes* (New York: Oxford University Press, 1953); David M. Potter, *People of Plenty: Economic Abundance and the American Character* (Chicago: University of Chicago Press, 1954); David Reisman, Nathan Glazer, and Reuel Denny, *The Lonely Crowd: A Study of the Changing American Character* (New Haven: Yale University Press, 1953).

3. Paul Valéry, "The Centenary of Photography," in Alan Trachtenberg, ed., *Classic Essays on Photography* (New Haven: Leete's Island Books, 1980), p. 195.

4. Siegfried Kracauer, "Photography," in Kracauer, *The Mass Ornament*, translated and edited by Thomas Y. Levin (Cambridge: Harvard University Press, 1995), p. 50.

5. Lady Elizabeth Eastlake, "Photography," in Trachtenberg, ed., *Classic Essays*, p. 65.

6. Walter Benjamin, "A Short History of Photography," in ibid., p. 215.

7. Quoted in Lisa Phillips, *The American Century: Art & Culture, 1950–2000* (New York: Whitney Museum of American Art, 1999), p. 11.

8. Quoted in Lois Gordon and Alan Gordon, *American Chronicle* (New Haven and London: Yale University Press, 1999), p. 522.

9. Eric Hobsbawm, *The Age of Extremes: A History of the World, 1914–1991* (New York: Random House, 1994), p. 235.

10. John Kenneth Galbraith, *The Affluent Society* (Boston: Houghton Mifflin Company, 1958), p. 5.

11. Hobsbawm, *The Age of Extremes*, p. 228.

12. Peter Jennings and Todd Brewster, *The Century* (New York: Doubleday, 1998), p. 326.

13. Hobsbawm, *The Age of Extremes*, p. 257.

14. Galbraith, *The Affluent Society*, p. 2.

15. Hobsbawm, *The Age of Extremes*, pp. 257–86.

16. Walter Benjamin, in Hannah Arendt, ed., *Illuminations* (New York: Harcourt, Brace, and World, 1968), p. 257.

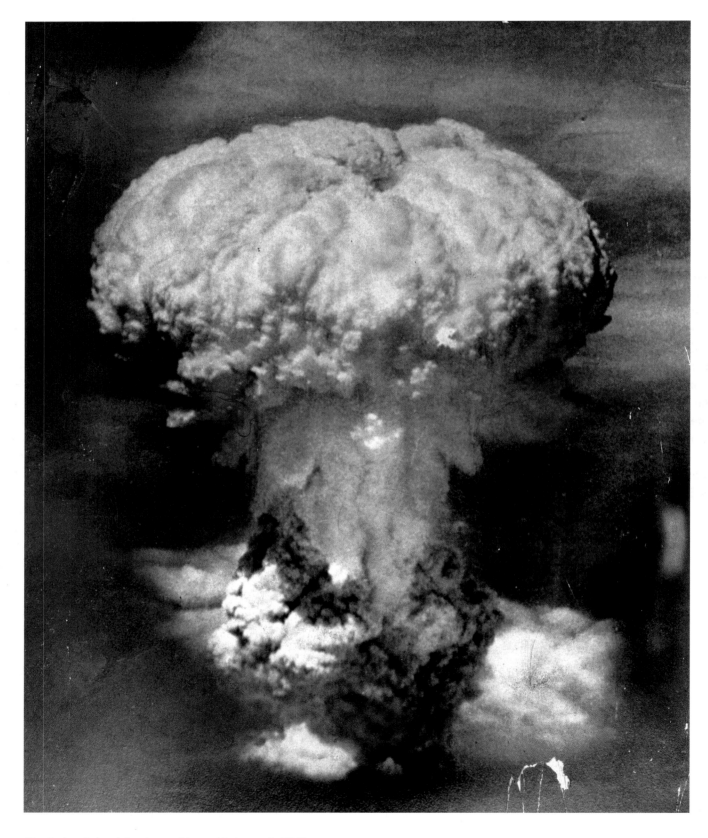

Fig. 1 Atomic bomb bursts over Nagasaki, August 9, 1945.
Courtesy The New York Times Photo Archives

PICTURES AMONG WORDS

Douglas Dreishpoon

Those who were young in 1900 have seen the world spinning down the groove of change faster and more giddily than they ever dreamed was possible. Tennyson's metaphor was drawn from the railways, which were new when he wrote "Locksley Hall." What he did not foresee was that the world might spin so fast and take sharp curves so recklessly that it would all end in a terrible smash-up. No one at the opening of the century foresaw that possibility, least of all those who were young then. The great surprise and disillusionment of that generation has been the fact that instead of an interesting ride and "getting somewhere" they have had to devote so much of their life to clearing up the wreckage.

"Topics of the Times," *The New York Times*,
January 1, 1950, p. 6E

ALTHOUGH IT APPEARED as only a short quip in *The Week in Review* section of the *New York Times*, published on the first day of a new decade, this editorial had a portent ring. "Fast and more fast" was its subheading, and like a Sunday sermon, its tone was prophetic, a call to order from an anonymous voice of reason. From the armchair perspective of the twenty-first century, the fifties appear animated by unbounded optimism on the one hand, covert skepticism on the other. From the fallout of a world war, the United States emerged a confident, global power. Still, a palpable ambivalence lingered in the minds of many. Science and technology had offered up the promise to improve and sustain human life but had also proven the ability to destroy life on an unprecedented scale. In the face of accelerated change, a national image emerged: a blustery facade tempered by an unlikely confluence of material prosperity, conformist ideologies, and conservative politics. Everything seemed possible from the outside. The psychic center, however, remained vulnerable.

More than 100 years old by 1950, photography had permeated the Western world with unsettling speed. As early as 1900, Alfred Stieglitz, the standard-bearer for photography as a fine art, had bemoaned the ever-increasing number of amateur "button-pushers" – a burgeoning cult of image mongers created by an industry named Kodak, that, by 1888, had marketed a portable, roll-film camera whose paper prints cost about ten cents to develop. Stieglitz defended art photography as a rarefied world of equivalence and metaphor. But the real world had developed an insatiable appetite for photographic images, and by the fifties there was no turning back. Cameras of all kinds, shapes, and sizes – Speed Graphics and Leicas, Contaxes and Rolleiflexes, 16 and 35 mm movie cameras, as well as the portable Bolex – had become a ubiquitous part of the cultural landscape. What distinguishes the decade is not the camera's persistent presence but the ever greater proliferation of its images in newspapers, tabloids, and magazines, as well as postcards and films. Thousands of camera eyes roving the world, seizing decisive moments – visual data for a history yet to be written.

From the admittedly jaundiced perspective of a media-saturated age, postwar America seems wildly naive. Perhaps the desire to return to order, to leave behind the chaos of war for a better quality of life, led to blind faith in utopian propositions. Regardless, the camera entered the cultural arena with little resistance. For savvy news photographers, it was a time of unlimited access; with a little moxie, any subject could be photographed. Today, lest they are caught off guard, people are more weary of the camera's presence, especially at potentially compromising moments. But in the fifties, the medium still had a privileged status (fig. 2). Images could be censored and were. But censorship

generally took place after the fact without hampering access. Perhaps the camera's appearance seemed entirely natural, benign, and still novel. Perhaps in people's minds, its presence conferred credibility. Perhaps the photographic documentation of events signified an inherently democratic practice, like other first-amendment privileges such as freedom of the press.

THE TIMES IN THE FIFTIES

By 1950, the *New York Times* had come a long way from its humble beginnings under Adolph Simon Ochs, the thirty-eight-year-old publisher of the *Chattanooga Times*, who purchased the New York paper in 1896 for $75,000.[1] If today's news becomes tomorrow's history, the *Times* prided itself on being in the forefront of all news-breaking events – international, national, local. In the early part of the decade, led by the capable Arthur Hays Sulzberger, the paper established offices in eleven national and thirteen international cities. And by the decade's end, the number of bureaus on both fronts had grown substantially. In the United States alone, seventeen offices occupied major cities in the East and West. In Europe, Asia, South America, India, Africa, Australia, and the Middle East, the *Times*'s presence increased nearly three-fold, with offices in Ankara, Buenos Aires, Cairo, Havana, Jerusalem, Johannesburg, Melbourne, Moscow, New Delhi, Rio de Janeiro, Santiago, and Tokyo. Points of access to a world in flux, these bureaus became the touchstone for an expanded international presence.

"The *Times* was distinguished by its foreign coverage during the fifties," boasted Arthur Gelb, former Managing Editor and an employee of the paper since 1944. "The War was over, Europe was making a comeback. Asia, Africa, and the Middle East were emerging as vital areas of interest. We sent our best correspondents abroad and that set the tenor of our foreign front, which blossomed. Our national coverage was good but our foreign coverage was brilliant."[2] By the war's end, in addition to its foreign bureaus, the paper had at least two staff photographers stationed abroad: George Alexanderson in China and Carl T. Gossett, Jr., in the Middle East. With or without staff photographers in the right place at the right time, it was still possible to access news photographs from numerous sources, among them the International News Service, United Press International, Magnum, Keystone, and Associated Press. Systems were already in place that guaranteed an abundance of newsworthy images for timely reproduction in the paper. Ironically, few made it to the printed page.

The *Times*'s relationship to photographic images has a fascinating, though complicated history. Early on, the paper recognized photography as a boon to the newspaper industry and set out to create its own photo service. The result was Times Wide World Photos, a syndicate established in 1919 to make photographs, to gather them for the *Times* from worldwide sources, and to distribute them to other newspapers.[3] By the late twenties, Times Wide World Photos had bureaus in Boston, Chicago, Washington, London, Paris, Frankfurt, Rome, and Vienna. Then in 1935, in response to the inauguration of a wirephoto network by the Associated Press, the *Times* developed its own facsimile system capable of transmitting photographs over ordinary, long-distance telephone lines. From that time on until 1941, when Times Wide World Photos was sold to the Associated Press, all photos transmitted by wire carried the credit line: Times Wide World Wired Photos. The *Times*'s commercial picture service in Europe,

Fig. 2 Senator Joseph R. McCarthy's charges of subversion in the State Department were first heard in 1950 by a Congressional Subcommittee headed by Senator Millard E. Tydings, seated second from right. McCarthy is partially visible behind him, April 1950. Courtesy The New York Times Photo Archives

Fig. 3 Front page of *The New York Times*, Sunday Magazine Supplement, September 6, 1896. Courtesy The New York Times Photo Archives

maintained for nine years following the sale of Times Wide World Photos, was eventually discontinued in 1950.

Picture services were one thing, images in the paper another. Context would often determine the play of photographs, whether they were featured, marginalized, or rejected. The first photographic halftones – thumbnail portraits of Stephen A. Douglas and John Bell, both presidential candidates in 1860 – appeared less than a

Fig. 4 *The New York Times*, Pictorial Supplement, January 22, 1905. Courtesy The New York Times Photo Archives

other exception is the "second front," literally the lead page of the paper's second section and a forum that came to have immense historical importance, especially for pictures. In this thirty-eight-page issue, the second front began on page twenty-five with an article on Australian scientists on expedition in the Antarctic, for which three photographs from the *Times* London bureau were run.[4]

The *Times* in the fifties was a news-dominated

month after Ochs purchased the paper in 1896, on page one of the first issue of the *Sunday Magazine* supplement (fig. 3). A new forum for photographs, it seemed, had been initiated. Nine years later, in 1905, the *Times* introduced the *Pictorial Supplement*: elegant portraits framed in elaborate borders and occupying entire spreads without columns of text (fig. 4). These were lavish layouts, with minimal captions for identification, a showcase for high-society and cultural events. There was also the *Mid-Week Pictorial*, initiated as the *Mid-Week Pictorial War Extra* in 1914, which ran large-format, action-packed photographs of Belgian, French, German, and Russian troops at the front lines of the Great War (fig. 5). Even at ten cents an issue, the *Mid-Week Pictorial*, a product of the new rotogravure process, was immensely popular, remaining in circulation with minor editorial adjustments until 1936. The *Times* may have promoted the generous use of photographs in its early supplements and rotogravure pictorials, but when it came to the main paper, other priorities took precedence.

A quick glance through the January 2, 1950, daily edition reveals the story. On the front page, among eight columns of text, appears a head shot of Albert V. Alexander with a *Times* photo credit (fig. 6). On page two, only text and advertisements appear. Pages three and four carry a single image with an AP credit line. On page three, an image of Chinese nationalist forces training with automatic weapons on the island of Formosa runs four columns wide; on page four an image of the Israeli parliament in session in Jerusalem runs three columns. Page five is all text and ads. In general, every other page, or every second page, displays a single image, except for the society and obituary pages, where multiple, single-column headshots consistently appear. The

paper. Words, not images, reigned supreme, even though exceptions were made for the *Sunday Magazine* and *Book Review* sections. (In the *Magazine*, pictures consistently received greater play. Unfolding across a spread, sometimes four to a page with captions and text, they had the allure of a genuine photo essay, comparable to the high-profile designs of *Life* and *Look*.) Compare an issue of the *Times* with a daily edition of, say, the *Daily News*, and the visual contrast highlights two radically divergent approaches (fig. 7). The *Times* avoided tabloid journalism, sensational content, and large-format reproductions in its daily

Fig. 5 Cover of *The New York Times Mid-Week Pictorial*, December 6, 1917. Courtesy The New York Times Photo Archives

Fig. 6 Front page of *The New York Times*, January 2, 1950. Courtesy The New York Times Photo Archives

Fig. 7 Front page of the *New York Daily News*, January 2, 1950. Courtesy Bell + Howell Publishing Services

editions. News had to be "fit to print." Fathered into its mandate, restraint not only ruled editorial decisions but determined the presence of pictures as well. Gelb put it succinctly when he said, "The word was the most important ingredient in the paper. Photographs played second fiddle. It was the reporter, who, early on in the paper's history, was the camera's eye, and he was selected for his ability to bring the reader into a scene. Reporters adept at using imagery were therefore prized. Photographs were not necessary to sell a newspaper. If anything, the *Times* looked down its nose at a tabloid approach to journalism."[5]

Even if the *Times* had favored photographs in its daily and Sunday editions, the paper's design layout was far from image friendly. An eight-column format, in use until 1976 when a wider six-column format was introduced, limited the size of photographs on any given spread.[6] From a design standpoint, the layout of the *Times*'s daily during the fifties was a piecemeal affair. The front page set the pace, with international, national, and metropolitan news introduced by headlines or subhead slugs. Articles were continued on subsequent pages throughout the paper, though locating them once one arrived at the right page could be challenging. Sometimes one column was inserted between two others, which disrupted the text and created irregular line breaks. Advertising, a necessary component in any paper, often ran roughshod over the text, at times corralling it into a corner or along the upper border of a page. In the glory days of Linotype ("hot metal") composition, mostly news editors and makeup men determined the main content and, ultimately, the look of each issue. With no uniform design, the paper's daily production was jockeyed between various departments. Under these circum-

stances, pictures desperately needed the partisan defense of a photo editor.

PICTURES IN THE PEN

There was nothing glamorous about the "bullpen." Even the name evokes a contentious arena, the journalistic equivalent of a DMZ, where heads bucked and egos flared. Dominated by the managing news editor and his assistants, the pen was a serious place; decisions made there determined the paper's primary content and coverage. The third-floor newsroom, where the bullpen was located, recalled Morton Stone, who joined the *Times* as a deputy picture editor in the early fifties, looked like "the set of an old movie . . . a huge, open room with dozens of old, battered wooden desks with manual typewriters." "Almost everyone smoked in those days," he reminisced. "Some guys even wore visors and armbands."[7] John Morris, whose appointment as Photo Editor in 1967 signaled an upper-management initiative to enliven the paper's presentation with more pictures, described the setup in his own words:

Along Forty-third Street the hierarchy extended east from [Clifton] Daniel to the four assistant managing editors: Manny Freedman, Abe Rosenthal, Harrison Salisbury, and Ted Bernstein, who had a small glassed-in office. Just outside it were the news editors of the bullpen. Next, for the convenience of the news editors, came the Picture Desk, actually six small desks shoved together covering an area about the size of a billiard

table. It was better equipped to handle words than pictures. Wire photo machines were at hand, but there were no photographers in sight; they worked out of the "studio" on the ninth floor, and their prints were delivered by lab men. The Art Department, which precisely cropped and if necessary retouched the pictures selected, was on the eighth floor. The picture archives were also on eight. Photos were engraved on the fifth floor, in a process that had changed little since the nineteenth century. A dumbwaiter delivered the resulting zinc cuts to the fourth-floor composing room. All very complicated.[8]

Complicated seems like wishful thinking given the convoluted machinations of the paper's production. Even by the late sixties, pictures were still anathema to most hard-core newsmen, provoking one of Morris's friends to remark jokingly that "becoming the picture editor of the *Times* is like becoming the recreational director at Forest Lawn [cemetery]."[9] "The wordmen were totally in control," Morris recalled. "News editors saw pictures as a necessary separation between stories and something to dress up the printed page. They were not picture friendly in the sense that they did not regard pictures as having reportorial value in themselves. If they did, it was as documents, something that would document a news story as text would."[10] Most of the editorial personalities in the pen, it seems, were so committed to news that pictures posed an imposition, especially when advertising was plentiful and column space scarce. Stories of dramatic episodes unfolding in and around the pen abound. Some have assumed an apocryphal aura. Eddie Hausner, a loyal *Times* photographer for more than fifty years, mentioned that Ted Bernstein, the night-time assistant editor and a kingpin in the pen, humorously kept a plaque discreetly in his desk that sported the following credo: "The reason for photographs in the *New York Times* is to break up the boredom of the written word."[11]

Needless to say, the bullpen was never a hotbed for pictures. Still, with the Picture Desk close by and a picture editor on call, images were, at least in theory, part of the mix. But what did it mean to be a *Times* photo editor? And what responsibilities came with the position? With Morris's appointment, the *Times* finally conceded to hire a professional with impeccable credentials and an acute sensibility.[12] Up until then, most entered the fray with little or no experience with pictures. One was expected to learn the ropes empirically. There was no job description, per se. If you knew your way around the newsroom as an editor or writer, or knew how the paper was produced and had a knack for managing diverse personnel, that was a good start. If you had an aptitude for looking at photographs, all the better.

During the fifties, three individuals claimed the unforgiving title of photo editor: Israel Cohen (fig. 8), John W. Randolph, and John S. Radosta. Cohen assumed the editorship in 1933 and held

Fig. 8 *The New York Times* Picture Editor Israel Cohen. Photo by The New York Times Studio, 1949. Courtesy The New York Times Photo Archives

on to it for nineteen years until his death in 1952.[13] Unlike his successors, he came to the job with some experience, having been a caption writer on the Sunday rotogravure news picture section and the night manager of rotogravures for Wide World Photos. After Cohen's death, Randolph took over but not for long. Only two years into his stint, in a more cavalier moment, he signed off on a racy picture – Marilyn Monroe and Joe DiMaggio poised to kiss in the judge's chamber before being pronounced man and wife – prominently on the paper's second front (fig. 9).[14] The repercussions were immediate; Randolph was banished from the Picture Desk to the sports department, where he quietly settled in as the column writer for "Wood, Field and Stream." Today, the episode claims an almost mythic stature. Apparently, the "kiss" picture transgressed the *Times*'s reputation as a "breakfast" paper by scraping against the grain of what was considered appropriate for its readership. In the future, photographic impropriety would not be tolerated, which of course made the incident a sobering reality check for those who followed.

When Radosta got to the Picture Desk in 1954, there were fourteen photographers on staff, twelve in New York City (fig. 10) and two in Washington, D.C. Radosta's tenure at the *Times* had begun nine years earlier, on the last day of 1945, first as a writer for *The Week in Review* section, then in a variety of editorial positions.[15] The transition from a writer and editor of the written word to an editor of photographs was not without its existential moments. Morris, who spent his first week at the *Times* observing, remembers Radosta dominated by the bullpen, which does not seem surprising given its photo-phobic inclinations. When it came to lobbying for pictures in the daily paper, Radosta was stymied

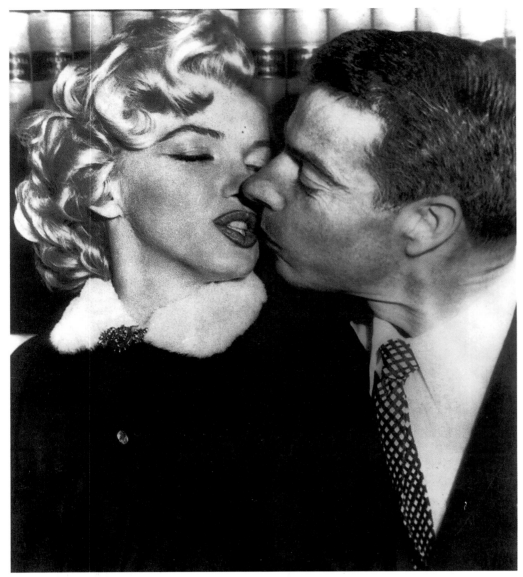

Fig. 9 Marilyn Monroe and Joe DiMaggio in the judge's chamber awaiting their marriage ceremony. Associated Press wire photo, published in *The New York Times*, January 15, 1954. Courtesy AP/Wide World Photos

Graphic . . . your angles, your shooting capacity, the speed and ease of shooting was so much better. So sensing this advantage, Radosta pushed for the transition to 35 mm all in a period of about two years."[16] Old habits, though, die hard, which may explain why, as late as 1957, Bill Eckenberg, Ernie Sisto, Sam Falk, Pat Burns, and Meyer (Mike) Liebowitz posed for their group portrait with their faithful Speed Graphics (fig. 11).

Many of the pictures selected for this exhibition, especially those by *Times* photographers, were taken with the trusty Speed Graphic. Developed in 1912 by the Folmer and Schwing division of Eastman Kodak, the camera used four-by-five-inch sheets of film and produced large negatives distinguished by precise detail and rich tonal passages. Fitted with a flashgun, the Speed Graphic became the standard camera of the press photographer from the late twenties through the fifties. Its cumbersome dimensions and limited film capacity, however, required adept technique. "In those days," Hausner explained, "using the Speed Graphic, you had to get the picture and you had to get it

by the conservative policies of "The Gray Lady." In other areas, however, he proved an effective manager, especially in the equipment department, where he encouraged staff to use smaller roll-film cameras.

"Radosta had great foresight," according to Hausner. "He decided that if *Look* and *Life* magazines could shoot 35 mm film, so could we. He was the first person to introduce the Rolleiflex, 120 roll-film format as standard *Times* equipment. There was opposition, though. The assignment editor at the time, John Dugan, literally couldn't see the smaller contact negatives because of poor eyesight. It became a personal thing. But Radosta finally won out and each of us was given a Rolleiflex to use in combination with the Graphic. 'Go out with your Graphic,' John would say, 'but try to shoot with this other camera in situations where it lends itself.' Well . . . we were all knocking them dead with the Rolleis, so we finally put our Graphics aside. With a standard lens, the Rolleiflex was more versatile than the

right the first time around if possible. If you didn't, you had to pull out the film holder and reset the next sheet, all of which took about five seconds if you were fast, before you could shoot another picture. So you always held off on the first one, because you wanted to be sure you had a gravy shot that would sustain the others. You needed a key shot – your lead picture – and you waited for it. Because of the equipment, you approached any given situation more cautiously."[17] Even though smaller, hand-held 35 mm Leicas had been in use since 1925 and were preferred by many European and American photojournalists, the Speed Graphic remained the camera of choice for most *Times* photographers, with the exception of Falk, who in the early fifties adopted the Contax for his *Sunday Magazine* assignments.[18]

Times photographers were a close-knit group. When they weren't out on the streets following leads for spot news, or installed behind a 500 mm lens at sport stadiums, many gathered at Gough's Place, the local watering hole across from the main

Fig. 10 *New York Times* photo staff on the day that the city of New York held a city-wide civil defense drill, November 28, 1951 (left to right): Carl T. Gossett, Jr., Larry C. Morris, George Alexanderson, Ernie Sisto, Patrick A. Burns, Arthur A. Brower (seated), John Dugan (assistant editor, seated), Fred Sass, Bill Eckenberg (Chief Photographer), Neil Boenzi, Meyer (Mike) Liebowitz, and Edward (Eddie) Hausner. Photo by Robert Walker. Courtesy Eddie Hausner and The New York Times Photo Archives

Fig. 11 *New York Times* photographers (left to right): Bill Eckenberg, Ernie Sisto, Sam Falk, Pat Burns, and Mike Liebowitz, April 1957. Courtesy The New York Times Photo Archives

building. When asked if the staff shared a common aesthetic or approach, Hausner responded, "There was no overriding style; everyone had their own way of shooting."[19] Morris concurred. "The photographers employed by the *Times* during the fifties," he said, "and the men I got to know well once I joined the paper, varied in temperament and in the quality of their work. What they had in common was a lot of history. Many had been with the *Times* a long time."[20] This was certainly the case for a core group consisting of Alexanderson, Burns, Eckenberg, Sisto, and Falk, all of whom had been hired in the twenties. Others, however, were hired later: Arthur Brower in 1936; George Tames and Liebowitz in 1945; Larry Morris in 1944; Gossett, Frederick Sass, Neil Boenzi, and Hausner in 1946. Some of these photographers (Brower, Burns, Liebowitz, Morris) had entered the profession without a formal education. Theirs had been on-the-job training, as printers and printer's assistants, messengers who delivered prints from the Photo Lab to the Picture Desk, or as squeegee-boys in the darkroom. Ambition and aptitude counted for a lot. So did creative imagination.

By the fifties, at least six photographers were on duty each day: four assigned to news stories and two to cover sports events. The Picture Desk included the day and nighttime picture editors, as well as three caption writers. Photographers usually received, either by phone or in person, daily assignments from the assignment editor, who arrived early each morning (around 6:30) to process numerous requests, usually in the form of memos left the night before by various departments – news, sports, fashion, and business. The fruits of a day's shoot were generally reviewed by the photo editor in the form of contact sheets from which the most promising frames were gleaned (fig. 12). Sometimes the photographer would make the first pass. Depending on the amount of film shot and developed for any given assignment, it was not uncommon to see work prints strewn across an office floor, as in Falk's picture of Radosta sorting through numerous photos by Harrison Salisbury, a foreign correspondent who shot his own film for several feature stories on Albania. (This back-bending method, efficient in a pinch and still deployed to this day, was mitigated by a

Fig. 12 Picture Editor John Radosta studying photographs taken by Harrison Salisbury for his feature stories on Albania, September 1957. Courtesy The New York Times Photo Archives

Fig. 13 Staff photographer Ernie Sisto manning a telephoto lens known as "Big Bertha," from the stands at Yankee Stadium, August 1952. Courtesy The New York Times Photo Archives

Fig. 15 Staff writer Charles Palmer and staff photographer Sam Falk on a radar tower 110 miles off of the New England coast, May 1956. Courtesy The New York Times Photo Archives

magnetic "picture wall," a well-lit horizontal surface where prints, or photocopies of prints, could be more easily reviewed.) Pictures were favored for their visual impact, their ability to draw the reader into a news article, feature story, or review. The process embodied a rectangular relationship between the photographer, photo editor, department head, and caption writer. Being staff in no way guaranteed that one's pictures made the final cut; others arrived daily over the wire and vied for precious space.

Fig. 14 The photo, taken by Neil Boenzi, published on November 26, 1951, was accompanied by the caption "A five alarm fire took place at a rubber plant at Concord and Gold Streets, Brooklyn this afternoon." Courtesy The New York Times Photo Archives

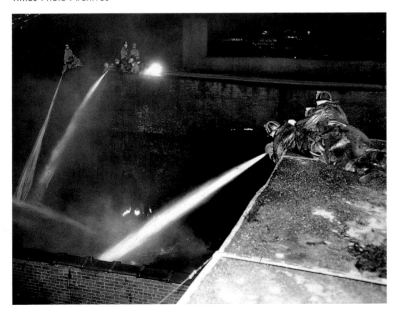

Images in newspapers remain anonymous unless identified by the name of their maker. There was no consistent policy regarding authorship at the *Times* until Morris arrived in the sixties and made bylines mandatory. Before then, some pictures appeared with a name, others with only a *Times* credit line. Today, one has to look on the back of the paper print to figure out who shot what, or to reference the original negative. With or without credit, certain *Times* photographers distinguished themselves. Sisto and Brower, for instance, were regularly assigned to sports events, and their work in this area is distinctive. "Sisto was an ace," Morris recalled, "especially gifted in sports photography, where his sense of timing was remarkable, even when wielding a cumbersome telephoto lens." (fig. 13) One can wait all day in the bleachers for a key play that clinches the game. Sisto and Brower anticipated those moments and recorded them with Big Bertha cameras.[21]

Mention staff photographers active during the postwar period and Boenzi's name inevitably comes up. Lauded for his ability to seize the essence of a scene, Boenzi's impeccable timing and intuition earned him the respect of editors and photographers alike. "He had an amazing set of eyes," beamed Mort Stone. "I've never seen anyone like Neil in his ability to take a few rolls out on the beat and return with remarkable pictures. There was nothing he couldn't do. In fact, if asked, he could probably shoot the history of humankind on three rolls."[22] Morris agreed. "Boenzi," he said, "was the star of the traditional staff. He never wasted film and could cover a story on one roll, where others might use three or four."[23] One look at Boenzi's dramatic picture of a five-alarm fire in Brooklyn, taken from the street, and his tal-

ents are obvious (fig. 14). Like any news photographer worth his salt, he knew when a situation had reached critical mass, when all elements crystallized into a compelling image.

Other worlds beyond Manhattan and the five boroughs were assigned to Falk and Tames, both of whom worked under the direction of Lester Markel's Sunday department.[24] The men traveled extensively and, compared to their

Fig. 16 "The 'Supernormal' Seven," cover story in *The New York Times* Magazine, August 16, 1959. Photographs by Sam Falk. Courtesy The New York Times Photo Archives

ing must stand between him and reality. He must absolutely be in the right place at the right time. No rewrite desk will save him. He must show it as it is. His editor chooses among those pictures to tell it as it was — or was it? Right or wrong, the picture is the last word."[25]

Leaving aside individual temperaments and nationalities, news photographers share a lot in common. Most see photography as a means of docu-

colleagues on the home front, had an elevated status, especially in the way their pictures were handled. Falk's, in particular, were consistently featured in the *Sunday Magazine*, as front covers, and inside as photo essays with captions and text. Tames gained an impressive reputation in Washington, D.C., where, as an insider to politics and a friend to politicians, he frequently came back with the picture as well as the scoop. Both photographers had great versatility. They covered everything from national conventions to the construction of a radar tower off the New England coast (fig. 15), or from a Klan rally near Montgomery, Alabama, to an Air Force base in Virginia, where seven individuals chosen by the NASA for Project Mercury trained to become the first United States astronauts (fig. 16). Quintessential photojournalists, they knew what it meant to get the picture, to be at the right place at the right time, and to bring back newsworthy material, even if, in the process, their own lives were put in jeopardy.

PHOTOGRAPHIC TRUTH

What drives a photographer to spot news or photojournalism? Is it the sense of adventure, the chance to witness history unfolding, to make images that influence the way people perceive the world? "Photographers are the most adventurous of journalists," Morris proposed. "They have to be. Unlike a reporter, who can piece together a story from a certain distance, a photographer must get to the scene of the action, whatever danger or discomfort that implies. A long lens may bring his subject closer, but noth-

menting life — its quotidian and dramatic expressions. Being journalistic photographers whose pictures are slated for newspapers and magazines, they tolerate cropping, just as they accept captions, with their potential to clarify and complement, falsify and obscure, the visual component. They tend to be pragmatic about the artistry of their work; a picture's formal integrity, they might say, is synonymous with a content grounded in life's unpredictable flux. In response to a question, "What is an artistic photographer?," posed by fellow *Life* photographer John Loengard, Cornell Capa replied, "Taking wonderful still lifes of things on tables, of landscapes which are bucolic and beautiful. I haven't taken a landscape picture which was not part of a story. If I saw a peasant working in the field . . . I took the picture of a peasant with a field. . . . The environmental and social condition became part of my photography."[26] When photographs aspire to journalism, meaning is contingent on context — the ruled and column pages of a newspaper or magazine, or, in special cases, the glossy pages of a book devoted exclusively to them. When they appear in the pristine galleries of a museum, other considerations come into play.

The *Family of Man* (fig. 17) probably seemed a godsend to photojournalists active before and after the Second World War. Conceived by Edward Steichen in 1955, for the hallowed halls of the Museum of Modern Art, the exhibition brought unprecedented prestige to this kind of work. Why should it matter, then, that the 503 pictures comprising the installation appeared without captions, were cropped and enlarged for dramatic effect, and were arranged according to subthemes that reinforced one

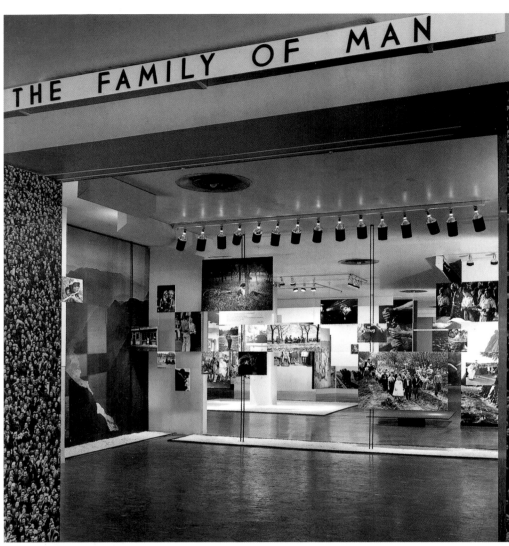

Fig. 17 Entrance to the exhibition *The Family of Man*, The Museum of Modern Art, New York. Designer Paul Rudolph; Curator Edward Steichen assisted by Wayne Miller and Dorothy Norman. January 24 – May 8, 1955. Photograph by Ezra Stoller © Esto. Courtesy The Museum of Modern Art, New York

expanded agenda for photography. Though his own career had begun in the rarefied fold of the Stieglitz circle, he eventually promoted photography as an expansive medium, whose coexistence with news, drama, advertising, and fashion made critical distinctions moot. He understood through firsthand experience the enormous influence news photography and photojournalism had on people's perception of the world, and in 1949, he organized an exhibition, *The Exact Instant*, which focused exclusively on news-inspired pictures. Long before television entered most American homes, picture magazines – *Life*, *Look*, *Fortune* – brought the world into people's living rooms. Photography could be a powerful ideological tool. Steichen realized this and set out, in collaboration with the architect Paul Rudolph, to design an exhibition whose sequencing produced an improbable continuum. His global family, the photographic equivalent to Joseph Campbell's *Hero with a Thousand Faces* en masse, was a composite, mythic trope, a timeless buffer against divisive forces.

man's humanitarian agenda? And why should it matter that the identities of individual photographers were subsumed by an archetypal theme with mass appeal? Perhaps such infractions seemed trivial compared to the project's conception "as a mirror of the universal elements and emotions in the everydayness of life – as a mirror of the essential oneness of mankind throughout the world."[27]

In what turned out to be the most ambitious curatorial undertaking of his career, Steichen orchestrated the work of 273 photographers, amateurs, and professionals from sixty-eight countries, to create a global family at a time when the family signified unification in a world threatened by dissolution. A lot has been written about the *Family of Man*, particularly its utopian implications, photography's reception at the Museum of Modern Art, and the politics of exhibition display.[28] That Steichen's project took place at mid-century, when the threat of nuclear devastation and Communist infiltration seemed imminent and the camera had brought the world to closer scrutiny, makes it germane to this study.

Steichen's curatorial appointment, in 1947, had come with an

Romantic at heart and a Modernist by choice, Steichen sustained the belief that photography had the ability to render Truth. "Photographers have always been concerned with the search for truth according to their individual conceptions and abilities"[29], he mused in 1963, in the twilight of life. But what did truth mean in a nuclear age? Had the world undergone a dramatic transformation, where absolute truths dissolved into relative propositions? Had history's inviolable continuum splintered into thousands of discrete principles? Was it still possible to envision photography as a voice of conscience, an all-seeing eye roving the world, retrieving images that offered a more authentic barometer for the times? Was it still possible to see photojournalists as truth seekers whose work stripped away the facade of conformity and material comfort to reveal the soft underbelly of a culture in transition? Or were such notions simply naïve, when the potential for photographs to be manipulated and recontextualized had existed since the medium's invention?

Truth is a relative proposition under any circumstance. In the field of news photography, where truth is presumed synonymous

with eye-witness reporting, does being in the right place at the right time guarantee a truthful perspective? Elian Gonzalez's seizure by Federal agents in Miami is a case in point. Entering the home of Lazaro Gonzalez just before dawn on April 22, 2000, Immigration and Naturalization Service agents discovered the boy hiding in a bedroom closet with Donato Dalrymple, the so-called fisherman who had rescued him five months earlier. And there was Associated Press photographer Alan Diaz, who, having gained entry to the house moments before the agents arrived, took some of the most controversial pictures of the entire saga.[30] One in particular, a face off between Elian and an agent whose MP5 submachine gun appears to be aimed pointblank at the boy and his caretaker, prompted outrage (fig. 18). The blatant use of force by government agents, in what turned out to be a peaceful household, became a sensitive issue. Questions ensued: Was the agent's gun pointed directly at the boy? Was his finger on the trigger? In the aftermath of a clandestine maneuver that took less than four minutes to complete, Diaz's picture became primary evidence. Ironically, though, given the angle from which it was shot, questions persisted. Even from the photographer's intimate vantage point, the picture remained ambiguous. If a single event can generate many pictures, each with a different point of view, who's to say which ones are more authentic? Does knowing the circumstances behind a picture clarify its content? Do captions provide a textual handle to meaning? What if the picture has been enlisted to illustrate an editorial point of view? What if the same image has been retouched, cropped, or in some way altered? How can one presume the truth of an image when so many variables affect its representation?

Truth becomes even more elusive in an age of digital technology. The transition from chemical to digital, from paper to pixel, poses significant challenges, especially to the field of news photography.[31] Retouching in the form of airbrushing had always been an accepted means of enhancing the compositional integrity of the paper print. Edges could be blurred, features softened, and prominent passages emphasized for better halftone reproduction without tampering with the picture's content. With digitization, an image can be atomized into multiple pixels, or picture elements, each controlling aspects of brightness and color in that

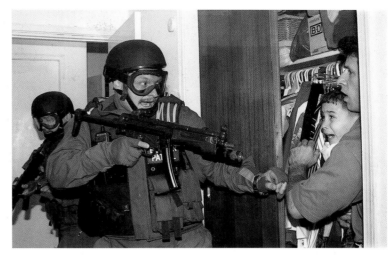

Fig. 18 Donato Dalrymple, right, one of two men who rescued Elian Gonzalez at sea, holds the 6-year-old in the bedroom of Lazaro Gonzalez during the pre-dawn hours Saturday, April 22, 2000, as Border Patrol agents enter the Miami home to seize custody of the boy. Photograph by Alan Diaz for Associated Press. Courtesy AP/Wide World Photos

sector of the image. While this development greatly facilitates design and layout procedures, it also enhances the potential for internal, as opposed to surface, manipulation. What are the ethical implications of morphing an image, pixel by pixel, through splicing and cloning? Has all photography, even news, become the site of subjective projections that render objective perceptions improbable?

What is to become of the *Times*'s morgue in the digital age? Does it continue to function, as an archival dinosaur, an antiquated repository for paper prints?[32] Time is suspended in the morgue. Still, its contents, exhumed, inspire time traveling; open any file, pull out any folder of prints, and begin to dream. Images conceived as news take on another life after facts become memories. Each print, though it carries its own history – multiple stamps and inscriptions, a palimpsest of signs and notations, the equivalent of a painting's provenance on its reverse – in the end remains a means to speculation; when pictorial journalism aspires to history, interpretation enters to propose another kind of world.

NOTES

1.	For a recent study of the *Times* and the family behind it, see Susan E. Tifft and Alex S. Jones, *The Trust: The Private and Powerful Family Behind The New York Times* (Boston, New York, London: Little, Brown and Company, 1999).

2.	Douglas Dreishpoon, "Unpublished interview with Arthur Gelb," New York, Dec. 1, 1999.

3.	The best source for the *Times*'s history with photography is the synoptic chronology compiled by Margarett Loke; see William Safire and Peter Galassi, *Pictures of the Times: A Century of Photography from the New York Times* (New York: The Museum of Modern Art, 1996), pp. 177–89.

4.	The second front was developed as a feature-type page to

break up the sequence of news in the first section of the paper. Although dominated by text early on, by the fifties more pictures had begun to appear on its pages. Gelb described the second front as "pioneering journalistic effort" and emphasized its importance in providing a consistent forum for pictures. By the late sixties, through the partnership of Gelb and John Morris, feature stories were generated with a visual component in mind. The second front eventually led to the multi-sectioned *Times* that exists today.

5. Dreishpoon, "Unpublished interview with Arthur Gelb."

6. The challenges of redesigning a major newspaper to be responsive to cultural changes and at the same time innovative in its presentation are discussed by Louis Silverstein in his book *Newspaper Design for the Times* (New York: Van Nostrand Reinhold, 1990). As Assistant Managing Editor of the *Times* and Corporate Art Director of the *New York Times* Company, Silverstein played a key role during the seventies in helping to revise the paper's layout, including the design of various sections.

7. Douglas Dreishpoon, "Unpublished interview with Morton Stone," New York, Nov. 29, 1999.

8. John G. Morris, *Get the Picture: A Personal History of Photojournalism* (New York: Random House, Inc., 1998), pp. 223–24.

9. Ibid., p. 226.

10. Morris, in response to author's questions faxed to Paris, France; recorded Feb. 3, 2000.

11. Douglas Dreishpoon, "Unpublished interview with Eddie Hausner," New York, Jan. 27, 1999.

12. Morris brought an impressive eye for compelling pictures to his six-year tenure at the *Times*, having previously worked as Picture Editor for *Life*'s London Bureau during the war years, Picture Editor at *Ladies' Home Journal*, and the first Executive Editor of Magnum Photos.

13. Obituary for Israel Cohen, *The New York Times*, Aug. 15, 1952.

14. The "kiss" picture ran two columns on page 21, Jan. 15, 1954.

15. Obituary for John Radosta, *The New York Times*, Apr. 24, 1988.

16. Dreishpoon, "Unpublished interview with Eddie Hausner."

17. Ibid. Film packs containing twelve sheets were available for the Speed Graphic. Still, setting the film for each shot required time. I want to thank Todd Gustavson, Curator of Technology at the George Eastman House, for clarifying this matter.

18. That Falk should be the only member of the *Times*'s photographic staff to adopt a smaller camera seems ironic when, as early as Jan. 1, 1950, the paper ran a promotional piece on the Contax, enumerating its various features and capabilities.

19. Dreishpoon, "Unpublished interview with Eddie Hausner."

20. Morris, in response to author's questions faxed to Paris, France.

21. Besides being an ace photographer, Sisto was also a technical wizard who invented a flashgun device for the Speed Graphic, an especially useful adaptation for indoor sports events, where high-speed shutter settings were essential. According to Hausner, Sisto later sold the idea for about $280 to Mendelsohn, who patented it as his own.

22. Dreishpoon, "Unpublished interview with Morton Stone."

23. Morris, in response to author's questions faxed to Paris, France.

24. The Sunday department, which included the entire contents of the Sunday paper, *Magazine* and *Book Review* sections, remained independent of the daily until Turner Catledge merged the two in the sixties.

25. Morris, *Get the Picture*, p. 9.

26. Cornell Capa, quoted in John Loengard, comp., *Life Photographers: What They Saw* (Boston, New York, London: Bulfinch Press, 1998), p. 250.

27. Edward Steichen, "Introduction," in *The Family of Man* (New York: The Museum of Modern Art, 1955), p. 4.

28. See Christopher Phillips, "The Judgement Seat of Photography," *October* (Cambridge, Mass.), Fall 1982, pp. 27–63, and Mary Anne Staniszewski, *The Power of Display: A History of Exhibition Installations at the Museum of Modern Art* (Cambridge, Mass.: MIT Press, 1998), pp. 235–59.

29. Edward Steichen, *A Life in Photography* (New York: Doubleday & Company, 1963), chapter 13, n.p.

30. In conversation with Douglas Dreishpoon, July 28, 2000, Alan Diaz confimed that a total of eleven images were shot, of which eight were sent out over the AP wire.

31. This and other issues provide the basis for a thoughtful study by Fred Ritchin. See *In Our Image: The Coming Revolution in Photography: How Computer Technology is Changing Our View of the World* (New York: Aperture Foundation, 1999).

32. Digital cameras appeared on the market around 1988 and with further advances in computer technology – the introduction of Quark Xpress typesetting and page-layout software, scanners, and more sophisticated modems – have become standard equipment for news photographers, even at the *Times*, where archival practice now incorporates software systems such as Merlin and Cumulous. I want to thank Carolyn Lee, Assistant Managing Editor, and David Frank, Manager of Picture Desk Technology, at the *Times* for clarifying internal procedures and developments with regard to digital processing.

A VIEW OF THE EXHIBITION

- Whenever possible, the photographer's name and affiliation are listed.
- Titles given to the photographs by the photographer or *The New York Times* are indicated in italics. If photographs are not titled, a descriptive title is given in brackets.
- Unless otherwise noted, all dates indicate the dates of publication in *The New York Times*. "Taken" indicates the day the photograph was shot. "Made" indicates the day the photograph was originally distributed.
- The geographical location of an image is provided when known.
- Captions published within quotation marks are transcriptions of captions that accompanied the pictures when they were published in *The New York Times*. Unpublished captions appear without quotation marks.
- Most of the plates in this publication are reproduced from slides of vintage black-and-white gelatin-silver prints.
- Prints range in size from about three-by-four inches to about sixteen-by-twenty inches; most are eight-by-ten inches.
- Some of the images have been cropped, cleaned, folded, or retouched and are reproduced in this book as is.

America in the World:
War Hot and Cold

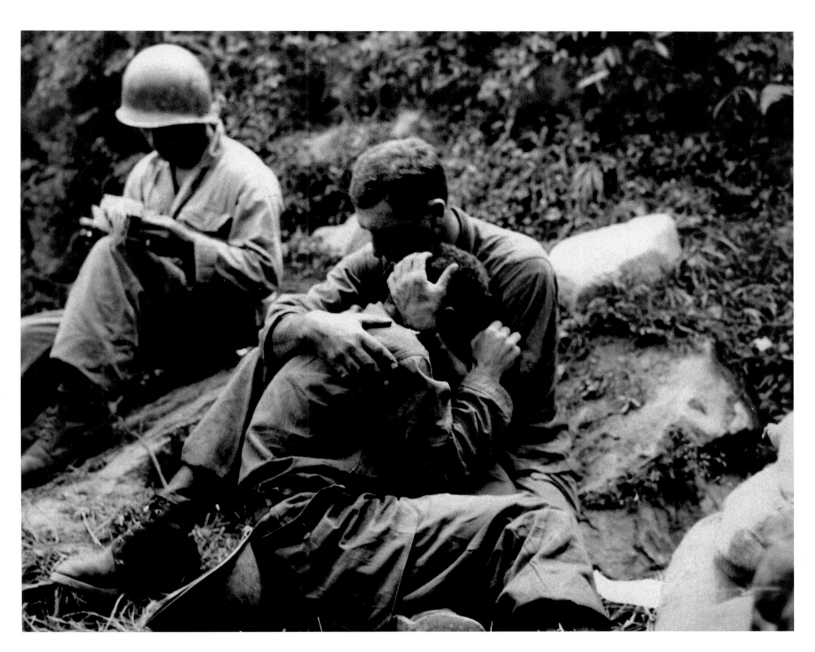

1 *War in Korea*, August 28, 1950 (taken)

A grief stricken American infantryman whose buddy has been killed in action is comforted by another soldier. In the background a corpsman methodically fills out casualty tags, Haktong-Ni area, Korea.

SFC Albert Chang/US Army, Courtesy US Army

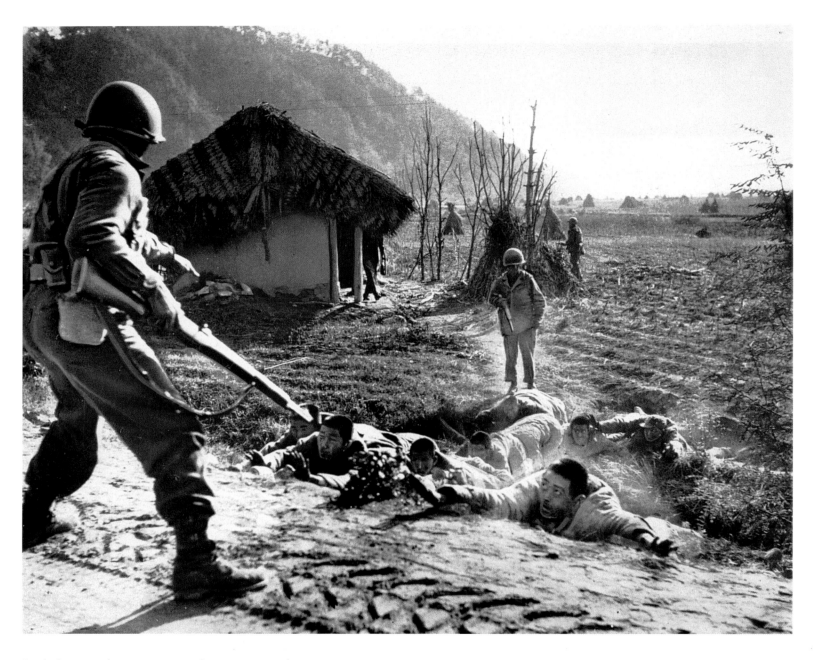

2 *Flushing out the Enemy in North Korea*, November 18, 1950

"An American patrol forces opposing troops to crawl along the ground with empty hands outstretched."

Hank Walker/TimePix, Courtesy TimePix

3 *Truman Gives A-bomb Warning*, November 30, 1950 (made)

Wearing the same stern expression that characterized his press conference appearance earlier, President Truman this afternoon repeats for camera men (who were excluded at the news session) his warning that U.N. forces would not back down in Korea and the atom bomb would be used if necessary to meet the military situation. The re-enactment was in the same executive office room where his press conferences are held.

Henry Griffin/Associated Press, Courtesy AP/Wide World Photos

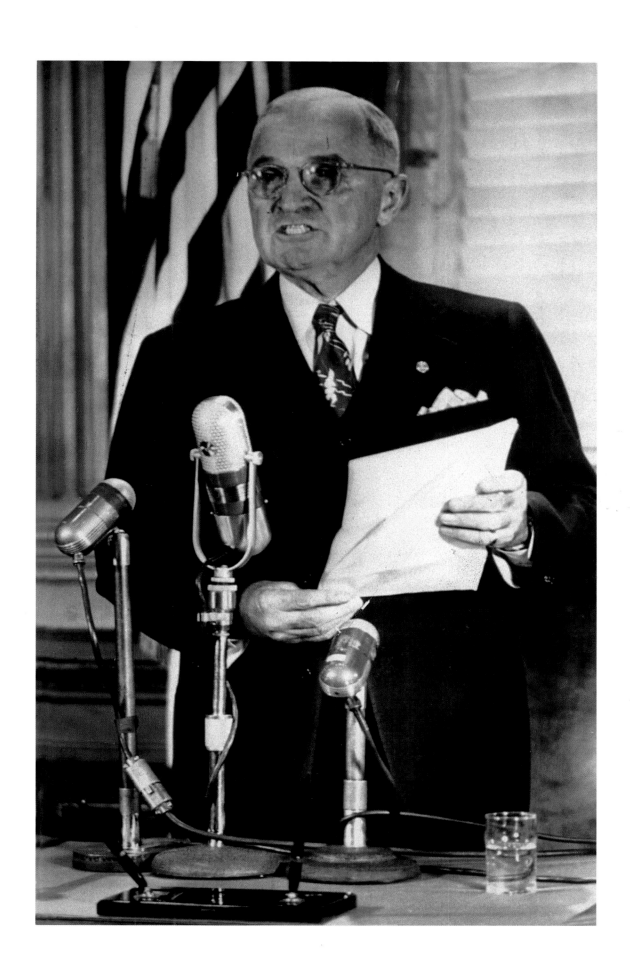

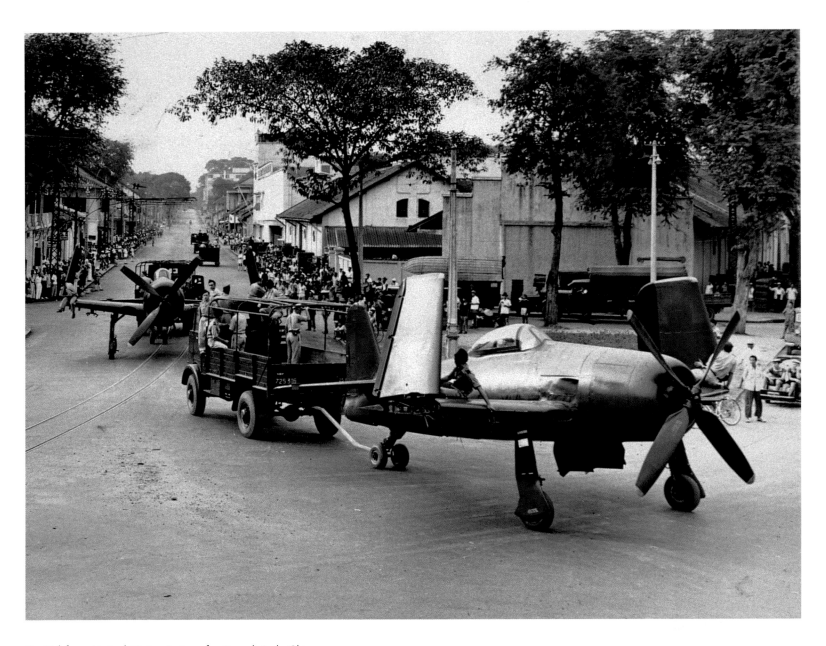

4 *Aid from United States Arrives for French Indo-China,*
February 11, 1951

"Surplus Navy Bearcat fighter planes are towed through the
streets of Saigon after they were unloaded from the escort
carrier Windham Bay. They are part of a shipment of forty-
four to be used in the fighting against the Communists."

Jean-Jacques Levy/Associated Press, Courtesy AP/Wide World Photos

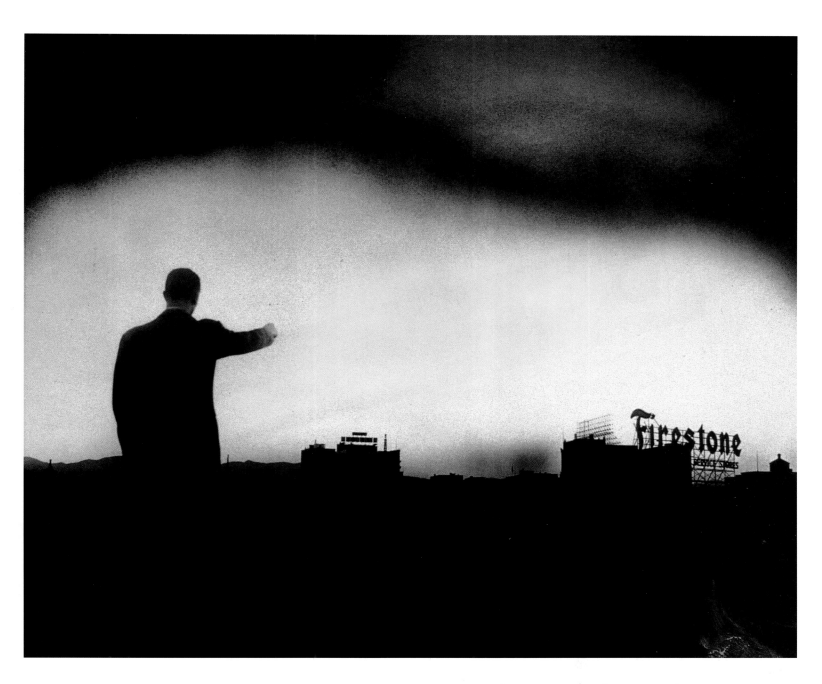

5 *Lights in Las Vegas*, February 11, 1951

"The glare of an atomic burst near the Nevada city seen from Los Angeles, 400 miles away."

Perry Bowler/International News Photo

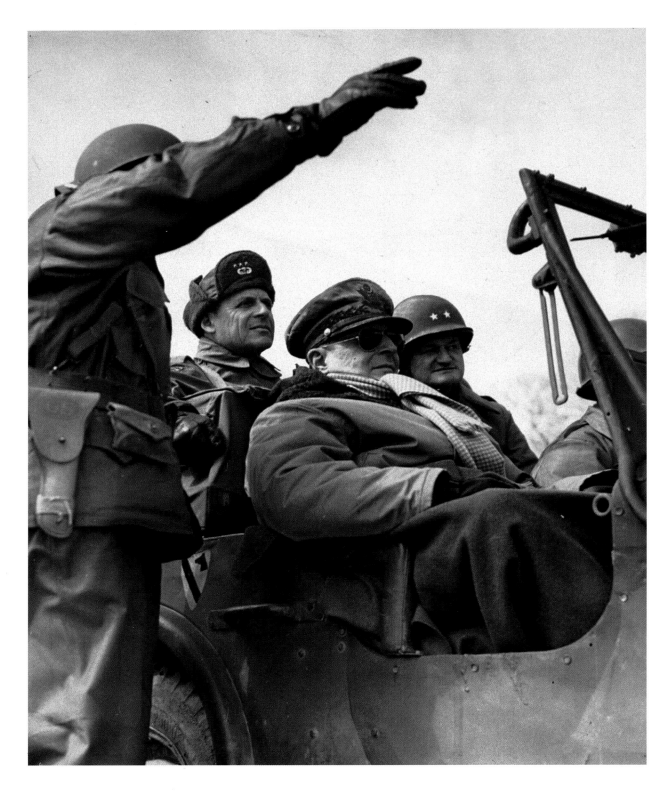

6 *The U.N. Commander gets the Direction*, March 13, 1951

"[Commander] of the Army Douglas MacArthur talking with Lieut.
Col. John W. Calloway, Greensboro, Ga., as he points toward the First
Cavalry Division's front lines during the general's tour of the Korean front
on March 7. With General MacArthur are Lieut. Gen. Matthew B.
Ridgeway, left, United States 8th Army commander and Maj. Gen.
Charles D. Palmer, commander of the first Cavalry Division."

Jim Pringle/Associated Press, Courtesy AP/Wide World Photos

7 Untitled [Immigrants arrive in America on U.S.S.
General H. Taylor], June 28, 1951 (unpublished)

Sam Falk/The New York Times, Courtesy The New York Times
Photo Archives

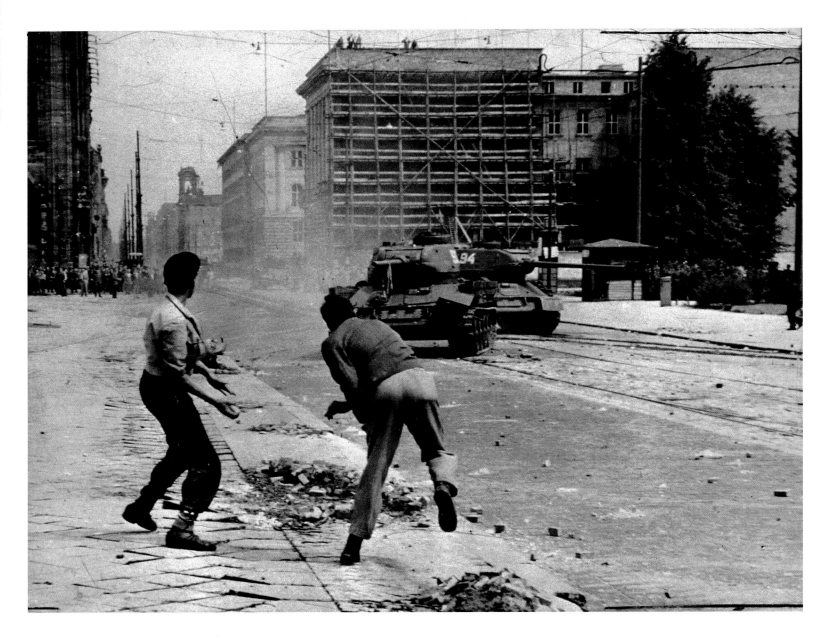

8 *Active Resistance*, August 23, 1953

"East Berliners stone Soviet tanks."

Anonymous/Associated Press, Courtesy AP/Wide World Photos

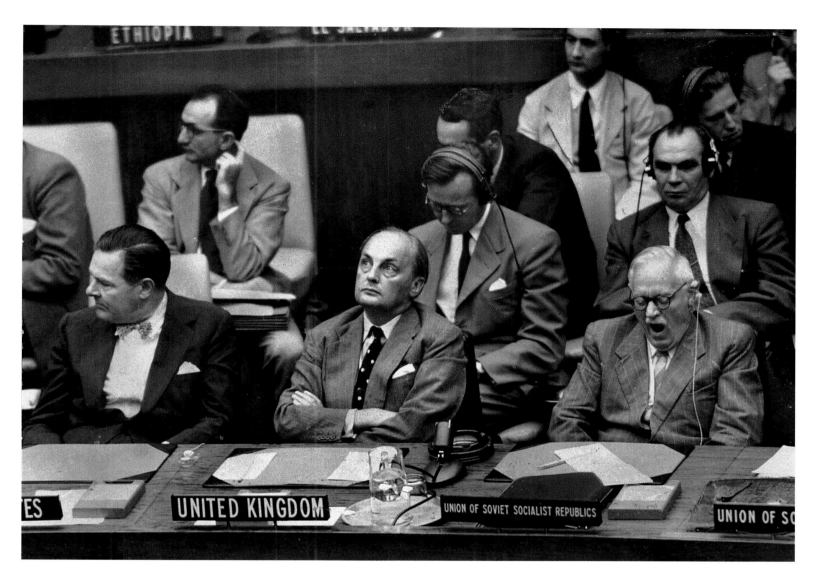

9 *Familiar Story*, August 25, 1953

"Three of the principal delegates to the United Nations as they listened yesterday to debate on Korea. Left to right, Henry Cabot Lodge, Jr. of the U. S., Sir Gladwyn Jebb of Britain and Andrei Y. Vishinsky of the Soviet Union."

Patrick A. Burns/The New York Times, Courtesy The New York Times Photo Archives

10 *Changing Guard* (Moscow, USSR), September 18, 1953

"It takes over at the Lenin-Stalin mausoleum."

Clifton Daniel/The New York Times, Courtesy The New York Times
Photo Archives

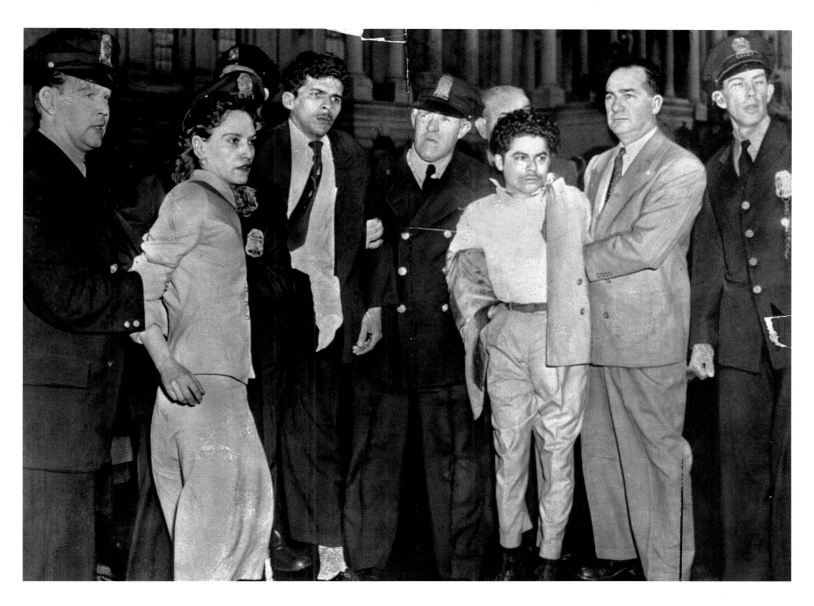

11 *Seized in Shooting*, March 2, 1954

"Capitol police hold three Puerto Rican Nationalists after they fired from gallery seats into House chamber, wounding five Representatives. Prisoners, left to right, are Lolita Lebron, Rafael C. Miranda and Andres Cordero."

Anonymous/Associated Press, Courtesy AP/Wide World Photos

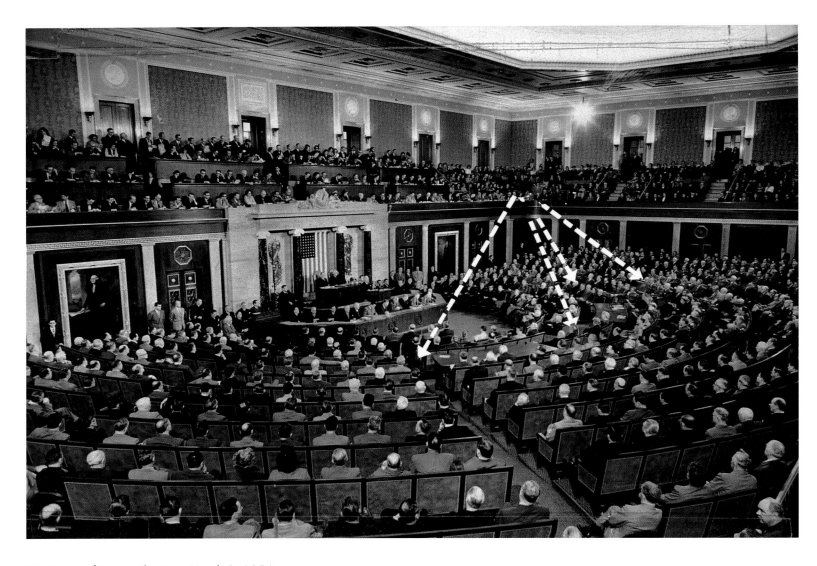

12 *Scene of House Shooting*, March 2, 1954

"Shots in yesterday's demonstration, estimated at 20 to 25 in all, were fired from a corner (A) of visitors' gallery. Positions where the five Representatives were shot were: (B) Ben F. Jensen, Republican of Iowa; (C) Alvin M. Bentley, Republican of Michigan; (D) Clifford Davis, Democrat of Tennessee, and Kenneth A. Roberts, Democrat of Alabama, who was seated directly in front of Mr. Davis, and (E) George H. Fallon, Democrat of Maryland. This photograph was made some time ago at a joint session of Congress, held in the House."

Bruce Hoertel/The New York Times, Courtesy The New York Times Photo Archives

13 *Chile*, June 19, 1954 (taken)

At Santiago, after a parade, pro-Arbenz students and workers burned an effigy of President Eisenhower and an American flag. They stoned the windows of an anti-Communist newspaper.

Anonymous/Associated Press, Courtesy AP/Wide World Photos

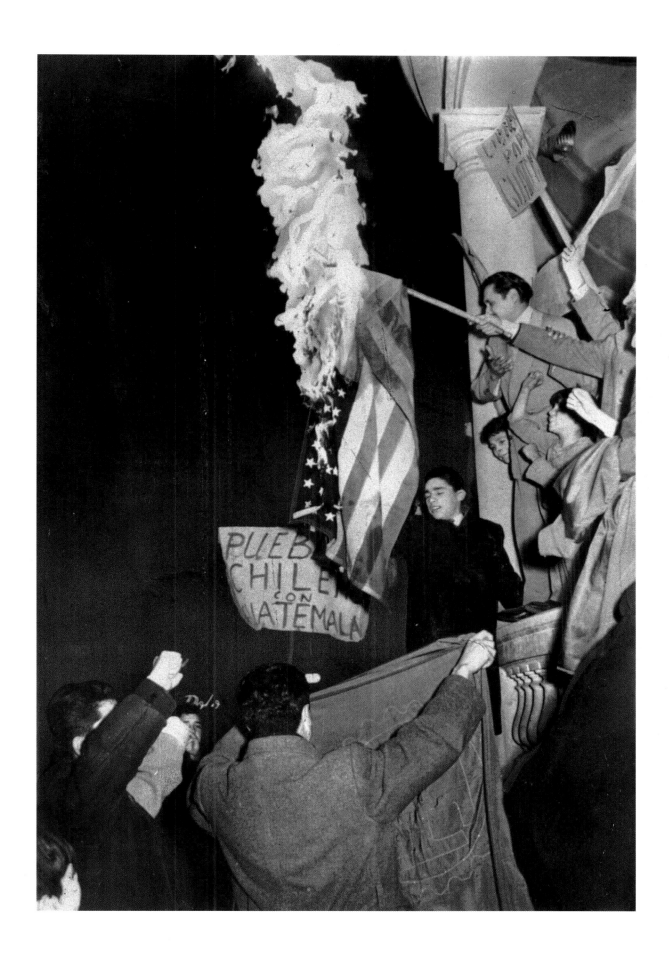

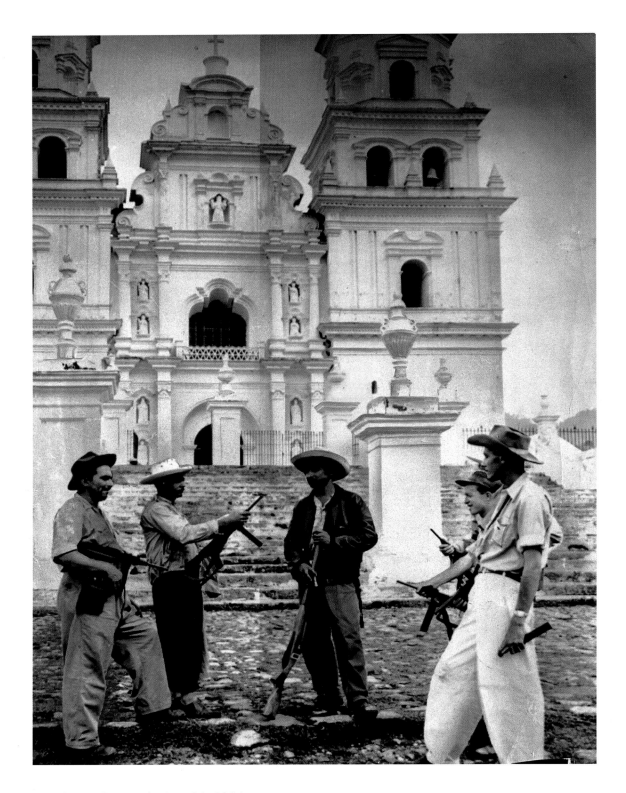

14 *War in Guatemala*, June 24, 1954

"Rebel troops carrying automatic weapons stand before church in Esquipulas, Guatemala, first city taken by them. Anti-Communists declared 500 townsmen joined them. Rebel Commander, Col. Carlos Castillo Armas, has his headquarters there.

Anonymous, Courtesy AP/Wide World Photos

15 *Churchill arrives at White House, June 25, 1954 (unpublished)*

George Tames/The New York Times, Courtesy The New York Times
Photo Archives

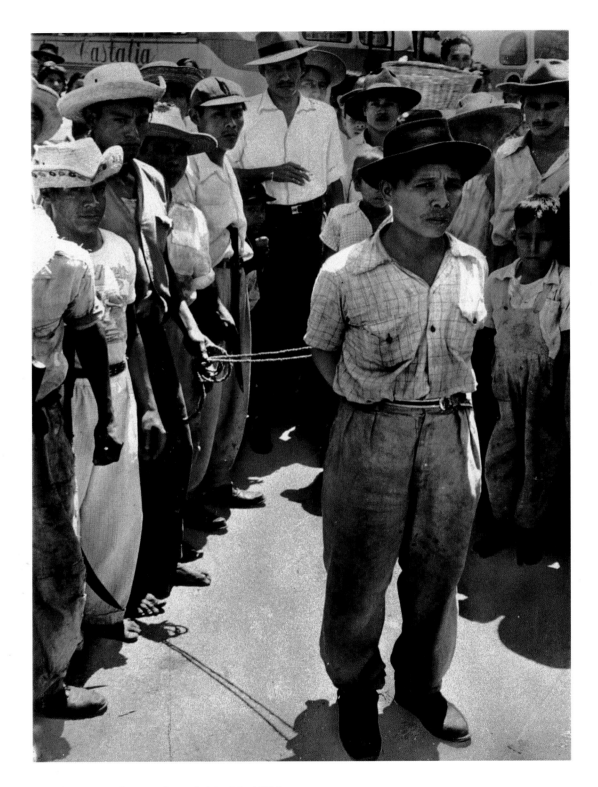

16 *Communist Suspect Seized*, July 16, 1954

"Guatemalans supporting new regime of Lieut. Col. Carlos Castillos
[sic] Armas lead a farm union official to jail. More than 2,000
suspected as Communist sympathizers have been rounded up since the
revolt."

Leonard McCombe/TimePix, Courtesy TimePix

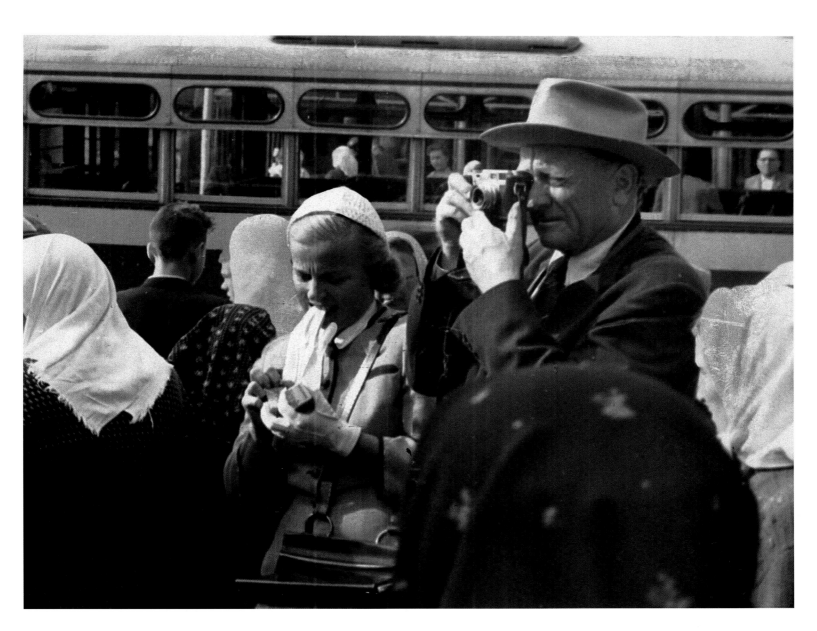

17 *Shutterbug Judge* (Moscow, USSR), September 8, 1955

"U.S. Supreme Court Justice William O. Douglas, with Mrs. Douglas, snaps the St. Louis Roman Catholic Church which they had just left."

Anonymous/International News Photo

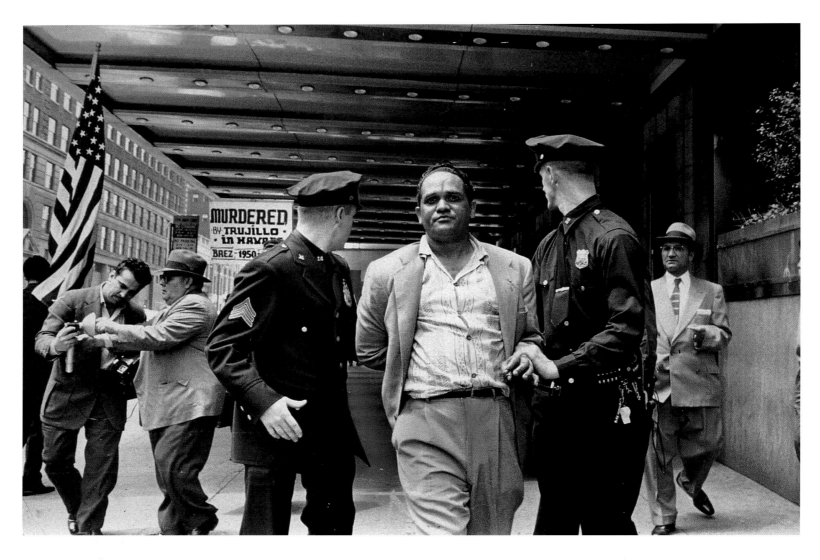

18 *Disorder Flares as Backers of Trujillo Hold a Rally*, June 4, 1956

"Mario Sanchez is led away by police after egg-throwing incident outside Manhattan center."

Carl T. Gossett, Jr./The New York Times, Courtesy The New York Times Photo Archives

19 *Rabbi at the Front*, November 4, 1956

"Col. Shlomo Coren, Chief Rabbi of Israeli armed forces, with a Torah and a sub-machine gun in Gaza campaign. As the operation began the colonel had told the Israelis: 'You are about to enter holy soil. For in this land Moses, our teacher, received the law'."

Radiophoto from Tel Aviv/Associated Press, Courtesy AP/Wide World Photos

20 *Reopening*, April 21, 1957

"An Italian liner, first passenger ship since October, moves through canal as Egyptian coast guardsman watches."

Raoul Fornezza/Associated Press, Courtesy AP/Wide World Photos

21 *Reception in Peking*, May 12, 1957

"Among the other guests is Marshal Chu Teh, Chinese Army commander (smiling)"

Anonymous, Courtesy Magnum Photos

23 *Credo*, September 22, 1957

"The President's message, at the entrance to the U.S. Pavilion at the Zagreb Fair says: 'All countries today stand on the threshold of a more widely shared prosperity, if they utilize wisely the knowledge of science and technology available to this age. International fairs help to spread this knowledge and to quicken man's imagination and ingenuity in the creation of a better life for all'."

Anonymous/US Department of Commerce, Courtesy US Department of Commerce

22 *Archbishop Makarios of Cyprus Greeted at City Hall*, September 12, 1957 (made)

Archbishop Makarios, the religious and national leader of the people of Cyprus, arrived in New York this morning aboard the S.S. Queen Frederica. He seeks American aid to win freedom for Cyprus. He was greeted at City Hall today by Mayor Wagner.

Arthur Brower/The New York Times, Courtesy The New York Times Photo Archives

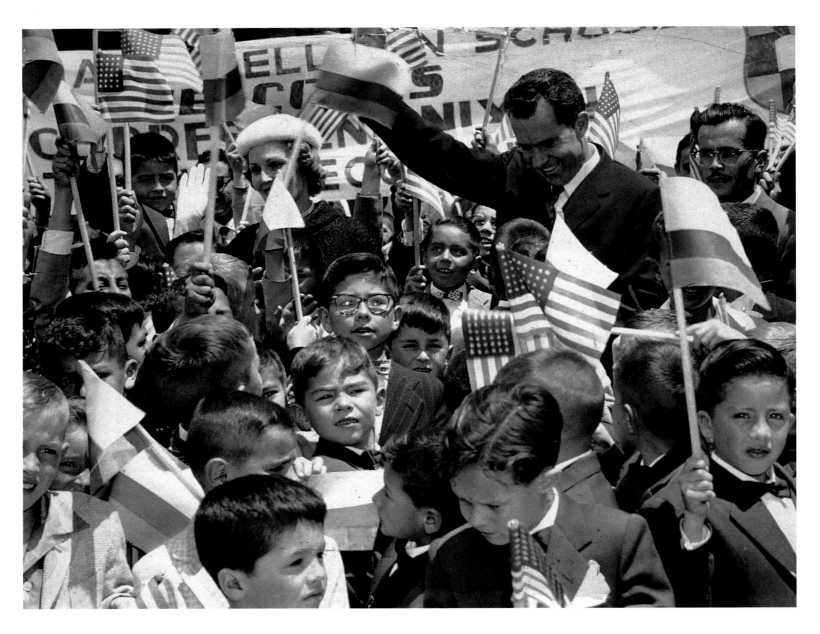

24 *Nixons Greeted in Ecuador*, May 12, 1958

"Vice President and Mrs. Nixon being welcomed by school children Friday at airport in Quito."

Henry Griffin/Associated Press, Courtesy AP/Wide World Photos

25 Untitled [Charles de Gaulle, Les Jardins de l'Elysée, Paris], June 8, 1958

"Charles de Gaulle is confronted with two of France's greatest problems; reform of the French political system, symbolized by the National Assembly, and the grim and costly Algerian war that has ground on for more than three and a half years."

Anonymous/Agence Intercontinentale

26 *Mass Interview*, August 31, 1958

"Americans in Moscow, with the help of U.S. guidebooks, answer questions about the United States put by curious Russians. Most of the questions, inspired in part by the image of American life created by Soviet propaganda, fall into three categories – social problems, such as race relations; living conditions under capitalism, and U.S. 'warmongering'."

Max Frankel/The New York Times, Courtesy The New York Times Photo Archives

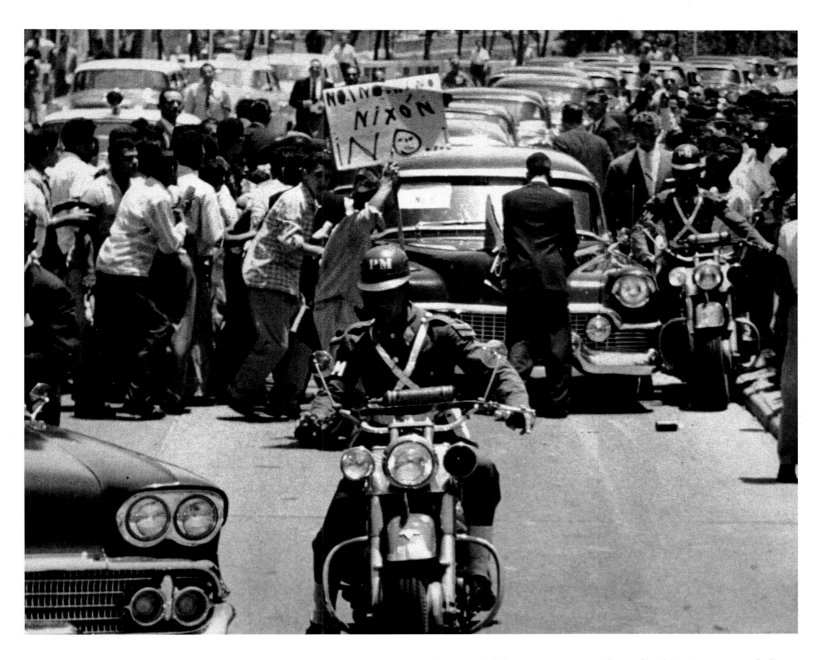

27 Untitled [On tour in Venezuela, Richard M. Nixon is reviled], 1958

Anonymous/United Press International, © Bettmann/Corbis

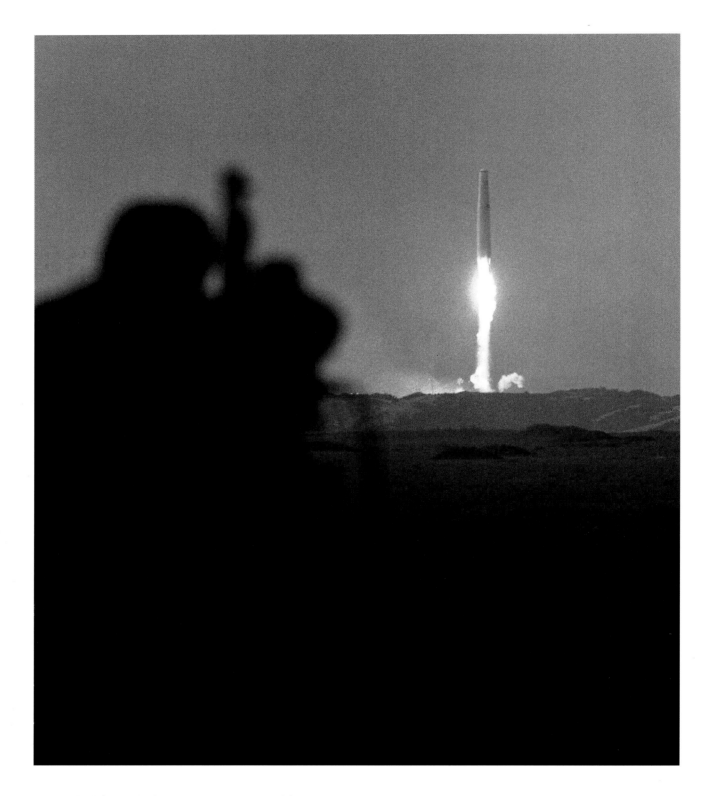

28 *Bird Aloft* (Vandenberg Air Force Base, California),
January 25, 1959

"Soaring on a pillar of flame, a Thor missile is off to a target 1,500
miles away. At the left a photographer records the launching.
Vandenberg's location on the Pacific shore makes it the only United
States base capable of firing missiles and satellites due south over an
unobstructed sea area, without hazard to populated regions."

Bill Bridges

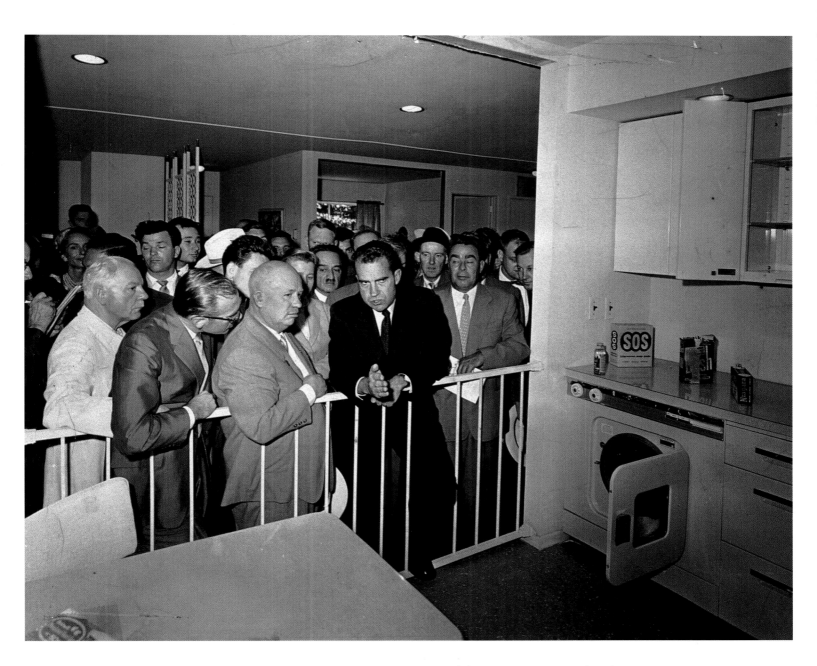

29 *Exhibition Conversation*, July 24, 1959

"Soviet Premier Nikita Krushchev, left, and Vice President Richard Nixon talk as they stand in front of display in kitchen area of the U.S. exhibit in Moscow's Sokolniki Park, July 24. The exhibit was formally opened this day in the Russian capital. The Vice President traded barbed comments with Soviet leader as they toured the exhibit."

Anonymous/Associated Press, Courtesy AP/Wide World Photos

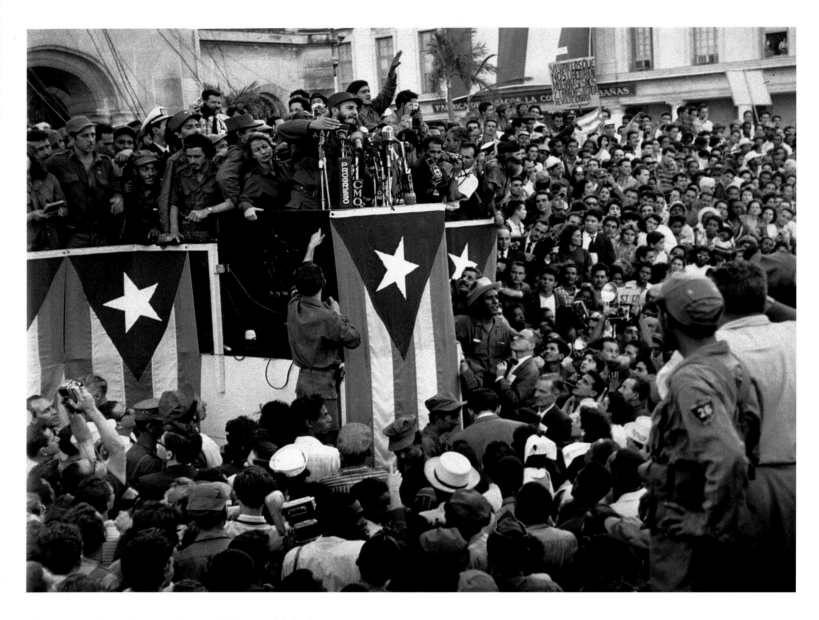

30 *Castro's Crowd*, December 1, 1959 (unpublished)

Fidel Castro, leader of Cuba's revolutionary forces, addressed Havana crowd in January and defended executions of former Batista men. Several hundred thousand persons jammed the park in front of Presidential Palace as Castro spoke.

Harold Valentine/Associated Press, Courtesy AP/Wide World Photos

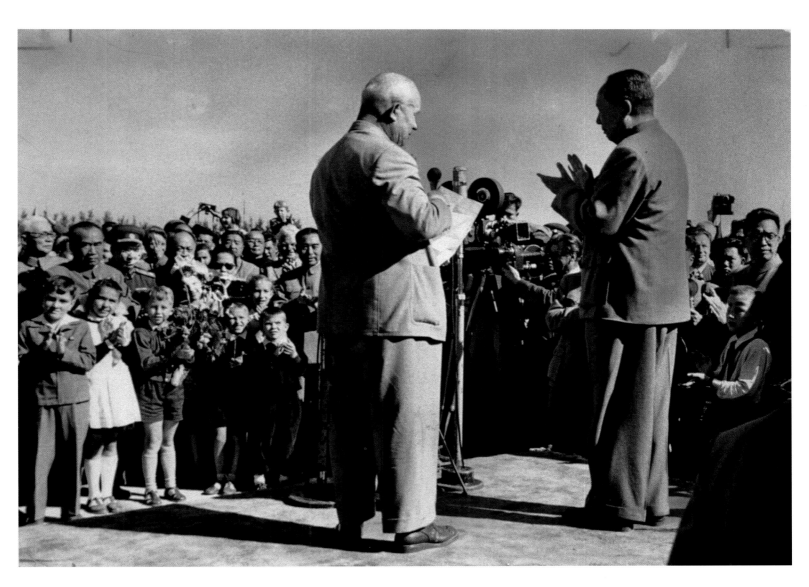

31 Untitled [Nikita Krushchev and Mao Tse-Tung), 1959
In Peking, 1959, with Mao – but already the rift was widening.
Brian Brake, Courtesy Photo Researchers, Inc.

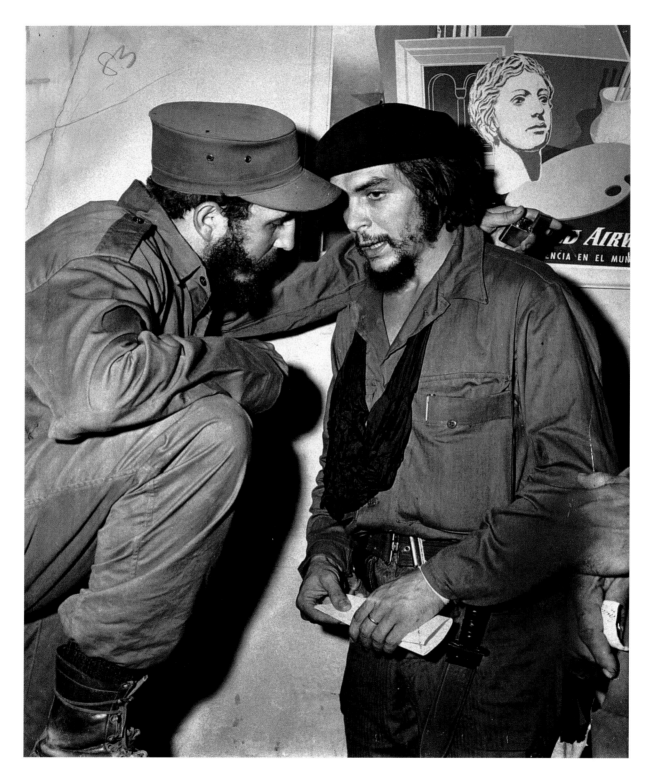

32 Untitled [Fidel Castro and Che Guevara], 1959

Fidel Castro confers with Che Guevara who commanded the Castro
forces at Second Front.

Anonymous

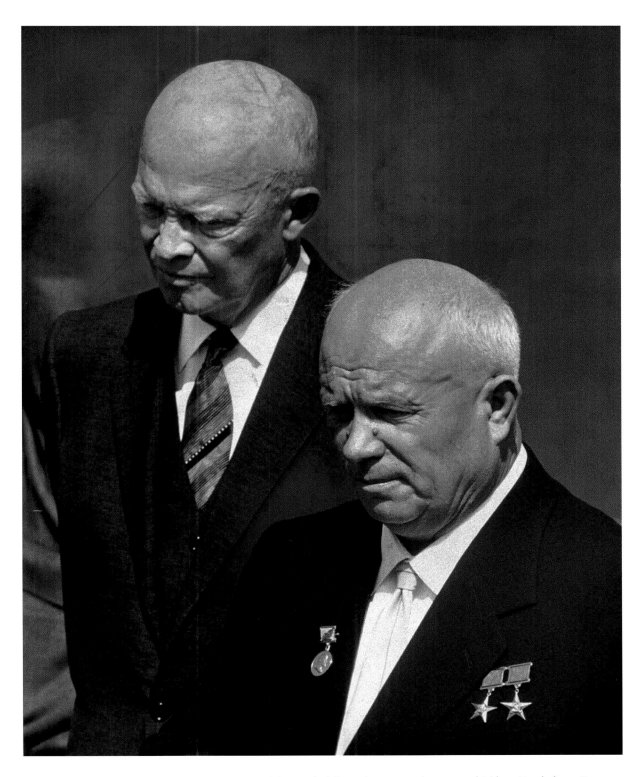

33 Untitled [Dwight D. Eisenhower and Nikita Krushchev, Camp David, Maryland], 1959

George Tames/The New York Times, Courtesy The New York Times Photo Archives

Mechanization in Command

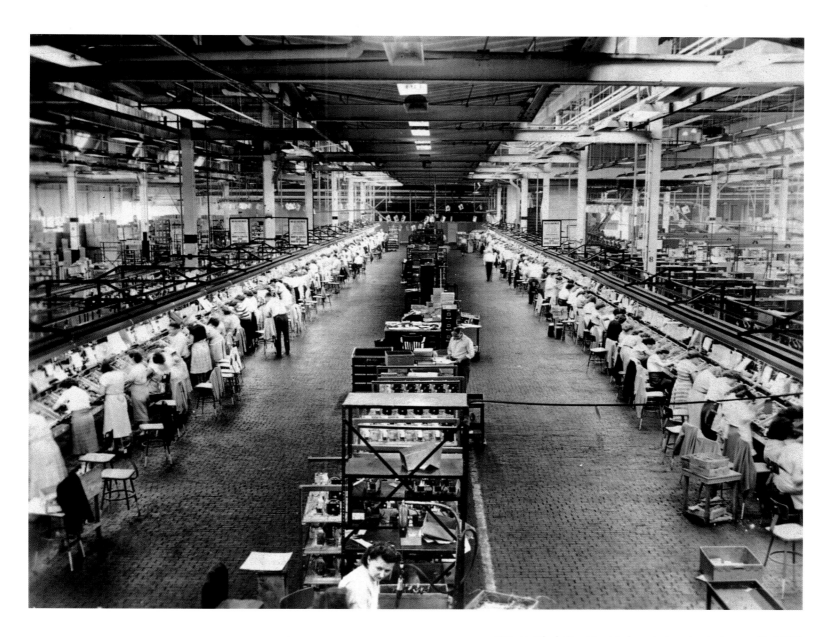

34 Untitled [Du Mont Laboratories, Inc.], August 8, 1951

"Two 464-foot conveyorized production lines at the Du Mont plant in East Paterson, N.J., which is undergoing conversion for war."

Anonymous/David O. Alber Associates, Inc.

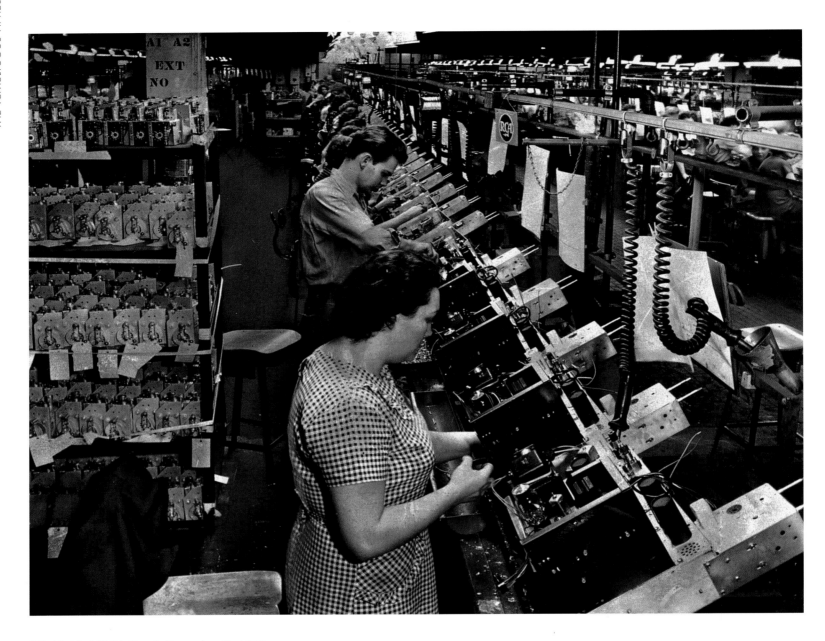

35 Untitled [RCA Plant], December 3, 1951

"Television chassis being speeded down the subassembly production line of the RCA Victor Division plant at Indianapolis, Ind."

Anonymous/RCA Victor

36 *Coast Guard Arouses New Interest in "Flying Saucers"*, August 2, 1952

"Photograph released in Washington yesterday, which was made by one of its photographers at an air station in Salem, Mass. at 9:35 A.M., July 16, showing four huge white lights in the sky."

Shell R. Alpert/US Coast Guard, Courtesy US Coast Guard

37 Untitled [Greenport Freight], 1952 (unpublished)

The Greenport freight passes the trim station at Cutchogue Steam
Locomotive #108, Cutchogue, 1952

John Krause/Long Island Railroad, Collection Ron Ziel

38 *Superfort Protector*, March 23, 1953

"As his B-29 penetrates deep into night skies of North Korea, A/lc Marcos E. Padilla of Las Cruce, N.M., a blister gunner with Japan-based U.S. Air Force 98th Bomb Wing, searches intently for Communist night fighters."

Anonymous/US Air Force, Courtesy US Air Force

39 *Disk Molding Machine*, March 21, 1954

"New manufacturing techniques are constantly being developed."

Dan Weiner/Brackman Associates, Courtesy Sandra Weiner

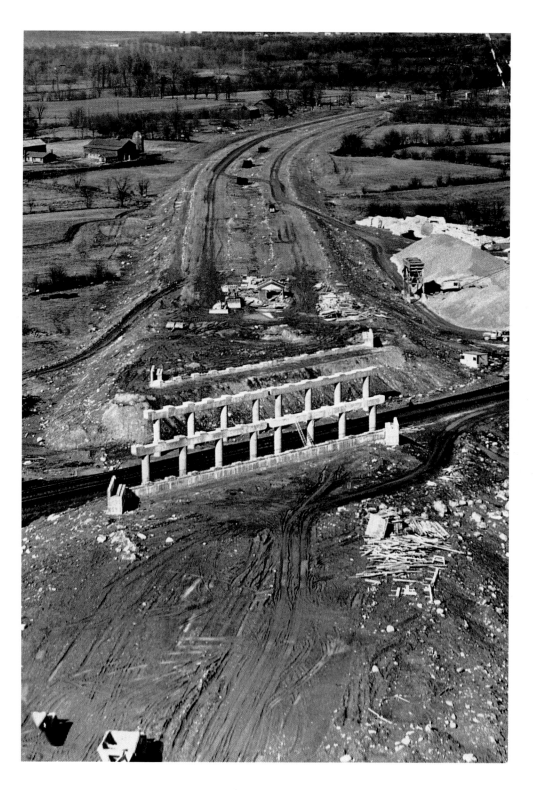

40 *Building an Overpass on New York's Thruway*
(Modena, New York), May 9, 1954

Meyer Liebowitz/The New York Times, Courtesy The New York
Times Photo Archives

41 *Prophet,* October 31, 1954

"This is the heart of the Univac electronic data system used on the election night in 1952 to forecast the outcome of the Presidential election. The inset shows the prediction taken from the machine at 8:30 P.M. The final actual vote was as follows: Eisenhower – thirty-nine states, 442 electoral votes and 33,936,252 popular votes. Stevenson – nine states, eighty-nine electoral and 27,314,992 popular votes. The '00 to 1' in the inset means more than 100 to 1, the machine having been instructed to record no more than those odds concerning any candidate's chances."

Anonymous/The New York Times, Courtesy The New York Times Photo Archives

42 *Oversized New Cars*, December 17, 1954

"In the Larkman Square parking area in Yonkers, a 1955 Buick extends beyond other and older cars parked nearby."

Eddie Hausner/The New York Times, Courtesy The New York Times Photo Archives

43 *Fueling Up* (White Sands Proving Ground, New Mexico),
October 30, 1955

"An hour later, the acid and liquid oxygen which power the big rocket
are piped from tanks set up in a safe spot in the open desert.
Crewmen wear special clothing as protection against spilled acid."

George Tames/The New York Times, Courtesy The New York Times
Photo Archives

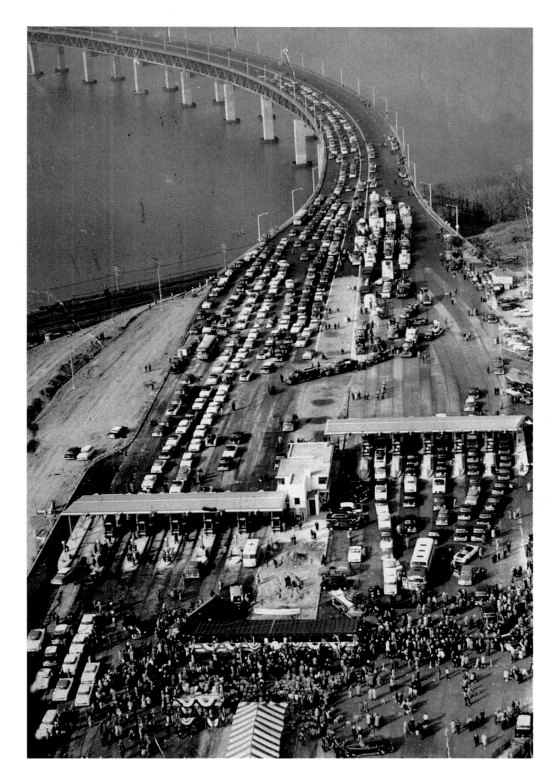

44 *Open for Business*, December 16, 1955

"Crowd at Tarrytown end of Thruway bridge yesterday for ceremony."

Meyer Liebowitz/The New York Times, Courtesy The New York Times
Photo Archives

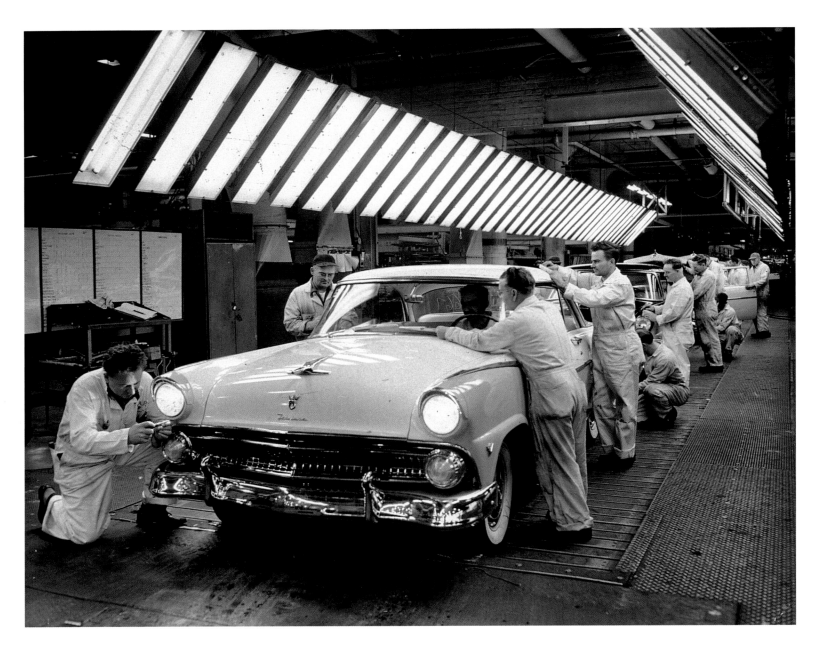

45 *1955 Assembly Line Photo*, December 1955 (unpublished)

Anonymous

46 Untitled [Chrysler Corporation Assembly Line,
Detroit, Michigan], March 25, 1956

"A symbol of U.S. industrial production – these automobiles are
coming off Chrysler Corporation's assembly line at the rate of one
every twenty seconds."

Anonymous/Chrysler, Courtesy Daimler Chrysler

47 *On the Texas Tower,* May 13, 1956

"On the first 'radar island,' off the New England coast, an Air Force sergeant works on a 'tropo dish'— an antenna that carries microwave, interference proof telephone communications from the tower built on Georges Shoal to the mainland, via the tropospheric layer high above the Earth."

Sam Falk/The New York Times, Courtesy The New York Times Photo Archives

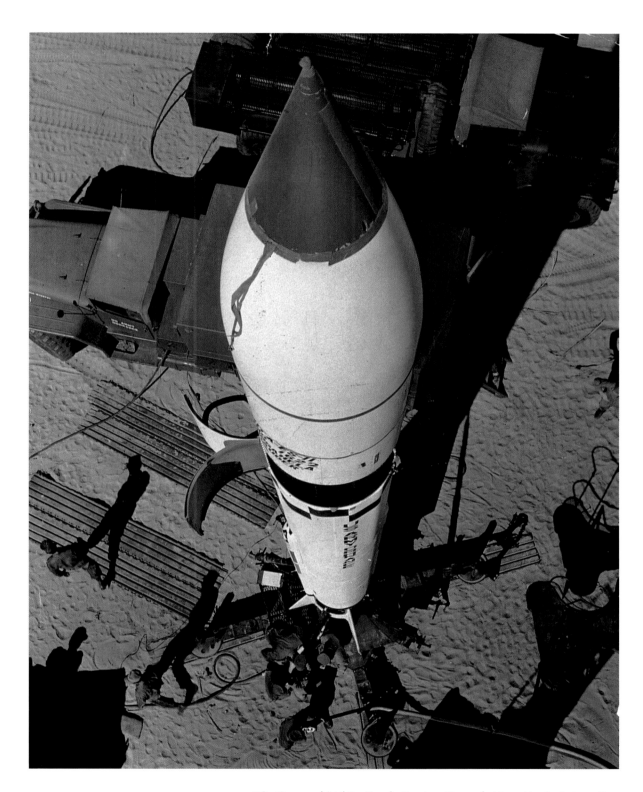

48 *Corporal* (White Sands Proving Ground, New Mexico), June 3, 1956

"The Army's 75-mile guided missile is checked for a test firing. One of the several missiles that are revolutionizing concepts of war, it can carry an atomic warhead."

George Tames/The New York Times, Courtesy The New York Times Photo Archives

49 *Aerial View*, July 5, 1956

"Gimbels is the 'key tenant' at Green Acres Shopping Center in Valley Stream, on Sunrise Highway just over the Queens County line. Irwin S. Chanin is architect of this development, which is being built by the Chanin Organization."

Patrick A. Burns/The New York Times, Courtesy The New York Times Photo Archives

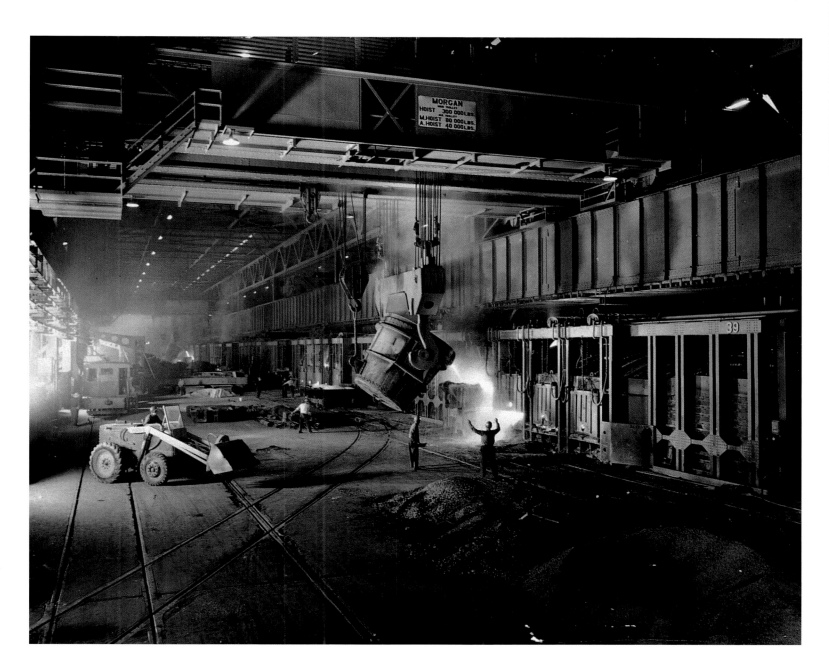

50 *Pittsburgh Works*, March 31, 1957

Molten iron from blast furnaces is poured from a giant ladle into one
of 11 open hearth furnaces at Jones & Laughlin Steel Corporation's
Pittsburgh Works Division.

d'Arazien/Jones & Laughlin Steel Corporation, Courtesy Library and Archives
Division, Historical Society of Western Pennsylvania, Pittsburgh

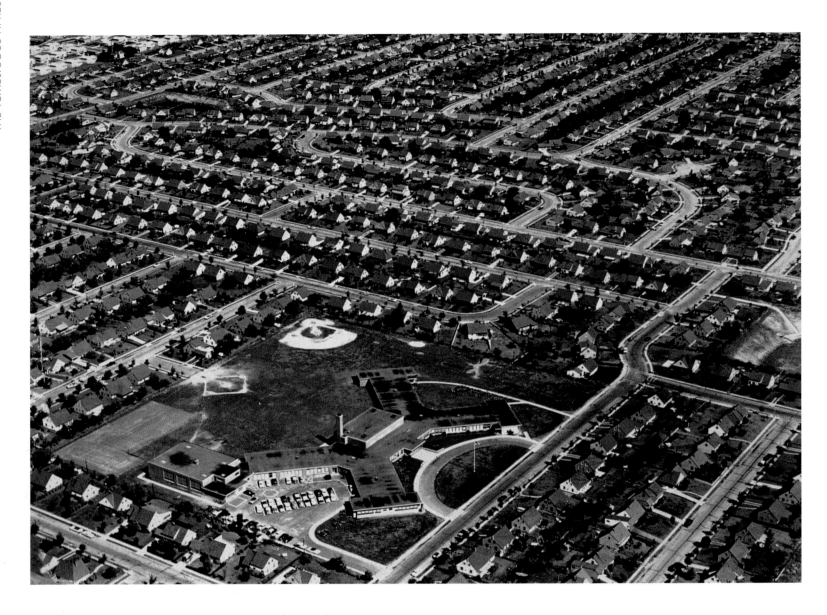

51 Untitled [Aerial view of Levittown, NY, used in article "Bias in Suburban Housing"], April 17, 1957

Meyer Liebowitz/The New York Times, Courtesy The New York Times Photo Archives

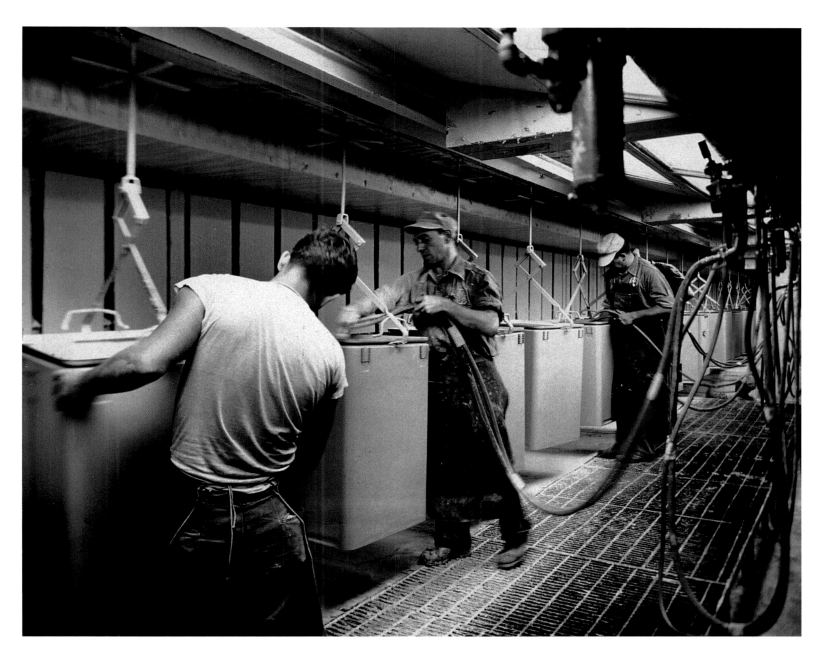

52 *Appliance Industry Insists that Dishes can be Easy* (Louisville, Kentucky), October 18, 1957

"Workers spray plasticol coating on inside of dishwashing machines at a G.E. plant."

Jim Silk/General Electric

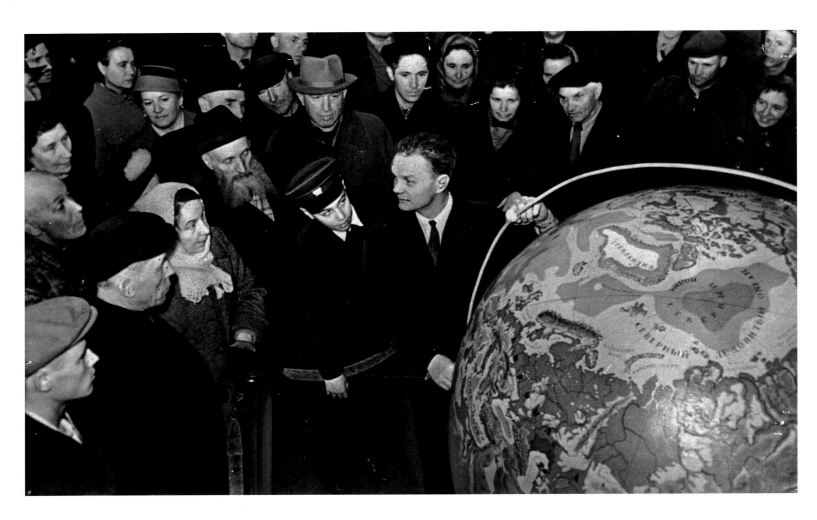

53 *Inside Information*, November 4, 1957

"Muscovites listening with interest to a lecture on the first Soviet satellite as its orbit is explained with the aid of a large globe. This photo was released Saturday by the Russian Embassy in Ottawa."

Courtesy AP/Wide World Photos

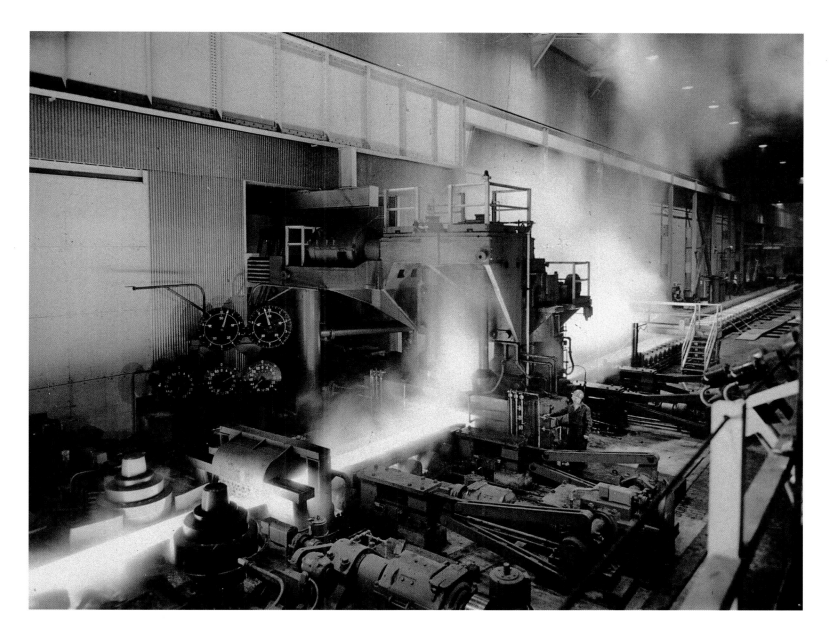

54 *Better Facilities Spur Steel Industry's Expansion*, January 14, 1958

"New automatic hot strip rolling mill installed by the Jones & Laughlin Steel Corporation in Aliquippa, Pa., exemplifies the expansion program of the steel industry. The reversing rougher, shown in picture, is controlled by an automatic programmed system."

Anonymous/Jones & Laughlin Steel Corporation

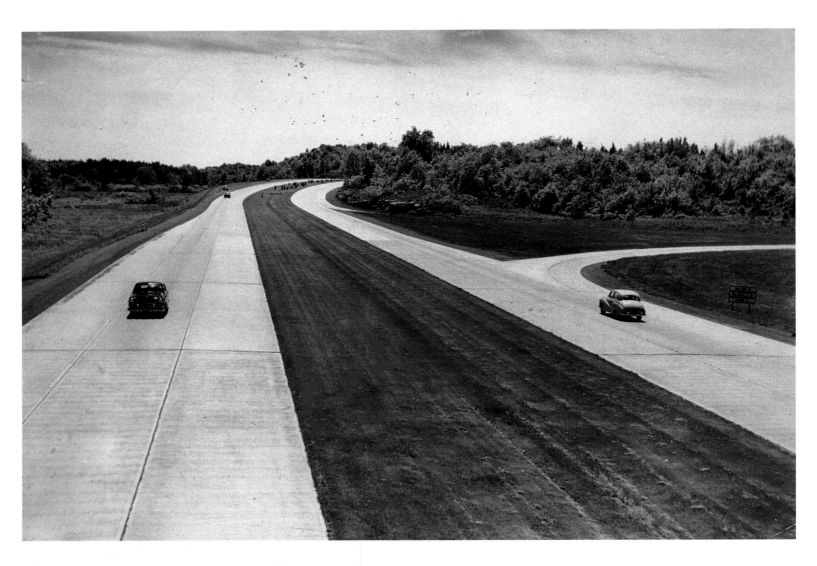

55 *Populated, East*, June 8, 1958

"Uncrowded New York State Thruway below Catskill."

Sam Falk/The New York Times, Courtesy The New York Times Photo Archives

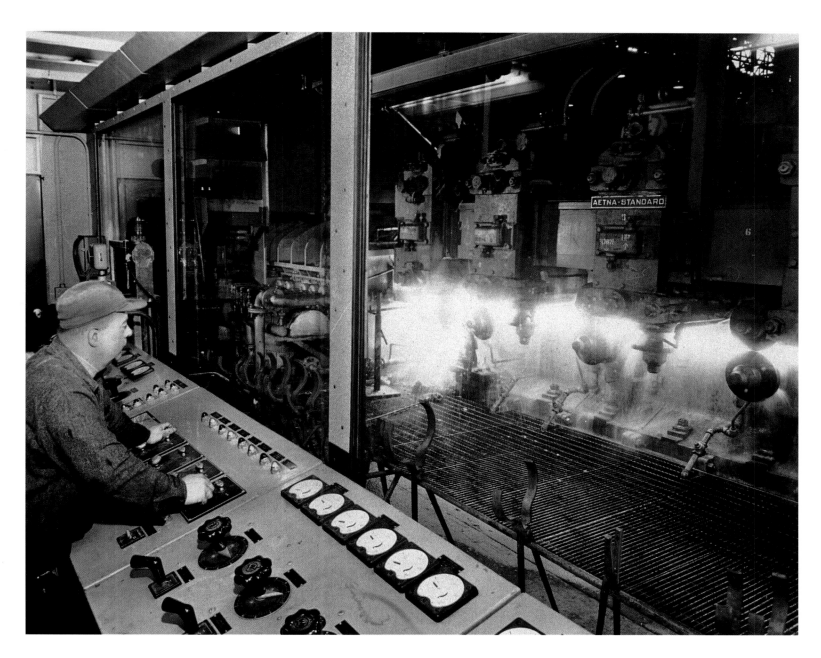

56 *Jones & Laughlin Starts Continuous-Weld Pipe Mill*, June 27, 1958

"An operator at Aliquippa, Pa., works of Jones & Laughlin Steel Corporation controls welding and forming stands at a new continuous weld and pipe mill of the corporation."

Anonymous/Jones & Laughlin Steel Corporation

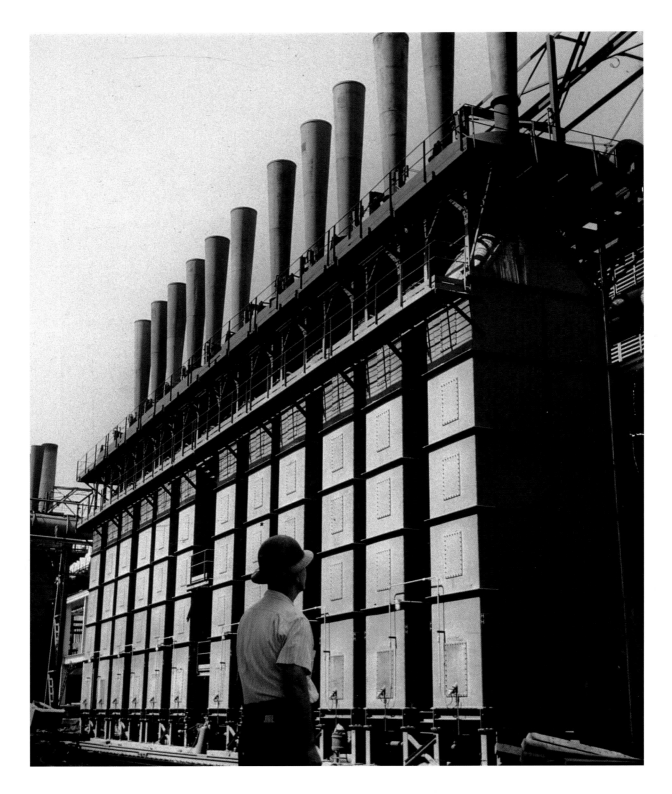

57 *U.S. Steel Constructs Automatic Mill in Chicago,*
September 12, 1958

"Workman pauses before towering stacks on the soaking pits, which
will serve new structural mill at South Works."

Anonymous/U.S. Steel Photo, Courtesy U.S. Steel Group of USX Corporation

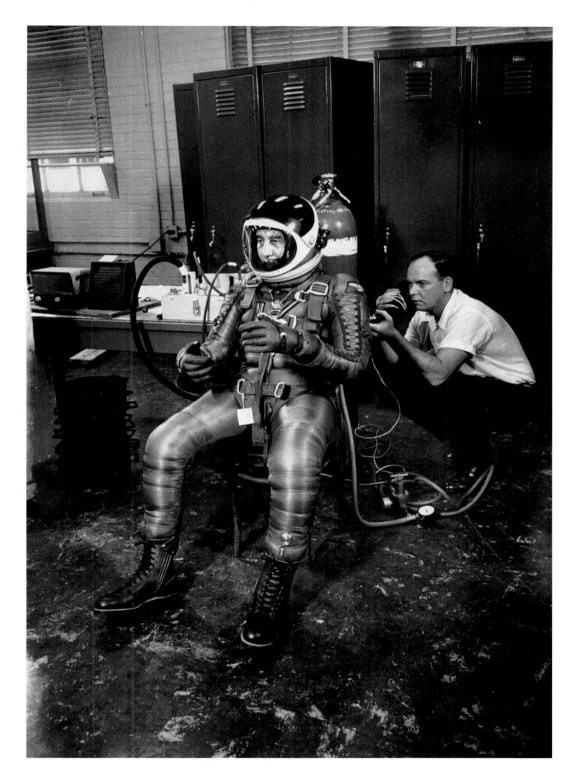

58 *Fit-Out* (Newport News, Virginia), August 16, 1959

"Virgil I. Grissom, 33-year-old Air Force captain, sits through a
meticulous measurement for his individual space suit. This model, borrowed from the Navy,
is used only for fitting purposes. From it a special Mercury suit will be made. Smooth fit,
free of binding or bulging, but with minimum mobility is required. The suit has been inflated
with about four pounds of air, to simulate conditions in actual flight, when both capsule and
suit will be pressurized. Grissom served in Korea and has since been in engineering chiefly
at Wright-Patterson and Edwards working on fighters."

Sam Falk/The New York Times, Courtesy The New York Times Photo Archives

Growing up American

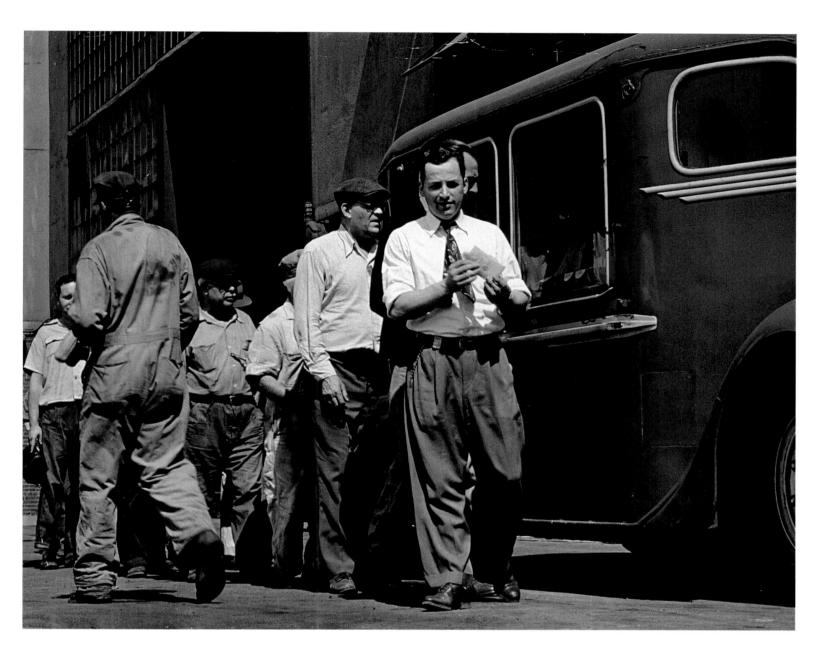

59 *Green Light for Detroit – And for Detroit's Auto Workers,*
June 4, 1950

Anonymous/Ford News Bureau, Courtesy Ford Motor Company

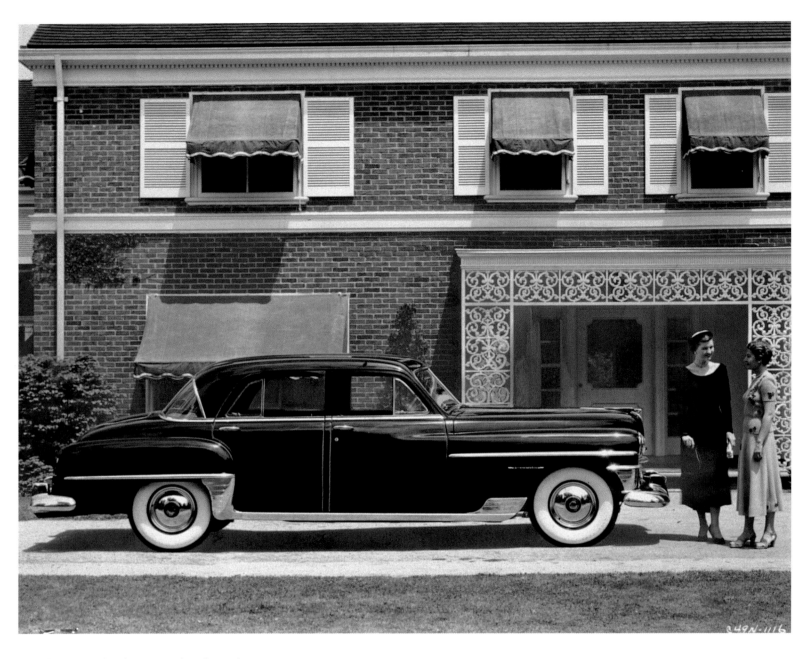

60 *The New Chrysler Imperial Sedan*, July 13, 1950

"Six-passenger model to sell for $3,185 here, which went on display yesterday."

Anonymous/Chrysler, Courtesy Daimler Chrysler

61 Untitled, January 21, 1951

"The price of polio – Children stricken in an outbreak of the disease lie in respirators at Roanoke, Va."

Anonymous/Associated Press, Courtesy AP/Wide World Photos

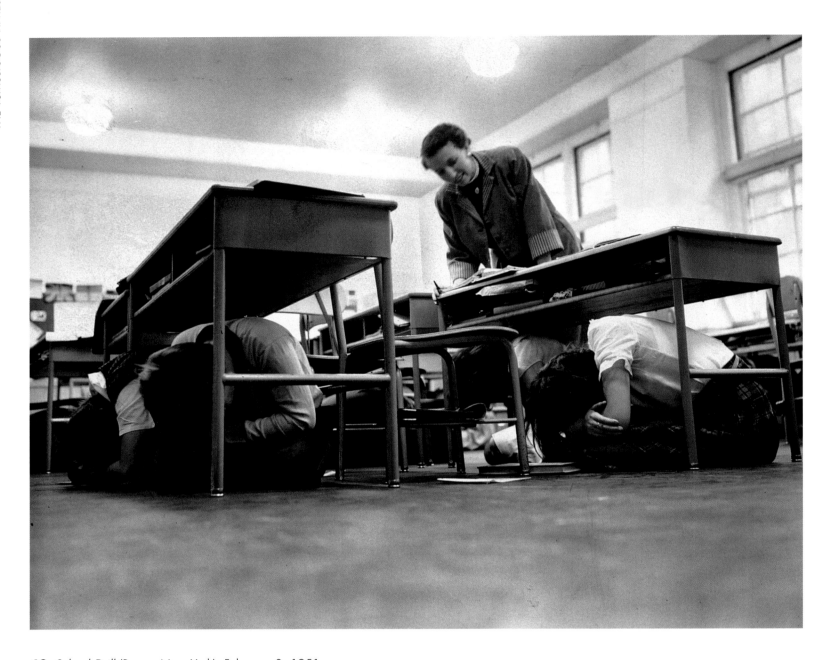

62 *School Drill* (Bronx, New York), February 8, 1951
"Pupils at Public School 75 taking shelter under their desks."
Ernie Sisto/The New York Times, Courtesy The New York Times Photo Archives

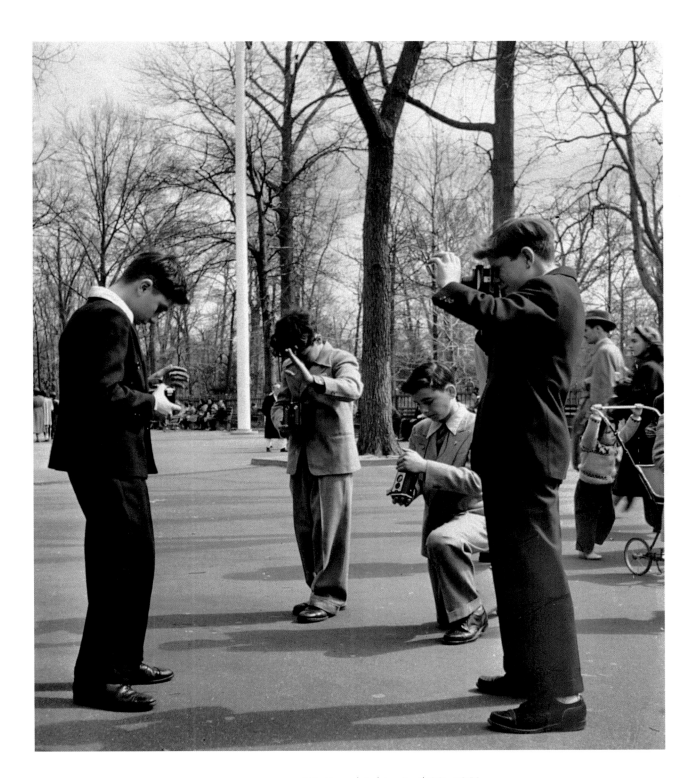

63 *Round Robin*, April 29, 1951

"The youngster in the center is taking a picture of the youngster on the left who is taking a picture of the youngster on the right who is taking a picture of the youngster on the left. The youngster kneeling isn't taking a picture quite yet – but he will."

Sam Falk/The New York Times, Courtesy The New York Times Photo Archives

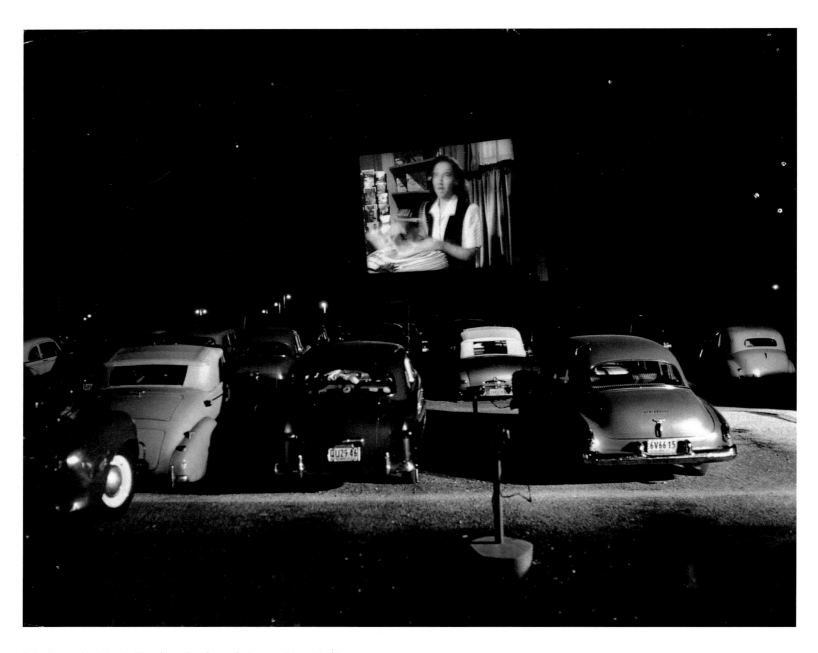

64 *Open-Air Movie* (Bruckner Boulevard, Bronx, New York),
March 9, 1952

"A metropolitan drive-in theatre."

Eddie Hausner/The New York Times, Courtesy The New York Times
Photo Archives

65 Untitled [Mickey Mantle], October 2, 1952

"Mickey Mantle of the Yanks is out at second on Yogi Berra's grounder in fourth inning to Gil Hodges, who tossed to Reese. The umpire is Larry Goetz."

Ernie Sisto/The New York Times, Courtesy The New York Times Photo Archives

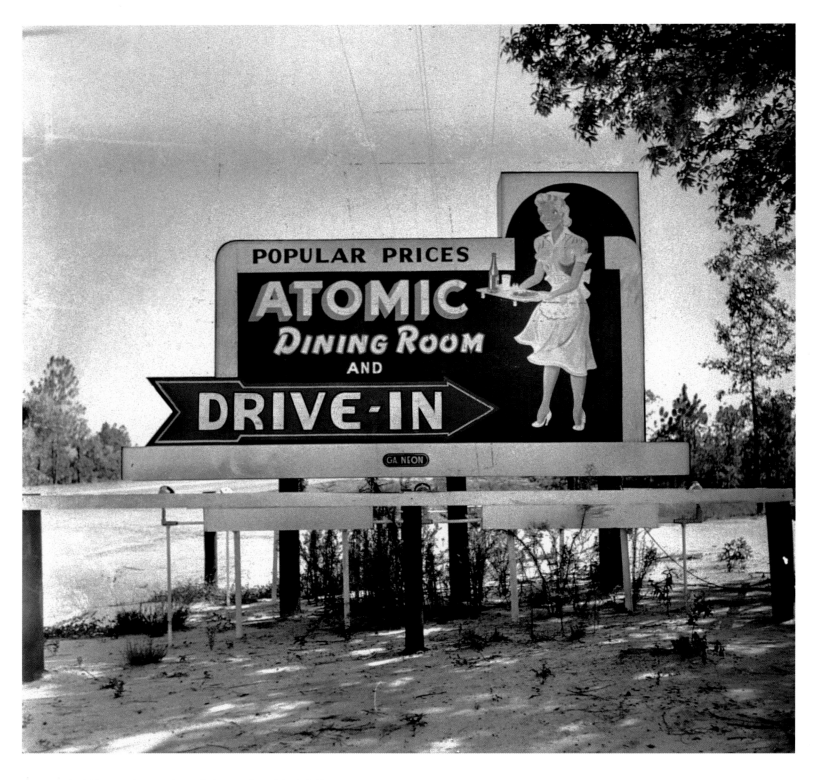

66 Untitled [Atomic Dining Room], November 30, 1952

"The Savannah River Project of the Atomic Energy Commission at Augusta, Georgia."

George Tames/The New York Times, Courtesy The New York Times Photo Archives

67 *Stanley Home Products, Inc.,* (Greensboro, North Carolina), 1952

Stanley Hostess Parties are often held outdoors, weather permitting. The Stanley dealer demonstrates the various products using a bridge table to show portions of the Stanley line of 150 products for household and good grooming uses.

Martin's Studio, Greensboro, North Carolina, © Carol W. Martin/Greensboro Historical Museum Collection

68 *March, March, March, July 5, 1953*

Louis P. Re, left, a student at Fordham, and Jerard S. Weigler of
Colgate, New York Air Force R.O.T.C. cadets, walk off demerits
received during their four week encampment at Mitchel Field, L.I.
They will be commissioned as second lieutenants on graduation next
year, but right now they are more concerned with getting demerit
slates clean.

Anonymous/US Air Force, Courtesy US Air Force

69 *79 Harlem Children Off for Interracial Vacation,* July 6, 1953

"Youngsters Leaving Grand Central Terminal yesterday for two weeks vacation in Vermont."

Neil Boenzi/The New York Times, Courtesy New York Times
Photo Archives

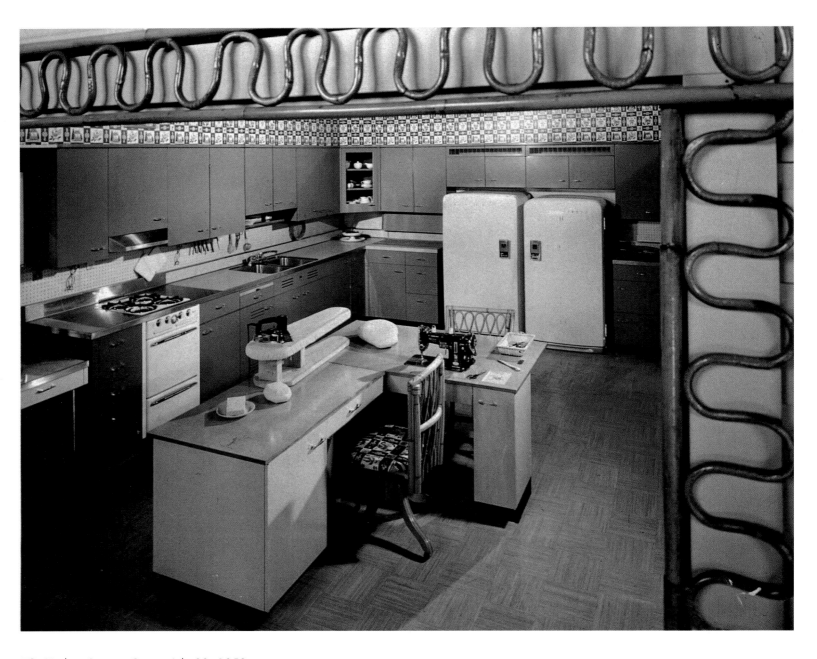

70 *Kitchen Sewing Center*, July 23, 1953

"Cabinets are arranged to provide 'sewing center' in kitchen shown
by St. Charles Manufacturing Company at conference American Home
Economics Association meeting."

Torkel Korling/Hedrich-Blessing, Courtesy Chicago Historical Society

71 *Slicking Up* (Colby, Kansas), July 26, 1953

"Slicking up for a night in town, this harvester is lucky to be working a farm not isolated from the bright lights."

George Tames/The New York Times, Courtesy The New York Times Photo Archives

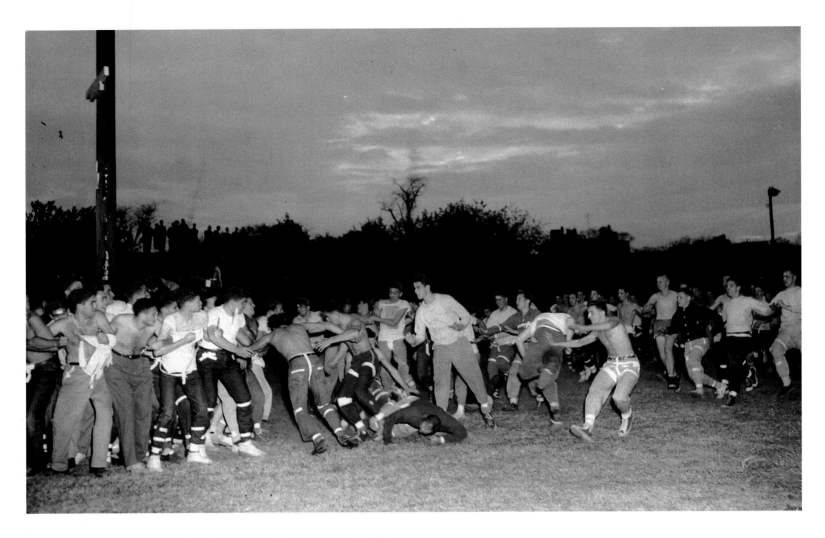

72 Untitled [Sophomores and Freshmen], October 23, 1953 (made)

Sophomores are charged by Freshmen as they guard the greased pole at the top of which was a Columbia banner which the Freshmen had to capture.

Ernie Sisto/The New York Times, Courtesy The New York Times Photo Archives

73 *Learning to Paddle their own Canoe* (Madison Square Garden, New York), February 21, 1954

"Mayor Wagner's sons, Duncan, in rear, and Robert, get some tips from Boyd Heath of Oklahoma, a half-breed Cherokee Indian, at the opening of the Sportsmen's Show in the Garden yesterday."

Ernie Sisto/The New York Times, Courtesy The New York Times Photo Archives

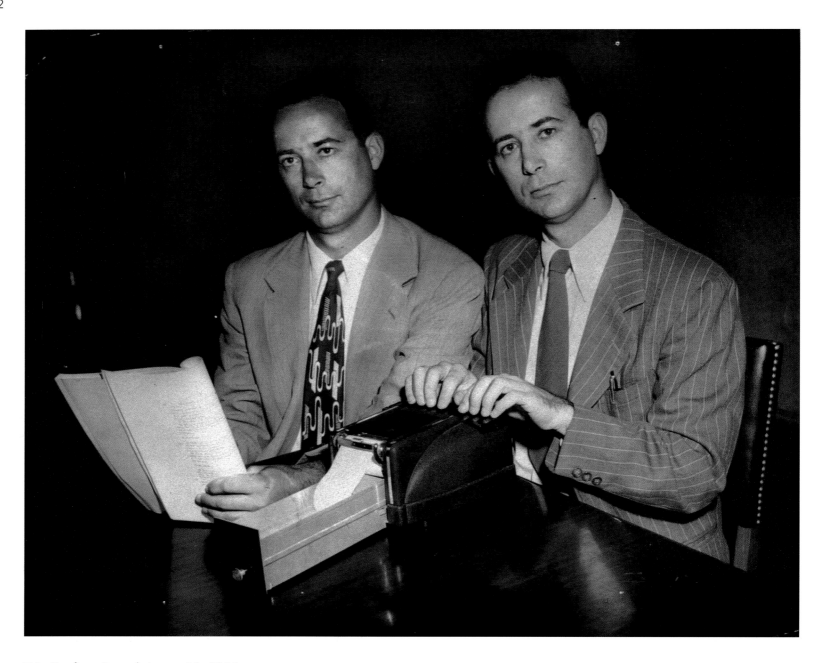

74 *Out for a Record*, August 15, 1954

"The Cohen twins, Arnold, left, and William, who will try next week to break their tie for the stenotype speed record of the United States. They are employed as court reporters in Nassau County."

Drennan for The New York Times, Courtesy The New York Times Photo Archives

75 *Rush Hour* (Wall Street, New York), January 16, 1955

"Decisions are made with split-second timing around the horseshoe-shaped trading posts. The pink, yellow and blue bits of paper on which transactions are recorded add color to the hurry-scurry."

Feingersh/Pix Incorporated

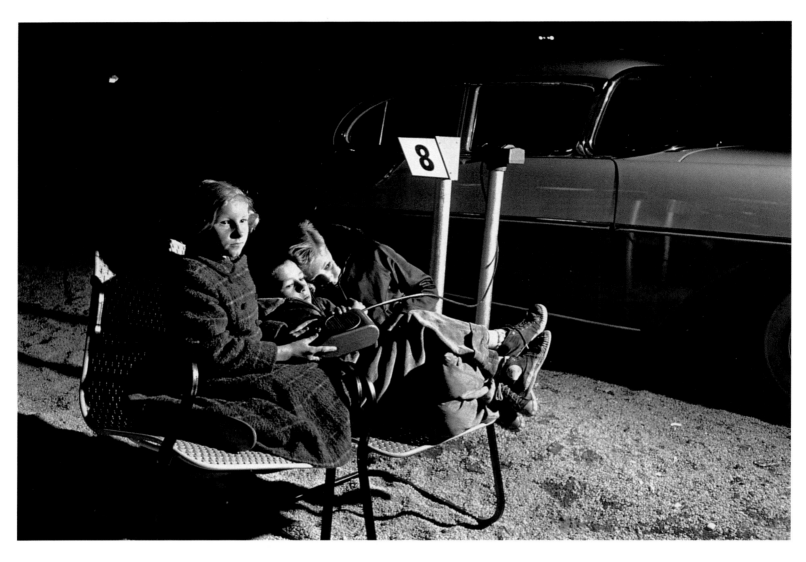

76 *Drive In Movie Theater*, May 28, 1955 (made)

Photographs taken at the Bayshore Drive-In Theater, Bayshore, Long Island, Friday night, May 27, 1955.

Sam Falk/The New York Times, Courtesy The New York Times Photo Archives

77 Untitled [Sweater Set], June 26, 1955

"The Sweater Set: woman's best friend in college or country. In cashmere, all colors. By Braemar. $53 a set; at Peck & Peck."

Sharland

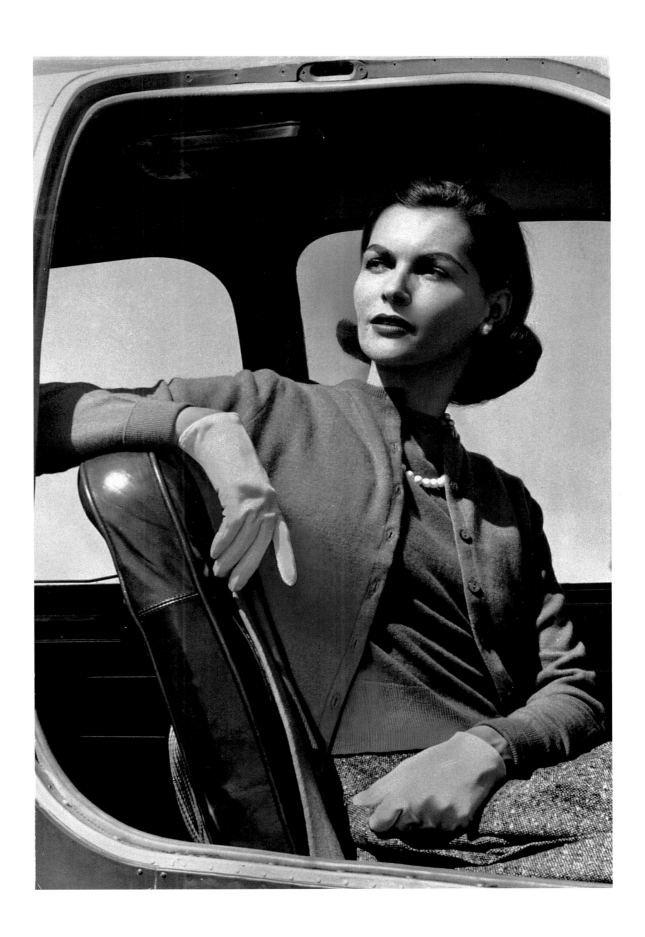

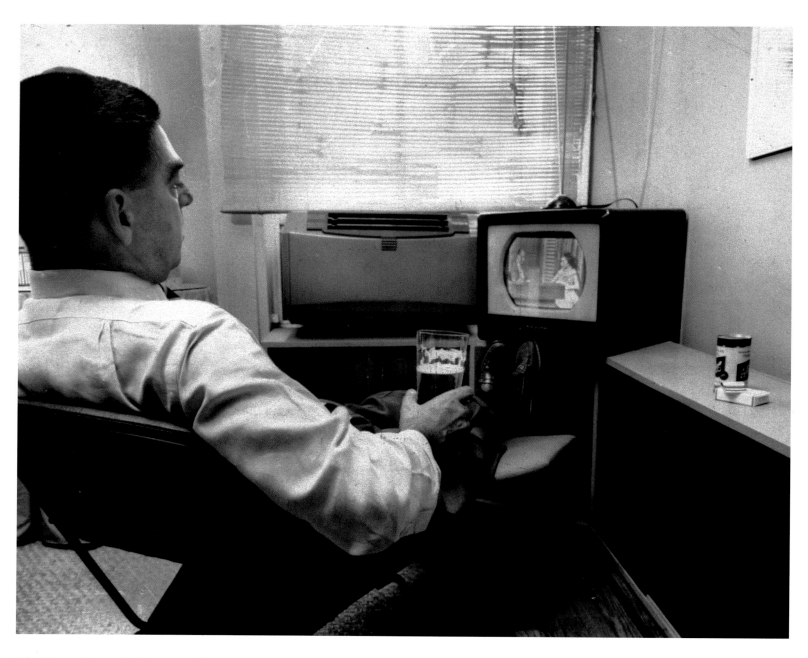

78 *How to Enjoy the Heat . . .* , July 23, 1955

"With air-conditioning and TV, this man stayed home . . ."

Ernie Sisto/The New York Times, Courtesy The New York Times Photo Archives

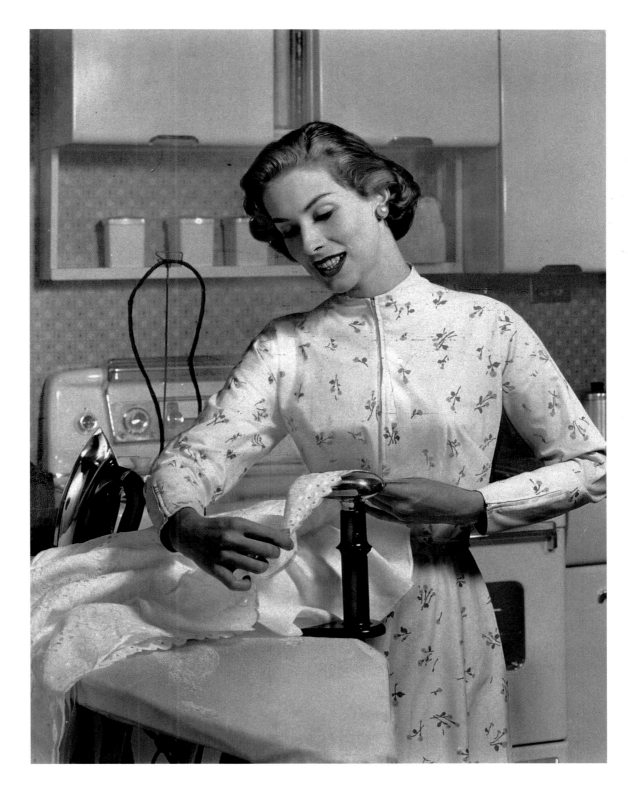

79 *Pressing Problems*, October 29, 1955

"'Little Smoothie', iron by Harris Industries, Inc.,
makes it easy to iron ruffles and deep-pile fabrics.
It has adjustable heat control. At Lewis & Conger
and Hammacher Schlemmer, $14.95."

Anonymous

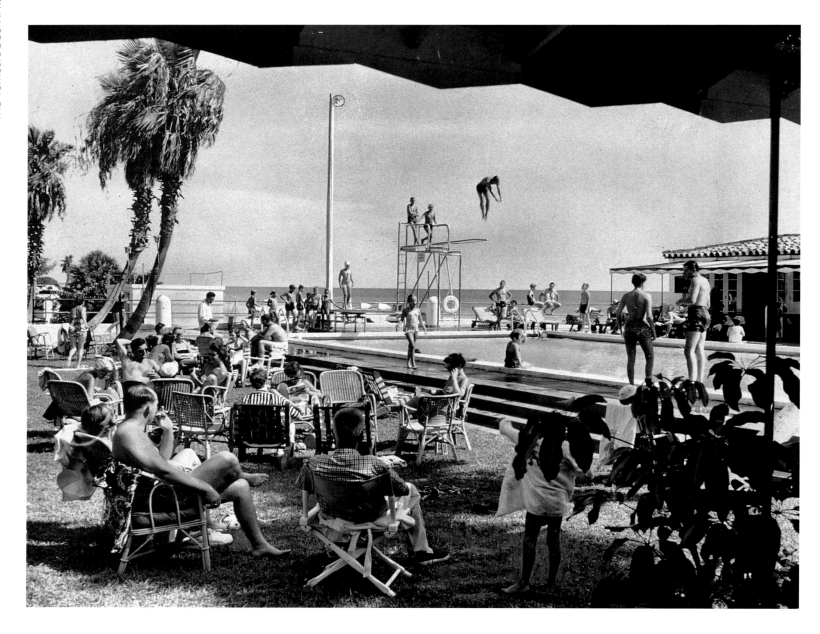

80 Untitled, December 11, 1955

"Pattern in sun and shade at a hotel pool on Florida's Gulf Coast."

Sam Shere

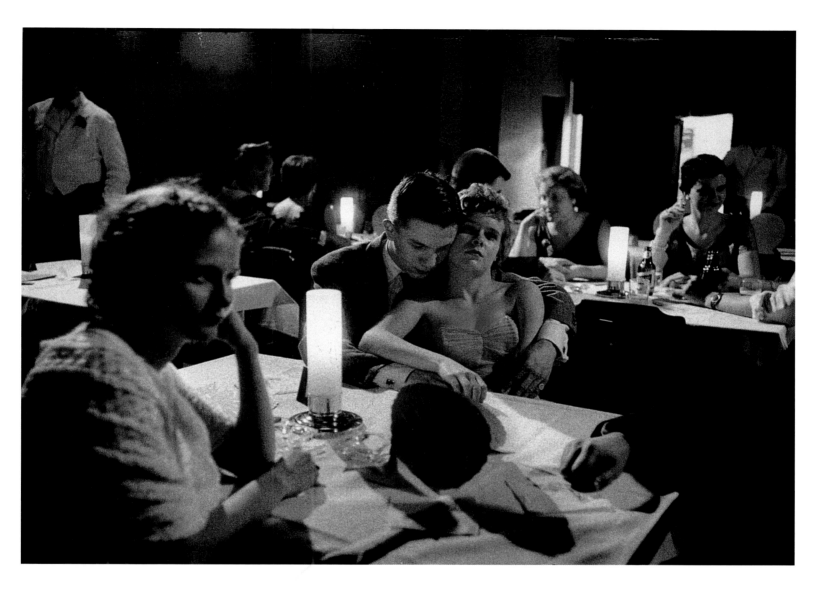

81 Untitled [Candlelight Couple], January 22, 1956

"At the top, a more elegant atmosphere prevails in the Candlelight Room, a night club created by the student union at Willard Straight Hall on the campus."

Sam Falk/The New York Times, Courtesy The New York Times Photo Archives

82 *Holiday Shopping*, February 23, 1956

"Self-service customers at S. Klein On-the-Square wait in line to pay for their purchases."

Anonymous/The New York Times, Courtesy The New York Times Photo Archives

83 *Behind the Scenes of the Jamaica Pari Mutuels*, April 24, 1956
"Ticket sellers, men on right side of Jamaica mutuel windows."
Ernie Sisto/The New York Times, Courtesy The New York Times Photo Archives

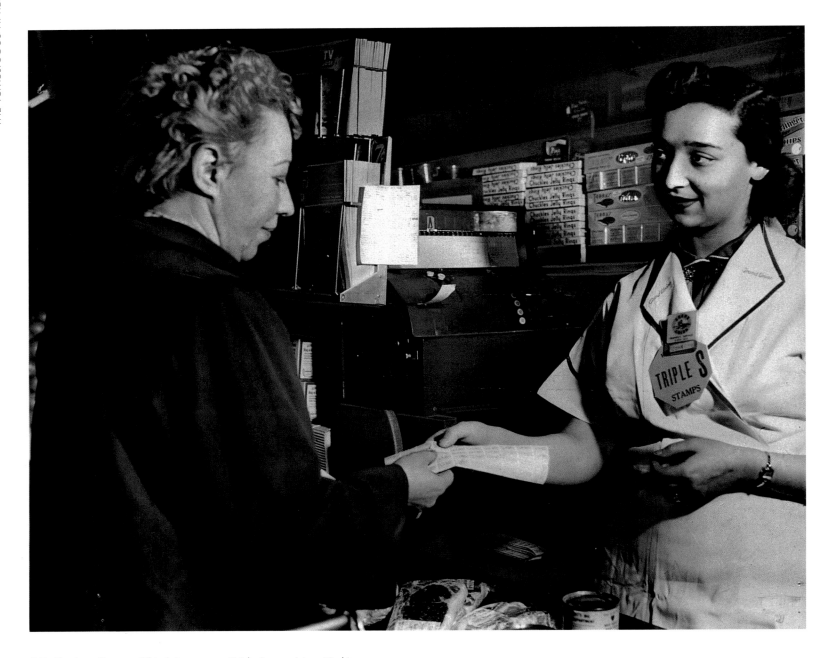

84 *Trading Stamps* (Third Avenue at 36th Street, New York),
May 6, 1956

"The trading stamp industry is growing in popularity in the U.S. In this
Grand Union supermarket, customer receives her stamps as purchases
are totaled at check-out counter."

Patrick A. Burns/The New York Times, Courtesy The New York Times
Photo Archives

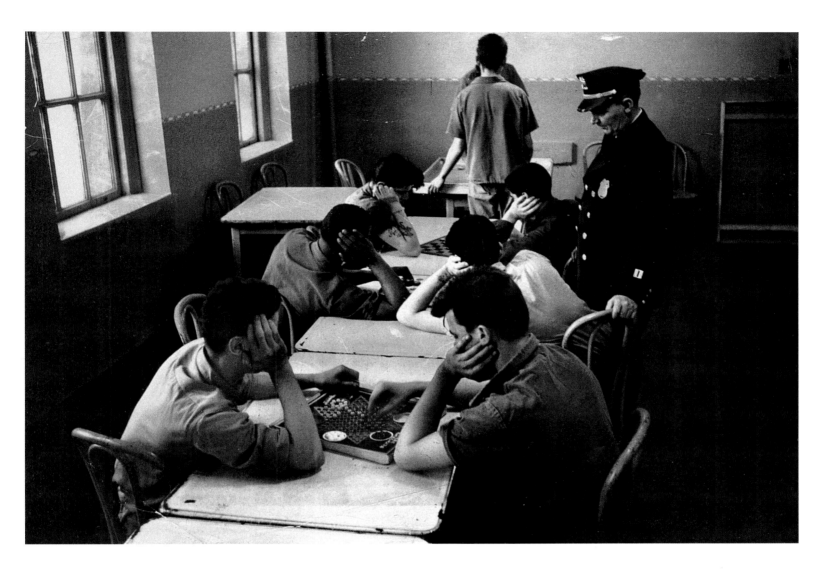

85 *Recreation* (City Prison, Brooklyn, New York), July 1, 1956

"What the jails provide today is mostly of the sedentary, time-killing kind, as above. There is little purposeful training."

Gertrude Samuels/The New York Times, Courtesy The New York Times Photo Archives

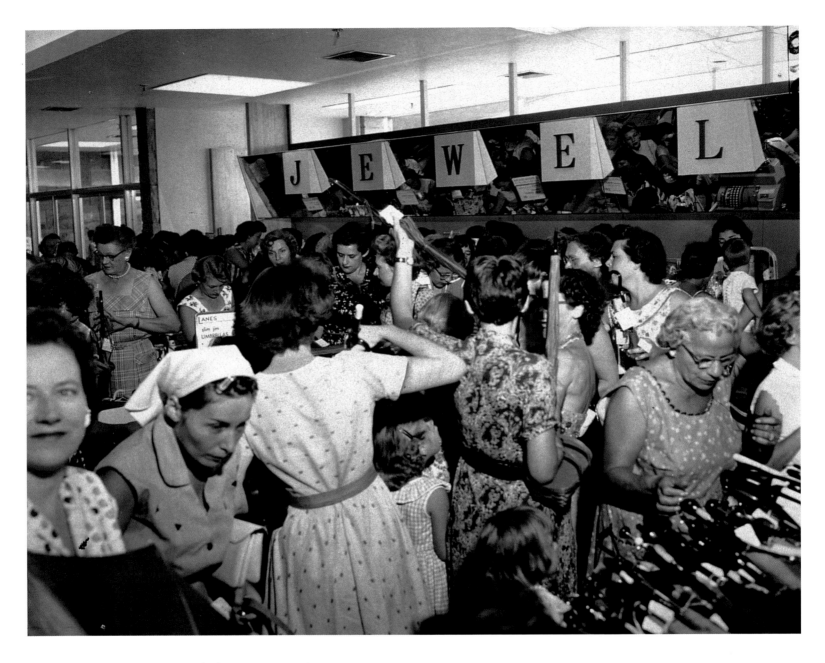

86 *Bargain-Hungry Customers Flock to New Lanes Store,*
August 17, 1956

"Bargain counters already were crowded by noon with opening-day
customers. Store, fully air-conditioned, was designed by Summer
Schein, Boston, and Cordes & Bartos, New York."

Anonymous/The New York Times, Courtesy The New York Times Photo Archives

87 *Weather-Conditioned Shopping Center Opens* (Minneapolis, Minnesota), October 9, 1956

"Interior of 300-foot temperature-controlled garden court, which has a sidewalk café and gardens. At the right stands one of two metal sculptured trees, forty-five feet tall."

Anthony Lane/Studio of Modern Photography

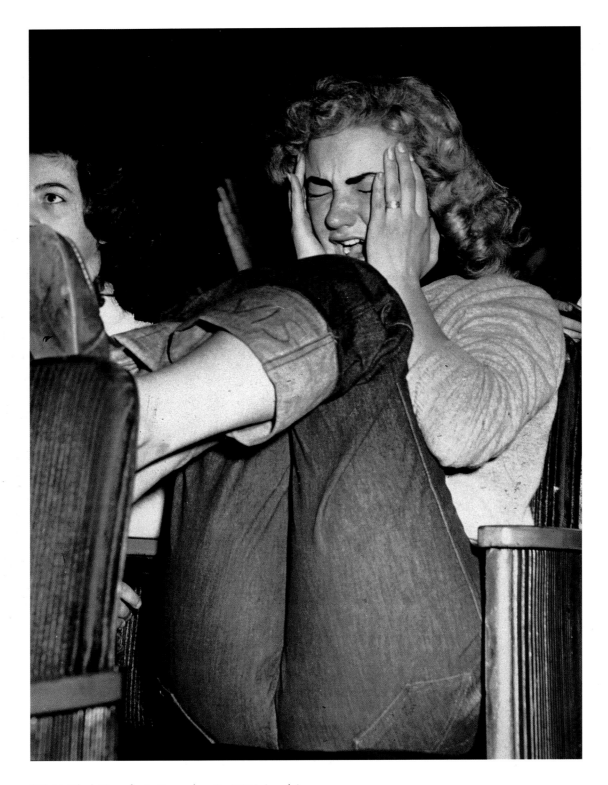

88 Untitled [Teen fan], December 2, 1956 (made)

This teenager suffered some anguish and could not bear to look at the screen when her idol, Elvis Presley, dies in his first movie "Love Me Tender," now showing in Toronto. Hundreds of young girls chanted in rock & roll style during the movie.

Anonymous/Federal News Photos of Canada

89 Untitled [Smokey the Bear], April 14, 1957

"The Forest Fire Prevention Program uses its symbol Smokey bear as a reminder to use care in woodlands."

Frank D. Mallett

90 *Guitarists* (Washington Square Park, New York), June 30, 1957

"With three chords and some faking, a man may qualify for the folk-song division. Anything from flamenco on to classical requires many lessons and much practicing."

Sam Falk/The New York Times, Courtesy The New York Times Photo Archives

91 *Mohawk Indians from Canada, Settled at Fort Hunter, N.Y.,*
August 16, 1957 (made)

Mohawk Indians, coming from Canada, have settled along the
Schoharie Creek outside Fort Hunter, N.Y., claiming that the land
belongs to them. Chief Standing Arrow teaches Paul, 4, how to use
bow and arrow.

Neil Boenzi/The New York Times, Courtesy The New York Times Photo Archives

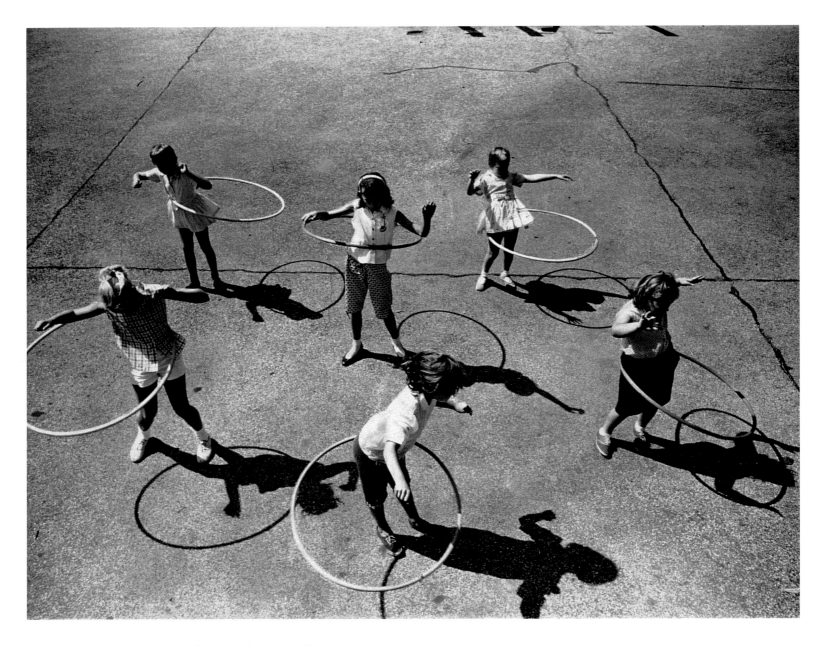

92 *On the Town* (62nd Street Playground, New York),
September 2, 1958

"The city was spinning under the impact of the plastic-hoop craze as
children made the most of a fast-fading summer."

Eddie Hausner/The New York Times, Courtesy The New York Times
Photo Archives

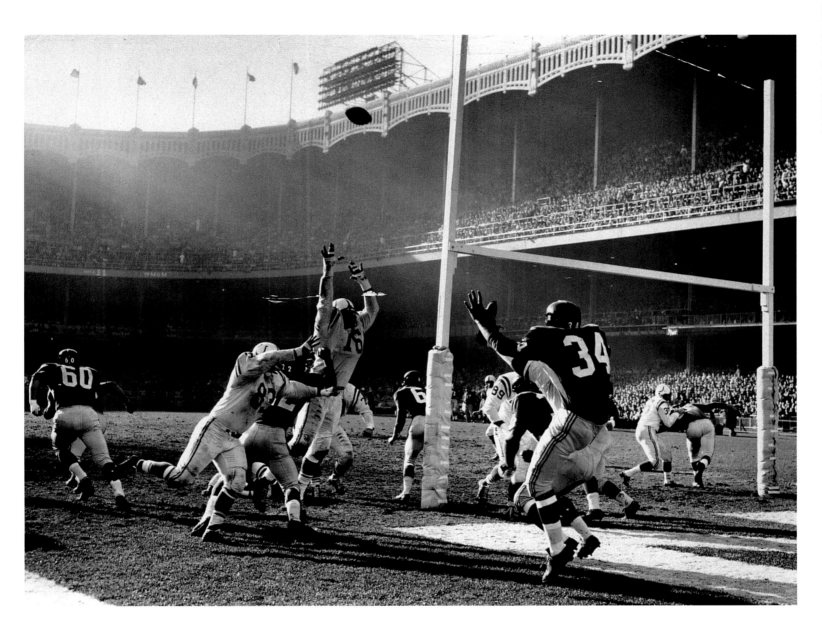

93 *There goes Trouble*, November 10, 1958

"Don Chandler, Giants' punting expert, kicks from behind his own goal line during first quarter of game against Baltimore at Yankee Stadium."

Ernie Sisto/The New York Times, Courtesy The New York Times Photo Archives

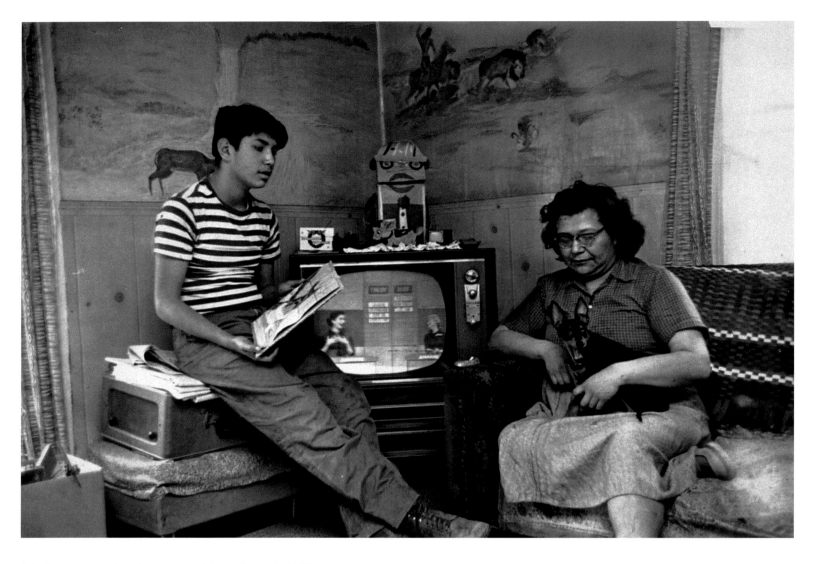

94 *Tuscarora Indian Reservation*, November 24, 1958

"Mrs. Walter Somont and her son, Nelson, in living room of their home. Mural was painted by Mrs. Somont. Most homes on reservation, where Indian and Caucasian patterns are combined, have TV sets. Tribe is a matriarchy, in which chiefs are chosen by women."

Patrick A. Burns/The New York Times, Courtesy The New York Times Photo Archives

Fame and Infamy

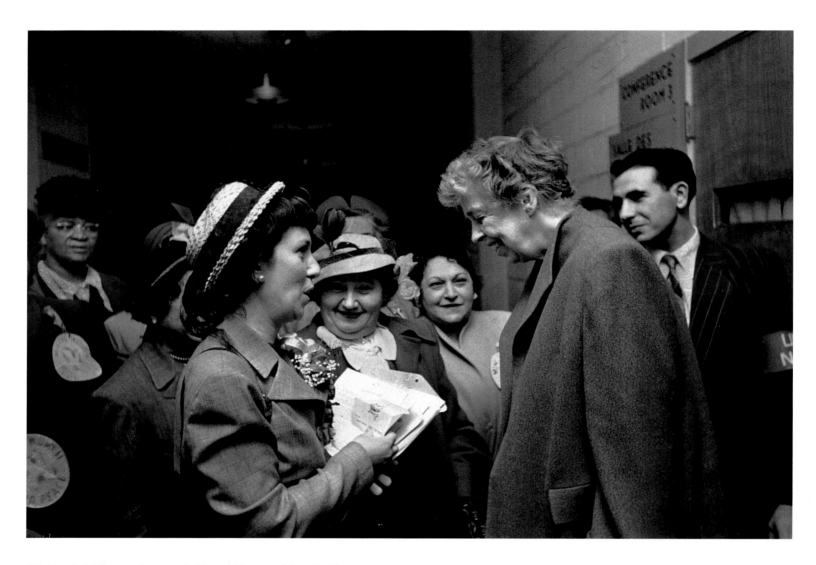

95 Untitled [Eleanor Roosevelt, United Nations, New York],
May 21, 1950

"Thrilled members of a women's peace delegation chat with Mrs.
Roosevelt as she leaves a Human Rights session."

Dan Weiner, Courtesy Sandra Weiner

96 Untitled [Milton Berle], September 17, 1950
"Milton Berle returns to N.B.C. television Tuesday at 8 P.M."
Anonymous/NBC Studios, Courtesy NBC Studios

97 *Backstage*, October 1, 1950

"Miss Merman with Russel Crouse (left) and Irving Berlin at the out-of-town opening of 'Call Me Madam' in New Haven."

Anonymous, Courtesy The New York Times Photo Archives

98 *"Guys and Dolls"*, December 24, 1950

"The newest entry in the wonder class of hit musicals cost $175,000 and is grossing $42,000 weekly. Above, Stubby Kaye as a Runyon type."

Eileen Darby/Graphic House, Inc.

99 Untitled [Albert Einstein and J. Robert Oppenheimer, Princeton, New Jersey], December 1950 (taken)

Dr. J. Robert Oppenheimer, director of the Institute of Advanced Study, drops into Prof. Albert Einstein's office for an impromptu conference on mutual problems.

Gertrude Samuels/The New York Times, Courtesy The New York Times Photo Archives

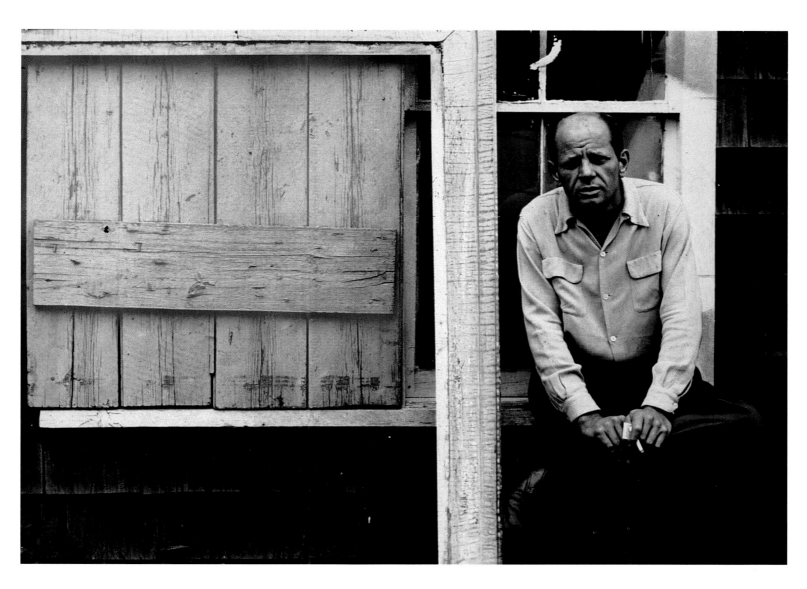

100 Untitled [Jackson Pollock], 1950

"Jackson Pollock outside his house in East Hampton in 1950"

Hans Namuth, Copyright © Hans Namuth Ltd.

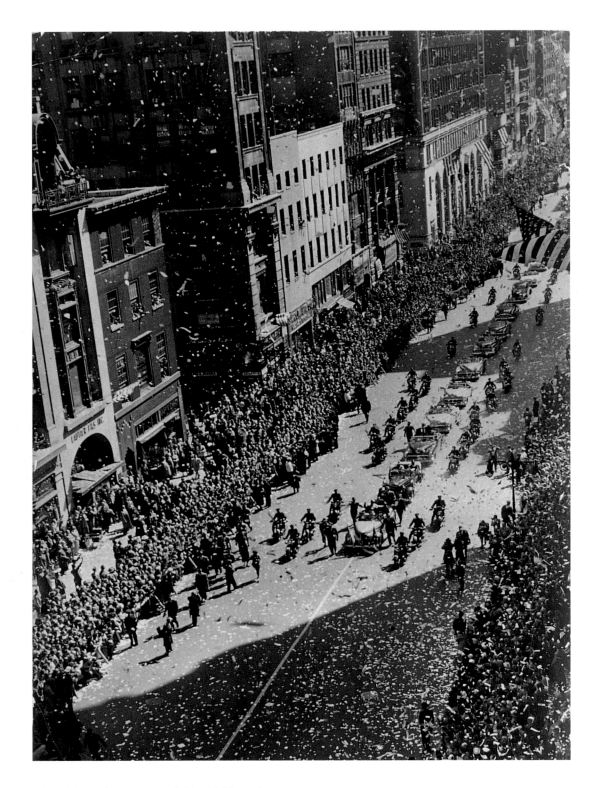

101 *MacArthur Day*, April 21, 1951

"The motorcade as it was hailed from the streets and the buildings along Fifth Avenue."

Carl T. Gossett, Jr./The New York Times, Courtesy The New York Times
Photo Archives

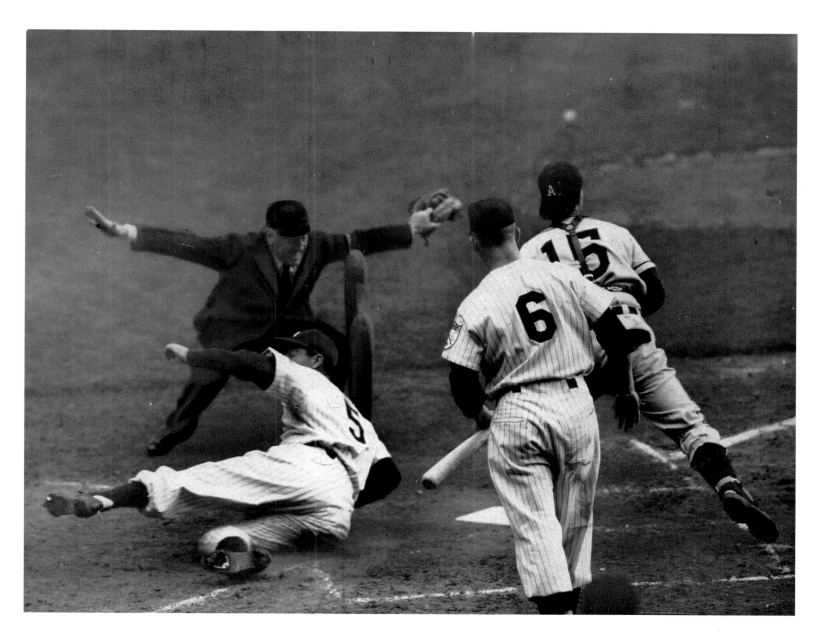

102 *The Yankee Clipper Sails Home at the Stadium,* April 24, 1951

"Joe DiMaggio scoring on Phil Rizzuto's single to left field in the sixth inning. Tipton, Athletics' catcher, waits for the throw as Umpire Grieve calls the play."

Meyer Liebowitz/The New York Times, Courtesy The New York Times Photo Archives

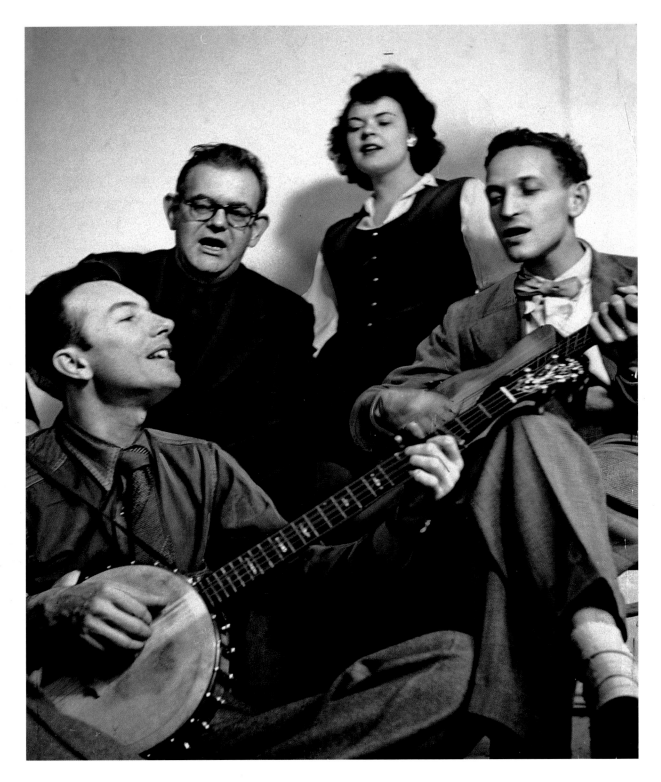

103 *Folk Singers*, December 16, 1951

"The Weavers [left to right: Pete Seeger, Lee Hays, Ronnie Gilbert, Fred Hellerman], who will present holiday concerts of 'songs around the world' and Christmas music at Town Hall Friday and Saturday."

Anonymous/The New York Times, Courtesy The New York Times Photo Archives

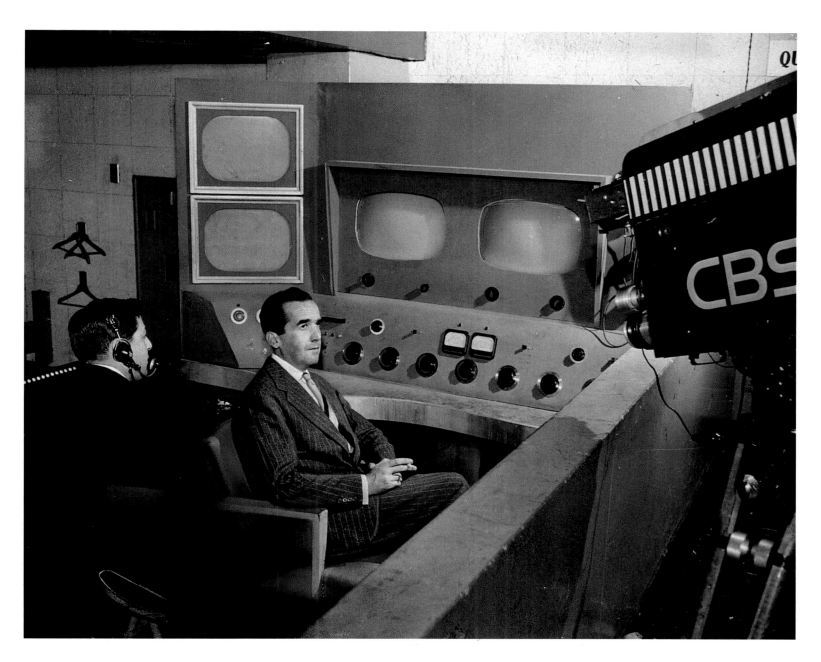

104 *Documentary*, December 30, 1951
"Ed Murrow – *See it Now*"
Anonymous/CBS, Courtesy CBS Photo Archive

105 *Death of a Salesman*, February 1, 1953

"Writing in a fluid form, Arthur Miller chronicled powerfully the tragedy of a traveling man who had founded his life on illusions." [Left to right: Mildred Dunnock, Lee J. Cobb, Arthur Kennedy, Cameron Mitchell]

Eileen Darby/Graphic House, Inc.

106 *Christine Comes Home,* February 12, 1953 (made)

Here's a smiling closeup of Christine Jorgensen, smiling and smartly dressed, on arrival at International Airport, New York, Feb. 12, from Denmark. The 26-year-old former GI had medical treatment which changed her from a man to a woman during her two years in Denmark. "I'm happy to be home," she told newsmen, "what woman wouldn't be?"

John Rooney/Associated Press, Courtesy AP/Wide World Photos

107 Untitled [Sid Caesar], September 6, 1953

"Mr. Caesar"

Sam Falk/The New York Times, Courtesy The New York Times Photo Archives

108 *Rocky Marciano* (Hampshire House, New York),
September 26, 1953

"Rocky Marciano, the winner and still champion, sees himself
connecting with long right in tenth."

Ernie Sisto/The New York Times, Courtesy The New York Times Photo Archives

109 *James Dewey Watson and Francis Crick*, 1953 (taken)

"Watson and Crick in 1953 with the Nobel-prize winning model of DNA's double-helix structure. The young scientists built many experimental models indebted in design to Rube Goldberg, who did not share in the prize."

Anonymous/Atheneum Publishing

110 *Time 3:59.4, May 6, 1954*

"Roger Bannister finishes his history making run and has to be supported. 'Real pain overtook me,' he declared."

Anonymous/Keystone Photo, Courtesy Hulton/Archive

111 *Marion Anderson Rehearses Opera*, December 25, 1954

"The first Negro singer who will appear at the Metropolitan Opera, Miss Anderson starts rehearsals for Verdi's "Un Ballo in Maschera." She will make her debut in this opera on Jan. 7."

Ernie Sisto/The New York Times, Courtesy The New York Times Photo Archives

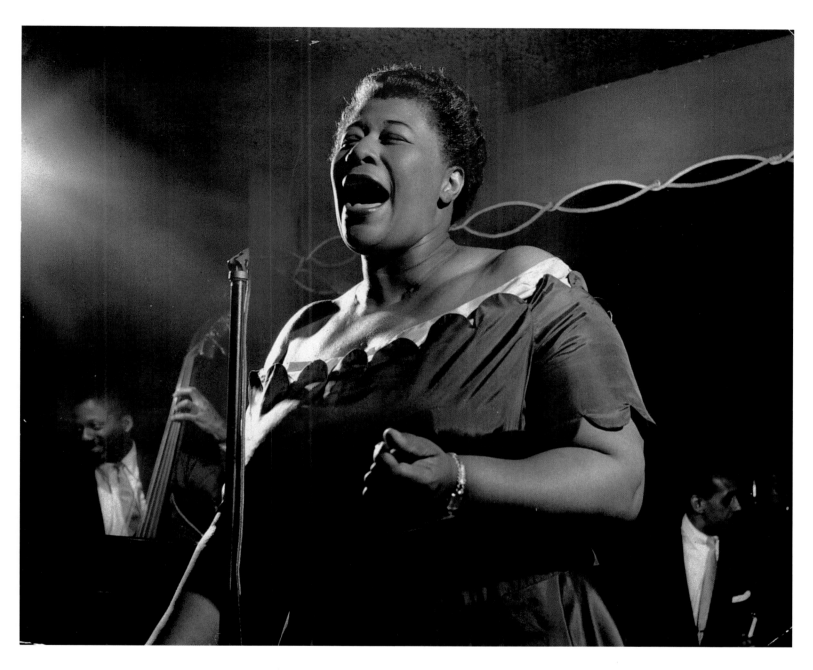

112 *Ella Fitzgerald* (Basin Street, New York), 1954 (taken)

Ella Fitzgerald in a 1954 concert.

Larry Morris/The New York Times, Courtesy The New York Times Photo Archives

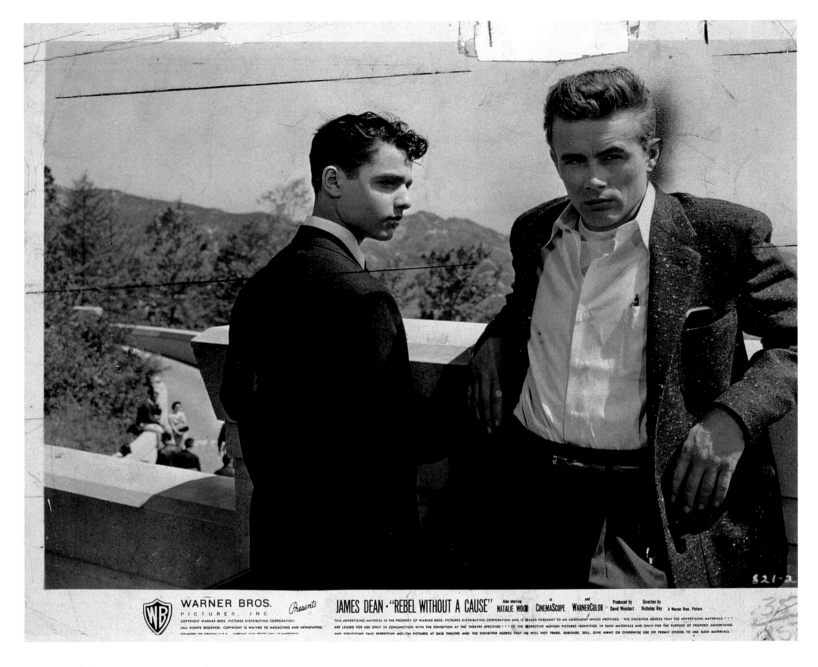

113 Untitled [James Dean], October 27, 1955

"The late James Dean in *Rebel Without a Cause*."

Anonymous/Warner Bros. Pictures, Inc., REBEL WITHOUT A CAUSE © 1955
Warner Bros. Pictures, Inc. All rights reserved

114 *Still Going Strong*, April 15, 1956

"Grandma Moses at work in her Eagle Bridge, New York, home."

Arthur Z. Brooks/Associated Press, Courtesy AP/Wide World Photos

115 *Here Comes the Punch that Kayoed Olson* (Chicago, Illinois), May 16, 1956

"Ray Robinson Knocking out Bobo Olson in 1955 to regain his middleweight title."

Preston Stroup/Associated Press, Courtesy AP/Wide World Photos

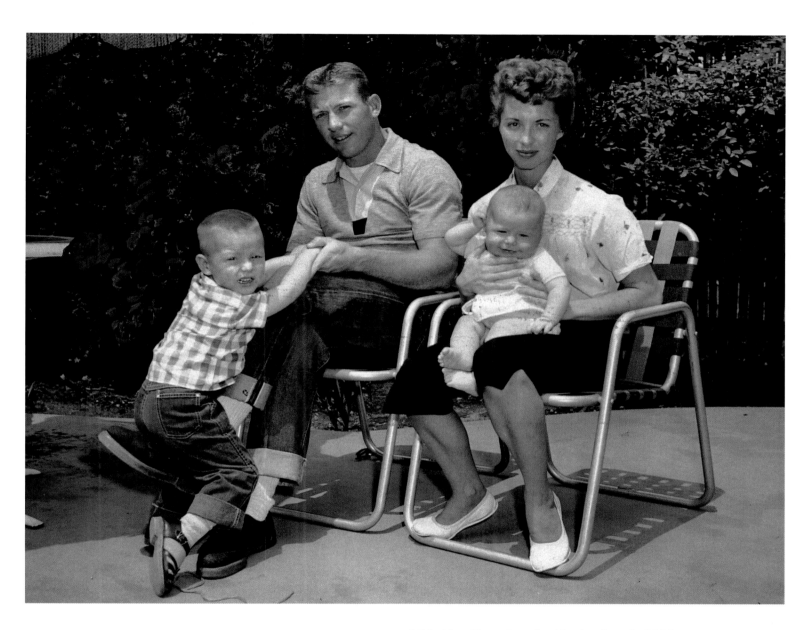

116 *New Home Base for Mantles,* June 2, 1956

"Mickey Mantle of Yankees, baseball's leading batter at .414, relaxes at home he is renting for season at River Edge, N. J. Mrs. Mantle and the children, Mickey Elvin, 3, and David, 5 months, flew East from Oklahoma on Thursday."

Anonymous/Associated Press, Courtesy AP/Wide World Photos

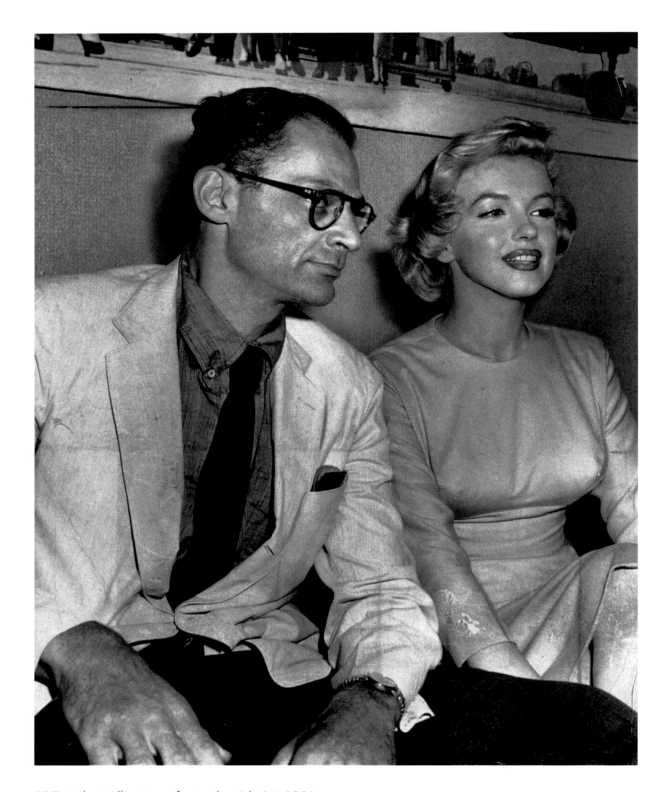

117 *Arthur Millers Leave for London*, July 14, 1956

"Miss Marilyn Monroe and her husband, Arthur Miller, waiting yesterday at Idlewild to board a London-bound plane."

Carl T. Gossett, Jr./The New York Times, Courtesy The New York Times Photo Archives

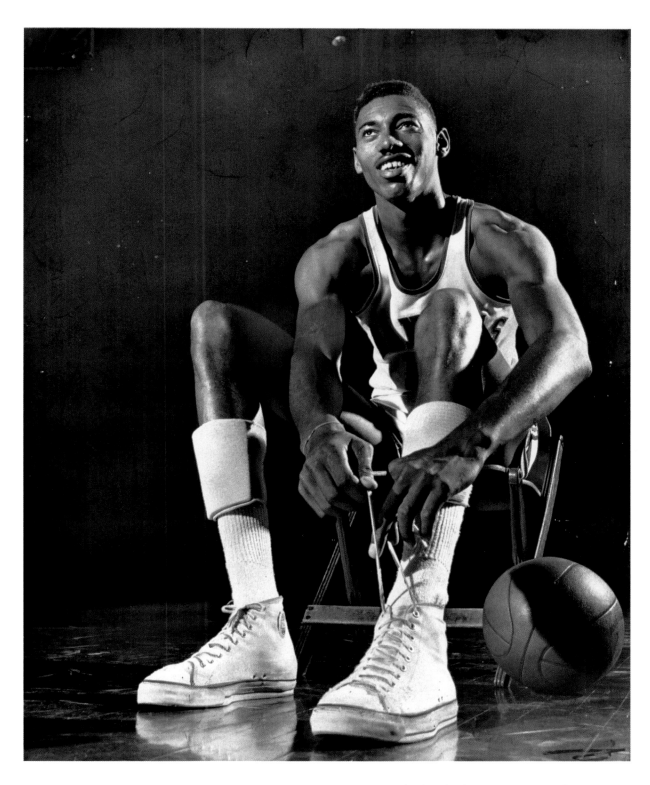

118 *Wilt Chamberlain* (Kansas), March 7, 1957

"All-American basketball team chosen in The Associated Press and United Press polls of sports writers and broadcasters and includes Wilt Chamberlain of Kansas Five."

Rich Clarkson, Courtesy Rich Clarkson and Associates LLC

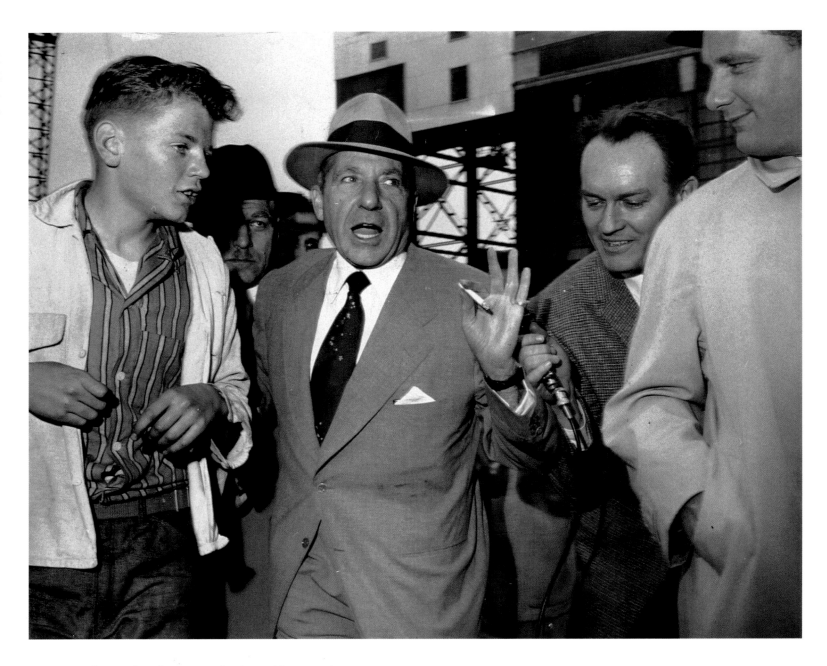

119 *Costello Freed on $1,000 Bail; Cheered by Crowd at Ferry Slip*, May 23, 1957

"Frank Costello arriving at Bronx Pier after being released."

Patrick A. Burns/The New York Times, Courtesy The New York Times Photo Archives

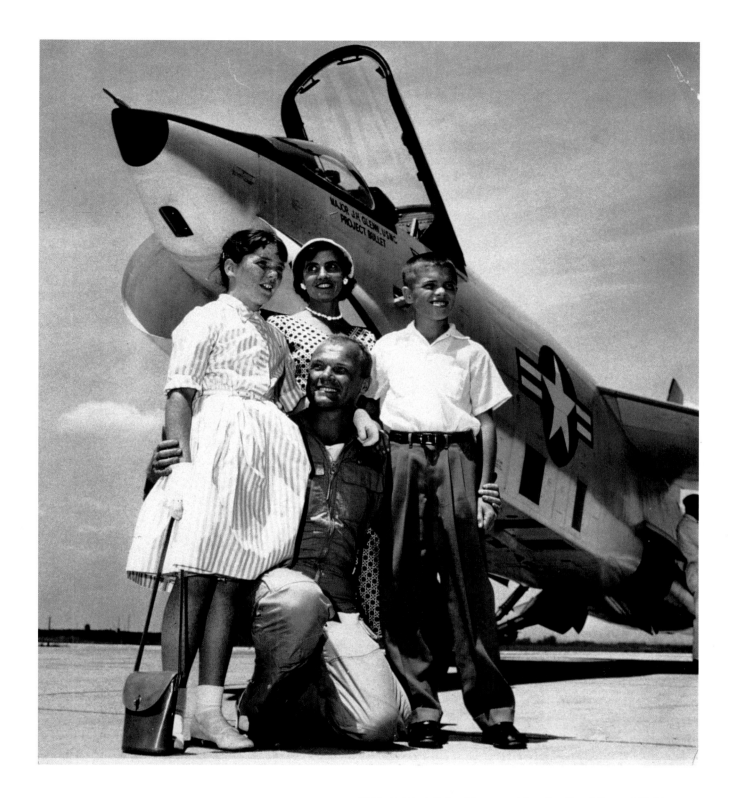

120 Untitled [John Glenn and Family, Floyd Bennett Field, Brooklyn, New York], July 6, 1957

"Major Glenn is greeted by his wife, Ann, and their two children, David, 11, and Lynn, 10."

Allyn Baum/The New York Times, Courtesy The New York Times Photo Archives

121 *Frank Sinatra*, August 18, 1957

"The singer goes on camera to make one of his forthcoming weekly shows scheduled for Fridays on A.B.C. TV."

Anonymous/ABC, Copyright 2001 ABC, Inc. Photography Archives

122 *Hoffa Leading Candidate* (Miami Beach, Florida), September 30, 1957 (taken)

James R. Hoffa, Teamsters vice president and leading candidate to succeed Dave Beck as president, waves to convention delegates at the opening of the Teamsters Union convention today.

Earl Shugars/Associated Press, Courtesy AP/Wide World Photos

123 *Master and Masterpiece,* January 5, 1958

"David B. Steinman looks up from a boat at Mackinac Bridge, his and the world's longest bridge."

H.D. Ellis/Mackinac Bridge Authority, Courtesy Mackinac Bridge Authority and the Michigan Department of Transportation

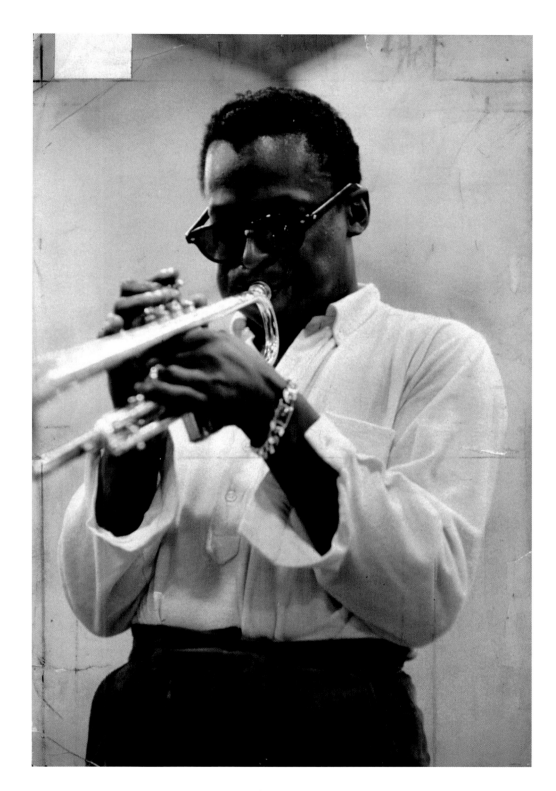

124 *Trumpet Player*, January 12, 1958

"Miles Davis, whose new LP disk [Milestones] reveals a promising talent sharply brought into focus."

Anonymous/Columbia Records

125 *Sought for Questioning in Triple Slayings*, January 28, 1958 (made)

Carol Fugate, 15, and Charles Starkweather, 19, both of Lincoln, were being sought by authorities today for questioning in a triple slaying discovered here last night, according to County Atty. Elmer Scheele. Found in outbuildings behind their home were bodies of Mr. and Mrs. Marion Bartlett and a daughter, 2. The parents had been shot. Carol is the daughter of Mrs. Bartlett by a previous marriage.

Anonymous/Lincoln Journal, Nebraska, /Associated Press, Courtesy AP/Wide World Photos

126 *1940*, March 30, 1958

" 'Letter to the World'," in which Miss [Martha] Graham was inspired by the life of poetess Emily Dickinson, is one of the classics of her career."

Arnold Eagle

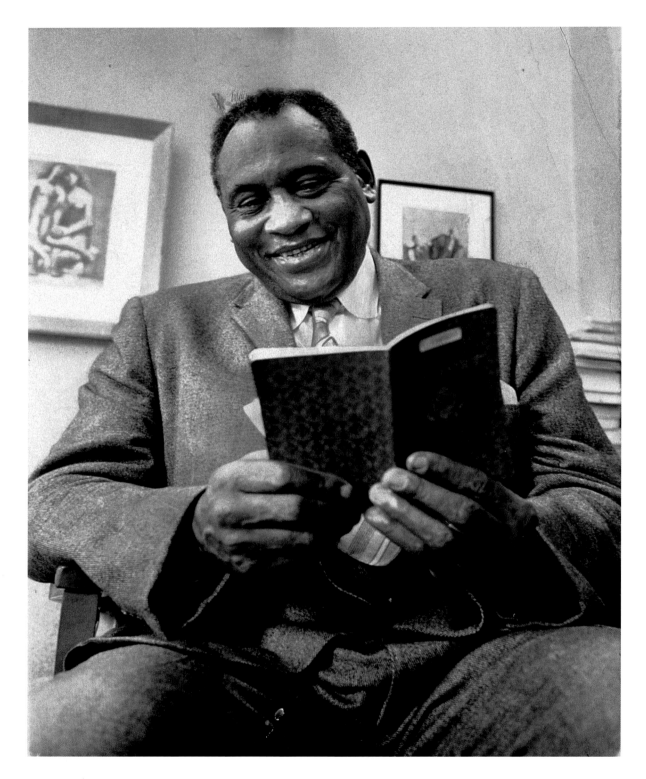

127 Untitled [Paul Robeson, New York], June 27, 1958

"Paul Robeson studies his new passport at lawyer's office."

Carl T. Gossett, Jr./The New York Times, Courtesy The New York Times
Photo Archives

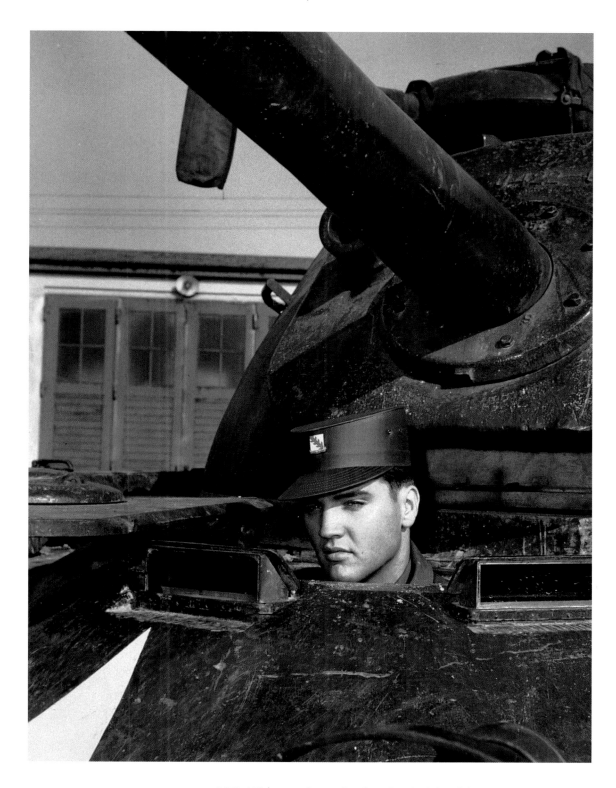

128 *Without a Song*, October 5, 1958 (made)

Pvt. Elvis Presley poses in tank driver's seat at Friedberg, West Germany, Oct. 3, where he is now assigned to the U.S. Army's Third Armored Division. If his rock'n'roll fans could only see him now.

Anonymous/Associated Press, Courtesy AP/Wide World Photos

129 *On the Set* [*Killer's Kiss*], October 12, 1958

"Youthful director Stanley Kubrick works out a scene for filming."

Anonymous/United Artists, © 1955 United Artists Corporation. All Rights Reserved. Courtesy MGMClip + Still

130 Untitled [*Father Knows Best*], 1958 (taken)

Left to right, front: Lauren Chapin and Jane Wyatt.
Back: Billy Gray, Elinor Donohue, Robert Young.

Anonymous/CBS, Courtesy CBS Photo Archive

131 *Highlight*, 1958 (taken)

"The show's range of talent has spread from the Animals to Maria Callas. Here its host welcomes the Moiseyev dancers in 1958. One observer says: 'There's only one thing you can be sure of on *The Ed Sullivan Show* – the first act opens the show'."

Anonymous/CBS, Courtesy CBS Photo Archive

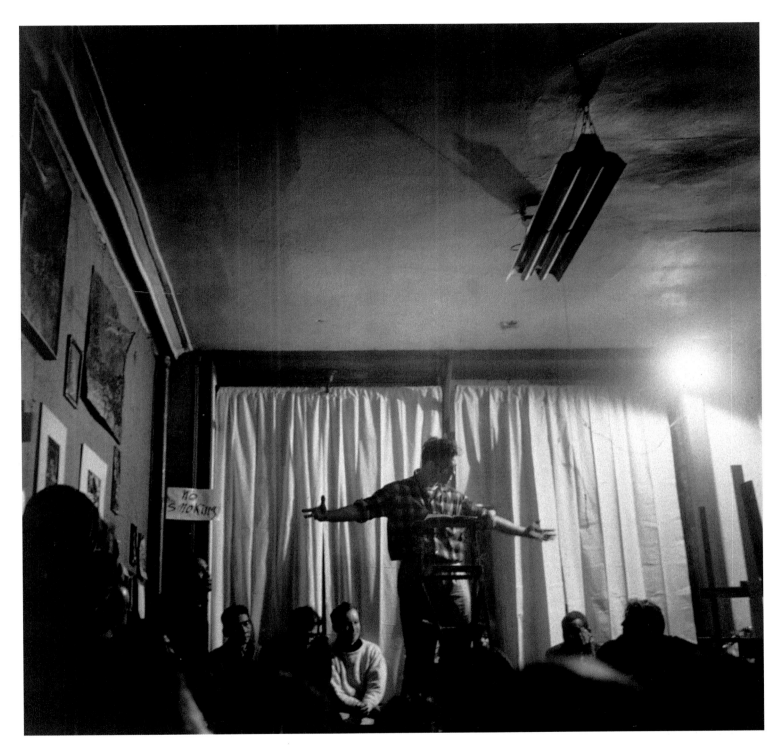

132 Untitled [Jack Kerouac], February 15, 1959 (taken)

"In 1959, Kerouac gave a dramatic reading of his poetry in an East Village loft."

Fred W. McDarrah, Copyright © Fred W. McDarrah

133 Untitled [Norman Mailer], November 1, 1959

"Norman Mailer in 1955"

Judy Scheftel

American Ways of Life

POLITICKING

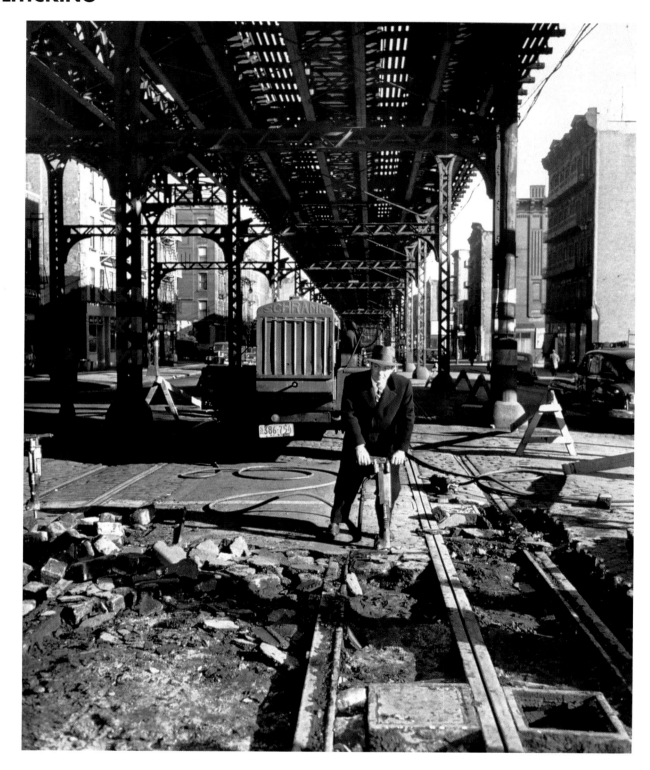

134 *Pulling up Trolley Tracks on Third Avenue,* February 6, 1952

"Manhattan Borough President Robert F. Wagner, Jr. using an air hammer to start operation that is expected to yield 20,000 tons of scrap."

Carl T. Gossett, Jr./The New York Times, Courtesy The New York Times Photo Archives

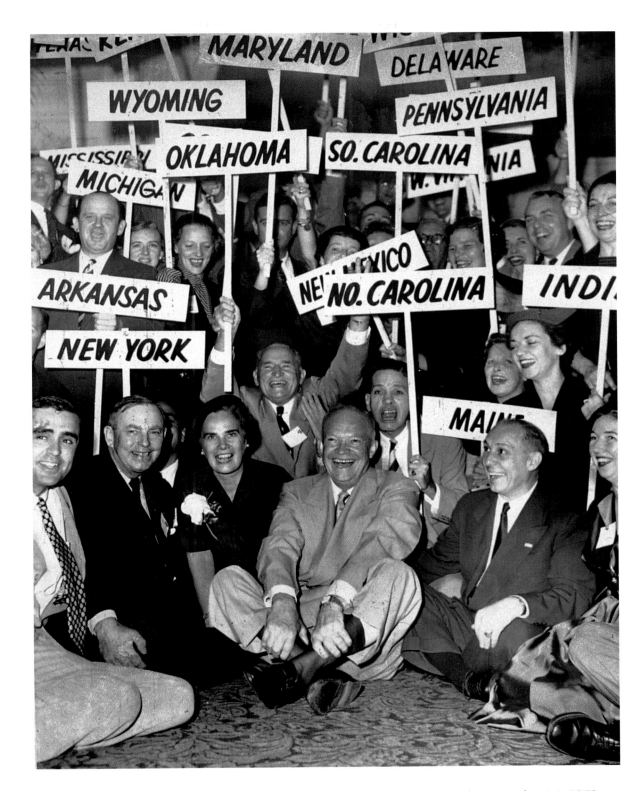

135 *Eisenhower with Supporters* (New York), September 14, 1952

"The Republican candidate sitting cross-legged at the Park Lane Hotel, is surrounded by Citizens for Eisenhower-Nixon holding state standards. Flanking the General are Mrs. Oswald B. Lord (left) and Walter Williams, co-chairmen."

Anonymous/The New York Times, Courtesy The New York Times Photo Archives

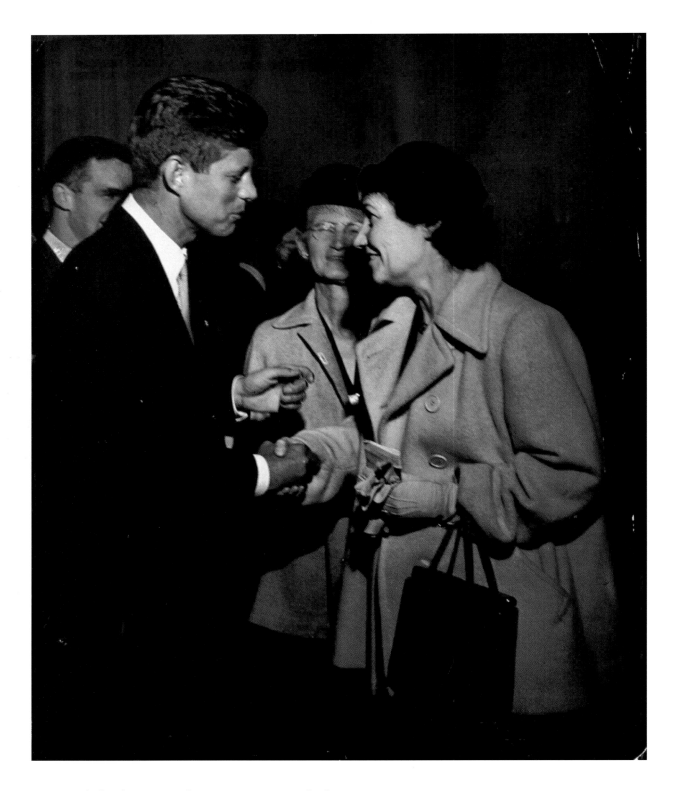

136 Untitled [John F. Kennedy Receiving Line, Cambridge, Massachusetts], October 26, 1952

"The receiving line at Cambridge took two hours to file past. From here the guests moved on to another room and there they were served a total of 8,600 cups of tea and coffee."

James Coyne/Black Star, Courtesy Black Star

137 Untitled [Richard M. Nixon], October 31, 1952

"It must be rated a major factor in the remarkable comeback staged by Richard Nixon after revelations concerning his private finances."

Anonymous/The New York Times, Courtesy The New York Times Photo Archives

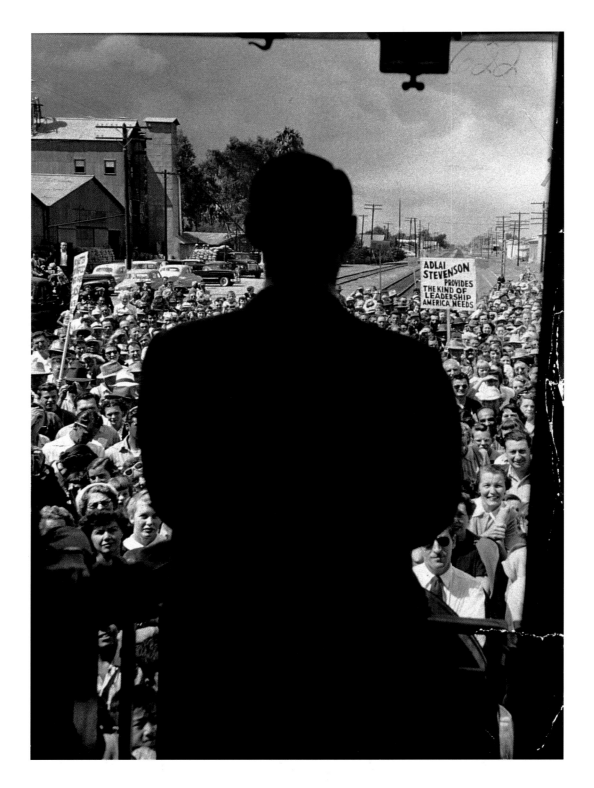

138 Untitled [Adlai Stevenson], 1952 (taken)

Candidate Adlai Stevenson speaks at a whistle stop during his 1952
presidential campaign.

Cornell Capa/Magnum Photos for Life, Courtesy Magnum Photos

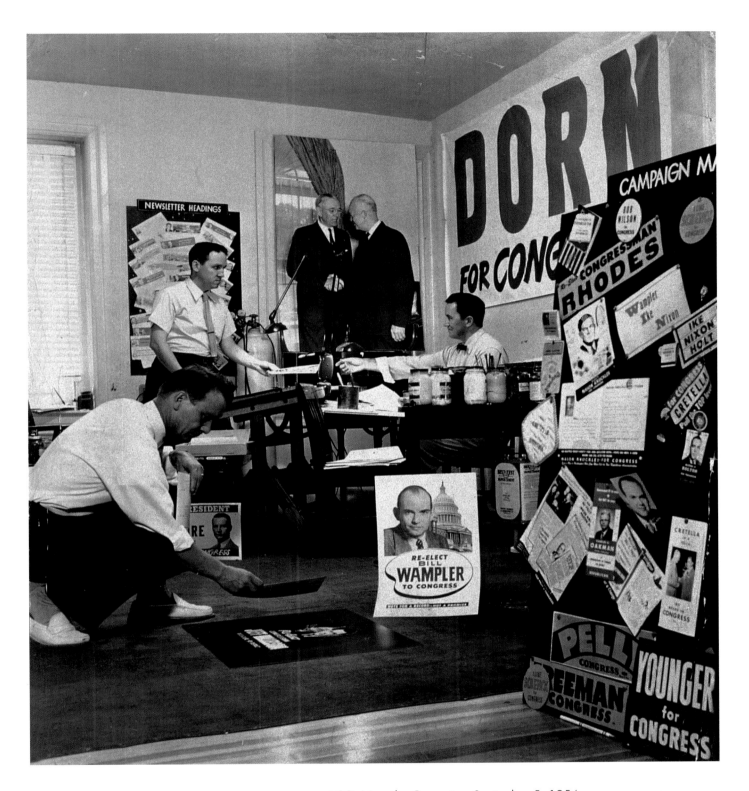

139 *Now the Campaign,* September 5, 1954

"1954 is a Congressional election year, and talk of Congressional election is topic No. 1 here at Republican House campaign headquarters in Washington, where art staff members are seen at work. In the background is one of a number of specially prepared photos of the President shaking hands with Congressional candidates he favors."

George Tames/The New York Times, Courtesy The New York Times Photo Archives

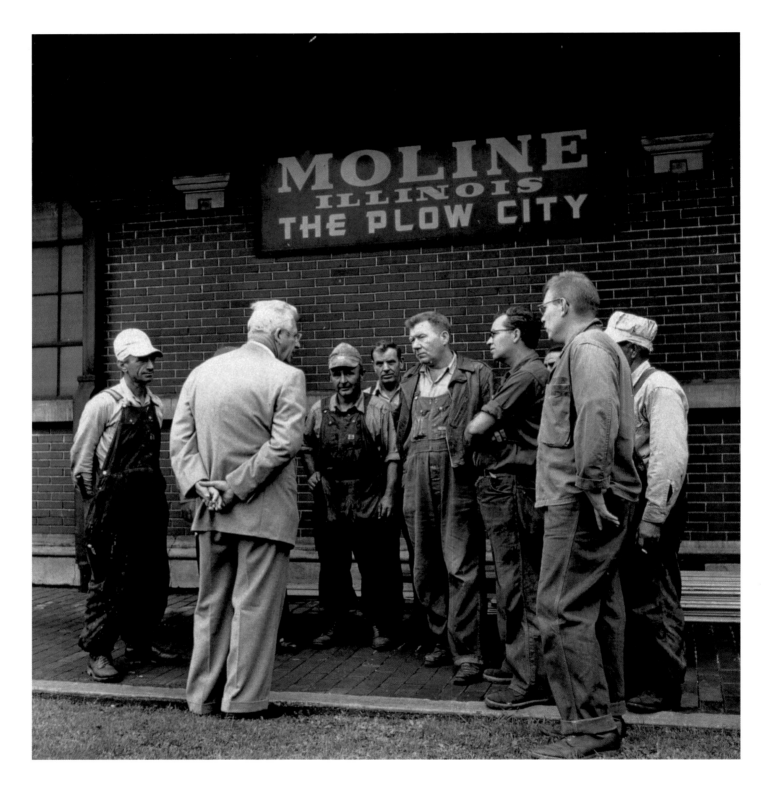

140 *Rock Island Line*, September 26, 1954

"Senator Douglas talks with railroad workers at Rock Island station in
Moline and explains the changes he is asking for in the social security
law."

George Tames/The New York Times, Courtesy The New York Times
Photo Archives

141 Untitled [Dwight D. Eisenhower throws out first ball],
April 19, 1956 (taken)

President Eisenhower throws out first ball at opening day game
between Senators and Yankees on April 19.

George Tames/The New York Times, Courtesy The New York Times
Photo Archives

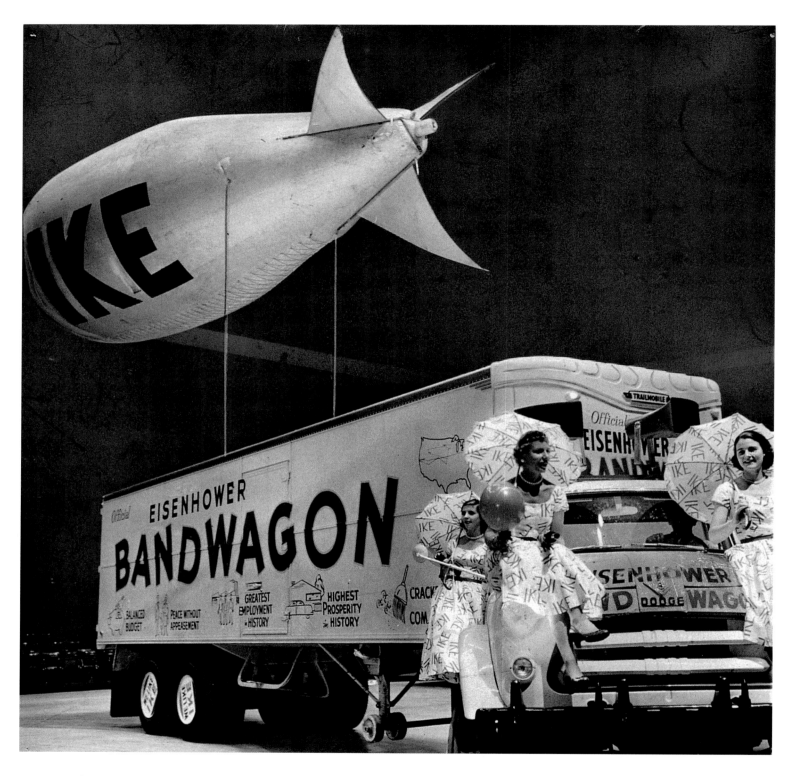

142 *Eisenhower Workers Learn How Bandwagon Runs*, July 12, 1956

"The Official Eisenhower Bandwagon displays its versatility at Madison Square Garden."

Larry Morris/The New York Times, Courtesy The New York Times Photo Archives

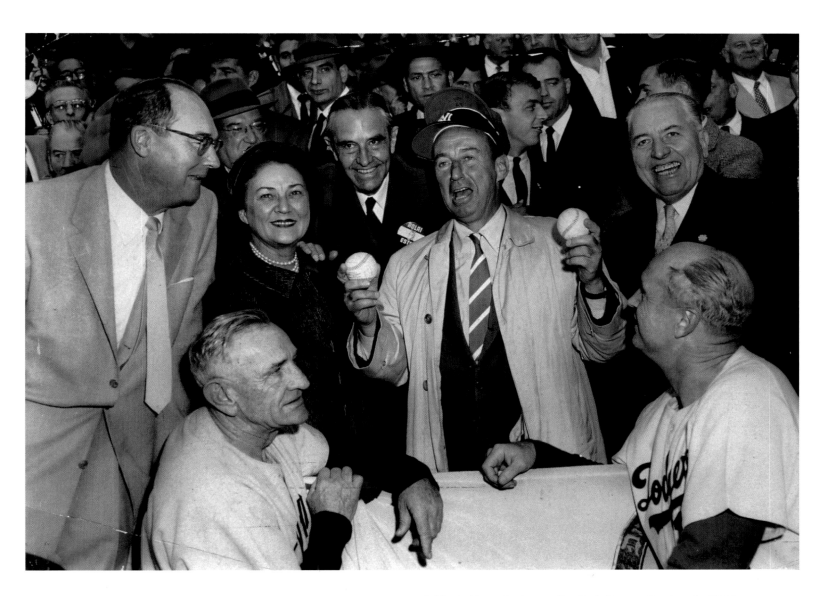

143 *In There Pitching – For Both Teams*, October 6, 1956

"Adlai E. Stevenson wore both Yankee and Dodger caps before start of second series game at Ebbets Field. From left: Del Webb, part owner of Yankees; Governor and Mrs. Harriman; Mr. Stevenson, and Councilman Joseph T. Sharkey. Foreground: Managers Casey Stengel, left, and Walt Alston."

Anonymous/The New York Times, Courtesy The New York Times Photo Archives

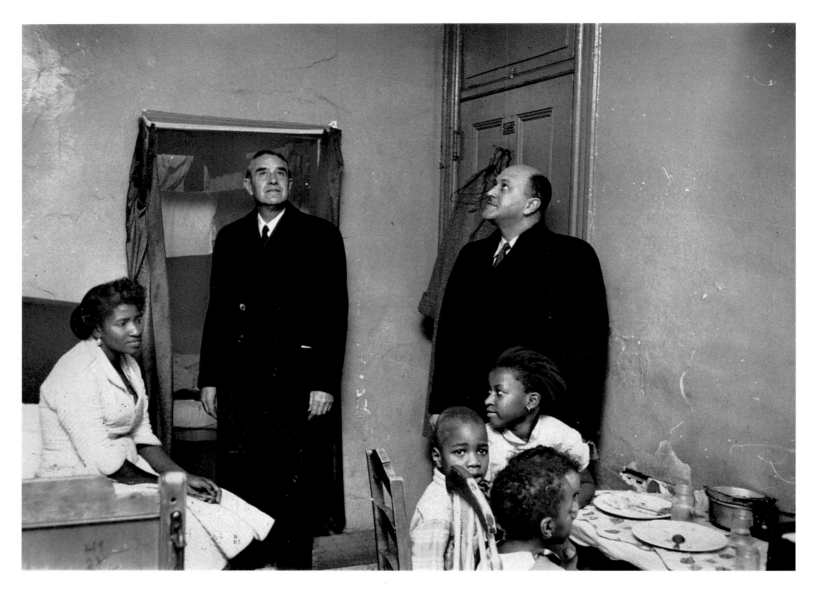

144 *Governor Tours High Rent Slums to Point up Loophole in State Law*,
February 18, 1957

"Governor Harriman, center, and Robert Weaver, State Rent
Administrator, with Mrs. Sara Barnes, who with her four children
occupies a two-room apartment on the second floor of tenement at 61
East 126th Street, near Madison Avenue."

Eddie Hausner/The New York Times, Courtesy The New York Times
Photo Archives

145 *Barnstorming Ex-President*, October 26, 1958

"Former President Harry ('give 'em Hell') Truman comes to the aid of *his* party with the flair of a political veteran who delights in hard campaigning. In San Francisco, he reaches out for a dollar bill being dropped from a window as a contribution to the 'Dollars for Democrats' drive."

Clarence Hamm/Associated Press, Courtesy AP/Wide World Photos

146 *The Moskva Boatmen, July 27, 1959*

"Russian bathers swarm around motorboat to greet Vice President Nixon during his cruise with Premier Nikita S. Khruschev [sic] on Moskva River. At right is Dr. Milton S. Eisenhower, President's brother."

Henry Griffin/Associated Press, Courtesy AP/Wide World Photos

SCAPEGOATING

147 Untitled [Congressional Hearings], April 30, 1950

"Senator Joseph R. McCarthy's charges of subversion in the State Department were first heard in 1950 by a Congressional subcommittee headed by Senator Millard E. Tydings, seated second from right. McCarthy is partially visible behind him."

Anonymous/The New York Times, Courtesy The New York Times Photo Archives

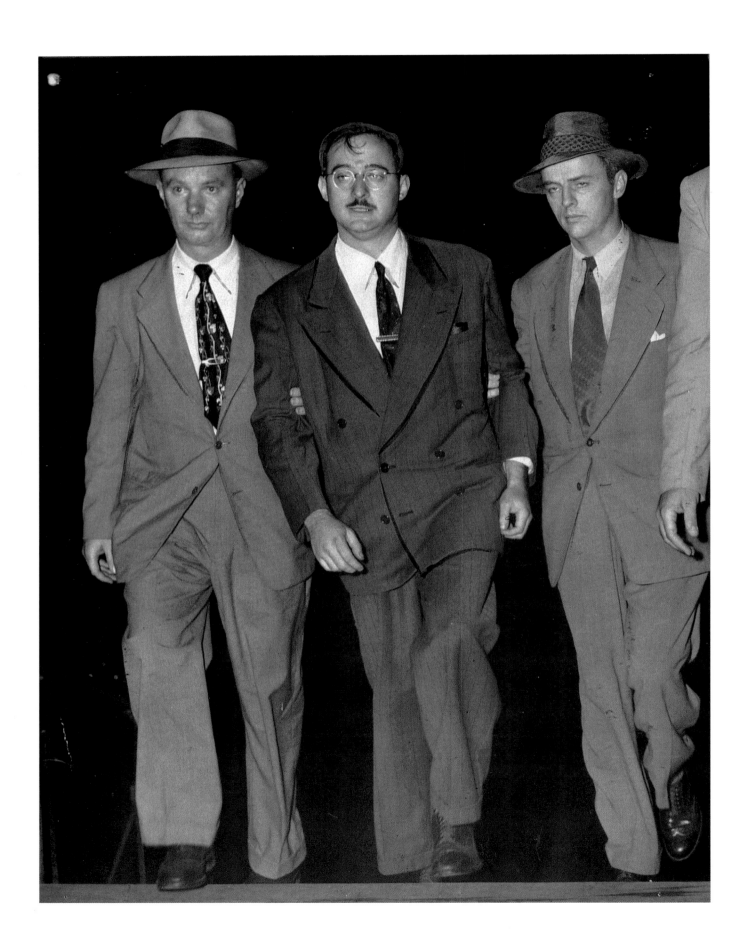

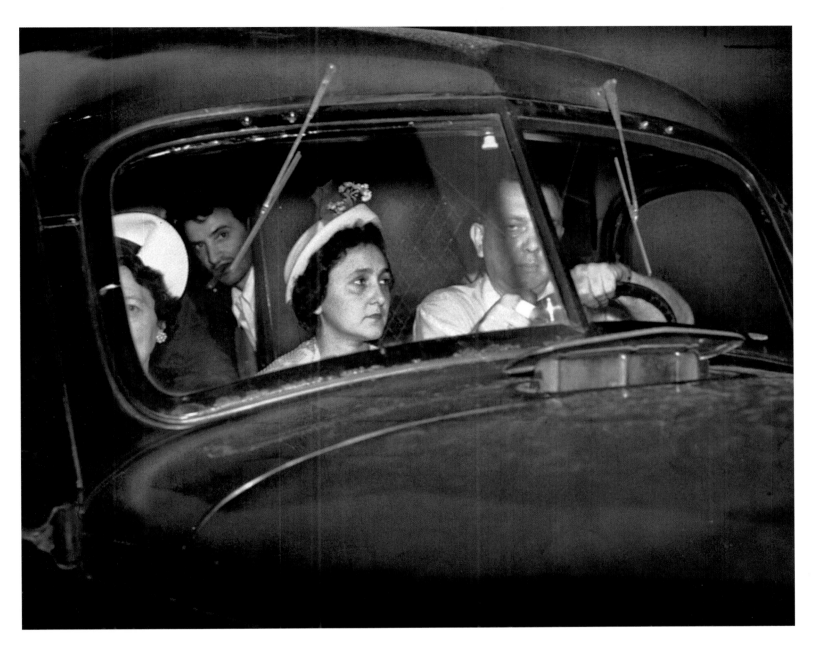

149 *Held by F.B.I. in Russian Spy Case*, August 12, 1950

"Mrs. Ethel Rosenberg on her way to Federal prison after being arraigned and committed in $100,000 bail."

Sam Falk/The New York Times, Courtesy The New York Times Photo Archives

148 *American Held on Espionage Charge*, July 19, 1950

"Julius Rosenberg (center), flanked by F.B.I. agents, being taken to Federal Building here for questioning."

Anonymous/Associated Press, Courtesy AP/Wide World Photos

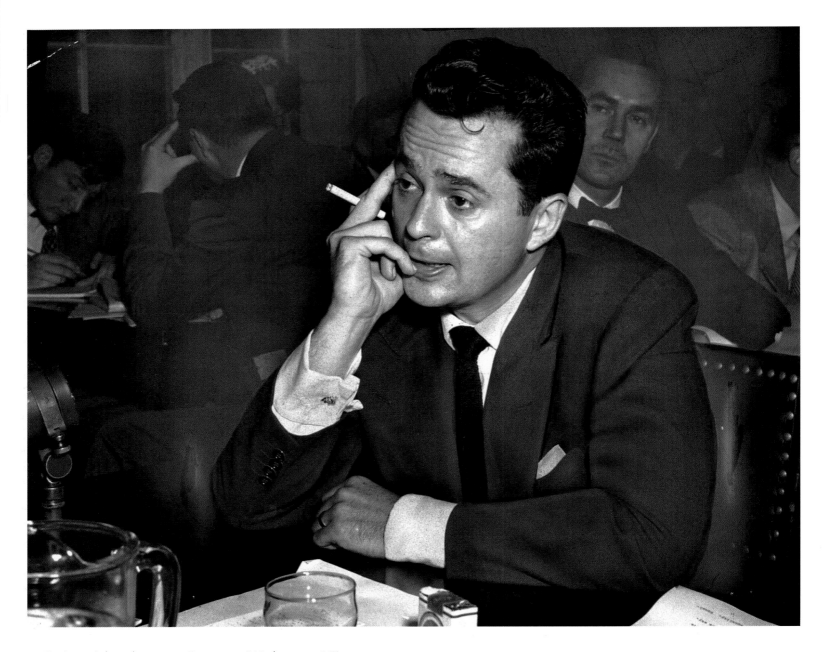

150 *Actor Admits he was a Communist* (Washington, DC),
March 22, 1951

"Larry Parks telling the House Committee on Un-American Activities that
he was a member of the party ten years ago, but later quit."

Bruce J. Hoertel/The New York Times, Courtesy The New York Times
Photo Archives

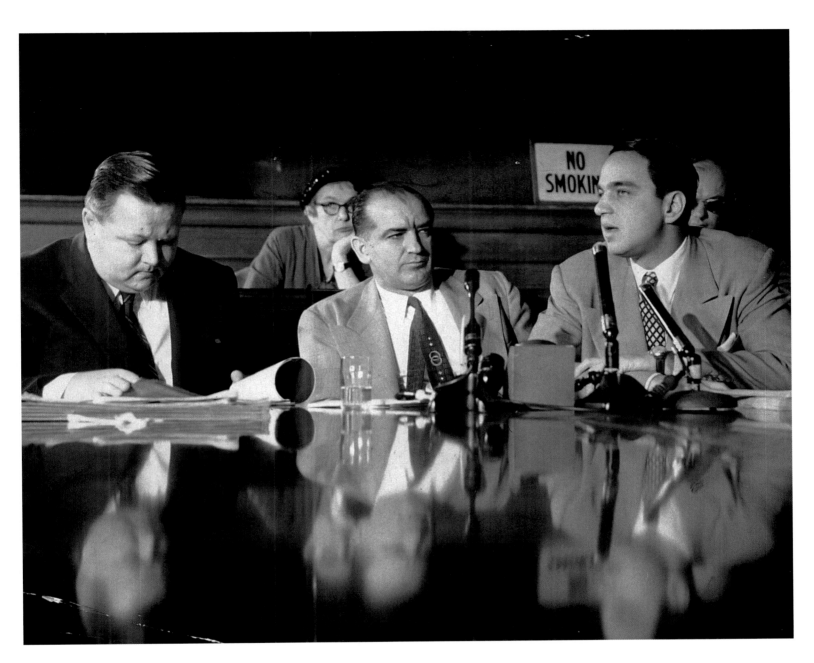

151 *Answers Truman* (Washington, DC), November 25, 1953

"Senator Joseph R. McCarthy of Wisconsin, who said last night in a television broadcast that former President Truman's Administration 'crawled with Communists'."

Meyer Liebowitz/The New York Times, Courtesy The New York Times Photo Archives

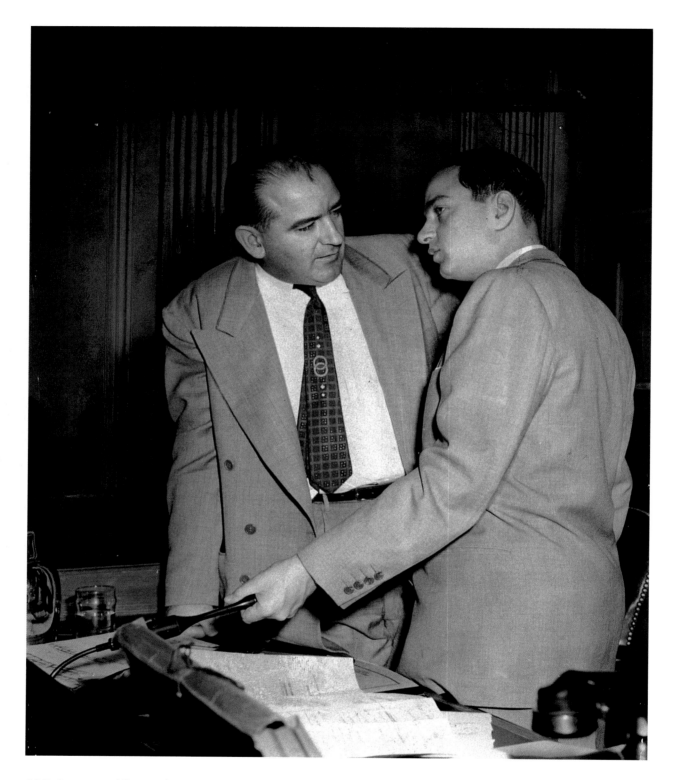

152 *Private Huddle* (Washington, DC), December 16, 1953

"Senator Joseph R. McCarthy, left, conferring with Roy M. Cohn, chief counsel of his Senate Permanent Subcommittee on Investigation, who held hand over microphone during session at the Federal Courthouse here."

Patrick A. Burns/The New York Times, Courtesy The New York Times Photo Archives

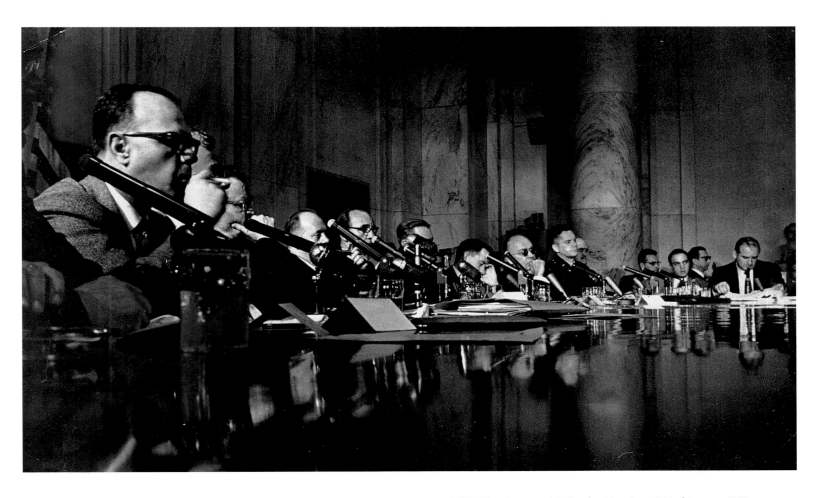

153 *The Stevens–McCarthy Hearings* (Washington, DC),
May 9, 1954

"The most serious charge is that in the antics of its investigative
capacity the Senate has demeaned its legislative function."

George Tames/The New York Times, Courtesy The New York Times
Photo Archives

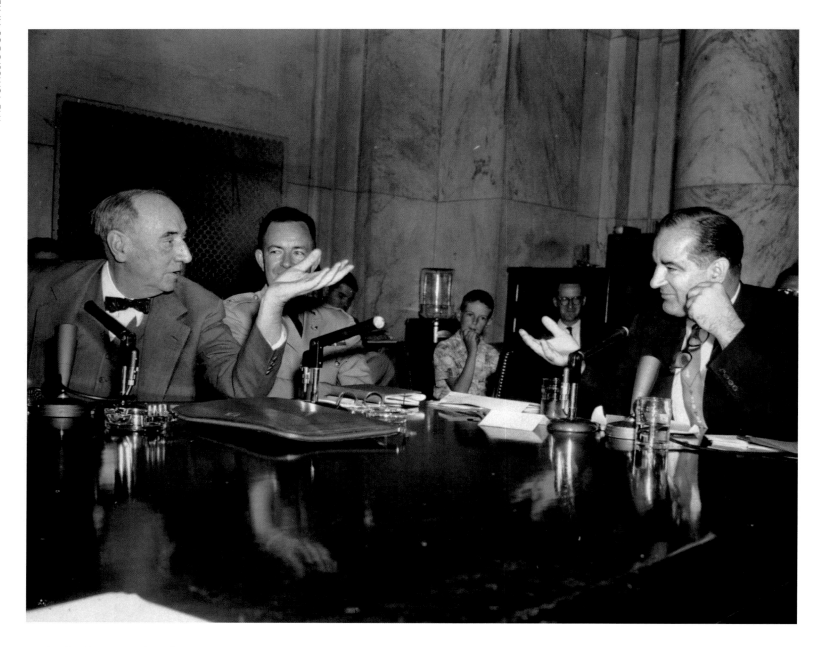

154 *The Opposition* (Washington, DC), May 3, 1957

"Joseph N. Welch, left, the Boston trial lawyer who served as special council to the Army in the hearings in the spring of 1954, faces Senator McCarthy across the table. Their exchanges sometimes drew laughs."

Anonymous/Associated Press, Courtesy AP/Wide World Photos

DEMONSTRATING

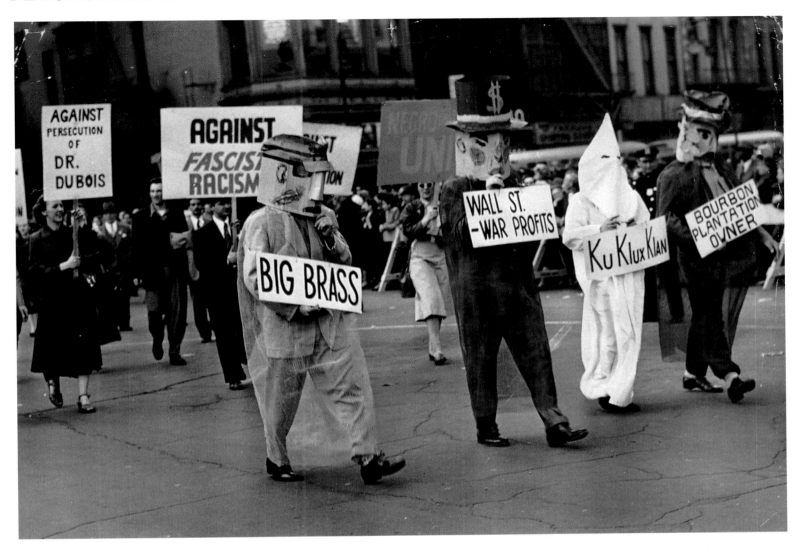

155 *May Day Parade in New York City,* May 27, 1951

"Keep the Communist party in the open where its very freedom of action demonstrates how little afraid of it we are."

Eddie Hausner/The New York Times, Courtesy The New York Times Photo Archives

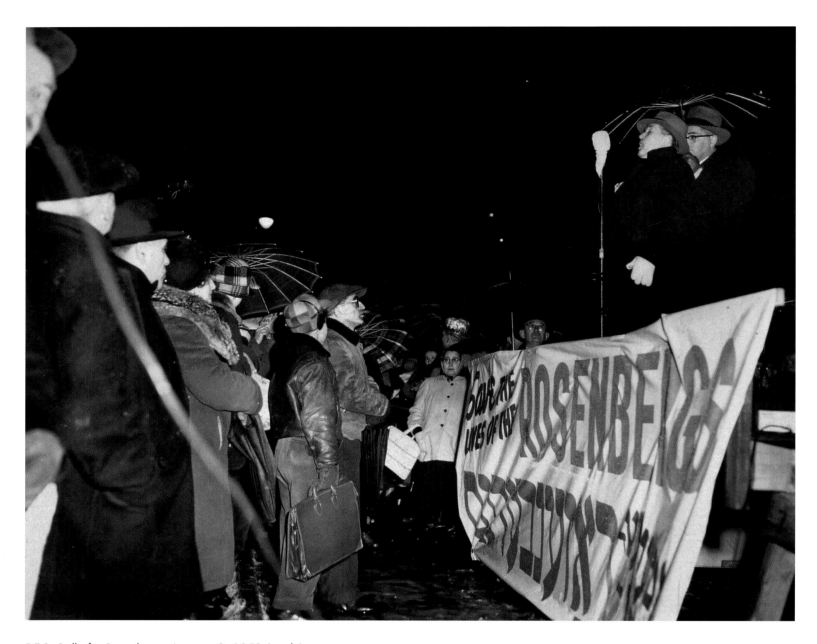

156 *Rally for Rosenbergs*, January 8, 1953 (made)

Cantor Jacob Kaminsky leading the crowd in a prayer for the
Rosenbergs during rally in Strauss Square on the East Side. Holding
the umbrella for the rabbi is Aaron Schneider, secretary of the N.Y.
Committee for Clemency for the Rosenbergs.

Robert Walker/The New York Times, Courtesy The New York Times
Photo Archives

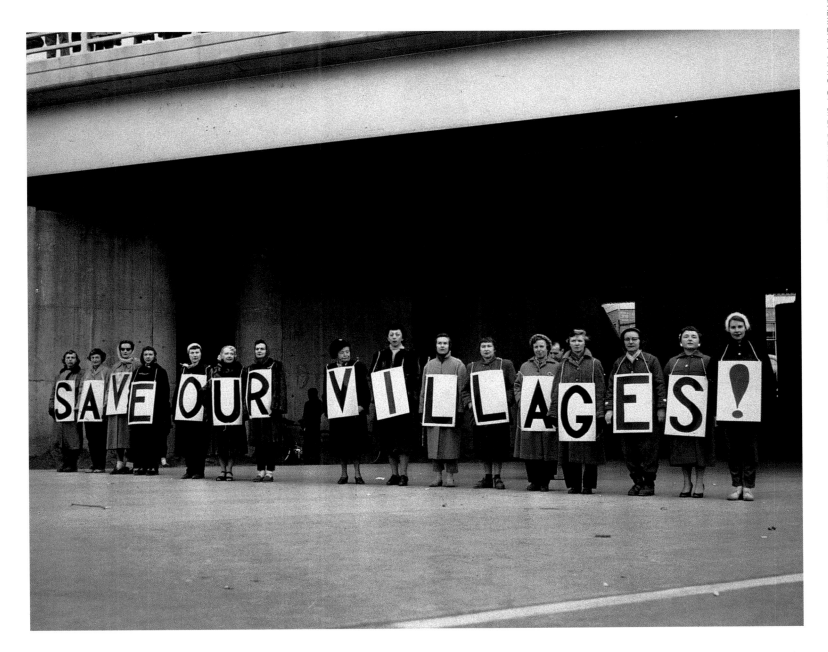

157 *Thruway Opening*, December 16, 1955

"Housewives demonstrate against proposal for connecting link between New York Thruway and New Jersey Turnpike. The women, from villages of Sparkill, Grand View and Piermont, staged protest before opening of Thruway bridge at Nyack."

Anonymous/The New York Times, Courtesy The New York Times Photo Archives

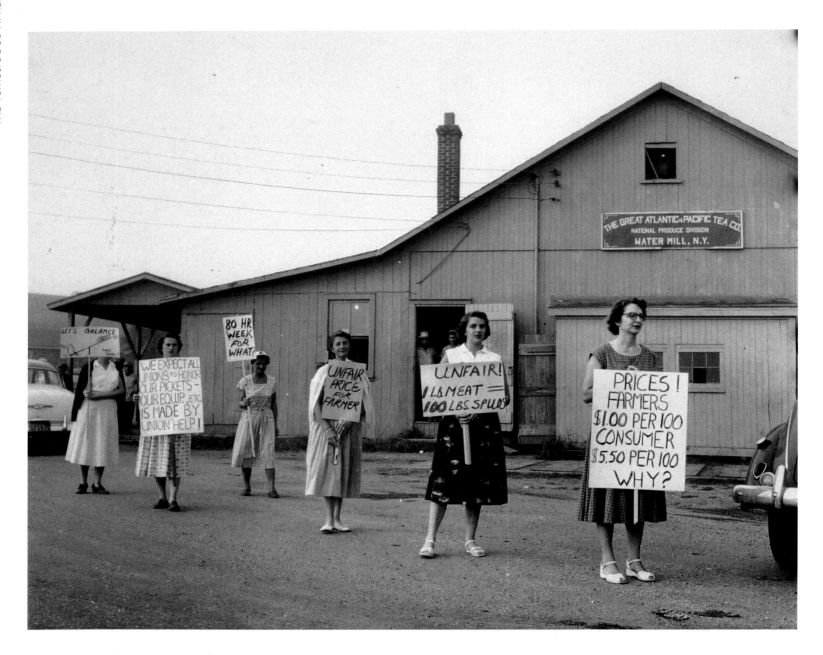

158 *Want Higher Prices*, September 6, 1956

"These are a few of the pickets, wives of potato farmers, who set up lines yesterday before grading houses in Suffolk County, L. I. This one was in Water Mill. Their protest was against present market prices, which they called too low."

Eunice Telfer Juckett for The New York Times, Courtesy The New York Times Photo Archives

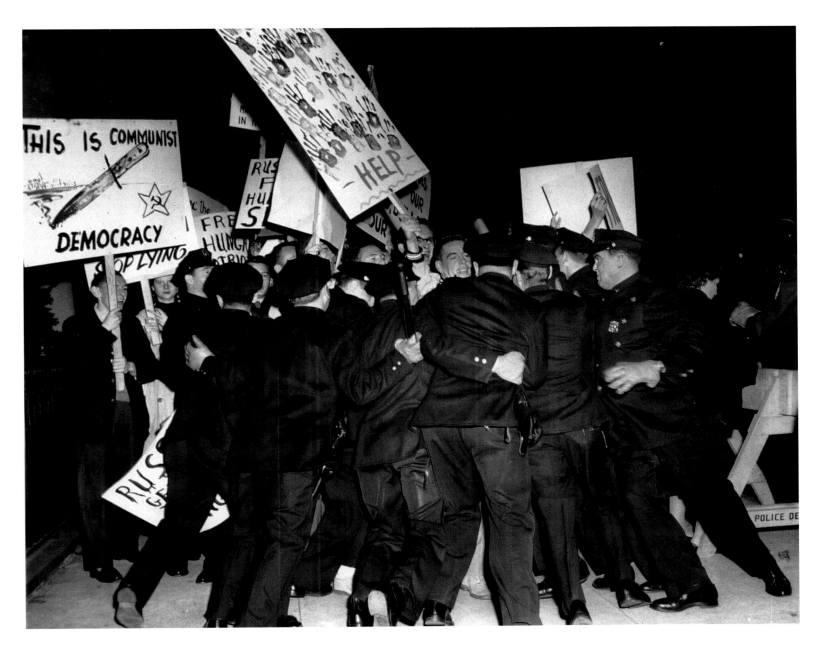

159 *1,500 Booing Pickets Besiege Soviet U. N. Delegates,*
November 8, 1956

"Policemen pushing back pickets last night outside Soviet U. N.
delegation's headquarters."

Neil Boenzi/The New York Times, Courtesy The New York Times
Photo Archives

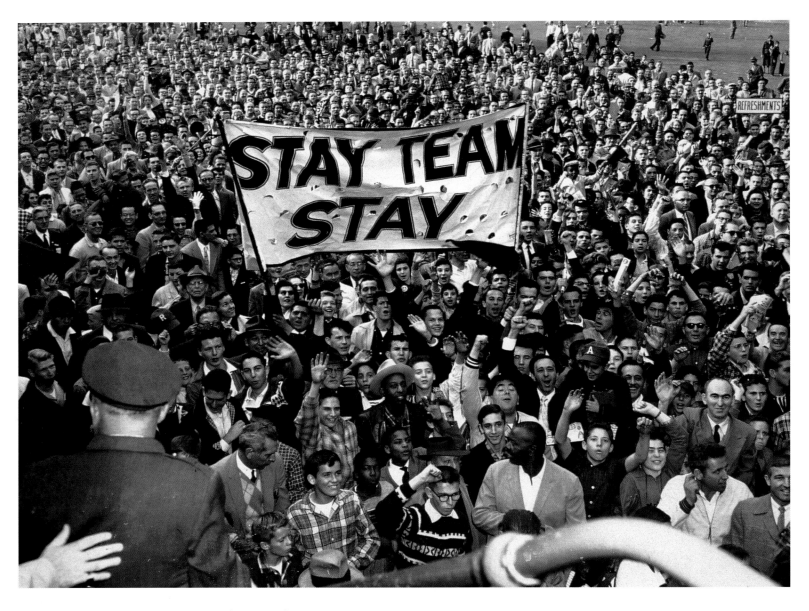

160 *Polo Grounds* (Brooklyn, New York), September 29, 1957 (made)

Fans gathered outside the clubhouse after today's game.

Anonymous/The New York Times, Courtesy The New York Times Photo Archives

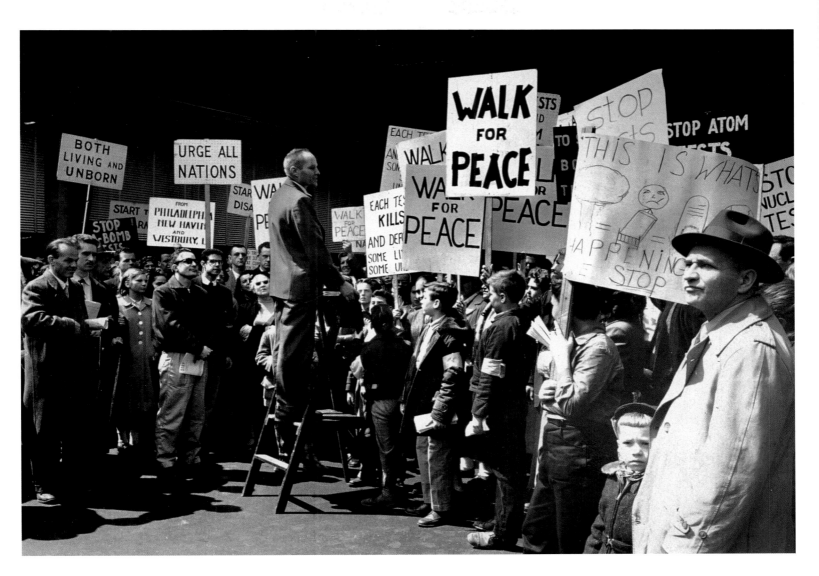

161 *Walk for Peace*, April 27, 1958

"Walk for Peace signs rally these U. S. pacifists who march through Manhattan to a street meeting."

Allyn Baum/The New York Times, Courtesy The New York Times Photo Archives

STRIKING

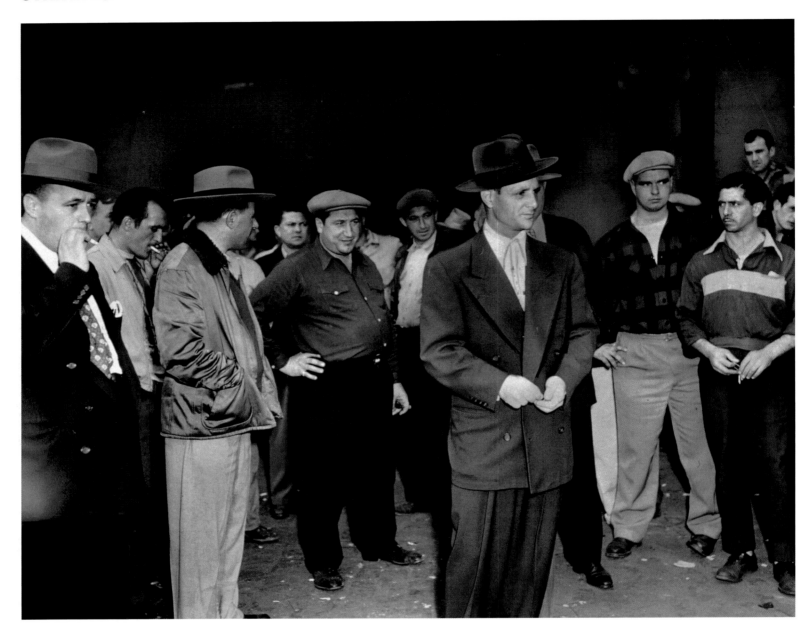

162 *Longshoremen's Strike* (Brooklyn, New York), October 18, 1951

"The Anastasia brothers, Anthony wearing leather jacket and Jerry in the foreground, watching developments at the pier of the Royal Netherlands Steamship Company, where they failed to get the men to go back to work."

Meyer Liebowitz/The New York Times, Courtesy The New York Times Photo Archives

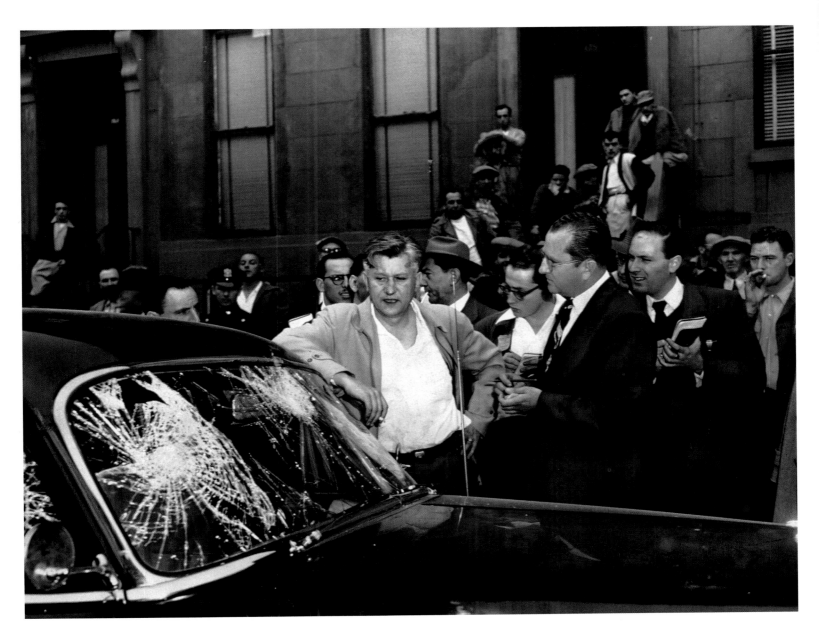

163 *Violence Flares in Wildcat Dock Strike*, October 23, 1951

"Frank Nawrocki, longshoremen's business agent, shows damage to his car after free-for-all at Hamilton Avenue pier in Brooklyn. He received minor hurts in the scuffle."

William C. Eckenberg/The New York Times, Courtesy The New York Times Photo Archives

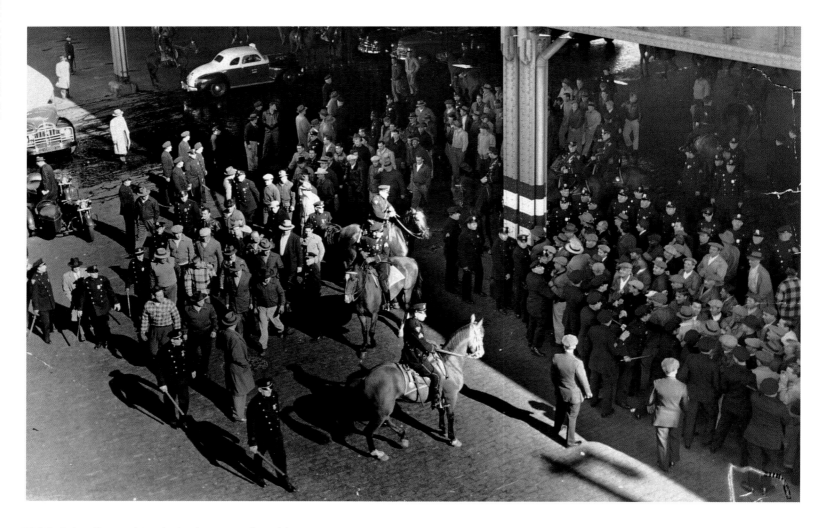

164 *Police-Escorted Dock Workers Breach Wildcat Lines Here,* October 30, 1951

"Non-strikers, left, on their way to unload the liner Queen Elizabeth, skirt hooting insurgents, right, who are being held in check by policemen."

Anonymous/The New York Times, Courtesy The New York Times Photo Archives

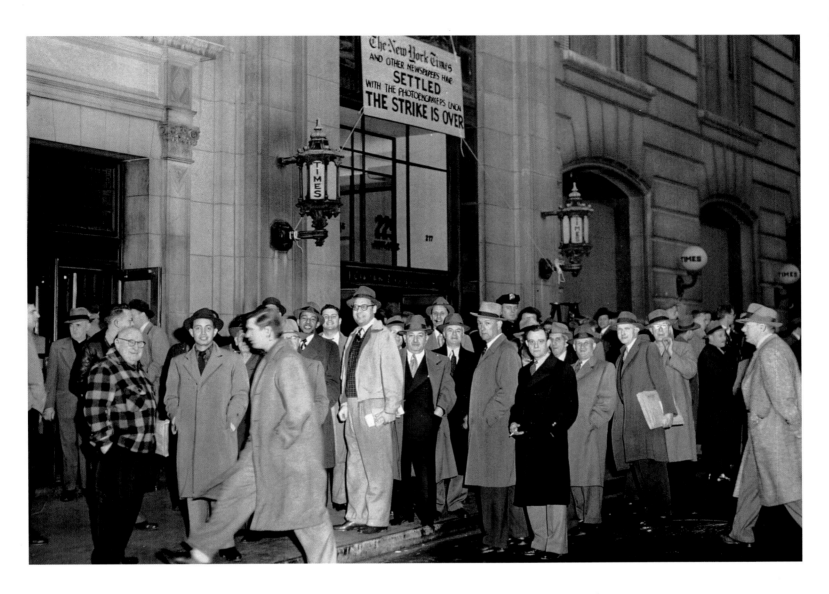

165 *Back to Work*, December 9, 1953

"Employees of the New York Times returning to jobs yesterday at end of photoengravers' strike."

William C. Eckenberg/The New York Times, Courtesy The New York Times Photo Archives

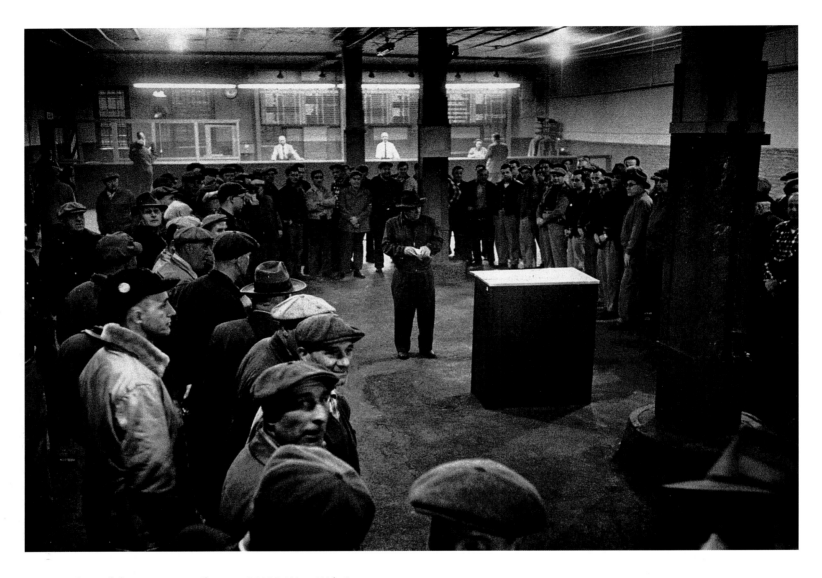

166 *In Place of the Notorious "Shape-up"* (610 West 56th Street,
New York), June 12, 1955

"A new system of hiring, through state-operated employment centers as
above, assures a fairer distribution of jobs for longshoremen."

Sam Falk/The New York Times, Courtesy The New York Times Photo Archives

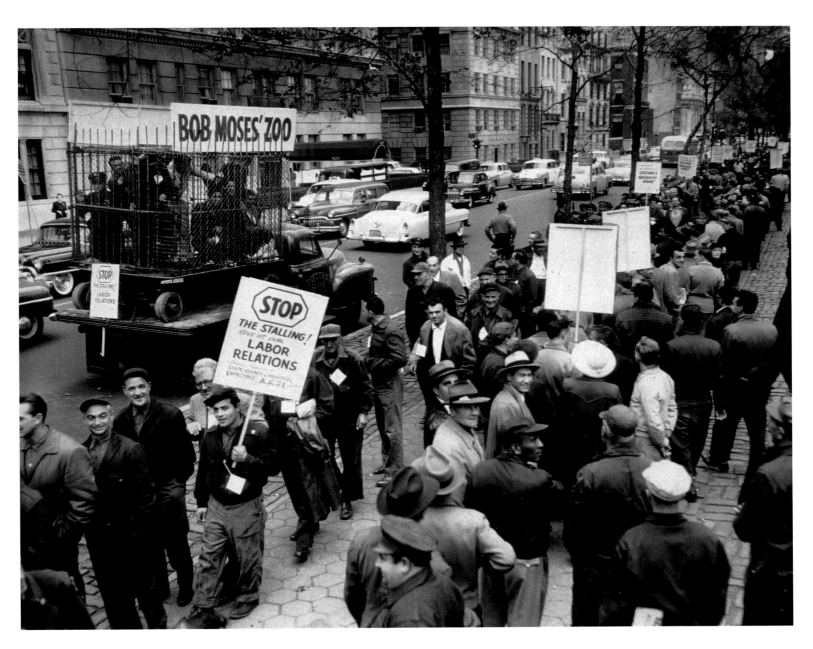

167 *Protest Against 'Inhuman Treatment,'* November 4, 1955

"A steel cage, occupied by uniformed park personnel, is highlight of rally of park employees outside Arsenal in Central Park."

Carl T. Gossett, Jr./The New York Times, Courtesy The New York Times Photo Archives

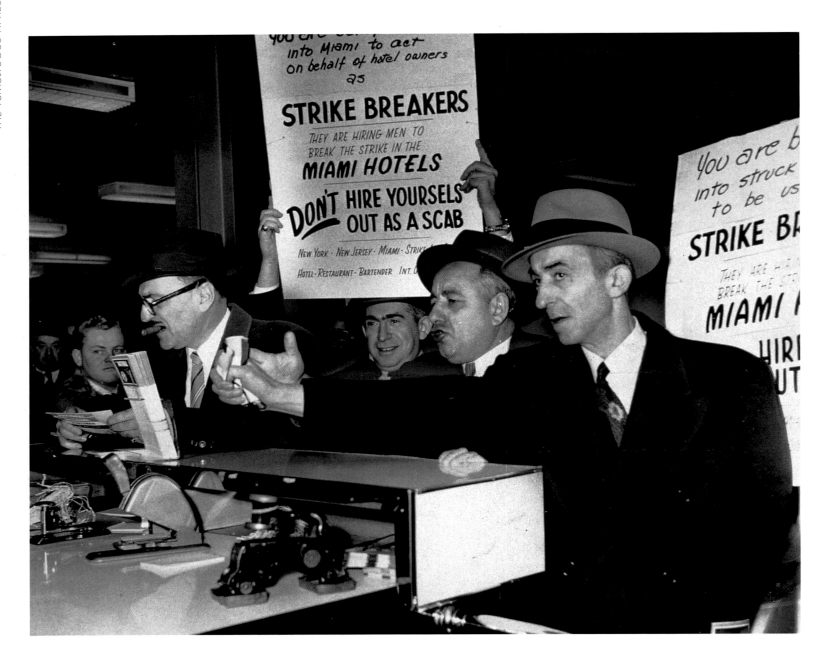

168 *Ticket to Nowhere,* December 30, 1955

"Angelo Raulli, right, gave up a trip to Miami yesterday when he was told of a labor dispute at Algiers Hotel, where he had planned to work. Next to him, at surrender of airline ticket at Idlewild, is union leader David Siegal. At left is Jack Miller, a brother-in-law of the hotel's owner. Raulli, a waiter, is member of union."

Meyer Liebowitz/The New York Times, Courtesy The New York Times Photo Archives

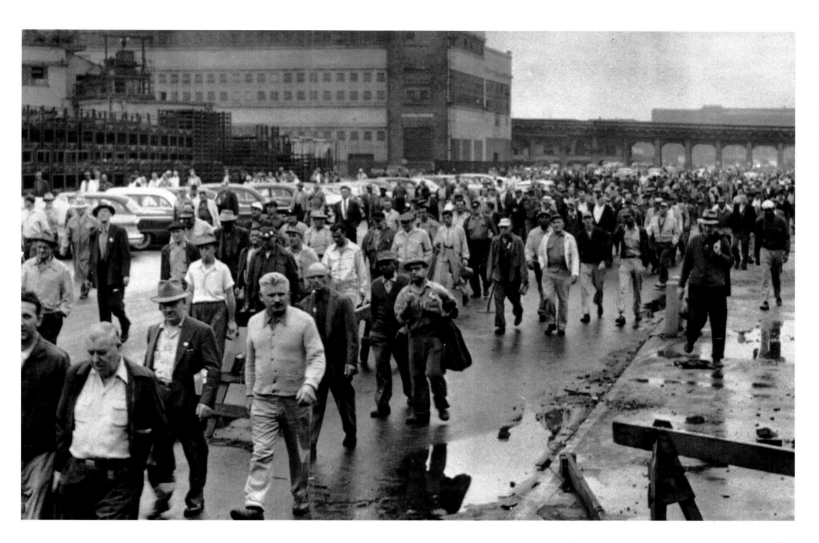

169 *Before Settlement*, September 18, 1958

"Members of United Automobile Workers union walk off jobs at Rouge plant of Ford Motor Company in Detroit. Agreement was reached later in day."

Alvan (C.Q.) Quinn/Associated Press, Courtesy AP/Wide World Photos

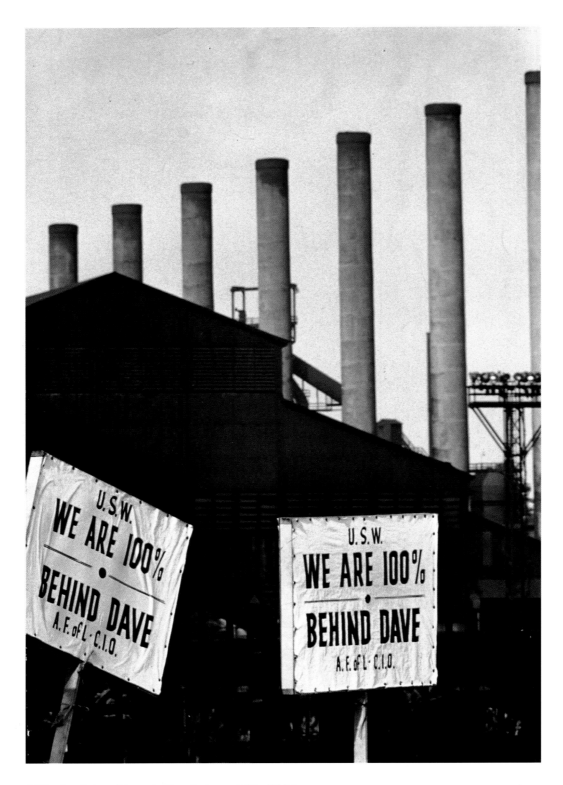

170 *Smokeless* (Gary, Indiana), August 30, 1959

"With only maintenance workers and management personnel inside
the plant, the tall stacks are plain evidence of the shutdown. 'Dave' on
the sign refers to David J. McDonald."

Mike Shea

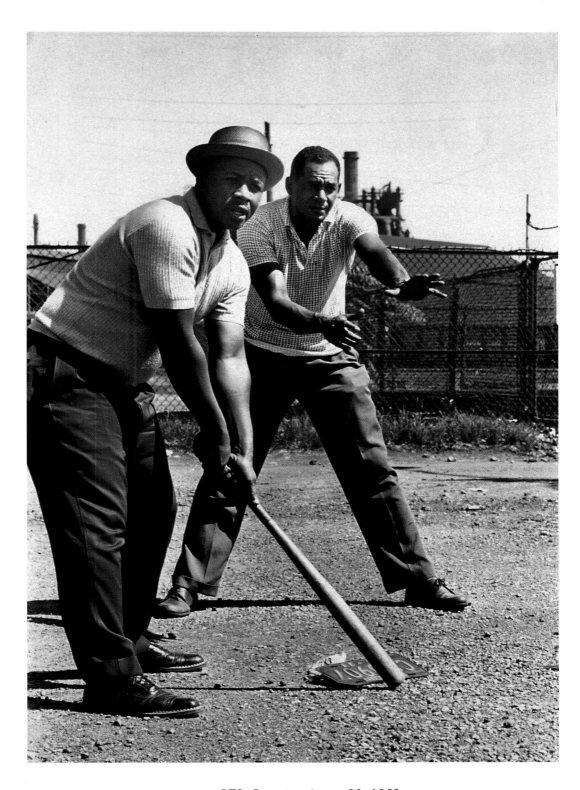

171 *Diversion*, August 30, 1959

"In a break from picket-line duty, two steel workers play softball. Others fish, swim or work on their homes."

Mike Shea

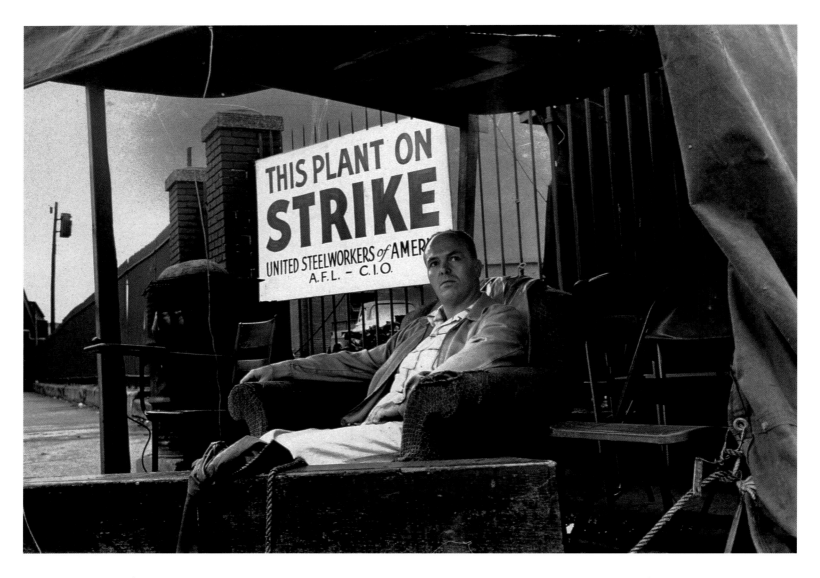

172 *On Duty*, October 6, 1959

"Lone picket relaxes at his post in front of the main gate of the
Bethlehem Steel plant in Lackawanna, N.Y. The plant normally employs
18,000 steel workers."

Carl T. Gossett, Jr./The New York Times, Courtesy The New York Times
Photo Archives

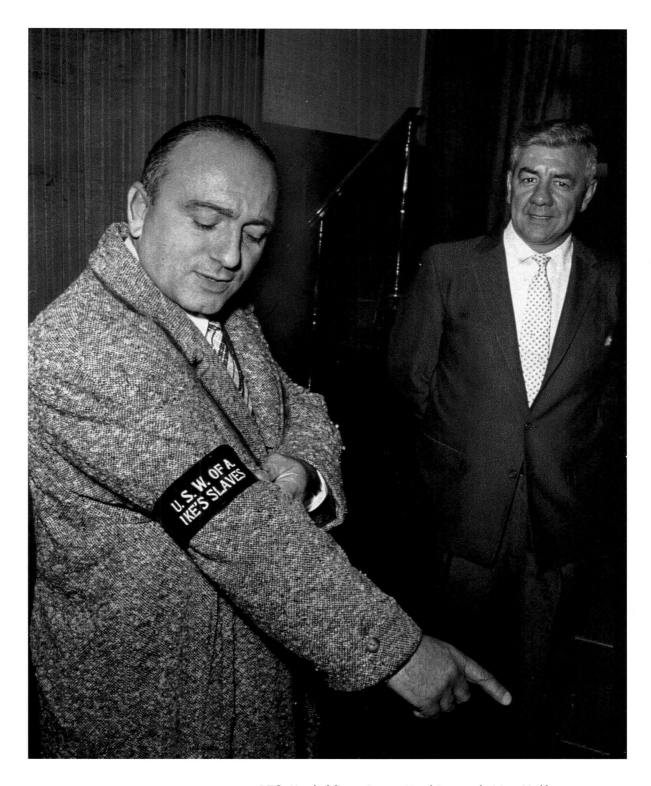

173 Untitled [Louis Pierro, Hotel Roosevelt, New York], November 13, 1959

"Louis Pierro, of the steel union's wage policy panel, with protesting arm band."

Carl T. Gossett, Jr./The New York Times, Courtesy The New York Times Photo Archives

SERVING

174 *Machine in Motion*, January 24, 1954

"Plainclothesmen and a policeman examine a suspect and a gun in a Manhattan precinct house."

Sam Falk/The New York Times, Courtesy The New York Times Photo Archives

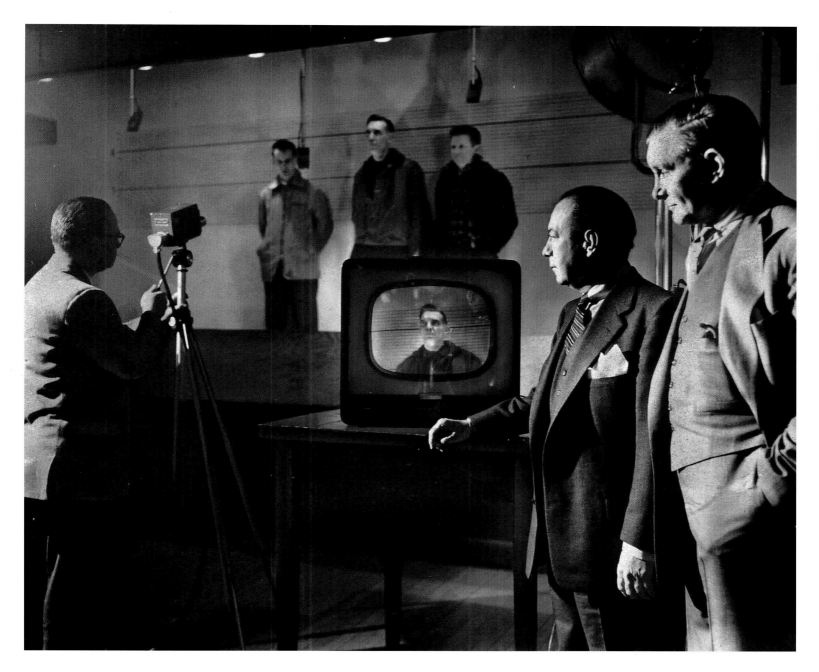

175 *Police Line-Up Televised*, February 9, 1954

"Police Commissioner Francis W. H. Adams, right, and Mayor Wagner watch as policemen taking roles of prisoners are photographed by TV camera at Manhattan headquarters. The picture was televised by closed circuit to Brooklyn headquarters on Bergen Street, where it was viewed by police officials and detectives."

Carl T. Gossett, Jr./The New York Times, Courtesy The New York Times Photo Archives

176 *3:30 A. M., December 19, 1954*

"Patrolman Jim Fitzgerald checks on two late strollers on his beat in New York's Greenwich Village."

Jerry Dantzic, © 2001 Jerry Dantzic Archives

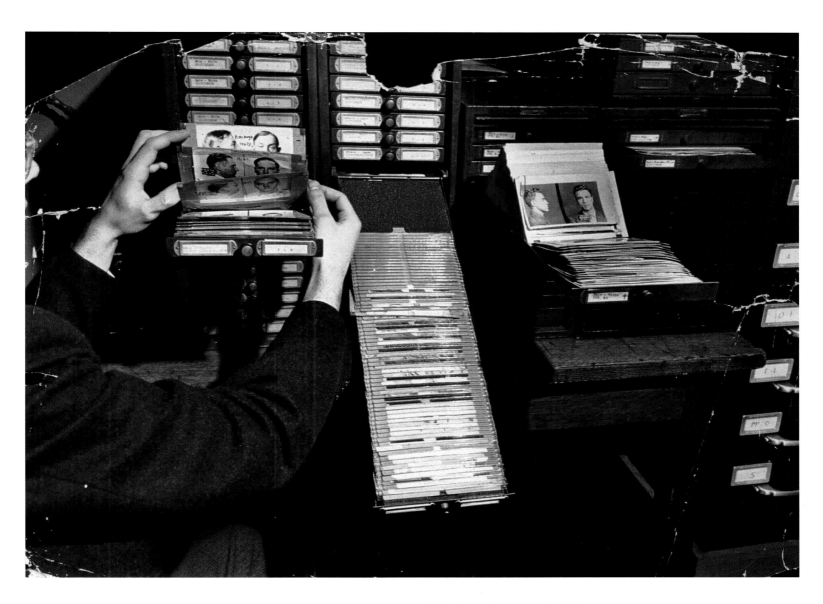

177 *Faces*, February 5, 1956

"More than 8,000 pictures of known con men and women are on file in New York; some have police records in nearly every city between here and Los Angeles."

Sam Falk/The New York Times, Courtesy The New York Times Photo Archives

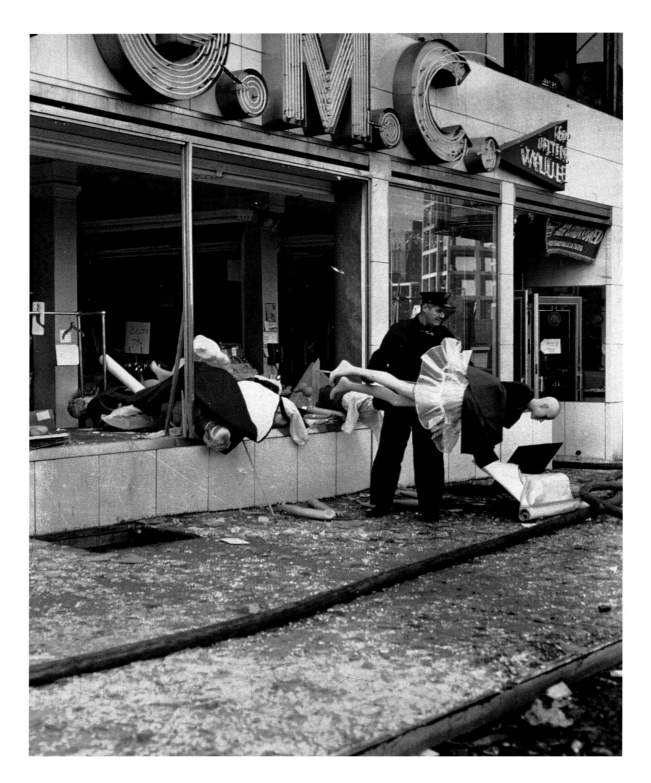

178 *Gas Explosion in Store Scatters Manikins on Sidewalk,*
November 24, 1956

"A fireman removes one of the 'casualties' from the G. M. C. Store at
1490 Madison Avenue."

Meyer Liebowitz/The New York Times, Courtesy The New York Times
Photo Archives

179 *Matters of Life – and Death,* February 21, 1957 (taken)

Fire fighting is the most hazardous peacetime occupation man pursues. Firemen battle a five-alarm fire in lower Manhattan.

Carl T. Gossett, Jr./The New York Times, Courtesy The New York Times Photo Archives

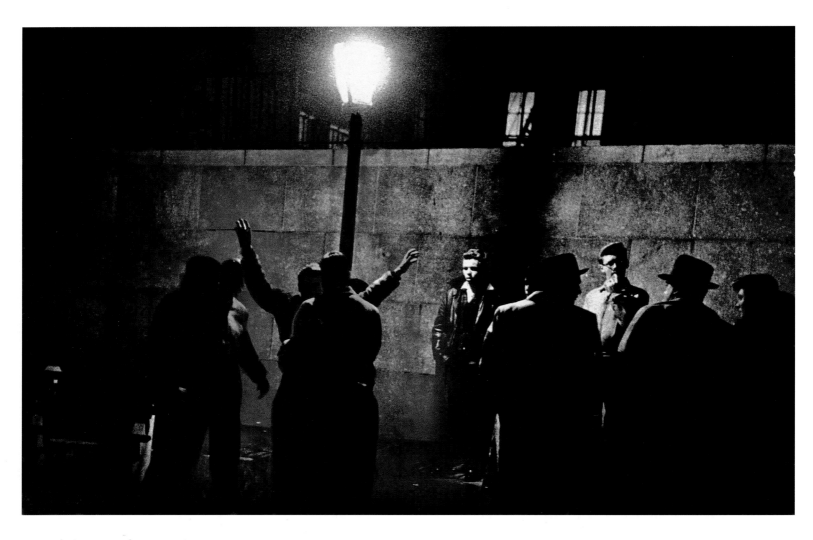

180 *Frisk*, May 11, 1957 (taken)

"Delinquency seems to spring from a common want of human solidarity."

Sam Falk/The New York Times, Courtesy The New York Times Photo Archives

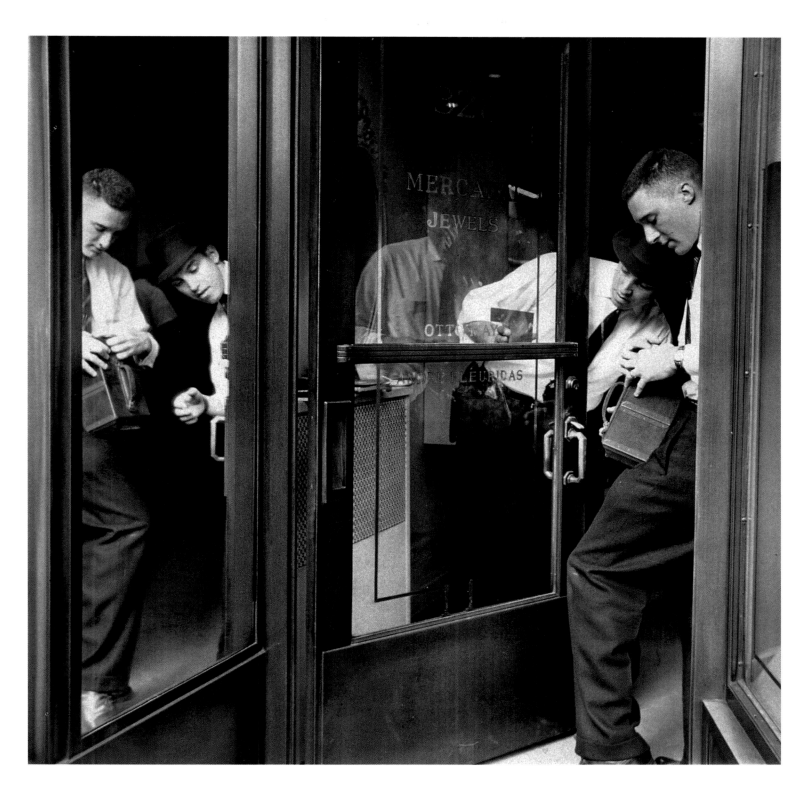

181 *Jewel Theft,* September 27, 1957

"Police search for fingerprints and photograph entrance to Mercadal Jewels at 328 Park Avenue. The shop was robbed of $100,000 worth of gems by two men."

Meyer Liebowitz/The New York Times, Courtesy The New York Times Photo Archives

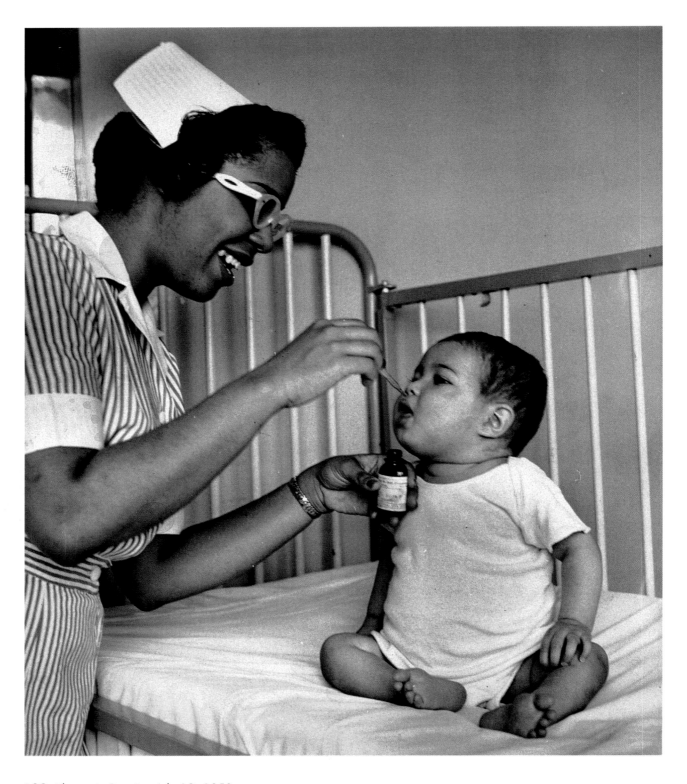

182 *Theory in Practice*, July 19, 1958

"Practical nurse student Barbara Phipps gives vitamins to Alga Flores, 13 months old, at the Hospital for Joint Diseases. Miss Phipps is at the Helene Fuld School of Practical Nursing at the hospital."

Ernie Sisto/The New York Times, Courtesy The New York Times Photo Archives

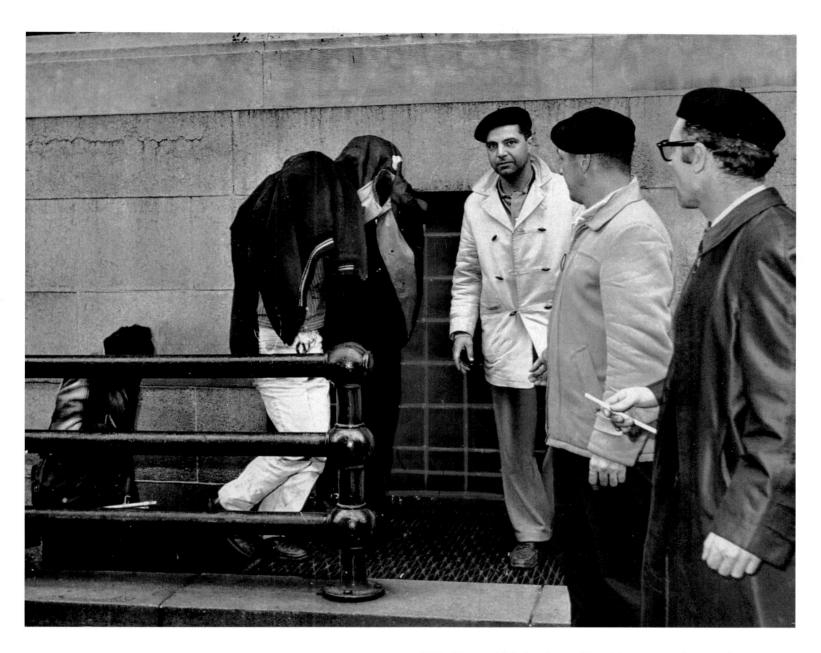

183 *"Beatnick" Police Seize 96 in Narcotic Raid*, November 9, 1959

"Suspects leave from rear of Police Headquarters. Three men at right are detectives."

Patrick A. Burns/The New York Times, Courtesy The New York Times Photo Archives

STRUGGLING

184 *Sumner* (Sumner, Mississippi), September 20, 1955 (made)

These 12 men seated today in the jury box to hear testimony and
decide the fate of Roy Bryant and J.W. Milam, who are charged with
the slaying of Emmett L. Till. (Left to right) in front row are Gus Ramsey,
James Toole, L.L. Price, J.A. Shaw, Jr., Ray Tribble, and Ed Devaney.
Back row: Travis Thomas, George Holland, Jim Pennington, Davis
Newton, Howard Armstrong, and Bishop Matthews. The alternate Juror
is not pictured.

Gene Herrick/Associated Press, Courtesy AP/Wide World Photos

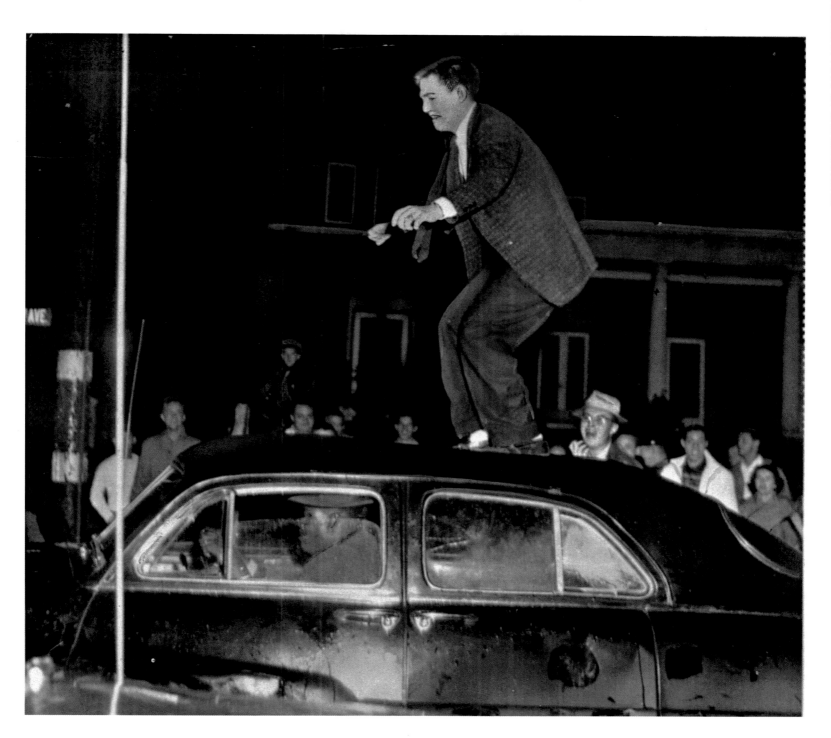

185 *Negro's Car Attacked*, February 7, 1956

"A demonstrator jumps on the automobile of a Negro who drove through University of Alabama campus in Tuscaloosa. Students were demonstrating there early on Sunday against the enrollment of the first Negro at the University."

Anonymous/Associated Press, Courtesy AP/Wide World Photos

186 *Drama in Tuscaloosa: White Citizens Council is Formed,*
February 26, 1956

"In the Tuscaloosa County Courthouse, applicants enroll in the West
Alabama White Citizens Council. The council was formed as an
outgrowth of the fight over the admission of a Negro student to the
University of Alabama."

George Tames/The New York Times, Courtesy The New York Times
Photo Archives

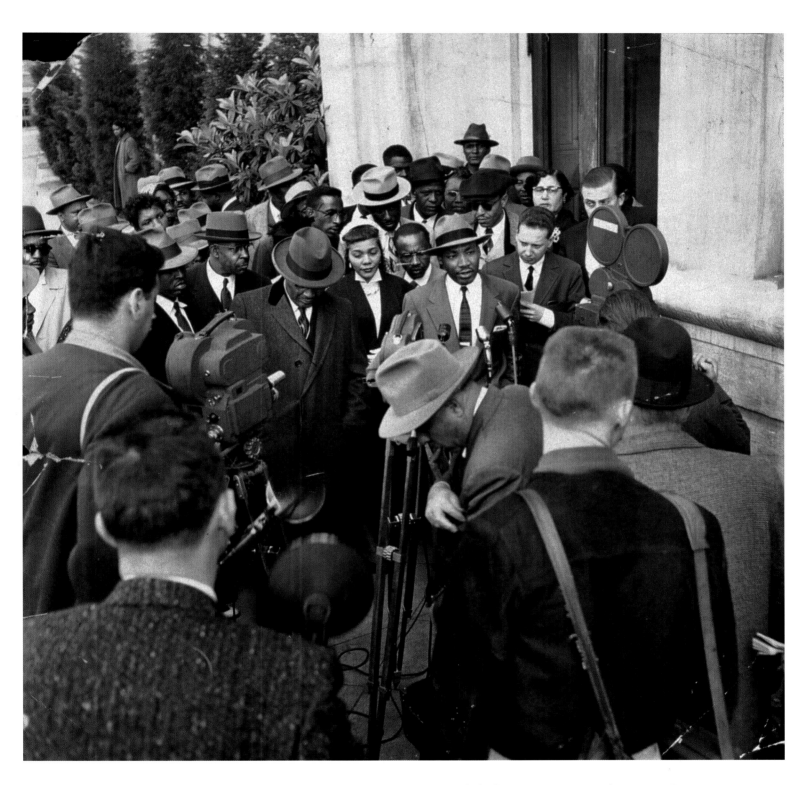

187 Untitled [The Rev. Dr. Martin Luther King, Jr.],
March 20, 1956 (taken)

"The Rev. Dr. Martin Luther King Jr., at microphones, leaves court after
being found guilty of leading the Montgomery, Ala., bus boycott,
which had begun in December. Dr. King developed the technique of
passive resistance."

George Tames/The New York Times, Courtesy The New York Times
Photo Archives

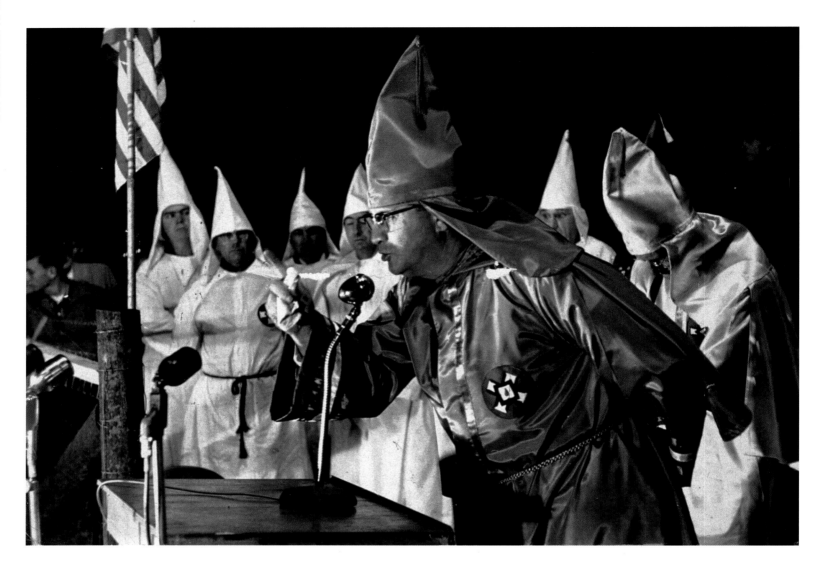

188 *Klan Rally* (Montgomery, Alabama), December 16, 1956

"A Klansman speaks at a meeting held at a racetrack near Montgomery. The Klan was forbidden to hold the meeting in town."

George Tames/The New York Times, Courtesy The New York Times Photo Archives

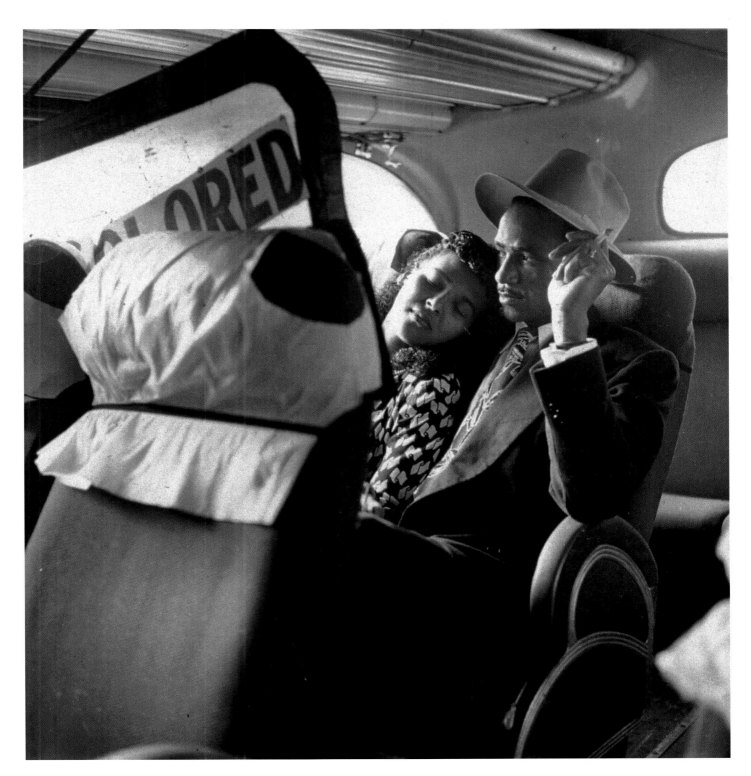

189 Untitled [Back of the Bus], 1956

Leo Bern Keating/Black Star, Courtesy Black Star

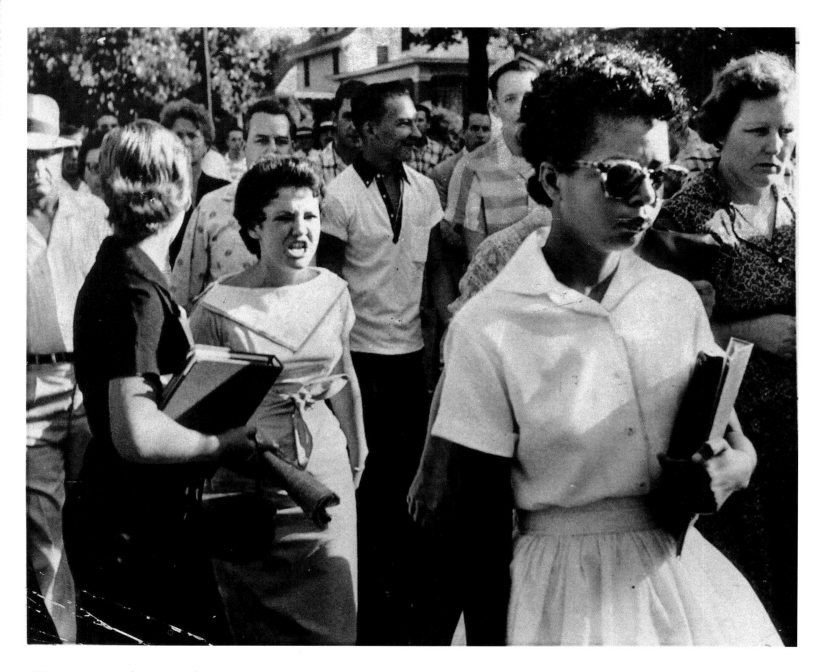

190 *A Jeering Student*, September 5, 1957

"A jeering student follows Elizabeth Echford [sic] as she walks down a line of National Guardsmen who barred her from entering the Central High School in Little Rock, Ark."

Will Counts/Arkansas Democrat, Little Rock, Courtesy AP/Wide World Photos

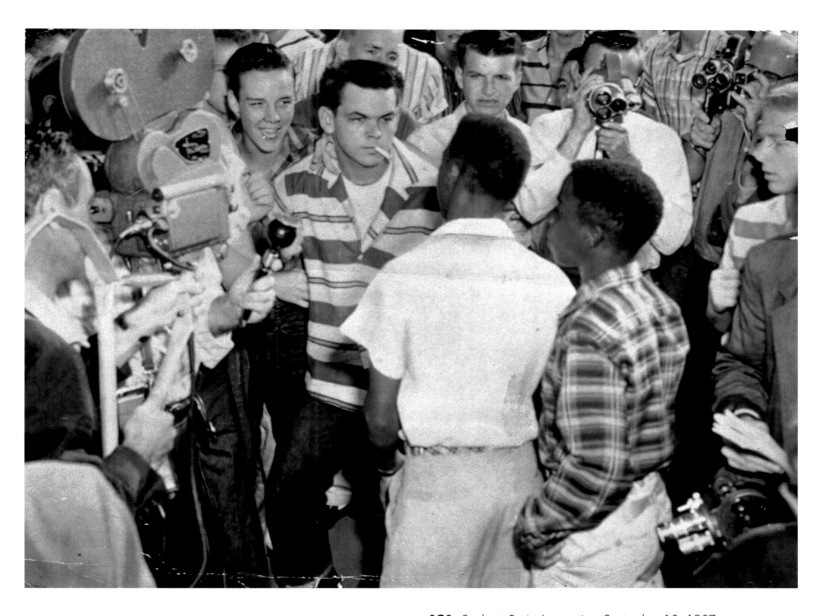

191 *Students Resist Integration*, September 15, 1957

"A white youth dares one of two Negro students to try to enter North Little Rock (Ark.) High School. The Negroes, among six turned away yesterday, were pushed down steps and onto sidewalk, where police intervened."

William P. Straeter/Associated Press, Courtesy AP/Wide World Photos

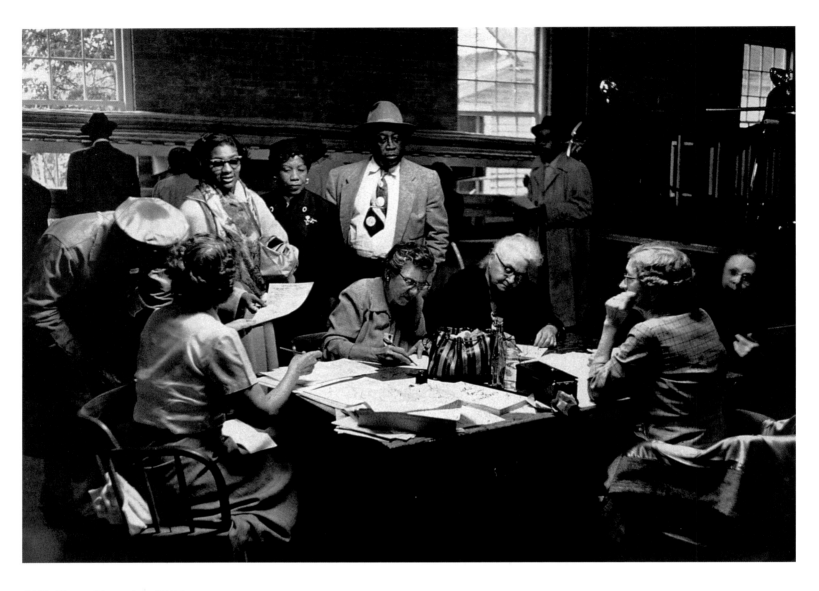

192 *Voters*, November 1957

"At a Little Rock firehouse, Negroes vote in the city election. Negro
ballots spelled the margin of victory for the 'moderates'."

George Tames/The New York Times, Courtesy The New York Times
Photo Archives

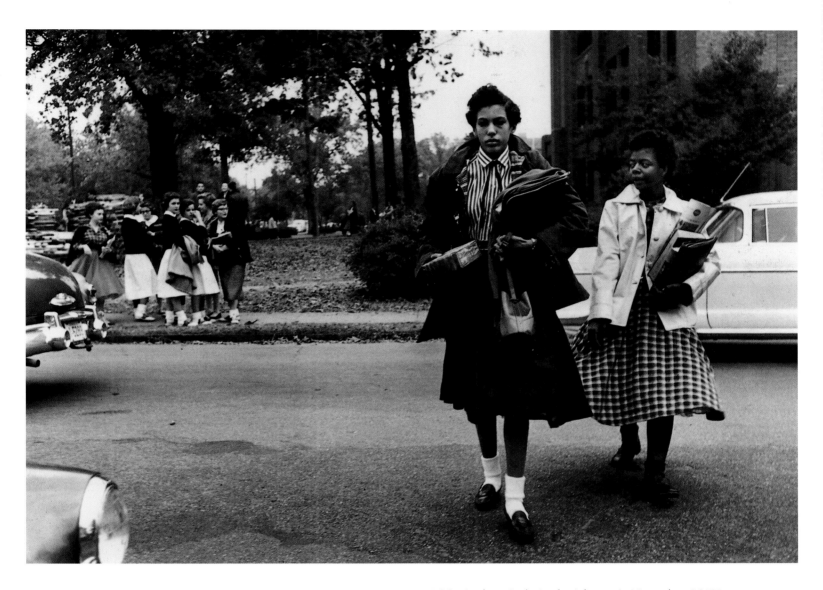

193 *Students* (Little Rock, Arkansas), November 1957

"Carlotta Walls and Elizabeth Eckford, right, leave school. Authorities deny reports of student 'incidents' inside the school."

George Tames/The New York Times, Courtesy The New York Times Photo Archives

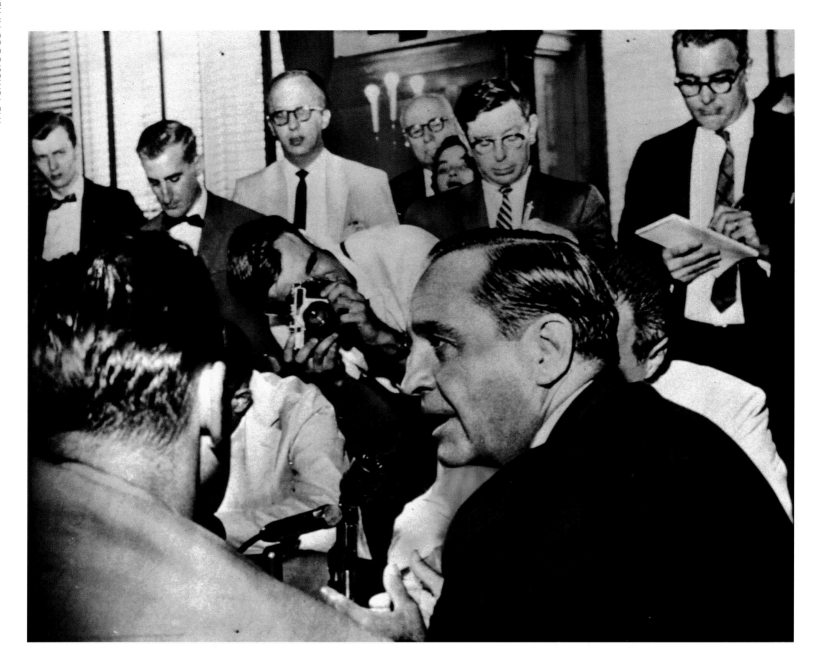

194 *Moves up Referendum Date*, September 17, 1958

"Gov. Orval E. Faubus of Arkansas at news conference in Little Rock yesterday. He set Sept. 27 as the date city's voters will go to polls to indicate whether or not they want integration. The referendum date had been originally set for Oct. 7."

Anonymous/Associated Press, Courtesy AP/Wide World Photos

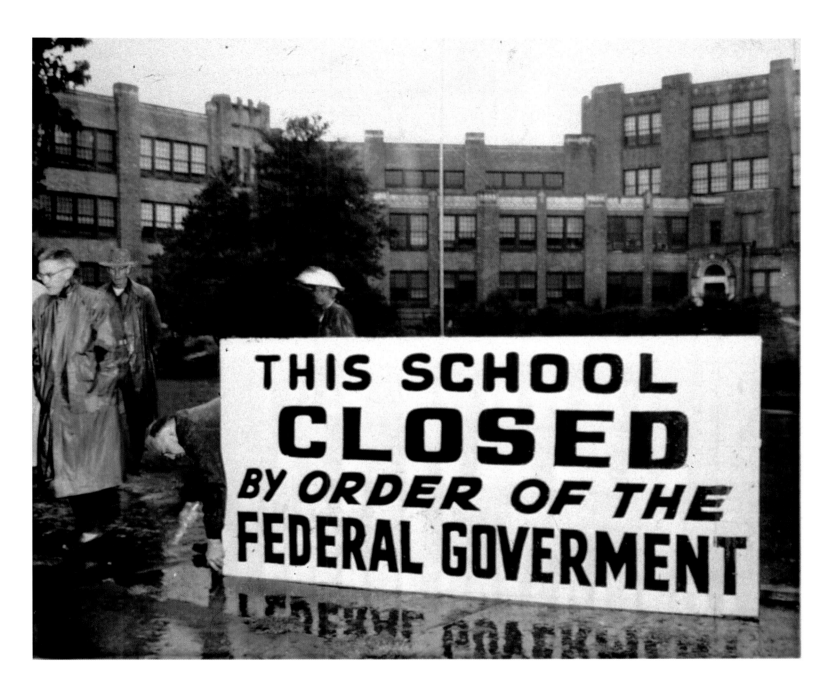

195 *Post Sign Announcing School Closed*, October 1, 1958

"A workman said to be employed by the Little Rock Private School Corporation places a misspelled sign in front of Central High School after some argument with armed guards."

Anonymous/Associated Press, Courtesy AP/Wide World Photos

Purchase Information

To order prints of photographs in the exhibition that were shot by *New York Times* photographers, or related *New York Times* products, call *The New York Times* at 212.556.3568. All black-and-white photographs are exhibition-quality silver-gelatin prints from original photos or negatives housed in the archives of the *Times.*

Associated Press photographs featured in this exhibition may be obtained for purchase or license by contacting AP/Wide World Photos, 50 Rockefeller Plaza, 2nd Floor, New York, New York 10020, 212.621.1930. wideworld@ap.org.

Works in the Exhibition

Whenever possible, the photographer's name and affiliation are listed.

Titles given to the photographs by the photographer or *The New York Times* are indicated in italics. If photographs are not titled, a descriptive title is given in brackets.

Unless otherwise noted, all dates indicate the dates of publication in *The New York Times*.

"Taken" indicates the day the photograph was shot. "Made" indicates the day the photograph was distributed.

America in the World: War Hot and Cold

1. SFC Albert Chang/US Army
War in Korea, August 28, 1950 (taken)
Courtesy US Army

2. Hank Walker/TimePix
Flushing out the Enemy in North Korea,
November 18, 1950
Courtesy TimePix

3. Henry Griffin/Associated Press
Truman Gives A-bomb Warning, November
30, 1950 (made)
Courtesy AP/Wide World Photos

4. Jean-Jacques Levy/Associated Press
*Aid from United States Arrives for French
Indo-China*, February 11, 1951
Courtesy AP/Wide World Photos

5. Perry Bowler/International News Photo
Lights in Las Vegas, February 11, 1951

6. Jim Pringle/Associated Press
The U. N. Commander gets the Direction,
March 13, 1951
Courtesy AP/Wide World Photos

7. Sam Falk/The New York Times
Untitled [Immigrants arrive in America on
U.S.S. General H. Taylor], June 28, 1951
(unpublished)
Courtesy The New York Times Photo Archives

8. Anonymous/Associated Press
Active Resistance, August 23, 1953
Courtesy AP/Wide World Photos

9. Patrick A. Burns/The New York Times
Familiar Story, August 25, 1953
Courtesy The New York Times Photo Archives

10. Clifton Daniel/The New York Times
Changing Guard (Moscow, USSR),
September 18, 1953
Courtesy The New York Times Photo Archives

11. Anonymous/Associated Press
Seized in Shooting, March 2, 1954
Courtesy AP/Wide World Photos

12. Bruce Hoertel/The New York Times
Scene of House Shooting, March 2, 1954
Courtesy The New York Times Photo Archives

13. Anonymous/Associated Press
Chile, June 19, 1954 (taken)
Courtesy AP/Wide World Photos

14. Anonymous/Associated Press
War in Guatemala, June 24, 1954
Courtesy AP/Wide World Photos

15. George Tames/The New York Times
Churchill arrives at White House, June 25,
1954 (unpublished)
Courtesy The New York Times Photo Archives

16. Leonard McCombe/TimePix
Communist Suspect Seized, July 16, 1954
Courtesy TimePix

17. Anonymous/International News Photo
Shutterbug Judge (Moscow, USSR), September
8, 1955

18. Carl T. Gossett, Jr./The New York Times
*Disorder Flares as Backers of Trujillo Hold a
Rally*, June 4, 1956
Courtesy The New York Times Photo Archives

19. Radiophoto from Tel Aviv/Associated Press
Rabbi at the Front, November 4, 1956
Courtesy AP/Wide World Photos

20. Raoul Fornezza/Associated Press
Reopening, April 21, 1957
Courtesy AP/Wide World Photos

21. Anonymous
Reception in Peking, May 12, 1957
Courtesy Magnum Photos

22. Arthur Brower/The New York Times
*Archbishop Makarios of Cyprus Greeted at
City Hall*, September 12, 1957 (made)
Courtesy The New York Times Photo Archives

23. Anonymous/US Department of Commerce
Credo, September 22, 1957
Courtesy US Department of Commerce

24. Henry Griffin/Associated Press
Nixons Greeted in Ecuador, May 12, 1958
Courtesy AP/Wide World Photos

25. Anonymous/Agence Intercontinentale
Untitled [Charles de Gaulle, Les Jardins de
l'Elysée, Paris], June 8, 1958

26. Max Frankel/The New York Times
Mass Interview, August 31, 1958
Courtesy The New York Times Photo Archives

27. Anonymous/United Press International
Untitled [On tour in Venezuela, Richard M.
Nixon is reviled], 1958
© Bettmann/Corbis

28. Bill Bridges
Bird Aloft (Vandenberg Air Force Base,
California), January 25, 1959

29. Anonymous/Associated Press
Exhibition Conversation, July 24, 1959
Courtesy AP/Wide World Photos

30. Harold Valentine/Associated Press
Castro's Crowd, December 1, 1959
(unpublished)
Courtesy AP/Wide World Photos

31. Brian Brake
Untitled [Nikita Krushchev and Mao Tse-Tung],
1959
Courtesy Photo Researchers, Inc.

32. Anonymous
Untitled [Fidel Castro and Che Guevara],
1959

33. George Tames/The New York Times
Untitled [Dwight D. Eisenhower and Nikita
Krushchev, Camp David, Maryland], 1959
Courtesy The New York Times Photo Archives

Mechanization in Command

34. Anonymous/David O. Alber Associates, Inc.
Untitled [Du Mont Laboratories, Inc.], August
8, 1951

35. Anonymous/RCA Victor
Untitled [RCA Plant], December 3, 1951

36. Shell R. Alpert/US Coast Guard
*Coast Guard Arouses New Interest in 'Flying
Saucers'*, August 2, 1952
Courtesy US Coast Guard

37. John Krause/Long Island Railroad
Untitled [Greenport Freight], 1952
(unpublished)
Collection Ron Ziel

38. Anonymous/US Air Force
Superfort Protector, March 23, 1953
Courtesy US Air Force

39. Dan Weiner/Brackman Associates
Disk Molding Machine, March 21, 1954
Courtesy Sandra Weiner

40. Meyer Liebowitz/The New York Times
Building an Overpass on New York's Thruway
(Modena, New York), May 9, 1954
Courtesy The New York Times Photo Archives

41. Anonymous/The New York Times
Prophet, October 31, 1954
Courtesy The New York Times Photo Archives

42. Eddie Hausner/The New York Times
Oversized New Cars, December 17, 1954
Courtesy The New York Times Photo Archives

43. George Tames/The New York Times
Fueling Up (White Sands Proving Ground,
New Mexico), October 30, 1955
Courtesy The New York Times Photo Archives

44. Meyer Liebowitz/The New York Times
Open for Business, December 16, 1955
Courtesy The New York Times Photo Archives

45. Anonymous
1955 Assembly Line Photo, December 1955
(unpublished)

46. Anonymous/Chrysler
Untitled [Chrysler Corporation Assembly Line],
March 25, 1956
Courtesy Daimler Chrysler

47. Sam Falk/The New York Times
On the Texas Tower, May 13, 1956
Courtesy The New York Times Photo Archives

48. George Tames/The New York Times
Corporal (White Sands Proving Ground, New
Mexico), June 3, 1956
Courtesy The New York Times Photo Archives

49. Patrick A. Burns/The New York Times
Aerial View, July 5, 1956
Courtesy The New York Times Photo Archives

50. d'Arazien/Jones & Laughlin Steel Corporation
Pittsburgh Works, March 31, 1957
Courtesy Library and Archives Division,
Historical Society of Western Pennsylvania,
Pittsburgh

51. Meyer Liebowitz/The New York Times
Untitled [Aerial view of Levittown, NY, used in
article "Bias in Suburban Housing"],
April 17, 1957
Courtesy The New York Times Photo Archives

52. Jim Silk/General Electric
*Appliance Industry Insists that Dishes can be
Easy* (Louisville, Kentucky), October 18, 1957

53. *Inside Information*, November 4, 1957
Courtesy AP/Wide World Photos

54. Anonymous/Jones & Laughlin Steel
Corporation
*Better Facilities Spur Steel Industry's
Expansion*, January 14, 1958

55. Sam Falk/The New York Times
Populated, East, June 8, 1958
Courtesy The New York Times Photo Archives

56. Anonymous/Jones & Laughlin Steel
Corporation
*Jones & Laughlin Starts Continuous-Weld Pipe
Mill*, June 27, 1958

57. Anonymous/U.S. Steel Photo
*U.S. Steel Constructs Automatic Mill in
Chicago*, September 12, 1958
Courtesy U.S. Steel Group of USX
Corporation

58. Sam Falk/The New York Times
Fit-Out (Newport News, Virginia),
August 16, 1959
Courtesy The New York Times Photo Archives

Growing Up American

59. Anonymous/Ford News Bureau
*Green Light for Detroit – And for Detroit's
Auto Workers*, June 4, 1950
Courtesy Ford Motor Company

60. Anonymous/Chrysler
The New Chrysler Imperial Sedan,
July 13, 1950
Courtesy Daimler Chrysler

61. Anonymous/Associated Press
Untitled, January 21, 1951
Courtesy AP/Wide World Photos

62. Ernie Sisto/The New York Times
School Drill (Bronx, New York), February 8,
1951
Courtesy The New York Times Photo Archives

63. Sam Falk/The New York Times
Round Robin, April 29, 1951
Courtesy The New York Times Photo Archives

64. Eddie Hausner/The New York Times
Open-Air Movie (Bruckner Boulevard, Bronx,
New York), March 9, 1952
Courtesy The New York Times Photo Archives

65. Ernie Sisto/The New York Times
Untitled [Mickey Mantle], October 2, 1952
Courtesy The New York Times Photo Archives

66. George Tames/The New York Times
Untitled [Atomic Dining Room], November
30, 1952
Courtesy The New York Times Photo Archives

67. Martin's Studio, Greensboro, North Carolina
Stanley Home Products, Inc. (Greensboro,
North Carolina), 1952
Courtesy © Carol W. Martin/Greensboro
Historical Museum Collection

68. Anonymous/US Air Force
March, March, March, July 5, 1953
Courtesy US Air Force

69. Neal Boenzi/The New York Times
*79 Harlem Children Off for Interracial
Vacation*, July 6, 1953
Courtesy The New York Times Photo Archives

70. Torkel Korling/Hedrich-Blessing
Kitchen Sewing Center, July 23, 1953
Courtesy Chicago Historical Society

71. George Tames/The New York Times
Slicking Up (Colby, Kansas), July 26, 1953
Courtesy The New York Times Photo Archives

72. Ernie Sisto/The New York Times
Untitled [Sophomores and Freshmen],
October 23, 1953 (made)
Courtesy The New York Times Photo Archives

73. Ernie Sisto/The New York Times
Learning to Paddle their own Canoe (Madison
Square Garden, New York),
February 21, 1954
Courtesy The New York Times Photo Archives

74. Drennan for The New York Times
Out for a Record, August 15, 1954
Courtesy The New York Times Photo Archives

75. Feingersh/Pix Incorporated
Rush Hour (Wall Street, New York),
January 16, 1955

76. Sam Falk/The New York Times
Drive In Movie Theater, May 28, 1955
(made)
Courtesy The New York Times Photo Archives

77. Sharland
Untitled [Sweater Set], June 26, 1955

78. Ernie Sisto/The New York Times
How to Enjoy the Heat . . . , July 23, 1955
Courtesy The New York Times Photo Archives

79. Anonymous
Pressing Problems, October 29, 1955

80. Sam Shere
Untitled, December 11, 1955

81. Sam Falk/The New York Times
Untitled [Candlelight Couple], January 22,
1956
Courtesy The New York Times Photo Archives

82. Anonymous/The New York Times
Holiday Shopping, February 23, 1956
Courtesy The New York Times Photo Archives

83. Ernie Sisto/The New York Times
*Behind the Scenes of the Jamaica Pari
Mutuels*, April 24, 1956
Courtesy The New York Times Photo Archives

84. Patrick A. Burns/The New York Times
Trading Stamps (Third Avenue at 36th Street,
New York), May 6, 1956
Courtesy The New York Times Photo Archives

85. Gertrude Samuels/The New York Times
Recreation (City Prison, Brooklyn, New York),
July 1, 1956
Courtesy The New York Times Photo Archives

86. Anonymous/The New York Times
*Bargain-Hungry Customers Flock to New
Lanes Store*, August 17, 1956
Courtesy The New York Times Photo Archives

87. Anthony Lane/Studio of Modern Photography
Weather-Conditioned Shopping Center Opens
(Minneapolis, Minnesota), October 9, 1956

88. Anonymous/Federal News Photos of Canada
Untitled [Teen fan], December 2, 1956
(made)

89. Frank D. Mallett
Untitled [Smokey the Bear], April 14, 1957

90. Sam Falk/The New York Times
Guitarists (Washington Square Park, New
York), June 30, 1957
Courtesy The New York Times Photo Archives

91. Neal Boenzi/The New York Times
*Mohawk Indians from Canada, Settled at Fort
Hunter, N.Y.*, August 16, 1957 (made)
Courtesy The New York Times Photo Archives

92. Eddie Hausner/The New York Times
On the Town (62nd Street Playground, New York), September 2, 1958
Courtesy The New York Times Photo Archives

93. Ernie Sisto/The New York Times
There goes Trouble, November 10, 1958
Courtesy The New York Times Photo Archives

94. Patrick A. Burns/The New York Times
Tuscarora Indian Reservation, November 24, 1958
Courtesy The New York Times Photo Archives

Fame and Infamy

95. Dan Weiner
Untitled [Eleanor Roosevelt, United Nations, New York], May 21, 1950
Courtesy Sandra Weiner

96. Anonymous/NBC Studios
Untitled [Milton Berle], September 17, 1950
Courtesy NBC Studios

97. Anonymous
Backstage, October 1, 1950
Courtesy The New York Times Photo Archives

98. Eileen Darby/Graphic House, Inc.
"Guys and Dolls", December 24, 1950

99. Gertrude Samuels/The New York Times
Untitled [Albert Einstein and J. Robert Oppenheimer, Princeton University], December 1950 (taken)
Courtesy The New York Times Photo Archives

100. Hans Namuth
Untitled [Jackson Pollock], 1950
Copyright © Hans Namuth Ltd.

101. Carl T. Gossett, Jr./The New York Times
MacArthur Day, April 21, 1951
Courtesy The New York Times Photo Archives

102. Meyer Liebowitz/The New York Times
The Yankee Clipper Sails Home at the Stadium, April 24, 1951
Courtesy The New York Times Photo Archives

103. Anonymous/The New York Times
Folk Singers, December 16, 1951
Courtesy The New York Times Photo Archives

104. Anonymous/CBS
Documentary, December 30, 1951
Courtesy CBS Photo Archive

105. Eileen Darby/Graphic House, Inc.
Death of a Salesman, February 1, 1953

106. John Rooney/Associated Press
Christine Comes Home, February 12, 1953 (made)
Courtesy AP/Wide World Photos

107. Sam Falk/The New York Times
Untitled [Sid Caesar], September 6, 1953
Courtesy The New York Times Photo Archives

108. Ernie Sisto/The New York Times
Rocky Marciano (Hampshire House, New York), September 26, 1953
Courtesy The New York Times Photo Archives

109. Anonymous/Atheneum Publishing
James Dewey Watson and Francis Crick, 1953 (taken)

110. Anonymous/Keystone Photo
Time 3:59.4, May 6, 1954
Courtesy Hulton/Archive

111. Ernie Sisto/The New York Times
Marion Anderson Rehearses Opera, December 25, 1954
Courtesy The New York Times Photo Archives

112. Larry Morris/The New York Times
Ella Fitzgerald (Basin Street, New York), 1954 (taken)
Courtesy The New York Times Photo Archives

113. Anonymous/Warner Bros. Pictures, Inc.
Untitled [James Dean], October 27, 1955
REBEL WITHOUT A CAUSE © 1955 Warner Bros. Pictures, Inc. All rights reserved.

114. Arthur Z. Brooks/Associated Press
Still Going Strong, April 15, 1956
Courtesy AP/Wide World Photos

115. Preston Stroup/Associated Press
Here Comes the Punch that Kayoed Olson (Chicago, Illinois), May 16, 1956
Courtesy AP/Wide World Photos

116. Anonymous/Associated Press
New Home Base for Mantles, June 2, 1956
Courtesy AP/Wide World Photos

117. Carl T. Gossett, Jr./The New York Times
Arthur Millers Leave for London, July 14, 1956
Courtesy The New York Times Photo Archives

118. Rich Clarkson
Wilt Chamberlain (Kansas), March 7, 1957
Courtesy Rich Clarkson and Associates LLC

119. Patrick A. Burns/The New York Times
Costello Freed on $1,000 Bail; Cheered by Crowd at Ferry Slip, May 23, 1957
Courtesy The New York Times Photo Archives

120. Allyn Baum/The New York Times
Untitled [John Glenn and Family, Floyd Bennett Field, Brooklyn, New York], July 6, 1957
Courtesy The New York Times Photo Archives

121. Anonymous/ABC
Frank Sinatra, August 18, 1957
© 2001 ABC, Inc. Photography Archives

122. Earl Shugars/Associated Press
Hoffa Leading Candidate (Miami Beach, Florida), September 30, 1957 (taken)
Courtesy AP/Wide World Photos

123. H.D. Ellis/Mackinac Bridge Authority
Master and Masterpiece, January 5, 1958
Courtesy Mackinac Bridge Authority and the Michigan Department of Transportation

124. Anonymous/Columbia Records
Trumpet Player, January 12, 1958

125. Anonymous/Lincoln Journal, Nebraska
Sought for Questioning in Triple Slayings, January 28, 1958 (made)
Courtesy AP/Wide World Photos

126. Arnold Eagle
1940, March 30, 1958

127. Carl T. Gossett, Jr./The New York Times
Untitled [Paul Robeson, New York], June 27, 1958
Courtesy The New York Times Photo Archives

128. Anonymous/Associated Press
Without a Song, October 5, 1958 (made)
Courtesy AP/Wide World Photos

129. Anonymous/United Artists
On the Set [Killer's Kiss], October 12, 1958
© 1955 United Artists Corporation. All Rights Reserved. Courtesy MGMClip+Still

130. Anonymous/CBS
Untitled [*Father Knows Best*], 1958 (taken)
Courtesy CBS Photo Archive

131. Anonymous/CBS
Highlight, 1958 (taken)
Courtesy CBS Photo Archive

132. Fred W. McDarrah
Untitled [Jack Kerouac], February 15, 1959 (taken)
Copyright © Fred W. McDarrah

133. Judy Scheftel
Untitled [Norman Mailer], November 1, 1959

American Ways of Life

POLITICKING

134. Carl T. Gossett, Jr./The New York Times
Pulling up Trolley Tracks on Third Avenue, February 6, 1952
Courtesy The New York Times Photo Archives

135. Anonymous/The New York Times
Eisenhower with Supporters (New York), September 14, 1952
Courtesy The New York Times Photo Archives

136. James Coyne/Black Star
Untitled [John F. Kennedy Receiving Line, Cambridge, Massachusetts], October 26, 1952
Courtesy Black Star

137. Anonymous/The New York Times
Untitled [Richard M. Nixon], October 31, 1952
Courtesy The New York Times Photo Archives

138. Cornell Capa/Magnum Photos for Life
Untitled [Adlai Stevenson], 1952 (taken)
Courtesy Magnum Photos

139. George Tames/The New York Times
Now the Campaign, September 5, 1954
Courtesy The New York Times Photo Archives

140. George Tames/The New York Times
Rock Island Line, September 26, 1954
Courtesy The New York Times Photo Archives

141. George Tames/The New York Times
Untitled [Dwight D. Eisenhower throws out first ball], April 19, 1956 (taken)
Courtesy The New York Times Photo Archives

142. Larry Morris/The New York Times
Eisenhower Workers Learn How Bandwagon Runs, July 12, 1956
Courtesy The New York Times Photo Archives

143. Anonymous/The New York Times
In There Pitching – For Both Teams,
October 6, 1956
Courtesy The New York Times Photo Archives

144. Eddie Hausner/The New York Times
Governor Tours High Rent Slums to Point up Loophole in State Law, February 18, 1957
Courtesy The New York Times Photo Archives

145. Clarence Hamm, Associated Press
Barnstorming Ex-President, October 26, 1958
Courtesy AP/Wide World Photos

146. Henry Griffin/Associated Press
The Moskva Boatmen, July 27, 1959
Courtesy AP/Wide World Photos

SCAPEGOATING

147. Anonymous/The New York Times
Untitled [Congressional Hearings],
April 30, 1950
Courtesy The New York Times Photo Archives

148. Anonymous/Associated Press
American Held on Espionage Charge,
July 19, 1950
Courtesy AP/Wide World Photos

149. Sam Falk/The New York Times
Held by F.B.I. in Russian Spy Case,
August 12, 1950
Courtesy The New York Times Photo Archives

150. Bruce J. Hoertel/The New York Times
Actor Admits he was a Communist
(Washington, DC), March 22, 1951
Courtesy The New York Times Photo Archives

151. Meyer Liebowitz/The New York Times
Answers Truman (Washington, DC),
November 25, 1953
Courtesy The New York Times Photo Archives

152. Patrick A. Burns/The New York Times
Private Huddle (Washington, DC),
December 16, 1953
Courtesy The New York Times Photo Archives

153. George Tames/The New York Times
The Stevens-McCarthy Hearings (Washington, DC), May 9, 1954
Courtesy The New York Times Photo Archives

154. Anonymous/Associated Press
The Opposition (Washington, DC),
May 3, 1957
Courtesy AP/Wide World Photos

DEMONSTRATING

155. Eddie Hausner/The New York Times
May Day Parade in New York City,
May 27, 1951
Courtesy The New York Times Photo Archives

156. Robert Walker/The New York Times
Rally for Rosenbergs, January 8, 1953
(made)
Courtesy The New York Times Photo Archives

157. Anonymous/The New York Times
Thruway Opening, December 16, 1955
Courtesy The New York Times Photo Archives

158. Eunice Telfer Juckett for The New York Times
Want Higher Prices, September 6, 1956
Courtesy The New York Times Photo Archives

159. Neal Boenzi/The New York Times
1,500 Booing Pickets Besiege Soviet U.N. Delegates, November 8, 1956
Courtesy The New York Times Photo Archives

160. Anonymous/The New York Times
Polo Grounds (Brooklyn, New York),
September 29, 1957 (made)
Courtesy The New York Times Photo Archives

161. Allyn Baum/The New York Times
Walk for Peace, April 27, 1958
Courtesy The New York Times Photo Archives

STRIKING

162. Meyer Liebowitz/The New York Times
Longshoremen's Strike (Brooklyn, New York),
October 18, 1951
Courtesy The New York Times Photo Archives

163. William C. Eckenberg/The New York Times
Violence Flares in Wildcat Dock Strike,
October 23, 1951
Courtesy The New York Times Photo Archives

164. Anonymous/The New York Times
Police-Escorted Dock Workers Breach Wildcat Lines Here, October 30, 1951
Courtesy The New York Times Photo Archives

165. William C. Eckenberg/The New York Times
Back to Work, December 9, 1953
Courtesy The New York Times Photo Archives

166. Sam Falk/The New York Times
In Place of the Notorious "Shape-up" (610 West 56th Street, New York), June 12, 1955
Courtesy The New York Times Photo Archives

167. Carl T. Gossett, Jr./The New York Times
Protest Against 'Inhuman Treatment,'
November 4, 1955
Courtesy The New York Times Photo Archives

168. Meyer Liebowitz/The New York Times
Ticket to Nowhere, December 30, 1955
Courtesy The New York Times Photo Archives

169. Alvin (C. Q.) Quinn/Associated Press
Before Settlement, September 18, 1958
Courtesy AP/Wide World Photos

170. Mike Shea
Smokeless (Gary, Indiana), August 30, 1959

171. Mike Shea
Diversion, August 30, 1959

172. Carl T. Gossett, Jr./The New York Times
On Duty, October 6, 1959
Courtesy The New York Times Photo Archives

173. Carl T. Gossett, Jr./The New York Times
Untitled [Louis Pierro, Hotel Roosevelt, New York], November 13, 1959
Courtesy The New York Times Photo Archives

SERVING

174. Sam Falk/The New York Times
Machine in Motion, January 24, 1954
Courtesy The New York Times Photo Archives

175. Carl T. Gossett, Jr./The New York Times
Police Line-Up Televised, February 9, 1954
Courtesy The New York Times Photo Archives

176. Jerry Dantzic
3:30 A. M., December 19, 1954
© 2001 Jerry Dantzic Archives

177. Sam Falk/The New York Times
Faces, February 5, 1956
Courtesy The New York Times Photo Archives

178. Meyer Liebowitz/The New York Times
Gas Explosion in Store Scatters Manikins on Sidewalk, November 24, 1956
Courtesy The New York Times Photo Archives

179. Carl T. Gossett, Jr./The New York Times
Matters of Life – and Death, February 21, 1957 (taken)
Courtesy The New York Times Photo Archives

180. Sam Falk/The New York Times
Frisk, May 11, 1957 (taken)
Courtesy The New York Times Photo Archives

181. Meyer Liebowitz/The New York Times
Jewel Theft, September 27, 1957
Courtesy The New York Times Photo Archives

182. Ernie Sisto/The New York Times
Theory in Practice, July 19, 1958
Courtesy The New York Times Photo Archives

183. Patrick A. Burns/The New York Times
"Beatnik" Police Seize 96 in Narcotic Raid,
November 9, 1959
Courtesy The New York Times Photo Archives

STRUGGLING

184. Gene Herrick/Associated Press
Sumner (Sumner, Mississippi),
September 20, 1955 (made)
Courtesy AP/Wide World Photos

185. Anonymous/Associated Press
Negro's Car Attacked, February 7, 1956
Courtesy AP/Wide World Photos

186. George Tames/The New York Times
Drama in Tuscaloosa: White Citizens Council is Formed, February 26, 1956
Courtesy The New York Times Photo Archives

187. George Tames/The New York Times
Untitled [The Rev. Dr. Martin Luther King, Jr.],
March 20, 1956 (taken)
Courtesy The New York Times Photo Archives

188. George Tames/The New York Times
Klan Rally (Montgomery, Alabama),
December 16, 1956
Courtesy The New York Times Photo Archives

189. Leo Bern Keating/Black Star
Untitled [Back of the Bus], 1956
Courtesy Black Star

190. Will Counts/Arkansas Democrat, Little Rock
A Jeering Student, September 5, 1957
Courtesy AP/Wide World Photos

191. William P. Straeter/Associated Press
Students Resist Integration,
September 15, 1957
Courtesy AP/Wide World Photos

192. George Tames/The New York Times
Voters, November 1957
Courtesy The New York Times Photo Archives

193. George Tames/The New York Times
Students (Little Rock, Arkansas),
November 1957
Courtesy The New York Times Photo Archives

194. Anonymous/Associated Press
Moves up Referendum Date,
September 17, 1958
Courtesy AP/Wide World Photos

195. Anonymous/Associated Press
Post Sign Announcing School Closed,
October 1, 1958
Courtesy AP/Wide World Photos

Chronology

Compiled by Holly E. Hughes

THE FOLLOWING SOURCES WERE CONSULTED IN COMPILING THIS CHRONOLOGY:

Chronicle of the 20th Century, North American Edition. Mount Kisco, New York: Chronicle Publications, Inc., 1987.

David Brownstone and Irene Franck. *Timelines of the Arts and Literature*. New York: HarperCollins Publishers, Inc., 1994.

Timelines of the 20th Century: A Chronology of 7,500 Key Events, Discoveries, and People That Shaped Our Century. Boston, New York, Toronto, London: Little, Brown and Company, 1996.

Timelines of War: A Chronology of Warfare from 100,000 BC to the Present. Boston, New York, Toronto, London: Little, Brown and Company, 1996.

Bernard Grun. *The Timetables of History: A Horizontal Linkage of People and Events*. Based on Werner Stein's Kulturfahrplan. New York: Touchstone Book – Simon and Schuster, 1982.

S. H. Steinberg. *Historical Tables: 58 BC – AD 1990*. Updated by John Paxton, 12th edition. [New York]: Garland Publishing, Inc., 1991.

International

London recognizes the People's Republic of China, provoking an international crisis with France and the United States.

Jerusalem becomes the official capital of Israel.

NATO is started as the United States signs with eight other Western European countries. Later in the year, General Dwight Eisenhower is named NATO commander.

Devastating earthquakes in Iran kill 1,500.

Atomic scientist Klaus Fuchs is jailed as a spy in London, England.

Communist leaders Joseph Stalin and Mao Tse-Tung sign accord with secret clause stating that the People's Republic of China will loan workers to the Soviet Union in exchange for the installation of Soviet officials in key positions within the Chinese Army.

Eugene Karp, a naval attaché at the American Embassy in Bucharest is brutally murdered on his way to Paris while traveling on the Orient Express, and his body is found in a railway tunnel south of Salzburg, Austria. Hungarian authorities claim he was a spy for the United States.

1950

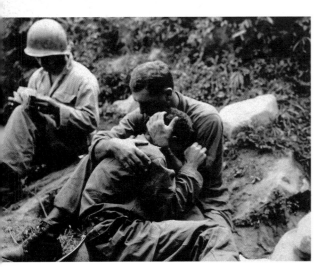

Plate 1, detail

Britain officially recognizes the state of Israel.

People's Republic of China offers autonomy to Tibet, but later invades country.

The White Assembly, 20% of the South African population, votes to divide the country into black and white areas.

Shortly after the Belgian Parliament authorizes his return, King Leopold III agrees to abdicate the throne in favor of his son, Baudouin.

A typhoon sweeps through the northern island of Hokkaido, Japan, leaving 300,000 homeless.

Radio Free Europe is established.

Korean War

North Korean forces cross the 38th parallel and invade South Korea.

The United Nations and United States agree to send troops to aid Seoul.

The United Nations declares war on North Korea as President Harry Truman extends the draft into 1951.

General Douglas MacArthur is named Supreme United Nations Commander of forces in Korea.

Selective Service calls 100,000 to serve in the Army.

President Harry Truman orders the mobilization of more American troops to South Korea and gives the military power to wage war.

Soviets call for cease-fire in Korea at the United Nations.

People's Republic of China calls on the United Nations to order United States to withdraw Seventh Fleet from Formosa patrol. President Harry Truman states that United States will withdraw only after Korean conflict is settled.

United Nations forces take Inchon.

United States Department of Defense reports casualties in Korea to be about 1,211.

People's Republic of China enters war.

Communist troops numbering 200,000 launch vehement attack on United Nations forces.

President Harry Truman states that if necessary, the United States will use the atomic bomb to secure peace in Korea.

United States exports to People's Republic of China are banned.

National

A robbery at the Brink's Armored Car Company in Boston, Massachusetts, receives national publicity after the eleven bandits, who are eventually caught, make away with $2.7 million.

Former State Department official Alger Hiss is sentenced to five years in prison for perjury because he denies divulging government secrets to Communist agent Whittaker Chambers.

President Harry Truman orders the Atomic Energy Commission to construct the hydrogen bomb.

Senator Joseph McCarthy draws national attention to his crusade against alleged Communism within the United States Government.

The longest running coal-miners' strike, lasting two months, ends after an ugly battle with the Truman Administration.

The Department of Defense and the Atomic Energy Commission release a 438-page guide on civilian defense against an atomic bomb attack.

In California, a B-29 bomber crashes into a trailer camp, killing seventeen and injuring sixty.

Government's crime injury reports suggest that organized crime is closing in on legitimate business in the United States.

The Mundt Bill, even after having been vetoed by President Harry Truman, is passed requiring Communist organizations to identify their officers and prove how they spent their funds. Truman feels that the bill will encourage Communism in America, not hinder it.

Two Puerto Rican nationalists, Oscar Collazo and Giselio Torresola, make an unsuccessful assassination attempt on President Harry Truman.

A countrywide blizzard kills 250 people.

This year, Mad Bomber George Metesky sets off the first of thirty bombs that he will plant during the course of eight years in various New York City sites.

Smokey the Bear becomes a national symbol for the prevention of forest fires.

Sports

The American Bowling Congress ends thirty-four-year rule that limited its membership to white males.

Maurice Herzog leads French team to top of the Himalayan peak Annapurna at 26,502 feet, the highest peak yet scaled.

Ben Hogan wins the United States Open despite doctor's predictions that he will never walk again following an automobile accident in 1949.

World record crowd of 199,854 attends the World Cup soccer game with Brazil versus Uruguay in Rio de Janeiro. Uruguay wins.

Florence Chadwick sets a new record swimming the English Channel from France to England in 13 hours and 20 minutes.

Althea Gibson becomes the first African-American to play the American Lawn Tennis Association Championships.

New York Yankees win the World Series, 4-0, against the Philadelphia Phillies.

Connie Mack retires as manager of the Philadelphia Athletics after a sixty-seven-year career as a player, club owner, and manager. At 87, Mack has the longest running career ever in major league baseball.

Arts & Living

World population is approximately 2.3 billion.

Minimum wage is set at 75¢ per hour due to an amendment in the Fair Labor Standards Act.

Rembrandt's *St. Peter Denying Christ* travels from Amsterdam to be exhibited in the United States for the first time.

Metropolitan Museum of Art, New York, is the first to exhibit *Vienna*, a collection of Hapsburg art.

French artist Henri Matisse is awarded the grand prize at the Venice Biennale, Italy. Nearly 80, he begins work on the Vence Chapel, France.

Ralph Bunche is awarded the Nobel Peace Prize for mediating the 1948 Arab–Israeli truce; he is the first African-American to receive a Nobel Prize. William Faulkner, author of *The Sound and the Fury*, takes the Prize for literature.

Cartoonist Charles Schulz creates *Peanuts*.

The "Irascibles" in New York demand recognition by the American avant-garde in a letter to the Metropolitan Museum of Art.

Diner's Club, first credit card, is introduced.

United Nations building in New York is completed.

Willem de Kooning, Arshile Gorky, and Jackson Pollock participate in the United States Pavilion at the Venice Biennale, Italy.

Science & Technology

Researchers at the University of California at Berkeley discover Californium, the heaviest known element.

RCA (Radio Corporation of America) introduces color television. Approximately nine percent of homes in the United States have TV sets.

The Brooklyn–Battery Tunnel, spanning New York Harbor, opens as the world's longest tunnel.

The world's longest oil pipeline, spanning 1,066 miles from United States-owned oil fields on the Persian Gulf to Sidom on the Mediterranean, is completed.

Antihistamines become a popular remedy for colds and allergies.

German-American biochemist Konrad Emil Bloch develops radiocarbon dating.

The first computer-generated twenty-four-hour weather predictions are produced.

Contact lenses, first introduced in the late 1800s, come into popular use.

Albert Einstein develops his "General Field Theory" in an attempt to expand the Theory of Relativity.

The first embryo transplants are performed on cattle.

Plate 99, detail

International

England's King George VI, after a fourteen-year reign, receives his first pay raise due to cost-of-living increases.

Iranian Premier General Ali Razmara is assassinated.

Spanish strikers, numbering 300,000, protest the high cost of living.

Scottish nationalists return 336-lb Coronation stone, Stone of Scone, to London.

United States begins broadcasting Radio Free Europe to the Eastern bloc from Munich.

1951

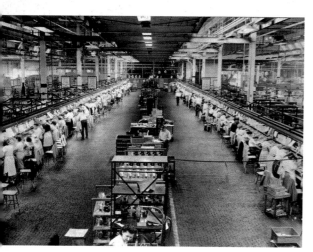

Plate 34, detail

At least 100 are dead after a major earthquake hits El Salvador.

Tibet submits to People's Republic of China and signs a seventeen-point agreement to relinquish control of its government.

King Abdullah of Jordan is assassinated.

Baudouin I is crowned, succeeding his father King Leopold III of Belgium.

Winston Churchill returns as Prime Minister in Britain after Labor Party loses control of Parliament.

Kingdom of Libya is established.

Korean War

Approximately 500,000 Chinese and North Korean troops break through the 38th parallel and take Seoul.

United Nations forces abandon Seoul; subsequently seize Pyongyang; retake Seoul.

People's Republic of China rejects General Douglas MacArthur's truce offer.

President Harry Truman dismisses General Douglas MacArthur after MacArthur publicly demands the right to bomb Chinese targets in Manchuria. Truman immediately names Lieutenant General Matthew Ridgeway as MacArthur's replacement.

Cease-fire talks begin between North Korean/Chinese negotiators and United Nations representatives.

Neutral zone is violated by North Korea. Cease-fire talks suspended by General Matthew Ridgeway but are resumed shortly thereafter.

United Nations troops take "Heartbreak Ridge."

Peace negotiations begin in Panmunjom, and a truce line is drawn.

Indochina War

French forces break Vietminh guerrilla attack on Hanoi.

Vietnamese forces link up with Pathet Lao and Khmer Rouge guerrilla armies.

French troops have limited control over cities and some fortified bases.

National

The First Amendment, guaranteeing freedom of speech, is altered by the Supreme Court ruling that "clear and present danger" of incitement to riot is cause for arrest.

President Harry Truman creates Commission on Internal Security and Individual Rights to monitor anti-Communist campaign.

President Harry Truman unveils Philadelphia, Pennsylvania, mural dedicated to four WWII chaplains.

In New Jersey, a commuter train plunges off its rails, killing 84 and injuring 330. Two weeks later, the Pennsylvania Railroad is indicted for manslaughter.

The twenty-second amendment is passed, limiting the United States presidency to two terms.

Julius and Ethel Rosenberg are found guilty of wartime espionage and are sentenced to death.

Oscar Collazo is sentenced to die for his attempt to assassinate President Harry Truman in November 1950.

American pilot Captain James Jabara becomes the world's first jet ace.

The United States Supreme Court upholds the states' rights to require job applicants to sign non-Communist affidavits.

A human birth is broadcast on television for the first time.

Federal jury in New York indicts 21 people as Communist party leaders.

William Hill, Jr. dies after attempting to go over Niagara Falls, New York, in an inner tube.

In Nevada, the United States Air Force tests the first air-to-ground tactical nuclear weapons.

Sports

Joe DiMaggio signs a $100,000 contract with the New York Yankees for a third consecutive year.

Sugar Ray Robinson wins world middleweight title by defeating Jake LaMotta. In July, Randy Turpin then defeats Robinson in fifteen rounds, taking world middleweight title until September when Robinson finally regains the title from Turpin in ten rounds.

At 20, Willie Mays joins the New York Giants.

Wimbledon Chairman Sir Louis Greg declares "no more bikini bathing dresses." In 1950 tennis player Gussie Moran horrified Wimbledon officials by wearing lace underwear beneath her tennis outfit, flashing onlookers with every play.

Emmanuel MacDonald of Belgrade sets a record time of 10.2 seconds for the 100-meter dash.

At age 16, Maureen Connolly becomes the youngest tennis player to win the United States Open women's singles.

The New York Yankees take the World Series, 4-3, over the San Francisco Giants.

Joe DiMaggio announces he will retire from baseball.

Australia defeats the United States for the Davis Cup.

Arts & Living

United States Department of Commerce reports that the average household income in 1950 was $1,436.

After working in ceramics for five years, Picasso returns to painting.

The Catcher in the Rye by J.D. Salinger is published and receives immediate attention from youths everywhere.

Frank Lloyd Wright designs the First Unitarian Meeting House in Madison, Wisconsin.

Robert Rauschenberg begins "Black Paintings" series.

Nat King Cole turns out two of his greatest hits, *Mona Lisa* and *Unforgettable*.

Lawrence Welk and his band begin broadcasting on television.

I Love Lucy debuts on television.

Science & Technology

The Atomic Energy Commission tests its second atomic explosion at Nevada testing grounds. It is the second in a series of ten tests executed by the United States since 1945. After completion of third atomic bomb test, Atomic Energy Commission reveals information on the first atom-powered airplane.

Charles Blair, Jr. sets a new record of 7 hours and 48 minutes for a New York-to-London flight. Taking advantage of the "jet stream," Blair opens up possibilities for swifter air travel.

As a result of atomic bomb tests in Nevada, atmospheric radiation is increasingly detected in the Eastern United States. Radioactive snow reported falling on Cincinnati, Ohio; Rochester, New York, and as far north as Quebec, Canada.

Leo Fender develops and begins to market the first electric bass guitar.

Fred Waller of the United States invents Cinerama, a wide-screen process using three adjacent, synchronized cameras for photographing and three corresponding projectors for showing the film.

The first general-purpose electronic data processing computer, UNIVAC I, is installed at the United States Census Bureau.

Plate 41, detail

International

A five-year accord is signed by the United States to give India $50 million for economic development.

As anti-British riots surge through Cairo, Egypt is placed under martial law.

King George VI of England dies, and Princess Elizabeth becomes queen.

Britain announces development of an atomic bomb.

Soviet proposal for an armed, reunified, neutral Germany is rejected by the United States, Britain, and France.

President Harry Truman signs peace treaty with Japan officially ending WWII.

Air France plane is attacked by a Soviet MIG-15 while en route from Frankfurt to Berlin.

1952

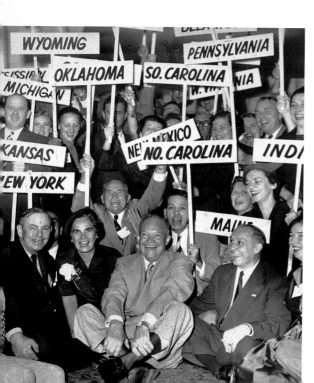

European Defense Community formed with United States, United Kingdom, France, Belgium, Italy, Holland, Luxembourg, and West Germany as participants.

East Germany officially sequesters itself from the outside world.

Argentina mourns the death of Eva Peron, their "Evita" who finally succumbs to ovarian cancer.

Eight hundred British troops are sent to East Africa to take action against the Mau-Mau, the anti-white society of Kenya.

Britain and Iran sever formal relations over oil dispute.

First international organization for birth control is established in Bombay, India.

Korean War

North Korea accuses United Nations of using germ warfare.

United Nations forces execute air strike on the city of Suan in North Korea.

United States Commander General Francis T. Dodd is seized by Communist prisoners on Koje-do Island.

General Mark Clark succeeds General Matthew Ridgeway.

United States troops storm Koje-do prisoner-of-war camps, removing Communist leaders.

United Nations planes bomb Pyongyang in the heaviest attack of the war.

President-elect Dwight Eisenhower pays a three-day visit to Korea.

Indochina War

Shortly following the death of French General Jean de Lattre de Tassigny, Communist guerrillas increase their attacks on French troops.

French troops move into the Vietminh territory.

French troops begin Operation Lorraine, cutting off the Vietminh food supply.

Detail of Plate 135

National

Dwight Eisenhower declares presidential candidacy and wins Republican nomination.

A massive series of tornadoes hits five states across the United States killing 200 people and injuring more than 2,500.

Court rules that the Miami Springs Country Club must admit "Negro" golfers. However, rules are established so that "Negroes" could tee off on Mondays only.

New York's Feinberg Law, which bans Communist teachers, is upheld by the United States Supreme Court.

University of Seattle, Washington, student James Leedom dies from bacteria-contaminated blood he was given while participating in a research experiment on blood preservation.

United States Supreme Court rejects appeal in the Rosenberg case.

Eisenhower, and his running mate Richard Nixon, are elected to office in a landslide victory over Adlai E. Stevenson and running mate John J. Sparkman. The election is the first to be reported on live television.

Sports

Baseball great Jackie Robinson becomes the highest paid player in the history of the Brooklyn Dodgers.

Nationalist China pulls out of the Summer Olympics in Helsinki, Finland, to protest plan to admit People's Republic of China.

Soviet flag is raised for the first time in Olympic history at the opening day of the Summer Olympics in Helsinki, Finland.

Olympic figure-skating champion Dick Button joins the Ice Capades.

Rocky Marciano wins world heavyweight championship from "Jersey Joe" Walcott.

London fur broker and speedboat racer John Cobb is killed in a boating accident during an attempt to set water-speed record in Loch Ness, Scotland.

Middleweight boxing champion Sugar Ray Robinson retires.

Ben Hogan wins both the American Masters Tournament and the United States Open.

Arts & Living

"Don't Walk" signs and three-colored traffic lights are introduced in New York to help reduce accidents.

Mrs. Vincent Astor, Mrs. Ogden Reid, and Mrs. Sheldon Whitehouse become the first female trustees at the Metropolitan Museum of Art, New York.

Leonardo da Vinci's 500th birthday is celebrated.

John D. Rockefeller donates $10 million to The Cloisters, a branch of the Metropolitan Museum of Art devoted to the art and architecture of medieval Europe.

Buckminster Fuller invents the Geodesic Dome House.

George Jorgenson becomes Christine Jorgenson through the use of hormone treatments, surgery, and the aid of a Danish medical team. Jorgenson makes history when he sells his sex-change story to *American Weekly* for $30,000.

Diary of Anne Frank (The Diary of a Young Girl) is published in English.

Charlie Chaplin leaves the United States after being ostracized for his left-wing views.

Fernand Léger begins murals for the United Nations General Assembly auditorium in New York.

Jackson Pollock paints *Convergence*.

L. Ron Hubbard founds the Church of Scientology.

A recital of *4' 33'* the first "silent" composition composed by John Cage, is held in Woodstock, New York.

Children's toy *Mr. Potato Head* is introduced.

The first issue of *TV Guide* is published.

Edward Haas introduces the *Pez* dispenser in the United States.

Hollywood develops "3-D" gimmick in order to compete with television's rising popularity, releasing *Bwana Devil*, first movie to use this technology.

Charles W. Fish designs McDonald's "golden arches."

Science & Technology

Peter During becomes the first patient to benefit from mechanical heart employed during surgery.

One million viewers witness broadcast of the first televised atom bomb blast.

Through charcoal analysis, Stonehenge is discovered to have originated in 1848 BC.

General Motors becomes the first auto manufacturer to offer cars with air-conditioning.

Atomic Energy Commission explodes first hydrogen bomb at Eniwetok, an atoll in the Marshall Islands.

First recorded nuclear accident occurs at Canada's experimental site at Chalk River, Ontario.

Jonas Salk invents polio vaccine.

British physician Douglas Bevis develops amniocentesis to aid in the detection of genetic problems prior to birth.

American psychologist William Charles Dement discovers REM sleep.

British biochemist Rosalind Franklin discovers DNA's helical structure and later James Dewey Watson and Francis Crick identify double helical structure. The new discoveries make it possible to visualize how genes replicate and transport information.

British archaeologist Kathleen Kenyon begins excavations on Jericho, in Jordan.

Plate 106, detail

International

Nine Jewish doctors are arrested in the Kremlin on charges of plotting to kill top Soviet leaders on orders of British and American intelligence agencies and Zionist organizations.

Soviet encyclopedia, which denies the existence of Israel and denounces Zionists as agents of United States and British imperialism, is published in Moscow.

Public-safety legislation is passed by Parliament in South Africa, giving the government increased power to suppress minorities.

Joseph Stalin dies, and Georgi Malenkov is named the new Soviet premier.

Six are killed by a bomb during a rally in Buenos Aires, Argentina.

Chief Jomo "Burning Spear" Kenyatta, leader of the Kikuyu tribe in Kenya, is sentenced to seven years of hard labor for organizing the Mau-Mau rebellion.

1953

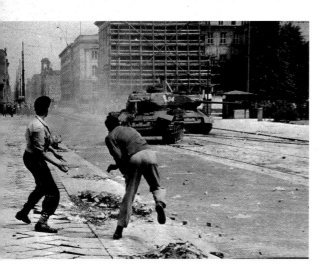

Plate 8, detail

Moslem nationalists riot in Nigeria for independence from Britain; 32 are killed.

Coronation of Britain's Elizabeth II.

Soviet tanks are sent into Berlin to fight workers rioting against the East German government.

Egypt becomes a republic ruled by military junta with new president and premier, Major General Mohammed Naguib.

Israel and the Soviet Union resume diplomatic relations.

Fidel Castro leads a failed attack on the Moncada barracks in Cuba and is captured; he is released two years later.

Moscow University opens in the Soviet Union.

Nikita Krushchev is elected first secretary of the Communist Party.

Korean War

United Nations plan for exchanging sick and injured prisoners of war is accepted by Communists.

Prisoners-of-war exchange begins; 30 Americans are freed.

United Nations truce banned by South Korean deputies.

Communist forces attack South Korea.

Korean armistice signed at Panmunjom. North and South Korea officially under two flags.

Indochina War

French troops destroy Vietminh factories hidden in jungle.

Vietminh troops, numbering 40,000, invade Laos.

General Eugene Navarre is appointed Commander-in-Chief of the French Union Forces in Indochina.

Vietminh base at Lanson crushed by French Union paratroopers.

France signs pact to give Laos independence within the French Union.

French paratroopers capture Dien Bien Phu.

National

Dwight Eisenhower is inaugurated thirty-fourth President of the United States.

Yeshiva University Medical School in New York becomes Albert Einstein Medical College.

Department of Health, Education and Welfare is established.

After sixty-three years, the bones of Sitting Bull are moved from North to South Dakota.

Senator Wayne Morse gives the longest speech in Senate history to date, 22 hours and 26 minutes, on the Offshore Oil Bill.

The Rosenbergs' appeal is denied for the third time. They are executed at Sing-Sing prison in Ossining, New York.

Sagamore Hill, Theodore Roosevelt's home, is made a national shrine.

Jehovah's Witnesses gather at Yankee Stadium, New York. A record 4,640 individuals are baptized in one day.

Cities begin to feel impact caused by the loss of well-to-do citizens who start migrating to the suburbs.

Senator John Kennedy and Jacqueline Bouvier are married.

In a television speech, Senator Joseph McCarthy declares that the Truman Administration "crawled with Communists."

President Dwight Eisenhower proposes the "atoms for peace" international energy stockpile.

For the first time ever, the White House allows the press to print direct quotations from press conferences.

Nuclear Scientist J. Robert Oppenheimer, who led effort to develop nuclear bomb, has his security clearance suspended by President Dwight Eisenhower. Next year, he is declared security risk.

Sports

Dizzy Dean and Al Simmons are inducted into the Baseball Hall of Fame in Cooperstown, New York. Bill Klem becomes the first umpire voted into the Baseball Hall of Fame.

John and Jennifer Nicks of Britain win the World Figure Skating Championships.

The Boston Braves are transferred to Milwaukee, Wisconsin, and the St. Louis Browns move to Baltimore, Maryland, to become the Baltimore Orioles.

Rocky Marciano keeps his heavyweight title against "Jersey Joe" Walcott in a fight that lasts 2 minutes, 35 seconds.

Edmund Hillary and Tensing Norgay of New Zealand become the first men to conquer Mount Everest.

August Piccard of Switzerland sets a diving record of 10,330 feet off the Italian Coast in a self-built craft.

Yankees win their fifth World Series in a row against the Brooklyn Dodgers.

Emil Zatopek of Czechoslovakia sets the world record for the 5,000 meter run at 29 minutes, 1.6 seconds.

Plate 108, detail

Arts & Living

Sidney Janis Gallery, New York, holds Dada exhibition.

Winston Churchill receives Nobel Peace Prize for literature.

Films *From Here to Eternity*, *Kiss Me Kate*, and *Gentlemen Prefer Blondes* are released at the box office.

The Robe is the first Cinemascope film shown in theaters.

David Smith begins "Tank Totem" series of sculptures.

The Crucible by Arthur Miller opens at the Martin Beck Theater, New York. The play, about the Salem witch hunts, is a commentary on the anti-Communist hysteria created by Senator Joseph McCarthy's Congressional hearings.

Hugh Hefner publishes first issue of *Playboy*.

Science & Technology

United States Department of Agriculture sets standards that allow for smaller holes in swiss cheese.

Polio vaccine is successfully tested.

Jacqueline Cochran becomes the first female pilot to break the sound barrier.

Ice-age artifacts, thought to be the world's oldest, are discovered in Algeria by archaeologists.

Soviet Union announces it has developed its own hydrogen bomb.

First pregnancy achieved by artificial insemination of frozen sperm.

Heart–lung machine, which can keep patients alive during heart surgery, is developed by John H. Gibbon, Jr.

American physicists Maurice Ewing and Bruce Charles Heezen discover rifts in the earth's crust beneath the Atlantic Ocean.

Robert H. Abplanalp invents aluminum spray can. Freon, which powers the spray can, is later found to break down the ozone layer.

Jonas Salk, developer of polio vaccine, develops a vaccine against influenza.

Cigarette smoking is reported to be a cause of lung cancer.

Plate 61, detail

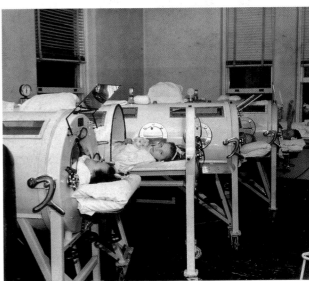

International

Avalanches kill 198 people in Austria, Switzerland, and West Germany.

Eleven Israelis are slain when their bus is ambushed by Jordanians near Beersheba.

Canada's first subway line is opened in Toronto.

A state of martial law is declared in Nicaragua after an assassination attempt on President Anastasio Somoza.

1954

British arrest more than 700 Mau-Mau activists after negotiations for their release fail.

Britain ends its seventy-two-year occupation of Egypt with the signing of the Suez Canal pact.

Eleven die in riots in Morocco as nationalists demonstrate against French-appointed sultan.

Pope allows American priests to deliver sacraments in English.

After deciding to step down, Brazilian president Getúlio Vargas commits suicide. Vargas's administration had been shaken by financial corruption and numerous other scandals.

The Soviet military detonates an atomic bomb near Totskoye, USSR., exposing 45,000 of their own soldiers and thousands of civilians to radiation.

India outlaws bigamy.

Mao Tse-Tung is reelected to another four-year term as Chairman of the People's Republic of China.

West Germany is admitted to NATO.

The Algerian War of Independence (1954–62) begins when National Liberation Front forces attack French forces in Algeria.

Desert locusts plague Morocco, destroying approximately $14 million in citrus crops.

Major uprising in Tibet is defeated by Chinese forces.

Unification Church is founded by Rev. Sun Myung Moon.

Indochina War

Communist guerrillas attack French forces at Dien Bien Phu.

United States begins transporting French paratroopers into Vietnam.

After siege of fifty-five days, French forces surrender and Dien Bien Phu falls to Communists. A cease-fire is agreed between France and China that results in the establishment of North and South Vietnam.

National

Television stations in the United States total 360.

American novelist and poet Maxwell Bodenheim and his wife are found murdered. Bodenheim, author of *Replenishing Jessica*, was a controversial poet and an important figure of the bohemian scene in New York City's Greenwich Village during the 1920s.

Ford Foundation grants $25 million to the Fund for Advancement of Education.

Senator Joseph McCarthy brings charges against the United States Army for alleged Communist activities.

Five Congressmen are shot by Puerto Rican nationalists in the House Chamber.

United States admits that in Marshall Islands tests, 264 natives and 28 Americans were exposed to radiation.

CBS commentator Edward Murrow accuses Senator Joseph McCarthy of engaging in half-truths and intentionally confusing the public about the internal and external threats of Communism.

First hydrogen bomb blast is shown on television.

Supreme Court orders integration of schools and declares school segregation unconstitutional. Chief Justice Earl Warren presides over landmark case *Brown vs. Board of Education of Topeka*.

Senate subcommittee hearings on the dispute between the Army and Senator Joseph McCarthy are concluded.

President Dwight Eisenhower signs bill to abolish the Communist Party as a political and legal entity in the United States.

Death penalty for espionage during peacetime is instituted by United States Congress.

White pupils march in Washington, D.C., and Baltimore, Maryland, against integration.

Senate votes sixty-seven to twenty-two to censure Senator Joseph McCarthy for conduct considered inappropriate for a senator. McCarthy says he will continue his anti-Communist inquiries.

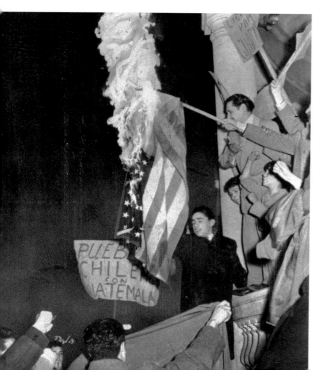

Plate 13, detail

Sports

Soviets win their first ice-hockey championship over Canada, 7–2.

The Detroit Red Wings win the Stanley Cup over the Montreal Canadiens.

Bill Vukovitch wins the Indianapolis 500 for the second year in a row.

British runner Roger Bannister sets a new record of 3 minutes and 59.4 seconds, breaking the four-minute mile.

Louison Bobet wins the Tour de France.

Willie Mays wins batting title and helps New York Giants to win National League pennant.

The New York Giants win World Series over Cleveland Indians, breaking New York Yankees' five-year winning spree.

Willie Mays is named National League's Most Valuable Player.

Sugar Ray Robinson, having retired from boxing in December 1952, announces his comeback.

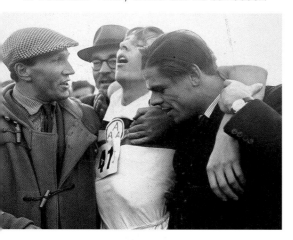

Plate 110, detail

Arts & Living

Second biennial international exhibition of modern art opens in São Paulo, Brazil.

Elvis Presley, at age 19, pays $4 to a Memphis, Tennessee, studio to record *Casual Love* and *I'll Never Stand in Your Way*.

South Pacific ends a Broadway run of four-and-a-half years.

The Morning Show first airs on CBS, creating competition for NBC's *Today Show*.

Modern art from the west is shown in Russia after being banned for twelve years by the government. On display at the Hermitage in Leningrad are works by Matisse, Picasso, and van Gogh.

On the Waterfront, A Star is Born, Rear Window, and *Dial M for Murder* are shown in movie theaters.

Louis Kahn designs the Yale University Art Gallery, New Haven, Connecticut.

High-fidelity stereophonic sound recording and playback become available.

Lord of the Flies by William Golding as well as *The Lord of the Rings* and *The Two Towers*, first two parts of *Lord of the Rings* trilogy by J.R.R. Tolkien, are published.

Joseph Papp founds New York Theater Workshop, now known as New York Shakespeare Festival.

Swanson's introduces the first TV dinner.

Fifty-five percent of homes in the United States have television sets.

French artist Henri Matisse dies.

Science & Technology

Electric power now reaches 50 million customers in the United States, an increase of 40 million since 1919.

Premium-grade gas is introduced in the United States.

Dr. William Mustard performs first successful heart surgery using hypothermia.

Cancer Society announces that smokers over the age of fifty have a seventy-five percent higher death rate.

New York State Thruway opens.

Soviet Union opens its first atomic power plant.

New York police initiate the use of the "drunkometer" to administer chemical analysis tests on drunk drivers.

A six-year-old study finds that smog in the Los Angeles area is caused by the chemical action of sunlight on automobile exhaust fumes and industrial emissions.

New Jersey installs automatic toll collectors on turnpike.

Pharaoh Cheop's solar ship, which was discovered in May 1954 next to one of the pyramids, is exposed to light after 4,700 years.

First successful kidney transplant is performed by Joseph E. Murray and a Harvard medical team.

The use of Thorazine, a synthetic tranquilizer, is introduced to control anxiety and hallucinations in mental patients. This drug aided in the eventual replacement of shock treatments as therapy.

First nuclear submarine, the *Nautilus*, is launched.

United States develops the intercontinental ballistic missile (ICBM).

1955

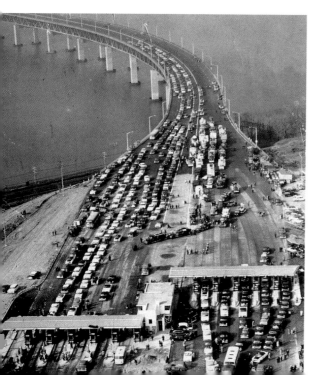

International

United States gives $216 million in aid to South Vietnam.

Sixty thousand peacefully protest the government's plan to relocate minorities outside Johannesburg in South Africa.

Georgi Malenkov resigns and Marshal Nikolai Bulganin assumes full power as the Soviet Premier.

Earthquake in the Philippines kills 200.

Winston Churchill retires, and Sir Anthony Eden succeeds him as Britain's Prime Minister.

Twenty-nine representatives of African and Asian countries meet in Bandung, Indonesia, to promote economic and cultural cooperation in opposition to colonialism.

Civil war breaks out in Saigon, Vietnam.

The Warsaw Pact is established, unifying militaries of the Eastern bloc nations.

Eighty people die and more than 100 are injured in the worst accident in the history of auto racing at Le Mans raceway, Paris, France.

The four superpowers, United States, Britain, France, and the Soviet Union, meet at the Geneva Summit.

Scientists from sixty-two nations meet in Geneva, Switzerland, to discuss atomic energy.

Peru grants women the right to vote.

West Germany and the Soviet Union establish diplomatic relations.

Argentine dictator Juan Peron flees to Paraguay after rebels seize control of the government.

South Africa walks out on a United Nations debate on racial conflict in South Africa.

The United States and People's Republic of China dispute over Formosa (Taiwan). China demands that the American protection of the Kuomintang government be withdrawn. The Senate authorizes President Dwight Eisenhower to use force, if necessary, to defend the island.

In Sudan, civil war begins between government forces led by the Muslims in the North and Christian and animist Black Africans of the South. The war continues for almost forty years until the 1990s.

National

President Dwight Eisenhower allows presidential press conference to be filmed for television and newsreel for the first time.

Document of 400,000 words containing the talks at the Yalta Conference in 1945 is published and released in the United States at the demand of Republicans.

A loaded Nike guided missile breaks loose of its launching pad and explodes in flight.

Last train travels on the Third Avenue Elevated in New York.

Presbyterian Church votes to begin accepting women as ministers.

Selective Service is extended by the House until 1959.

After a twelve-hour strike, 600,000 steelworkers in Pittsburgh, Pennsylvania, receive a 15¢ pay raise.

United States Congress votes to build 45,000 public housing units.

Emmett Till, a 14-year-old "Negro" boy, is lynched in Mississippi for apparently whistling at a white woman. Two of his alleged murderers were acquitted by an all-white jury.

President Dwight Eisenhower is hospitalized after suffering a mild heart attack.

New York Stock Exchange endures a $44 million loss in one day.

United States Army commissions a male nurse for the first time.

Rosa Parks is arrested after refusing to give up her seat to a white person on a bus in Montgomery, Alabama. The incident sparks a bus boycott led by Rev. Martin Luther King, Jr., and marks the beginning of the Civil Rights movement in the United States.

New York State Thruway is completed with the opening of the Tappan Zee Bridge.

Plate 44, detail

Sports

Maureen Connolly is forced to retire from tennis due to a serious leg injury sustained in a horseback riding accident in 1954.

Canada regains the world-hockey championship title from the Soviet Union in a 5–0 win.

Two thousand athletes participate in the Pan-American games in Mexico City, Mexico.

One hundred are arrested when hockey fans in Montreal, Canada, riot in protest against the NHL suspension of Maurice "the Rocket" Richard, who had been suspended when he hit Boston Bruin player Hal Laycoe and attacked another linesman who intervened.

The Detroit Red Wings defeat the Montreal Canadiens to retain the Stanley Cup.

Kentucky Derby is won by jockey Willie Shoemaker riding Swaps.

Louison Bobet wins the Tour de France for third time.

Soviet runner Vladimir Kuts sets a new 5,000 meter record of 14 minutes, 46.8 seconds.

Leo Durocher resigns as manager for the New York Giants.

Brooklyn Dodgers win their first World Series.

Roy Campanella of the Brooklyn Dodgers is named National League Most Valuable Player.

Sugar Ray Robinson regains world middleweight title over Carl "Bobo" Olson.

Los Angeles Rams win pro football title over Cleveland Browns, 38–14.

Arts & Living

Contralto Marian Anderson becomes the first "Negro" to sing at the Metropolitan Opera House as Ulrica in Verdi's *Un Ballo in Maschera*.

Scrabble debuts in stores across the United States.

The Family of Man, a sixty-nine-nation photography exhibition organized by Edward Steichen, opens at The Museum of Modern Art, New York.

Rock Around the Clock is number-one hit by Bill Haley and the Comets.

Disneyland opens in Anaheim, California.

Minimum wage is increased to $1 per hour.

Primitive painter Grandma Moses, who began to paint in her late seventies, turns 95.

James Dean at age 24 dies in a car crash before his two movies, *Rebel without a Cause* and *East of Eden*, open at the box office.

Jasper Johns takes hold of the New York art scene with his Pop-art piece *Target with Four Faces*.

J.R.R. Tolkien publishes *The Return of the King*, the last installment in his *Lord of the Rings* trilogy.

Vladimir Nabokov publishes *Lolita*, and Nikos Kazantakis publishes *The Last Temptation of Christ*.

Picasso exhibitions open in Paris, France, and in Germany, in Hamburg, and Munich.

Frank Lloyd Wright designs the H. C. Price Tower in Bartlesville, Oklahoma.

Davy Crockett films on television inspire the coonskin-cap rage.

The *Mickey Mouse Club* premieres on television.

Poet Allen Ginsberg recites "Howl" at the Six Gallery, San Francisco, California.

Museum of Modern Art, New York, holds Léger memorial exhibition, August 19 to September 18, following the artist's death earlier that year.

Leo Burnett agency creates the "Marlboro Man" cigarette campaign.

The first issue of *The Village Voice* is printed.

Science & Technology

Atomic clock accurate to within one second in 300 years is developed by scientists at Columbia University, New York.

RCA develops music synthesizer.

Britain has ability to produce a hydrogen bomb.

Missile with atomic warhead is tested in Nevada.

United States Air Force reveals its work on self-guided missiles.

First birth-control pill is developed by Gregory Pincus, American biologist.

Dorothy Crowfoot Hodgkin, with the aid of a computer, is the first to identify the structure of vitamin B12.

British engineer, Christopher Cockerell, patents the "hovercraft," a vehicle that has the capability to travel over land and water.

Italian-American physicist Emilio Segrè and American physicist Owen Chamberlain discover the antiproton. In 1959, they shared the Nobel Prize for physics.

Radio waves emitted from Jupiter are detected by American astronomer Kenneth Linn Franklin.

Synthetic diamonds are successfully produced for the first time by combining carbon atoms at extremely high temperatures and pressures.

The first "newborn" stars in the region of the Orion nebula are discovered by American astronomer George Howard Herbig.

Atomically generated power is first used in the United States in Schenectady, New York.

Nobel Prize winner Albert Einstein dies. Einstein revolutionized modern science with his Theory of Relativity.

Plate 111, detail

International

Sudan proclaimed an independent republic.

Reports from Kenya state that the British have killed 10,173 Mau-Mau rebels since October 1952.

Nikita Krushchev proclaims that Communism can exist without violence and exposes the crimes of "Stalinism" during a speech to the 20th Congress of the Soviet Communist Party.

Revolution in Budapest due to unrest caused by Krushchev's speech, ultimately crushed by Soviet troops on November 4. Uneasiness spreads throughout Eastern Europe.

British forces in Cyprus push Makarios III, Greek-Orthodox archbishop of Cyprus and Cypriot national leader, into exile.

Morocco and Tunisia become independent nations from France.

Pakistan becomes the first Islamic Republic.

In Berlin, 100,000 march for the reunification of Germany.

Forty Peronist counterrevolutionaries in Argentina are put to death for attempted revolt.

Full-scale war erupts in Algeria.

Egyptian President Abdul Nasser nationalizes the Suez Canal, provoking military action from Britain, France, and Israel.

Nearly 2,000 are killed, and 1,200 injured when a typhoon hits Chekiang Province, People's Republic of China.

Cuban Revolution begins when Fidel Castro lands in Cuba with guerrilla troops.

Japan is admitted to the United Nations.

National

FBI finally solves the Brink's robbery, which occurred in January 1950 in Boston, Massachusetts.

Autherine Lucy becomes the first "Negro" student to be admitted to the University of Alabama after a Federal Court rules that the university must admit "Negro" students.

Police arrest 115 in Montgomery, Alabama, for involvement in a bus boycott protesting the arrest of Rosa Parks in December 1955. The Rev. Dr. Martin Luther King, Jr. is found guilty of organizing the boycotts.

Bus lines are integrated in the South after Supreme Court rules that segregation in public transportation is unconstitutional.

United States Army gets its first official flag.

President Dwight Eisenhower signs bill that authorizes more than $33.4 billion for a nationwide network of highways.

President Dwight Eisenhower and Vice President Richard Nixon are renominated to run against Democrats Adlai Stevenson and Senator Estes Kefauver. Eisenhower and Nixon reelected for second term.

Drag racing becomes increasingly popular on abandoned runways and unused roads.

United States opens its doors to 21,500 Hungarian refugees.

United States experiences beginning of a suburban housing boom.

1956

Detail of Plate 171

Sports

Winter Olympic Games open in Cortina d'Ampezzo, Italy.

Tenley Albright of the United States wins the Olympic gold medal in women's figure skating.

Austrian Toni Sailer becomes the first skier to take all three gold medals in Alpine events, of downhill, slalom, and giant slalom.

Undefeated Rocky Marciano retires from boxing.

Pat Flaherty wins the Indianapolis 500, averaging 128.5 miles per hour.

Roger Walkowiak wins the Tour de France.

Don Larsen of the New York Yankees pitches a perfect no-hitter in the World Series, leading the team to a 2–0 victory over the Brooklyn Dodgers.

Floyd Patterson defeats Archie Moore, becoming the youngest to hold the world heavyweight boxing title.

Mickey Mantle wins the first of his three Most Valuable Player Awards.

XVIth Summer Olympic Games open in Melbourne, Australia.

American Al Oerter wins the first of four gold medals for discus throwing. Oeter went on to win three more gold medals in the 1960, 1964, and 1968 Olympic Games.

Montreal Canadiens win their first of five consecutive Stanley Cup championships.

Arts & Living

My Fair Lady, starring Rex Harrison and Julie Andrews, opens on Broadway and receives rave reviews.

Metropolitan Museum of Art, New York, exhibits *Steuben Glass Etchings of Japan's Suekichi Akaba*.

Billie Holiday's *Lady Sings the Blues* is published.

Prehistoric art is found in the Rouffignac grotto, France.

Abstract Expressionist painter Jackson Pollock is killed in car crash.

Allen Ginsberg publishes his first poetry collection *Howl and Other Poems*, gaining recognition as a major "Beat" poet.

Ludwig Mies van der Rohe begins the Seagram Building in New York (completed in 1958) and designs Crown Hall at the Illinois Institute of Technology.

Elvis Presley achieves fame when *Love Me Tender*, *Heartbreak Hotel*, and *Hound Dog* hit number one on the billboard charts.

Films *The Ten Commandments*, *The King and I*, and *The Seventh Seal* are the big hits at the box office.

Mark Rothko paints *Orange and Yellow* and Albert Giacometti sculpts *Nine Standing Figures*.

The Fall by Albert Camus and *A Walk on the Wild Side* by Nelson Algren are published.

The first indoor shopping mall opens in Bloomington, Minnesota.

Play-Doh is introduced as wallpaper cleaner, however, its non-toxicity and clay-like tendencies are recognized as excellent toy qualities.

Museum of Modern Art, New York, holds Jackson Pollock memorial exhibition, December 1956 to February 3, 1957.

Science & Technology

Closed-circuit television is installed in Schenectady, New York, public schools to aid classroom instruction.

The Lockheed Starfighter, a 1,500-mph jet with the ability to carry nuclear bombs, is introduced by the United States.

First prefrontal lobotomy is performed.

The first cross-Atlantic telephone cable goes into operation, spanning 2,250 miles from Newfoundland to Scotland.

World's largest nuclear plant is opened in the United Kingdom.

First gorilla is born in captivity at the Columbus Zoo, Ohio.

Albert Sabin develops a new polio vaccine that is less expensive and easier to store than the vaccine developed by Jonas Salk.

Chinese-American biochemist Choh Hao-Li isolates the human growth hormone that is made by the pituitary gland.

Computer programming language comes into use to aid programmers with writing instructions for new machines.

The use of tranquilizers on mental patients becomes controversial as critics argue that patients were not being drugged for their own benefit, but to make them easier to handle and care for.

"Liquid Paper," correction fluid originally called "Mistake Out," is invented by Bette Nesmith.

Plate 48, detail

Plate 100, detail

International

President Dwight Eisenhower proposes the "Eisenhower Doctrine," which emphasizes direct military confrontation with the Soviet Union and promise of American support on behalf of any Middle Eastern country attacked by the USSR.

Death penalty is instituted in Hungary for acts of government opposition.

Ghana becomes an independent state.

Israelis protest the United Nations demand for withdrawal from the Gaza Strip.

Britain adopts plan to triple its nuclear energy production by 1965.

Anglo-Jordanian treaty of 1948 ends. British troops are required to withdraw in six months.

Philippine President Ramon Magsaysay is found dead in plane crash.

European Common-Market treaty is signed in an attempt to create a "common market" for all products and services of France, West Germany, Luxembourg, Italy, Belgium, and the Netherlands.

Tunisia and Morocco sign friendship treaty.

Following accusations of Communist ties, Canadian ambassador Herbert Norman kills himself.

Algerian nationalist kills Algerian vice president during soccer game in France.

United States agrees to give Poland $48.9 million in surplus farm equipment.

Nearly 2,000 are killed by earthquakes near the Caspian Sea, Iran.

Fidel Castro leads 200 rebels on army post raid in Cuba.

First "United States style" supermarket opens in the Eastern bloc in Zagreb, Yugoslavia.

President Dwight Eisenhower apologizes after Delaware restaurant refuses to serve finance minister from Ghana.

Egyptian troops land in Syria to block possible Israeli-Turkish attack.

British government announces women will sit in the House of Lords for first time in history.

Queen Elizabeth II abolishes the presentation of debutantes at court.

National

Bus service comes to a halt in Tallahassee, Florida, in an attempt to stop integration efforts.

Playwright Arthur Miller is indicted by a grand jury for contempt in House on UnAmerican Activities Committee inquiry.

Senate begins hearings on corruption in the Teamsters' Union.

Teamsters' Vice President Jimmy Hoffa is arrested by the FBI on bribery charges and later acquitted.

Three makers of arthritis pain-relief formulas come under attack by the Federal Trade Commission in accusations of false advertising.

Vice President Richard Nixon meets with Rev. Martin Luther King, Jr. to discuss racial relations.

In *Roth vs. The United States*, Supreme Court rules that obscenity is not protected by the constitutional guarantee of free speech.

Rev. Billy Graham draws 100,000 to New York's Yankee Stadium.

Juvenile crime is reported to be on the rise.

President Dwight Eisenhower proposes to suspend nuclear bomb tests for two years.

A "Negro" minister is beaten in Birmingham, Alabama, while attempting to enter his daughter and others to school.

In an attempt to uphold integration, President Dwight Eisenhower sends federal troops to Little Rock, Arkansas.

Jimmy Hoffa is elected president of the International Brotherhood of Teamsters.

Jimmy Hoffa is expelled from the AFL-CIO on grounds of massive corruption.

Mass murderer Charles Starkweather and fourteen-year-old girlfriend Carol Ann Fugate go on killing spree and murder eleven people, including three in Fugate's family.

Senator Joseph McCarthy, leader of the Senate investigations on Communist activities, dies.

1957

Plate 122, detail

Sports

Jackie Robinson announces retirement from baseball.

Ted Williams signs $100,000 contract with the Boston Red Sox, becoming the highest paid player to date.

Georgia Senate bans interracial athletics.

Sugar Ray Robinson defeats Gene Fullmer to regain the middleweight title for the fourth time, but then loses it to Carmen Basilio.

American Medical Association votes to study the use of stimulants among athletes.

Jacques Anquetil wins the Tour de France.

Floyd Patterson regains the heavyweight title, defeating Tommy Jackson.

Milwaukee Braves win the World Series over the New York Yankees, 4–3.

Baseball Most Valuable Players Mickey Mantle in American League and Hank Aaron in National League.

Boston Celtics win the National Basketball Association Championship, their first win of nine over the next ten years.

Detroit Lions take pro-football title over the Chicago Bears, 59–14.

University of Pennsylvania track star Bruce Dern resigns from team when told he must shave his Elvis Presley-style sideburns.

Arts & Living

Metropolitan Museum of Art, New York, celebrates the 152nd birthday of Hans Christian Andersen.

Film *Twelve Angry Men* starring Henry Fonda premieres in the United States.

The Rock 'n' Roll Show, first prime-time network special on rock music, is hosted by Alan Freed.

CBS airs documentary on Cuban revolution featuring interview with Fidel Castro.

Paul Gauguin's *Still Life with Apples* sells for $225,000.

New York Philharmonic names Leonard Bernstein musical director.

French author Albert Camus receives Nobel Prize for literature.

Wild Strawberries, written and directed by Ingmar Bergman, premieres.

"Beat" author Jack Kerouac publishes his classic novel *On the Road*.

Leonard Bernstein's musical *West Side Story* opens on Broadway at the Winter Garden Theater, New York.

Thirteen-year-old Bobby Fischer emerges as chess champion.

Ansel Adams begins publishing his five-volume *Basic Photo Series*, which is completed in 1969.

Jerry Lee Lewis's *Great Balls of Fire* debuts on music billboard charts.

Metropolitan Museum of Art, New York, pays $30,000 for Jackson Pollock's *Autumn Rhythm*.

The Museum of Modern Art, New York, organizes a *Picasso: 75th Anniversary* retrospective exhibition, May 22 to September 8.

Science & Technology

Experts report that "beyond a reasonable doubt," cigarette smoking causes lung cancer.

Britain detonates its first hydrogen bomb.

Soviet Union launches *Sputnik I*, first artificial satellite, into orbit. Later in the year, *Sputnik II* is sent into orbit with Laika, on board, the first dog in space.

Massive explosion of buried nuclear waste occurs at Chelyabinsk, a Soviet plutonium-producing facility, contaminating at least 400 square miles, and killing or exposing an unknown number of people.

Dutch-American physician Willem J. Kolff develops artificial heart. Implanted in a dog, the device keeps animal alive for 90 minutes. This same device, refined 25 years later, is implanted in a human being.

Largest radio telescope spanning 250 feet across is built at Jofrell Bank Experimental Station, Britain. Tracks *Sputnik I* during its orbit of Earth.

Alick Isaacs and Jean Lindemann discover interferon, a virus-fighting protein that is naturally produced by the body.

Soviet Union develops a long-range intercontinental ballistic missile.

1958

International

The United States and Soviet Union agree to widen cultural exchanges.

More than 100 people are killed or wounded during a civilian-rebel uprising in Caracas, Venezuela. General Marcos Perez Jimenez's dictatorship is overthrown.

Egypt and Syria create an alliance, forming the United Arab Republic.

Nikita Krushchev becomes Soviet premier.

Brussels World's Fair opens with pavilions from fifty-one countries.

Japanese tradition is broken when Prince Akihito is allowed to choose his own bride, rather than enter into an arranged marriage.

Americans Linus Pauling and Detlev Bronk are elected to the Soviet Academy of Science.

Lebanese officials ask United States to help stem arms flow from the United Arab Republic to Lebanese rebels.

Fidel Castro's forces arrest 28 United States Marines near an American Naval base in Guantanamo.

United States sends 5,000 Marine troops to Lebanon.

Queen Elizabeth II gives son Prince Charles official title "Prince of Wales."

Nikita Krushchev and Mao Tse-Tung meet in Peking to discuss Communism.

Fidel Castro declares war on the Batista government in Cuba.

Cardinal Angelo Giuseppe Roncalli is elected 262nd pontiff, to be known as Pope John XXIII.

Queen Elizabeth II attends Thanksgiving dinner hosted by Vice President Nixon at United States Embassy in London.

People's Republic of China begins "The Great Leap Forward," an economic plan aimed at revitalizing all sectors of the economy.

National

Gallup Poll reports that Eleanor Roosevelt is the most admired woman in the United States.

Thor missile is successfully tested by the United States Air Force.

Two military planes collide mid-air in California, killing forty-seven people.

United States launches first space satellite, Explorer I, around Earth.

According to Werner von Braun, United States space research is several years behind that of the Soviet Union.

Research reports that the United States has two-thirds of the world's television sets: 47 million.

Unemployment in the United States at its highest since 1941, at almost 5.2 million.

An unarmed atom bomb is accidentally dropped on farm home in South Carolina, injuring six.

While on tour in Venezuela, Vice President Richard Nixon is stoned, threatened, and spat on by protesters against United States policies in that part of the world.

Explorer IV is launched to explore cosmic-ray data.

Conviction against Arthur Miller for contempt of Congress is reversed.

National Defense Education Act is signed, providing college students with loans and aid for technical education.

The Rev. Dr. Martin Luther King, Jr. is arrested in Alabama for loitering and is fined $14 for refusing to obey police.

Clinton High School, Tennessee, is destroyed in dynamite explosion.

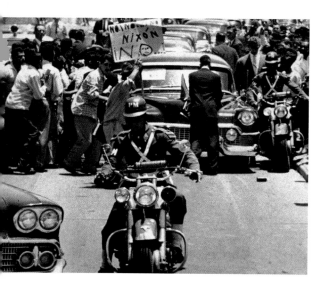

Plate 27, detail

Sports

Sugar Ray Robinson gains middleweight title for the fifth time.

Arnold Palmer wins his first Masters Tournament.

Jimmy Bryan wins the Indianapolis 500 and Pat O'Connor is killed in thirteen-car crash during race.

Wilt Chamberlain joins the Harlem Globetrotters.

Brazil wins World Cup over Sweden, 5–2.

Charly Gaul of Luxembourg wins Tour de France.

United States wins America's Cup for fourth time in a row.

New York Yankees defeat the Milwaukee Braves to win World Series, 6–2.

Baltimore Colts defeat the New York Giants, 23–17, in NFL Championship.

Bill Russell of the Boston Celtics wins National Basketball Association Most Valuable Player Award.

The Brooklyn Dodgers move to Los Angeles, and the New York Giants move to San Francisco.

World Amateur Golf Council is organized.

Arts & Living

Retrospective performance of John Cage's work in New York.

New York Metropolitan Opera's 75th anniversary.

Boris Pasternak's novel, *Doctor Zhivago*, is published in English. Pasternak later refuses to accept the Nobel Prize for literature. Westerners believe that the Soviet government convinced him to decline, although Pasternak maintained that it was a "voluntary refusal."

Cat on a Hot Tin Roof, starring Elizabeth Taylor and Paul Newman, and musical hit *South Pacific* are released at the box office.

The Donna Reed Show debuts on television.

Marc Chagall begins his stained-glass window for the cathedral at Metz, France.

Ludwig Mies van der Rohe designs the exterior of the Museum of Fine Arts, Houston, Texas.

Soviet Union publishes a ninety-volume set of Leo Tolstoy's works.

A fire at the Museum of Modern Art, New York, causes $320,000 in damage, affecting in particular two water-lily paintings by Monet.

"Beatnik" movement begins to spread from California across United States and Europe.

The American Dance Theater is founded by Alvin Ailey.

Christo makes his first "wrapped" objects.

Jasper Johns is given his first solo exhibition at the Leo Castelli Gallery, New York.

Paramount sells television rights to pre-1948 films for $50 million.

Science & Technology

Edmund Hillary, who conquered Mount Everest, reaches the South Pole with an expedition from New Zealand.

United States launches first space satellite, *Explorer I*.

National Aeronautics and Space Administration (NASA) is established by the United States to oversee the space program.

First moon rocket is launched from the United States but fails to reach its location.

Nautilus submarine sails under ice at the North Pole, making it the first undersea voyage in history.

The United States Food and Drug Administration withholds Thalidomide from the market due to suspicions about its safety for pregnant women. Those who obtained it abroad for morning sickness give birth to babies with severe birth defects.

First pacemaker is implanted in a human.

Plate 132, detail

International

Pope John XXIII calls ecumenical council, seeking unity among Catholics and other religious orders.

Fidel Castro imposes Communist government in Cuba, initiating new era in country's history, and takes oath as Cuban Premier.

Iran renounces 1921 treaty with Soviet Union.

France pulls its Mediterranean fleet out of NATO in case of war.

Dalai Lama flees Tibet, leaving it to Chinese rule, and asks for United Nations intervention.

Fidel Castro arrives in United States for eleven-day visit.

Great Lakes are linked to Atlantic Ocean with the opening of the St. Lawrence Seaway.

Census puts Soviet population at 208.8 million.

Vice President Richard Nixon meets with Soviet Premier Nikita Krushchev in Moscow, USSR, to discuss capitalism and Communism.

More than 1,000 are killed by typhoon that sweeps through Tokyo, Japan.

People's Republic of China celebrates tenth anniversary of Communist takeover.

Soviet Union signs accord with the United States for cooperation in science, sports, and culture.

Twelve nations sign pact to set Antarctica aside as a preserve for scientific research, banning any nuclear explosions or dumping of radioactive waste.

Charles de Gaulle is elected French president.

National

Alaska becomes forty-ninth state.

National Aeronautics and Space Administration (NASA) selects 110 prospective candidates for the first United States space flight.

Titan intercontinental ballistic missile is fired from Cape Canaveral for the first time.

Vanguard II, first United States weather station in space, is launched.

Studies are begun on nuclear fall-out effects from tests.

After fifty-one years, Oklahoma ends Prohibition by referendum.

Japanese-Americans regain citizenship lost during WWII.

Benjamin O. Davis becomes the first "Negro" to gain rank of major general in the United States military.

George Washington, the first United States submarine with ballistic missiles, is launched.

Lady Chatterley's Lover is banned from United States mail by Postmaster General on obscenity grounds. Ruling reversed in 1960.

American Steelworkers of America go on strike, shutting down steel industry for four months.

Hawaii becomes fiftieth state.

Massive power failure hits New York's Manhattan, affecting more than 500,000 people.

Explorer IV takes first television pictures of Earth.

1959

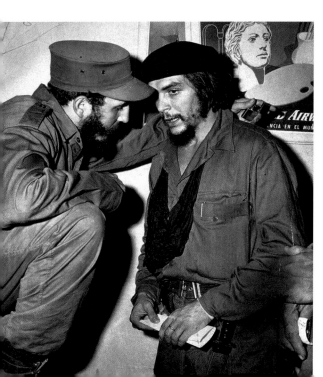

Plate 32, detail

Sports

United States Supreme Court outlaws Louisiana ban on fights between white and "Negro" boxers.

People's Republic of China, not Taiwan, is represented at Olympics.

Rodger Ward wins Indianapolis 500.

Wimbledon champion Alex Olmedo is expelled from National Clay Court Championships for listless play.

Federico Bahomontes of Spain wins Tour de France.

Los Angeles Dodgers win World Series over Chicago White Sox, 4–2.

Jockey Willie Shoemaker wins both the Kentucky Derby and the Belmont Stakes.

Floyd Patterson loses the world heavyweight boxing title to Ingemar Johansson but regains it in a rematch in 1960.

Jacques Plante of the Montreal Canadiens introduces the regular use of a protective mask for hockey goalkeepers.

Baltimore Colts win National Football League Title over the New York Giants, 31–16.

Arts & Living

Musicians Buddy Holly, J.P. "Big Bopper" Richardson, and Richie Valens are killed in a plane crash near Mason City, Iowa.

Rubens's *Adoration of the Magi* is sold to British collector Leonard Koester for $770,000.

Several television "quiz shows" are found to be fixed after a contestant on the $64,000 Question claims to have been "fed an answer."

Architect Frank Lloyd Wright dies before his seminal Guggenheim Museum in New York opens.

Marilyn Monroe and Tony Curtis star in *Some Like it Hot*; Gregory Peck and Ava Gardner are featured in Stanley Kramer's anti-nuclear war film *On the Beach*; and Alfred Hitchcock's *North by North West* opens at the box office.

Science-fiction series *The Twilight Zone*, hosted by Rod Sterling, and *The Untouchables* are the most popular television series.

Sidney Poitier stars in Broadway production of *A Raisin in the Sun*.

Barbie is introduced by Mattel.

Berry Gordy, Jr. founds Motown Records.

Marcel Duchamp by Robert Lebel is published.

John Lennon, Paul McCartney, George Harrison, and Stuart Sutcliffe form The Silver Beatles and later, in 1960, rename themselves The Beatles.

Science & Technology

American Airlines begins first coast-to-coast jet service from New York to Los Angeles, California.

United States satellite *Vanguard II*, the first weather station in space, transmits television photographs of cloud cover on Earth.

Radar contact is made with planet Venus.

Archaeologists find ruins of Nero's gardens in Rome, Italy.

United States launches *Savannah*, the world's first atomic merchant ship.

First telephone cable linking Europe and the United States is established.

United States paddle-wheel satellite transmits the first television pictures of Earth from space.

Soviet satellite *Lunik 3* takes the first photographs of the backside of the moon.

Louis and Mary Leakey discover two-million-year-old remains of *Homo habilis*.

Selected Bibliography

1938 Bessie, Simon Michael. *Jazz Journalism: The Story of the Tabloid Newspapers.* New York: E.P. Dutton & Co., Inc., 1938.

1946 Whiting, John R. *Photography is a Language.* Chicago and New York: Ziff-Davis Publishing Company, 1946.

1951 Berger, Meyer. *The Story of the New York Times, 1851–1951.* New York: Simon and Schuster, 1951.

1952 Hicks, Wilson. *Words and Pictures: An Introduction to Photojournalism.* New York: Harper & Brothers Publishers, 1952.

1962 Riesman, David, in collaboration with Reuel Denney and Nathan Glazer. *The Lonely Crown: A Study of the Changing American Character.* New Haven and London: Yale University Press, 1962.

1965 Rothstein, Arthur. *Photojournalism: Pictures for Magazines and Newspapers.* New York: American Photographic Book Publishing Co., Inc., 1965.

1971 Baynes, Ken; Tom Hopkinson; Allen Hutt; and Derrick Knight. *Scoop, Scandal, and Strife: A Study of Photography in Newspapers.* New York: Visual Communication Books/Hastings House, Publishers, Inc., 1971.

1973 Lee, Alfred McClung. *The Daily Newspaper in America: The Evolution of a Social Instrument.* New York: The Macmillan Company, 1937. Reprinted, New York: Octagon Books, 1973.

Szarkowski, John, ed. *From the Picture Press.* New York: The Museum of Modern Art, 1973.

1978 Keylin, Arleen. *The Fabulous Fifties.* New York: Arno Press, 1978.

1979 *The American Image: Photographs from the National Archives, 1860–1960.* Introduction by Alan Trachtenberg. New York: Pantheon Books, 1979.

1985 *The Fifties: Photographs of America.* New York: Pantheon Books, 1985.

1988 Fulton, Mariann, ed. *Eyes of Time: Photojournalism in America.* Boston, Toronto, London: Little, Brown and Company, in association with the International Museum of Photography at George Eastman House, 1988.

1989 Trachtenberg, Alan. *Reading American Photographs: Images as History, Mathew Brady to Walker Evans.* New York: Hill and Wang, 1989.

1990 Lhamon Jr., W.T. *Deliberate Speed: The Origins of a Cultural Style in the American 1950s.* Washington, D.C. and London: Smithsonian Institution Press, 1990.

1992 Carlebach, Michael L. *The Origins of Photojournalism in America.* Washington, D.C. and London: Smithsonian Institution Press, 1992.

Coontz, Stephanie. *The Way We Never Were: American Families and the Nostalgia Trap.* New York: Basic Books – A Division of Harper Collins Publishers, Inc., 1992.

Spigel, Lynn. *Make Room for TV: Television and the Family Ideal in Postwar America.* Chicago and London: The University of Chicago Press, 1992.

1993 Halberstam, David. *The Fifties.* New York: Villard Books, 1993.

1994 Marling, Karal Ann. *As Seen on TV: The Visual Culture of Everyday Life in the 1950s.* Cambridge, Mass. and London: Harvard University Press, 1994.

1996 Anderson, Paul F. *The Davy Crockett Craze: A Look at the 1950's Phenomenon and Davy Crockett Collectibles.* Hillside, Ill.: R&G Productions, 1996.

De Salvo, Donna. *Forces of the Fifties: Selections from the Albright-Knox Art Gallery.* Columbus, Ohio: Wexner Center for the Arts, 1996.

Emery, Michael; Edwin Emery, and Nancy L. Roberts. *The Press and America: An Interpretive History of the Mass Media.* Boston: Allyn and Bacon, 1996.

Safire, William and Peter Galassi. *Pictures of the Times: A Century of Photography from the New York Times.* Edited by Peter Galassi and Susan Kismaric. New York: The Museum of Modern Art, 1996.

1997 Carlebach, Michael L. *American Photojournalism Comes of Age.* Washington, D.C. and London: Smithsonian Institution Press, 1997.

Foreman, Joel, ed. *The Other Fifties: Interrogating Midcentury American Icons.* Urbana and Chicago: University of Illinois Press, 1997.

1998 Belgrad, Daniel. *The Culture of Spontaneity: Improvisation and the Arts in Postwar America.* Chicago and London: The University of Chicago Press, 1998.

Morris, John G. *Get the Picture: A Personal History of Photojournalism.* New York: Random House, Inc., 1998.

Loengard, John. *Life Photographers: What They Saw.* Boston, New York, Toronto, London: A Bulfinch Press Book – Little, Brown and Company, 1998.

Staniszewski, Mary Ann. *The Power of Display: A History of Exhibition Installations at the Museum of Modern Art.* Cambridge, Mass.: MIT Press, 1998.

1999 Frankel, Max. *The Times of My Life: and My Life with The Times.* New York: Random House, Inc., 1999.

Ritchin, Fred. *In Our Own Image: The Coming Revolution in Photography: How Computer Technology is Changing Our View of the World.* New York: Aperture Foundation, Inc., 1999.

Tifft, Susan E. and Alex S. Jones. *The Trust: The Private and Powerful Family Behind the New York Times.* Boston, New York, London: Little, Brown and Company, 1999.

Index